# PICTURE PERFECT

KIKU ADATTO

# PICTURE PERFECT

❧

*Life in the Age of the Photo Op*

NEW EDITION

PRINCETON UNIVERSITY PRESS
PRINCETON AND OXFORD

Published by Princeton University Press, 41 William Street,
Princeton, New Jersey 08540
In the United Kingdom: Princeton University Press, 6 Oxford Street,
Woodstock, Oxfordshire OX20 1TW
All Rights Reserved

Library of Congress Cataloging-in-Publication Data
Adatto, Kiku, date.
Picture perfect : life in the age of the photo op / Kiku Adatto. — New ed.
        p.        cm.
Includes bibliographical references and index.
ISBN 978-0-691-12439-1 (hardcover : alk. paper) —
ISBN 978-0-691-12440-7 (pbk. : alk. paper) 1. Mass media—Influence.
2. Television in politics—United States. 3. Mass media and culture—
United States. 4. Photography, Artistic. 5. Popular culture—United States.
6. Images, Photographic. 7. Television broadcasting—United States.
8. Journalism—United States. 9. Motion pictures—Social aspects—
United States. 10. Photojournalism. I.Title.
P94.A33 2008
324.7'30973—dc22        2007043298

British Library Cataloging-in-Publication Data is available
This book has been composed in Minion
Printed on acid-free paper. ∞
press.princeton.edu
Printed in the United States of America
1   3   5   7   9   10   8   6   4   2

*For Lily and Michael, with love*

# Contents

꽃

*Acknowledgments*
ix

INTRODUCTION: The Age of the Photo Op
1

CHAPTER 1: Picture Perfect
41

CHAPTER 2: Photo-Op Politics
67

CHAPTER 3: Contesting Control of the Picture
106

CHAPTER 4: Exposed Images
141

CHAPTER 5: Mythic Pictures and Movie Heroes
187

CHAPTER 6: The Person and the Pose
243

*Notes*
263

*Index*
279

## *Acknowledgments*

In the first edition of *Picture Perfect*, I explored America's fascination with image making in politics and the movies, in everyday life and on television, in popular culture and art photography from the 1960s through the early 90s. Given the dramatic changes brought by the Internet and the digital revolution, I was eager to take a fresh look at the media landscape—from network news to YouTube, from photo ops to Photoshop, from cell phone pictures to new trends in photojournalism—and so a new book was born from the old.

This book got its start when I was a fellow at the Joan Shorenstein Center on the Press, Politics, and Public Policy at Harvard's John F. Kennedy School of Government. I am grateful to the faculty and fellows who were at the center at that time, including Marvin Kalb, Ellen Hume, Bill Wheatley, John Ellis, and Scott Matheson, and to the Markle Foundation, which awarded me a grant to support the writing of the first edition. To test my ideas about the changing role of images in television coverage of political campaigns, I interviewed some sixty-five network reporters and producers, media consultants, and politicians. I would like to thank all of them for their willingness to watch the videotaped excerpts I showed them, and to share their insights and experiences. I owe special thanks to Bob Schieffer, Sanford Socolow, Sander Vanocur, and Bill Wheatley for their generous help and support.

Writing the new edition involved more than bringing the story of photo ops and image making into the age of Facebook and YouTube. It also involved thinking through the meaning of photography in politics and everyday life. I can think of no setting

more congenial than the Harvard Humanities Center, where, as a scholar in residence, I researched and wrote the new version of *Picture Perfect*. Homi Bhabha, the center's director, Steve Biel, the executive director, and Mary Halpenny-Killip, the center's gifted administrator, created a climate of bracing yet warm intellectual exchange.

I would like to thank the students in my seminars at Harvard who were always brimming with ideas and insights, and especially my resourceful and talented research assistants—Katie Hatch, Meg Parekh, Carrol Chang, Ilan Graff, Joy Gragg, Gloria Park, Paula Nisbett, and Sherelle Ferguson. I owe a special debt of gratitude to my friend Susan Gilroy, the head reference librarian at Harvard's Lamont Library, who was wonderfully generous with her time and research skills.

For me, thinking and writing go best when they emerge from animated conversation—whether in the seminar room, at the dinner table, or on long walks with colleagues, family and friends. My ideas about images and image making were refined and enlarged through conversations with Jeffrey Abramson, Fouad Ajami, Pearl Bell, Sacvan Bercovitch, Homi Bhabha, Jackie Bhabha, Heather Campion, Chuck Campion, Jack Corrigan, Kathleen Corrigan, Diane Coutu, Jean Elshtain, Thomas Friedman, Marc Hauser, Stanley Hoffmann, Margo Howard, Ada Louise Huxtable, Alex Jones, Esther Kartiganer, Bill Kovach, Lisa Lieberman, Debby Loewenberg, Steve Love, Marcela Mahecha, Harvey Mansfield, Marcia Marcus, Russ Muirhead, Barbara Norfleet, Tom Patterson, Le Proctor, David Riesman, Tom Rosenstiel, Penny Savitz, Andy Savitz, Susan Shell, Sandy Socolow, Bernie Steinberg, Doris Sommer, Joy Sandel, Matthew Sandel, Judith Shklar, Monique Doyle Spencer, Valya Shapiro, and Susan Tifft.

I was fortunate to work with Ian Malcolm, my editor at Princeton University Press, who believed in this book throughout, and shepherded it to publication with intelligence and grace. Dawn Hall, Sara Lerner, and Sol Kim Bentley provided invaluable help in bringing the book to completion.

I am especially grateful for the support of my family. My brother Richard and my sisters Vicki and Debbie were a constant

source of encouragement—reading chapters and offering many helpful comments. My sons Adam and Aaron spurred me on to the finish line, and provided many welcome writing breaks—cooking together, walking on the beach at Sanibel, and taking Asa for runs in the park. My father Albert Adatto, an immigrant to this country, made me alive to photos as markers of memory.

Above all, I am grateful to my mother Lily Adatto and my husband Michael Sandel, the two people who were my greatest sources of support. My mother has the eye of an artist and the ear of a writer. She not only read the entire manuscript but also discussed the ideas with me as they evolved. Michael made my work better and my life a joy. I am the luckiest woman in the world to have him by my side.

# PICTURE PERFECT

INTRODUCTION

# The Age of the Photo Op

On Thursday, May 1, 2003, President George W. Bush soared above the Pacific in a Navy Viking jet. The Navy pilot then made a dramatic tail-hook landing on the nuclear-powered aircraft carrier, the USS *Abraham Lincoln*, just returning from the Iraq War. Bush emerged from the plane in a flight suit and helmet, strode across the deck, shook hands, posed for pictures with members of the crew, and then watched a dramatic flyover by F-18 fighter jets. Later, in suit and tie, with a big banner proclaiming "Mission Accomplished" in the background, Bush stood before the assembled crew and dignitaries and declared the end to major combat operations in Iraq.

It was a perfect set of pictures, and the media was quick to take note of the fact. One after another, television newscasts described Bush's tail-hook landing as "historic," and compared it to heroic landings in blockbuster Hollywood movies like *Top Gun*, *Air Force One*, and *Independence Day*. Reporters noted that Bush took control of the Viking jet for a third of the journey, and they interviewed the self-effacing pilot about the awesome responsibility of having the president of the United States as his copilot. To heighten the excitement, CNN had one of their correspondents ride in another F-18 fighter jet with her cameraperson to be an "eye in the cockpit" to describe the sights and sensations of taking off and landing.[1]

Yet, even as television reporters praised, even reveled, in the pictures, they were also quick to call attention to the stagecraft. So similar was the language of the commentators from the three major cable news networks that they sounded like theater critics

comparing notes. "Who dreamt this up?" asked Keith Olbermann, host of MSNBC's show *Countdown*. "Who orchestrated this?" "Probably somebody from their communication shop. . . . Whoever it was, it was brilliant," observed Kirk Hanlin on FOX News Network, "There's an election less than a year and a half away and having him standing on the deck of one of the mightiest warships on the planet is definitely a good image." It's the "ultimate photo opportunity" declared CNN anchor Aaron Brown. Chris Matthews of MSNBC saw the event as Bush's direct challenge to the Democrats: "Do you really think you've got a guy in your casting studio . . . who can match what I did today?"[2] The *New York Times* joined the chorus, declaring in a subsequent front-page story: "George W. Bush's 'Top Gun' landing on the deck of the carrier *Abraham Lincoln* will be remembered as one of the most audacious moments of presidential theater in American history."[3]

Television and newspaper reporters spent a lot of time taking their readers backstage and behind the scenes. A controversy raged for months afterward in the media about who put up the sign that read "Mission Accomplished." Was it just a group of enthusiastic sailors aboard the ship, or was it Bush's savvy media team who were embedded aboard the ship days before the event? At first, Bush claimed that he did not have advance men that "ingenious," and it was all the sailors' idea. Later news reports noted that the Bush team (headed by a top former television news producer) had indeed produced and arranged for the sign to be placed strategically before the cameras. It also came out that the *Abraham Lincoln* was supposed to be hundreds of miles out at sea for the big event, but the ship had made faster progress than anticipated and was only thirty miles from the California shore. To simulate the feel of a ship far out at sea, the massive nuclear-powered aircraft carrier was turned around so as not to reveal the coast of San Diego in the background.[4]

Some eight months after the "Mission Accomplished" pictures aired on television, Joseph Darby, a sergeant and army reservist stationed in Iraq, was hoping to take home some of his snapshots of the Babylon Palace, Al Hillah, and other places he'd been. But the sun and heat of Iraq had not been kind to his photos.[5] To his

dismay, the pictures had begun to curl and peel. So Darby thought of a great solution for his melting photos: Why not borrow some digital photos of the places he wanted to remember? One evening, with his laptop at the ready, Darby was volunteering at a satellite cybercafe on the military base. He spotted a fellow reservist, Spec. Charles Graner, and asked him if he could borrow a digital picture file of the sights and scenes of their Iraq tour. Graner was happy to oblige and handed Darby a couple of CDs. Darby downloaded the picture files onto his laptop computer and gave them back to Graner. An evening or two later, Darby sat down to look at the pictures. The first CD contained the pictures Darby had asked for. The second CD contained photos of a very different sort. An image appeared of a pyramid of naked Iraqi prisoners with American guards posing for the camera.

This was the first of a series of photographs of prisoner abuse by American soldiers at Abu Ghraib prison outside Baghdad, once an infamous place of torture and death under the dictatorship of Saddam Hussein. The Abu Ghraib photographs were troubling not only for the abuse they depicted but also for their style. The photographs, taken by U.S. servicemen and women with digital cameras and shared via e-mail, conveyed the happy normalcy of snapshots from a family vacation: "Look at me and see what a great time I'm having." One of the first images to come up was of Charles Graner and a female prison guard, Pvt. Lynndie England, standing arm in arm, smiling broadly, and giving a thumbs-up to the camera as they stand behind a pyramid of naked Iraqis. In another photograph, Lynndie England poses holding a leash attached to a naked prisoner's neck. The mugging for the camera continued as England poses for the camera, cigarette dangling from her mouth, while pointing to the naked bodies of Iraqi prisoners lined up against a wall. Other photos showed prisoners being beaten or made to assume sexually explicit and humiliating poses. One of the starkest pictures (which later became an icon of the Abu Ghraib prison abuse) showed an Iraqi prisoner with a black pointed hood over his face, draped in a black cloth, and standing on a box with electrical wires attached to his body.

Viewing picture after picture on his computer screen, Joseph Darby was disgusted. It was not that he considered himself a Boy Scout. He knew that in the heat of the moment during the war he had exceeded the proper use of force. He had kept secrets in the past for his fellow soldiers and did not consider himself the kind of person who would "rat" on others. But these pictures "crossed the line," and Darby felt he had no choice but to do what was "morally right." He burned a copy of the CD and turned it in to the authorities. The pictures prompted an investigation by the U.S. military in January of 2004 that later pronounced the acts of the guards at Abu Ghraib prison as "sadistic, blatant, and wanton criminal abuses."[6]

The Abu Ghraib photographs became public when *60 Minutes II* broke the story on April 28, 2004, and the photographs were soon disseminated worldwide via the Internet, newspapers, magazines, and on television. Arab television stations showed them repeatedly as evidence of the hypocrisy and brutality of America's effort to bring democracy to Iraq. What started as the sharing of private picture files among friends was soon magnified on multiple screens imprinting the images over and over again. Joseph Darby thought that when he turned in the CD of the Abu Ghraib photos the offending prison guards would be taken off duty and tried, but he did not think "the world would ever hear about it."[7] "If there were no photographs, there would be no Abu Ghraib, no investigation," observed Javal Davis, a member of the military police who was charged with prisoner abuse, court-martialed, and sentenced to six months in prison. "It would have been, 'O.K., whatever, everybody go home.'"[8] An Amnesty International spokesperson noted that the Abu Ghraib pictures are "an object lesson for human rights activists in terms of the visual impact of the horrible stuff we write about all the time. . . . People can't understand the description, but they can understand the pictures."[9]

Two and a half years after the Abu Ghraib story broke, Americans pondered a different set of pictures—this time video images. As the sun was ready to rise over Baghdad on Saturday, December 30, 2006, Saddam Hussein, Iraq's brutal dictator, was hanged after

being tried and convicted by Iraq's Shiite-led government.[10] Only Iraqi officials, executioners, and guards were present.[11] The Iraqi government released an official video of the hanging, which aired on the state-controlled Iraqi television and then on American television. In a war filled with brutal, bloody, and violent images, the official execution video was not a standout. A subdued Saddam Hussein dressed in a black overcoat and white shirt is led to the gallows by a group of executioners wearing black ski masks. They converse with Hussein, tie a black scarf around his neck, and then fit him with the noose. The actual hanging is not shown. The video had no soundtrack. Iraqi and American television networks provided the commentary and context.

For those who oppose capital punishment, the notion of a dignified execution, much less a dignified videotape of an execution, is an oxymoron. For their part, Iraqi officials declared that justice had been served, that the execution was carried out by the letter of Iraqi, Islamic, and international law, and that Saddam Hussein had gone to the gallows soberly and quietly.[12] After the hanging, a statement issued by President George W. Bush praised the execution as "an important milestone on Iraq's course to becoming a democracy," noting that, "We are reminded today of how far the Iraqi people have come since the end of Saddam Hussein's rule."[13]

Then all hell broke loose. The semblance of order conveyed by the silent state-sponsored video of the execution was shattered by the appearance of an unauthorized, eyewitness cell phone video of the execution that shot across the Internet and television. Shot from below the gallows, the camera jerks back and forth from the gallows to the floor, to the staircase, to the noose around the dictator's neck. But the force of the video was not its raw, cinema verité quality or its resemblance to an amateur horror film. It was the presence of sound, sound that shocked the sensibilities of the American public. Guards and witnesses chant "Muqtada, Muqtada," referring to Muqtada al-Sadr, a Shiite religious leader and leader of a large Iraqi militia with death squads. Saddam Hussein tells the guards to go to hell, and they tell him to go to hell. Voices call out the name of a revered Shiite leader executed by Saddam.

Saddam utters a final prayer. There is the sharp bang of the trap door as he falls to his death. The camera jerks around. A final close-up shows the dead dictator's face, his neck wrenched by the hanging, then darkness.

Paired with the dark, murky, jumpy images, the soundtrack revealed the violent sectarian divisions in Iraq and the dark disordered soul of war. It also had the startling effect of making the brutal dictator and mass murderer look like the victim and the taunting Shiite witnesses look like thugs. John Burns, veteran reporter of the Iraq War for the *New York Times*, when asked by CNN's Anderson Cooper if the Iraqi government was trying intentionally to mislead people with the official video, responded, "Of course, they had their own expedient reasons in those first hours to present this thing as having been done in a dignified fashion. And now they are trying to reconstruct it in the face of that video, which you know, is, it seems to me, whistling against thunder. We know what that video meant. We know what happened there with an absolute certainty."[14]

Taken together, the "Mission Accomplished," Abu Ghraib, and Saddam execution pictures tell more than a story about the Iraq War. They reveal much about the media landscape in which we live, and the power of pictures in our time. In the age of the Internet, the battle for control of the pictures, once waged primarily on television by politicians and the networks, now includes a host of new players. Digital, satellite, and wireless technology, the proliferation of cell phone video cameras, laptops, blogs, and the 24-hour news cycle have speeded the transmission of news and vastly increased the picture-taking power of the individual. A citizen activist in Albuquerque or a terrorist in hiding in Afghanistan can take a picture with a webcam, video camera, or cell phone, and immediately send it via e-mail, or post it on the Internet for worldwide viewing. Major news organizations now regularly incorporate and solicit cell phone pictures taken by ordinary citizens of breaking news and offer an array of online offerings—photographs, slide shows, podcasts, picture-sharing sites—in order to keep viewers engaged and tuned in.

The presence of the camera today in all its many forms—cell phone cameras; webcams on home computers; "pan, tilt, and zoom" surveillance cameras in stores, buildings, on city streets and highways; satellite cameras; and military surveillance drones—means that we can survey the world or be surveyed, expose someone or be exposed at any time. The documentary power of the camera has vastly increased, but so has the ability of the camera not only to falsify information but also to falsify ourselves. We have more opportunities to live at the surface, continually posing, to see and measure ourselves by the images we make and the images others make of us.

## The Photo-Op Culture

My book is the story of the rise of a new form of image consciousness—a photo-op culture—that has been unfolding since the Second World War in photography, politics, popular movies, television, the Internet, and in everyday life. When the photograph was first invented in the nineteenth century, people were fascinated by the realism of the camera even as they acknowledged the artifice of the pose. In contemporary American culture, our sensibility has shifted. Now we are alive as never before to the artifice of images. Today we pride ourselves on our knowledge that the camera can lie, that pictures can be fabricated, packaged, and manipulated.

We have even developed an affection for artifice and an appreciation of slick production values, whether in political campaigns, Super Bowl commercials, celebrity photographs, or a favorite movie. A political cartoon that appeared during the 1992 presidential primaries captures this tendency well. Two rural southerners sit on the front porch of a ramshackle general store called Bubba's, talking politics. One says to the other, "I like Buchanan's sound bites, but Clinton and Tsongas have slicker production values." Now, the guys at Bubba's could log onto their laptop computers and evaluate the Web sites of the current batch of political candidates, or create their own political blogs, or

watch a video of the latest misstep or gaffe of a politician on Internet picture-sharing sites like YouTube or MySpace.

If one side of us appreciates, even celebrates, the image as an image, another side yearns for something more authentic. We still want the camera to fulfill its documentary promise, to provide us with insight, and to be a record of our lives and the world around us. But because we are so alive to the pose, we wrestle with the reality and artifice of the image in a more self-conscious way than our forebears.

## Photo-Op Politics

This tension is most vividly displayed in television coverage of presidential politics. As politicians mastered the art of television image making, reporters shifted from recording their words to exposing their images and revealing their contrivances. George W. Bush's "Mission Accomplished" moment on the deck of an aircraft carrier was part of a long tradition of attempts by presidents to control their television image and to use images to convey their political messages. In the early 1960s, John F. Kennedy mastered the new medium of television. He knew how to play to the camera in the Nixon-Kennedy debates. He created the Camelot presidency, which featured warm, inviting, and arresting photographs of his young family and glamorous wife. He displayed a quick wit, humor, and an easy repartee with reporters in his televised press conferences. Yet Kennedy's mastery of the medium still drew mostly on traditional forms of political events—speeches, rallies, and debates.

It was not until the presidency of Ronald Reagan in the 1980s that a politician and his media term mastered the art of the media event. So successful was the Reagan team at setting up compelling television images—from using the beaches at Normandy as a backdrop to portraying Reagan sitting astride his horse at his ranch looking like a classic American cowboy—that subsequent presidents and presidential candidates emulated the art of stage

sets, backdrops, and gripping visuals to convey their messages through pictures.

Politicians became so adept at manipulating television images that the reporters who covered them had to find a way to strike back, to bring to the attention of their viewers and readers all the contrivances and manipulations behind the images they were seeing. This desire to remind the viewers and readers of the behind-the-scenes attempts to control the pictures fundamentally changed the way politics and especially political campaigns have been covered over the last three decades. Today, presidential campaign coverage is as much about *how* candidates are setting up their pictures and projecting their images as it is about their policies and pronouncements. Reporters try to unmask the image making to expose the staged media events and machinations of media advisers.

Yet, for all their attention to the pose behind the picture, the networks remain entangled in the artifice of the images they show. By lavishing attention, even critical attention, on photo opportunities, media events, and political commercials, they give yet more airtime to the politicians' potent pictures. And, too often, no amount of reporting on their status as images diminishes their impact.

Such television and newspaper coverage conveys, in effect, a paradoxical message: Behold these striking pictures. But as you behold them, beware of them, for they are not real. They are setups, the products of politicians, media consultants, and spin-control artists who are trying to move you or manipulate you or persuade you. So do not take these pictures at face value. They are photo ops, contrived for the sake of our television cameras, and in this sense, our cameras lie.

The term *photo op* is so familiar that it has become synonymous with the word *picture* itself. It wasn't always this way. In 1968, in the presidential campaign between Richard Nixon, Hubert Humphrey, and George Wallace, the term *photo opportunity* was used only once on the network evening newscasts during the entire general election coverage. This despite the fact that Richard Nixon had learned from his loss of the 1960 television debate to

John Kennedy the importance of television and went to great lengths to control his television image.

Television reporters in 1968, however, still concentrated on what the candidates said and did and not on how they constructed images for television. The one lone example of the use of the term *photo opportunity* came in a *CBS Evening News* report by John Hart on October 15. Reporting on Nixon's appearance with television star Jackie Gleason on a Florida golf course, Hart used the term with derision. Nearly everything Nixon does these days is programmed. Hart then described Nixon's "deliberately casual moments, moments his programmers have labeled 'photo opportunities.' "[15]

"In 1968, I thought it was a joke," Hart recalled. "I thought if you said the campaign is calling this a 'photo opportunity,' people would laugh, and photo opportunities would be disgraced. People would say, 'Oh, we see through it now.' But over the years, I've seen reporters use it in a neutral sense without the irony. It was created cynically, in a manipulative sense. And suddenly the act and what it represents is accepted."[16]

But if many pictures of politicians today are mere photo ops, why do the television networks persist in airing them? Why not simply refuse to show them? Some network reporters and producers reply that their job is to show what happens each day since presidential campaigns consist largely of contrived media events, ads, and Web images, and that is what they must show on the evening news. Others, including politicians, media advisers, and some television journalists, observe that given competitive pressures for ratings and profits, the networks cannot resist showing the visually arresting pictures the campaigns produce.

There is truth, no doubt, in the various explanations—economic, political, and technological—for the transformation of television news. But what intrigues me most in watching political coverage and talking to the participants is something else. Whatever the causes of the photo-op style of television news, it creates a tension or dilemma for television and newspaper journalists. On the one hand, the growing entertainment orientation of network news compels reporters and producers to get the best possi-

ble picture, even if this makes them accomplices in artifice; on the other hand, the traditional documentary ambition of television journalism compels them to puncture the picture, to expose the image as an image. Although network reporters and producers do not think of their job in these terms, they find themselves engaged in the dual role of first perfecting and then puncturing the picture, by calling attention to its self-conscious design.

Although we often blame television for all that is wrong with contemporary politics, the preoccupation with political image making is not unique to our time. Since long before the advent of television, politicians have sought to manipulate the power of images, and journalists have struggled with the realism and artifice that pictures convey.

Those who despair at the triviality of modern campaigns often complain that Abraham Lincoln would never have triumphed in our picture-driven age. But Lincoln was far from innocent of the political use of pictures. When he became president he wryly thanked his photographer Mathew Brady for providing him with the dignified image that helped him win the White House. His presidential campaign was the first to distribute mass-produced portraits of the candidate. Their popular appeal led one of Lincoln's advisers to conclude, "I am coming to believe that likenesses broad cast, are excellent means of electioneering."[17]

When Nancy Reagan, on stage at the 1984 Republican convention, blew a kiss to an image of her husband, Ronald Reagan, portrayed on a giant video screen above the podium, the delegates applauded wildly. But for all its technological novelty, the scene recalled an earlier celebration of a presidential likeness in Abraham Lincoln's bid for the presidency. As the Republican convention of 1860 nominated Lincoln, supporters in the balcony showered the delegates with portrait prints of the candidate, which they greeted with "perfectly deafening applause, the shouts swelling into a perfect roar." When Lincoln was declared the nominee, a large portrait was exhibited from the platform, to further cheers.[18]

The Lincoln likenesses distributed at the 1860 convention and during the election campaign differs from the now-familiar Lincoln image that adorns the penny. Between his election and inau-

guration, Lincoln made an apparently image-conscious decision, encouraged by supporters who hoped to improve his appearance: he grew a beard. "[A]fter oft-repeated views of the daguerreotypes," a group of Republicans wrote Lincoln, "we have come to the candid determination that these medals would be much improved in appearance, provided you would cultivate whiskers and wear standing collars. Believe us nothing but an earnest desire that 'our candidate should be the best looking as well as the best of the rival candidates,' would induce us to trespass upon your valued time."[19]

Replying to a young girl who had written with similar advice, Lincoln seemed to resist the suggestion. "As to the whiskers, having never worn any, do you not think people would call it a piece of silly affect[at]ion if I were to begin it now?" But just as later politicians would overcome their distaste for wearing makeup on television, Lincoln overcame his fear of affectation. By the time he was inaugurated, the whiskers had appeared.[20]

## Failed Photo Ops and the Obsession with Gaffes

In the fall of 2005, President George W. Bush went to Beijing to meet with President Hu Jintao of China. The *New York Times* reported the story on the front page, noting in the lead paragraph, "In a day of polite but tense encounters, President Hu Jintao of China told President Bush on Sunday that he was willing to move more quickly to ease economic differences with the United States but he gave no ground on increasing political freedoms."[21]

The article proceeded with the usual thoroughness and gravity. The accompanying pictures were a different story. Four large color pictures of Bush stretched like a cartoon panel down the front page and below the fold. The first picture shows Bush walking toward a door in a formal meeting hall with bright red panels, the second catches Bush with a goofy expression on his face as he clutches a large brass door handle, the third shows Bush looking across the room as an aide gestures toward the proper exit, and the last shows Bush waving as he begins his exit. The caption reads, "After meeting with reporters in Beijing, Mr. Bush tried to

exit through a locked door. Realizing the mistake, he made a mock grimace, and an aide pointed the way. He joked: 'I was trying to escape. It didn't work.' "

Why were these pictures in the paper? And why do similar photos appear with growing frequency in the *Times*, other newspapers, and on multiple Internet sites? The answer has less to do with any overall policy or political bias on the part of the media than with a larger cultural trend. One side of photo-op coverage features how public figures set up their "perfect pictures." The *Times*'s front-page coverage of Bush's "Mission Accomplished" moment, "Keepers of Bush Image Lift Stagecraft to New Heights," falls into that category. Another side of photo-op coverage is to elevate minor mishaps—gaffes, spills, squealing microphones— or backstage behavior—putting on makeup, combing one's hair, or choosing a jacket and tie—into front-page news.

The magnification of politicians' mishaps or the construction of "failed photo ops" reflects a kind of guerrilla warfare between the media and politicians, an attempt to resist manipulation by puncturing the images the politicians and their media teams dispense. The more the politicians seek to control their images, the greater the temptation among reporters and photographers to beat them at their own game, to deflate their media events by magnifying a minor mishap into a central feature of the event.

One gets a glimpse into how the press rationalizes what they do by looking at the way the public editor of the *New York Times*, Byron Calame, responded to readers' criticism of the Bush in Beijing photos about two weeks after they appeared. Calame noted that, "Mr. Bush gets his fair share of serious, staged appearances on Page 1," and quotes *Times* editor Martin Gottlieb's rationale for running the Bush pictures as "a choice between a photo op [a picture of Mr. Bush riding a bicycle with a group of Chinese riders] or a picture of something that happened spontaneously." Bill Keller, the *Times*'s executive editor, thought the locked-door photos of Bush were "amusing," "depicted a real event," and "would draw people into the paper."[22]

We can see the *Times* editors straining to find news value in the picture, rationalizing that it was "spontaneous" and "a real event," when in fact it was a scrimmage in the battle between the

press and politicians for control of the picture. Making bloopers and minor gaffes big news is an alluring, often irresistible ploy, even if it means a departure from standard news values. Readers, used to watching baseball bloopers or outtakes of their favorite stars goofing up scenes during the final film credits, will laugh or be outraged depending on how they feel about Bush.

The public editor of the *Times* was right about one thing. The *Times*, along with other newspapers and the television networks, gives Bush his fair share of "serious staged appearances." In fact, like the networks, the *Times* helps produce and perfect them. Photo ops, after all, are not facts of nature. It always takes "two to tango" with a photo opportunity. The media advisers set up the "opportunity," but the press has to take the photo. Here is where the news decision comes in: Does the press accept or reject the opportunity? Do you take the picture, and, more important, do you decide to run it?

Just as television embraced Bush's "Mission Accomplished" moment, the *Times* embraced the photo opportunity on many occasions. During the Iraq War years, the *Times* ran various flattering front-page photos of Bush: presenting a Thanksgiving turkey to the troops in a Norman Rockwell–like scene; defending a classified eavesdropping program while framed by a painting of Teddy Roosevelt as a Rough Rider on a rearing horse; or standing tall in a heroic *Star Wars*–style photo at the U.S. Naval Academy, framed in rich blue and gold with not one, but two strategically placed signs saying "Plan for Victory."

The question remains: Does fairness and balance in reporting mean perfecting some photo ops and puncturing others? Is there a way the press can resist the photo-op mentality altogether?

## The Pros and Cons of Framing the Flaw

There are times a politician's misstep caught on camera reveals an important, if unsavory, part of who he or she is. In such cases, the camera provides an important reality check; it witnesses and documents what might otherwise be hidden from public view.

This was the case when Republican senator and presidential contender George Allen of Virginia used an obscure racial epithet, *macaca*, in reference to a young American college student of Indian descent who was videotaping his reelection campaign rally for his Democratic opponent, Jim Webb. Tracking opponents is a common political practice. In fact, Allen had met the young man, and his campaign had treated him courteously, even offering him food at their public events. But on this day, Allen decided to acknowledge his presence for the first time: "Let's give a welcome to macaca here," declared Allen as he played to the crowd. "Welcome to America and the real world of Virginia."[23] The Webb campaign posted the video on YouTube; it went "viral," spreading quickly on the Internet and getting huge media exposure on television and in newspapers, magazines, and blogs. Within weeks, the Allen campaign was in a nosedive; his macaca gaffe was compounded by awkward, defensive statements about his mother's Jewish background. He lost his bid for reelection.

The presence of the digital—cell phone and video camera and picture-sharing sites—widens the opportunities for "gotcha moments" when a public figure is brought down. As one *Washington Post* headline put it, "Blundering Pols Find Their Oops on Endless Loop of Internet Sites." The author of the article, Paul Farhi, makes an important point: "Unlike a 'negative' campaign commercial, online video is typically cheap to produce and distribute. Video clips also aren't subject to campaign finance limits of Federal Election Commission disclosure requirements (the ubiquitous 'My name is [blank] and I approve this message'). Since YouTube allows users to post videos under aliases, it can be nearly impossible to tell exactly who is disseminating a particular clip."[24]

Sometimes critics deplore a politics of "gotcha moments" and negative campaign ads, but such a generalization is a mistake. The question is, "gotcha" doing what? If it is singing "The Star Spangled Banner" off key, a minor slip of the tongue, or choking on food, the gotcha moment trivializes and dehumanizes politics. It turns the camera into a petty panopticon, forever searching for mistakes, and turns politicians into overly cautious, guarded figures contriving to avoid mistakes. The American public is

left disenchanted with politics, even if temporarily amused with the foibles of politicians. Instead of political debate fostered by a searching press acting as democracy's watchdog, we have an image war of posing and posturing between the media and the politicians.

Yet, the presence of cell phone cameras and video cameras is an important check on misconduct, and can enlarge the meaning of the public square or the town meeting writ large. A politician can no longer pander to the prejudices of select audiences. He or she is forced to speak in a larger, more open public square. As one Republican strategist put it: "YouTube has every campaign on notice that someone's watching. This has been a real wake-up call to a lot of candidates who shoot from the lip when there isn't a big TV affiliate standing in the room."[25]

Another argument for calling attention to photo ops is that failed photo ops, like successful ones, function as metaphors, symbols, or condensed arguments in public debate. Pictures, like words, are fair game, part of the language of partisan politics in a democracy. For example, when the Democratic nominee John Kerry went goose hunting in Iowa to boost his appeal to hunters and rural voters during the 2004 presidential campaign, the Republicans were quick to strike back. "The Second Amendment is more than a photo opportunity," quipped Vice President Dick Cheney. "I understand he bought a new camouflage jacket for the occasion, which did make me wonder how regularly he does go goose hunting. My personal opinion is his new camo jacket is an October disguise, an effort he's making to hide the fact that he votes against gun-owner rights at every turn."[26] For their part, the Democrats, as the party out of power for eight years, used the term *photo op* as a stand-in for all they considered misguided about Bush's policies, accusing Bush of "photo opportunity" politics and a photo-op foreign policy. After Bush's Thanksgiving visit to the troops in Iraq generated great front-page pictures, for example, retired general Wesley Clark, a Democratic presidential hopeful, remarked on CNN, "A visit, a photo op, or whatever it was to Baghdad does not make up for a failed strategy."[27]

The battle to control the picture and the use of failed photo ops extends well beyond domestic politics. Even the U.S. Army is deploying failed photo ops in their antiterrorist campaigns. During the Iraq War, American troops raided an abandoned hideout of Al Qaeda leader Abu Musab al-Zarqawi in a town south of Baghdad. Zarqawi, along with other camera-savvy terrorists, was a master at manipulating pictures and had released Internet videos of beheadings, hostage takings, threats to opponents, and proclamations to adherents. His latest video portrayed him as a picture-perfect jihadist firing long bursts from his machine gun. In the raid the U.S. Army confiscated Zarqawi's videos and used the outtakes to mock him at a news briefing in Baghdad. In one scene, Zarqawi appears not to know how to use the machine gun, and an aide off camera calls, "Go help the sheik." Another scene shows the fearsome terrorist wearing white New Balance sneakers beneath his flowing black robe. "What you saw on the Internet was what he wanted the world to see," General Lynch said. "Look at me, I'm a capable leader of a capable organization, and we are indeed declaring war against democracy inside of Iraq. . . . What he didn't show you were the clips that I showed."[28] The "failed images" video may have been satisfying to make, but it was not viewed on the most popular Arab channels, Al Jazeera and Arabiya, stations attuned to a different sort of photo-op politics.[29]

For all the framing of the flaw and creation of failed images, one has to ponder the failed images that we do not even recognize—the ones that look right, that we believe are documents, but fail us because they are not what they seem. This was the case with the image of the toppling of the statue of Saddam Hussein early in the Iraq War. The way the picture played on the news, it looked like the toppling of the statue had the force of the Berlin Wall coming down. That's because the networks showed the statue close up. But if they had pulled the camera back, it would have revealed a different truth. The square was fairly empty. There were few Iraqis present. The operators of the equipment were members of the U.S. military.[30]

## The Photoshopped Photo Op

In the age of the Internet and digital technology, perfecting the picture has been taken to a new level—the "Photoshopped photo op." These days, if the setting or backdrop or camera angle is not good enough to get the perfect picture, political campaigns may be tempted to doctor or enhance the picture using digital technology and photo-editing software like Photoshop.

During the 2004 presidential campaign, for example, President Bush's campaign had to pull a television ad after admitting that a photograph of the president addressing American soldiers had been digitally enhanced. A liberal blog, DailyKos, exposed the fact that the same soldiers' faces appeared in several different places in the crowd, and word of the doctored photo quickly spread via the Internet. A spokesman for the Bush campaign explained that the original photograph had been altered because the president and his podium obscured part of the crowd. In defense of the digitally enhanced picture (which had removed the president and the podium to make room for the duplicated soldiers), Republican adviser Steve Schmidt told the *Los Angeles Times*, "The soldiers are all real."[31]

Another example of a digitally altered photograph occurred earlier in the 2004 presidential campaign. Republican opponents of Democratic front-runner John Kerry tried to undermine his status as a war hero by portraying him as an anti-American war activist who exaggerated his military record. To dramatize the point, someone not officially connected to the Bush campaign decided to create a digitally doctored picture of John Kerry standing next to controversial Hollywood actress Jane Fonda at an antiwar rally. The photo combined a photograph of Kerry attending a 1971 antiwar rally with a photo of Jane Fonda at a different rally. To make the doctored picture of Kerry and Fonda look like an authentic news photograph, it was circulated on the Internet with the official logo of the Associated Press.[32]

Media advisers of politicians are not the only ones who digitally enhance images. When reality won't do, the major television net-

works have also engaged in digital manipulation. A long-standing television tradition is to cover the countdown to the New Year in Times Square and to show the New Year's ball fall. What if you are CBS and plan to usher in the new millennium live from Times Square, but right next to the New Year's ball is a Budweiser ad and the logo of a rival network—the NBC Astrovision? No problem. CBS digitally imported its own billboard and logo, obliterating the other images. As anchorman Dan Rather commented on the festivities during the live broadcast on December 31, 1999, he was framed by a prominently placed CBS billboard. The billboard, of course, did not exist in Times Square. You only saw it if you were watching CBS news. CBS executive producer Steve Friedman defended the digital doctoring by claiming it did not distort the content of the news: "We were looking for some way to brand the neighborhood with the CBS logo. . . . It's a great way to do things without ruining the neighborhood."[33]

As the line between news and entertainment, serious news and tabloid news has eroded, the producers of the news are embracing theater rather than apologizing for it. Picture-perfect news needs pretty faces, and, in the case of women, pretty bodies on display. Especially on local and cable news channels, women are encouraged to dress as if they are going out on the town, wearing sequined sweaters and low-cut tops. A CNN ad for news anchor Paula Zahn gained notoriety before it was pulled off the air after it stirred a controversy. In promoting Zahn's show, *American Morning*, a male announcer asks, "Where can you find a morning news anchor who's provocative, super-smart, oh yeah, and just a little sexy?" The word "sexy" then flashes on the screen, accompanied by a noise that sounded like a zipper unzipping.[34]

Even *Watch*, the in-house magazine for the more sober CBS network, could not resist giving their first solo woman anchor, Katie Couric, a "digital diet" to slim down her face and figure in a picture featured in their pages.[35] Would they have done the same for Walter Cronkite?

Katie Couric's digital diet follows a practice long employed in fashion photography and increasingly on the cover of magazines. An issue of *TV Guide* displayed a picture of Oprah Winfrey with

the actress Ann-Margaret's body. After homemaking maven Martha Stewart was released from prison, a *Newsweek* cover showed her confidently smiling, with the title "Martha's Last Laugh: After Prison She's Thinner, Wealthier and Ready for Prime Time." But she was not thin enough for *Newsweek*. The image was actually a composite of Stewart's face and a model's body. Lynn Staley, assistant managing editor at *Newsweek*, saw no problem with the digital doctoring: "The piece that we commissioned was intended to show Martha as she would be, not necessarily as she is."[36]

Some editors argue that digitally enhanced photographs are labeled "photo illustrations" and should not be held to the same standard as news photographs. Lynn Staley made this argument during the flap over the Martha Stewart *Newsweek* cover, noting that a credit accompanying the table of contents stated that the picture was a photo illustration. The same argument was made by James R. Gaines, managing editor of *Time* magazine, in response to the controversy generated by a 1994 *Time* cover portrait of O. J. Simpson that was digitally darkened by an artist who was asked to "interpret" the Los Angeles Police Department's photo of Simpson. *Time* credited the artist and the "photo-illustration" on the bottom of page three of the magazine. Since few readers look at the fine print, these episodes raises some hard questions: Doesn't the display of photographs in news magazines constitute a contract with the readers that they are seeing photographs of people and places as they actually are? Or should we look at *Newsweek* or *Time* as we would a supermarket tabloid where we expect outlandishly doctored photographs, or fashion magazines that digitally enhance the faces and bodies of the models as a matter of course?

In defense of digital enhancement in fashion photography, Pascal Dangin, the founder and head of one of the foremost photo retouching firms in the United Sates, told a reporter, "Hey, everybody wants to look good. Basically we're selling a product—we're selling an image. To those who say too much retouching, I say you are bogus. This is the world we're living in. Everything is glorified. I say live in your time." Holding a printout from an Yves Saint Laurent ad campaign, he quipped, "This world is

not reality. It's just paper." Yet even Dangin drew a line when it came to making digital composites of a head with a different body: "I would not put an actress's head on a stylist's body—no! People can get very upset. They put it in the same pool as human cloning."[37]

These days even world leaders can catch a break from the media and get a digital slim down. Recently a media stir was created when French president Nicolas Sarkozy's love handles magically disappeared in a photo of him in a swimsuit taken while vacationing with his family at Lake Winnipesaukee in New Hampshire. As one newspaper quipped, "President Nicolas Sarkozy is one of the rare democratic leaders who can say the media helps him look better in print than he does in real life."[38] *Paris-Match*, the celebrity magazine owned by one of the French president's best friends, Photoshopped away his roll of fat to give him a svelte figure in a photo that showed Sarkozy canoeing with his nine-year-old son. The Élysée Palace denied it had a hand in tweaking Sarkozy's physique. "We only deal with the President's political and diplomatic line," presidential spokesman David Martinon said. "For the rest, we're rather bad at working with Photoshop." *Paris-Match*, while admitting to enhancing the photo, tried to squirm out of accepting full blame. "The position of the boat exaggerated this protuberance," the magazine coyly responded. "When we reduced the shadows, the correction was exaggerated in the printing process."[39]

One does not have to be a television star or a media personality to crave a little enhancement. Hewlett Packard's new Photosmart digital camera promises a lot more than correcting for red eye. Press the right setting and it can slim off up to ten pounds even *before* the picture is taken. The Photosmart is being pitched to the growing market of female digital camera users who do not want to bother with computer software to retouch photographs. "Slimming" is one among twenty-seven "artistic" features including "gauzy," a convenient way to do away with wrinkles as well as extra pounds. The appeal of the "slimming" feature was discovered in focus groups in which people "admitted that they did not like to be photographed because they didn't like the way they

looked." "We want to lower people's resistance," noted product manager Linda Kennedy. When asked if the "slimming" feature "will contribute to visual fraud," she responded, "I can't imagine it'll be the first time. We're not enabling anything other than what's already out there."[40]

For those who want to take the plunge into photo retouching, there are a lot of options. You can purchase many digital retouching programs for your computer for a reasonable price, teach yourself, or take a course to brush up your skills. Or you can go online and let one of the many photo-retouching services do it for you. There is a brisk business for companies that market their services to the 40 million people who use Internet matchmaking sites. LookBetterOnline.com offers professional photo shoots and digital enhancement of existing photographs to their clients.[41] Other companies like E-Cyrano.com and ProfileHelper .com will actually write up the personal statements and guide their clients in crafting their initial e-mail conversations with prospective dates. A Touch of Glamour offers from "light" to "extreme" "glamorization," a process that includes shaving inches from the waist, reshaping noses, enlarging lips, rebuilding eyelashes, and straightening teeth. Another company, Anthropics Technology is marketing a software program, PortraitProfessional, for only $39.95 that will give the user around eighty different ways to enhance "beauty" with "algorithms that automatically shift and reshape the parts of the face."[42] The CEO of the company, Andrew Berend, noted that his research team tested their product by posting before and after pictures on HotOrNot.com (a popular picture-ranking site with a 1 to 10 scale) and transformed a lowly 2-rated photograph into an appealing 8.[43]

Even as people try to look as good as the celebrities, some celebrities have said, "enough is enough" when it comes to digital enhancement. Actress Kate Winslet got a lot of media attention when she protested a 2003 British edition of *GQ* that showed her in a skin-tight outfit, high heels, amazingly thin thighs and a "to die for" flat stomach. "I look about 100 pounds in that thing," Winslet told the *New York Post*, adding: "After I did *Titanic*, I realized that there was a lot of pressure on women to be a certain

size to be successful as an actress. And I thought, isn't that insane? So I just came out in an interview and said, 'Look, I'm doing well at the things that I love doing and I'm not starving myself.' "[44] Tennis star Andy Roddick mocked a 2007 cover of *Men's Fitness* magazine that showed him standing confidently in a t-shirt with bulging arms crossed under a barrel chest flanked by two banner headlines, "Lose Your Gut" and "How to Build Big Arms." Referring to the way *Men's Fitness* decided to make their point by building his big biceps digitally, Roddick quipped, "little did I know I have 22-inch guns," noting with self-deprecating humor: "[I'm] not as fit as the *Men's Fitness* cover suggests."[45]

Meanwhile, high school yearbook companies now offer a range of digital enhancements. It's really an extension of the elaborate way senior pictures are now staged with special outfits, backgrounds, locations, and poses all intended to make the students "feel like stars."[46] Photographers and students alike find digital imaging liberating. No need to reschedule the photo for the usual glitches that can ruin a picture. Standard fare is digitally removing blemishes and braces and whitening teeth, but some studios "keep libraries of teeth images to use as replacements during the retouching process." Others discourage this practice. "When you start replacing the whole smile line, the family is going to notice," noted Willard "Mac" McDonald, who works as a photo lab associated with studios that cater to high school students.[47]

In the quest for the perfect senior picture, studios can also slim students, fix closed eyes and open months, and do a bit of digital plastic surgery like removing scars and moles. Here again the question is: when does a picture become so perfect that the person is lost in the process? "It's those little imperfections that make you who you are," noted one high school senior.[48] But then again, it is hard to resist the allure of digital enhancement. Portrait studios hope that students will be so happy with the results that they will return for wedding and family portraits.

It is no mystery that people, no matter how media savvy, and no matter how inner directed, do not like the way they look. The camera-enhanced, Photoshopped body is everywhere—in fashion magazines, movies, billboards, ads, and on television. We know

the images are fake, but, on another level, we are seduced by what we see, and we measure ourselves by the images around us.

## Broadcast Yourself

In striking ways, the picture-perfect mentality, the self-conscious attention to the construction of images, and the focus on gaffes that reveal the artifice of the pose figure prominently in everyday life and contemporary culture. One way to appreciate our changing relation to the camera is to think of the difference between *Candid Camera, America's Funniest Home Videos,* and the videos posted on YouTube, MySpace, and other Internet picture-sharing sites.

In the 1960s, the popular program *Candid Camera* regaled viewers with the spectacle of ordinary people encountering unexpected circumstances, but the point of the comedy was that the subjects were innocent, unaware of the television camera. Only the punch line, "Smile, you're on *Candid Camera,*" revealed that others were watching. By the 1990s and early 2000s, Americans tuned in to watch and laugh at scenes of people getting stuck in dishwashers, having their pants fall down, or finding a hand reaching out of their soup pot on the popular program *America's Funniest Home Videos.* But there was a difference, which marks an important shift in American popular culture.

In *America's Funniest Home Videos,* the presence of the camera is no surprise. The participants hold the camera in their hands. Many episodes are not candid but posed, home videos self-consciously constructed to play before a national audience on television. While *Candid Camera* enjoyed a revival in the 1990s, the far more popular *America's Funniest Home Videos* exemplified the new photo-op mentality.

Unlike *Candid Camera, America's Funniest Home Videos* draws our attention to the image as an image. In the opening of the show, the camera focuses on the upper tier of the television studio, where a family watches television in a staged living room. A variation of this theme is played out in the studio below. A huge

screen displays the home videos competing for the prizes. The stars of the program are the contestants themselves, now in the studio audience, shown watching their videos on television.

With the advent of Internet social networking and picture-sharing sites, homemade videos of all kinds can be uploaded directly from a home computer. No need for a television program to play the middleman. With a few clicks, you can post your own video for the world to see. Many of the most popular videos on sites like YouTube are crazy stunts and embarrassing moments generated by high school- and college-aged kids. It is a way of generating a failed photo op for comic ends, though sometimes, embarrassing pictures are uploaded without the permission of the person featured.

On *Candid Camera* and *America's Funniest Home Videos*, the identity of the person in the picture was no secret. On YouTube, MySpace, and other Internet sites, the line between the person and the picture is often traversed since the posters often use pseudonyms. A popular video blog on YouTube called "lonely-girl15," for example, began as a chronicle of the daily life of a home-schooled teenage girl from a strict religious family. When the daily musings became infused with a bizarre narrative of secret occult practices and the mysterious disappearance of the parents, fans of the blog began to suspect that the whole story was a fabrication. And indeed it turned out to be true. The *Los Angeles Times* reported that "lonely girl" was actually an actress, Jessica Lee, assisted by two professional screenwriters.[49] The exposé and new round of media attention did not diminish the appeal of the blog. Fans enjoyed following the fabrications as much as the so-called authentic memoir.

Short of broadcasting ourselves on the Internet, the home video camera makes it far easier to record family events than the old 8-millimeter home movie camera. This technological change carries consequences for the role of images—and image making—in our lives. Not only birthdays and weddings and family vacations, but also such intimate moments as childbirth are now captured on videotape. As one labor-room nurse notes, "Historically, women developed their birth stories through what they re-

membered, what their families told them, and what they discussed with caregivers. With advanced methods of recording childbirth, women's memories are changing. The 'truth' revealed by today's audio and video technology reframes the memories of labor and birth."[50] As more obstetricians and labor-room nurses find themselves on "candid camera," they've decided to take back control of the delivery room. A 2006 *Newsweek* article, "No Candid Camera," reported that hospitals are banning videotaping of childbirth, citing concerns about privacy, safety, and the fear that the birth videos could be used in malpractice suits.[51]

As always with photography, the camera's eye is never innocent. The documentary ambition to record the moment lives in constant tension with the impulse to pose. In the early 1990s, the *New York Times* ran a story that highlighted the growing tendency for people to arrange their lives and occasions to accommodate the video camera. While some parents still use the video camera, like the old home movie camera, to document the important moments of their lives, others fall into "talking like Hollywood types. [They] do not speak of taking the kids to the park and the zoo. They go 'on location.' "

Our strenuous efforts to capture important moments on videotape often transform these moments by the self-consciousness the camera induces. Even children quickly learn that going to the park to be videotaped is a different experience from just going to the park. As writer Don Gifford notes of the early video cameras, "The tapes made of family occasions would seem to promise spontaneity but . . . tend to be dominated by staged bits of action (just as still photographs of such occasions are so frequently dominated by the posed shot)." Gifford wonders how this new orientation is changing the way we see and live our lives. Much as the image-conscious coverage of presidential campaigns leads to a focus on mishaps and gaffes, he suggests that the growing image consciousness of ordinary life could have a similar effect. "The genuinely funny, unselfconscious family moments may be threatened with displacement by contrived, frenetic, half-comic scenes of pratfalls and other embarrassments."[52]

The phenomenon of "wedding photojournalism," which has been popular since the late 1990s, is another example of the photo-op sensibility in everyday life. Instead of recording posed or idealized moments, wedding photojournalists aspire to capture the bride and groom in so-called unscripted and unguarded moments on the wedding day. I say *so-called* because bride and groom are fully aware of the camera's presence. On the day I went online to the site of *WedPix*, the online magazine of the Wedding Photojournalist Association, the feature article was accompanied by a behind-the-scenes photo of a bride in a dressing area having makeup applied, with half her head cut off by the frame and her wedding dress hiked up by a bridesmaid to reveal her garter. "Real moments—you can't fake them," notes Peggy Bair, an award-winning Wedding Photojournalist Association photographer.[53]

But what counts as real? Like reality television programs, the so-called real moments often focus on the risqué, the voyeuristic, or like *Candid Camera* or YouTube, the downright silly—people dancing badly, looking bored, or otherwise caught unaware. As the *Wall Street Journal* reported in a 2006 article, "Brides Gone Wild," "Brides are revealing themselves at a time when popular culture has pushed the limits of privacy with boundary-blurring reality TV shows and dating sites that let users swap revealing photos." As one mother-in-law told the uninhibited bride, "You're going to have to show them to your kids one day."[54]

Those in the media find, to their surprise, that the people they cover are now fluent in the language of video production. As early as the 1990s, Beth Pearlman, a producer for the CBS affiliate station WCCO in Minneapolis, was struck by the way media jargon has become public knowledge. "I go out on a story, and the person I'm going to talk to will ask me if I'm doing a feature or just a sound bite. Someone asked me the other day, 'Do you want to shoot B-roll before we have our interview?' B-roll is video that you run under the narration of the reporter. How do they know?"[55]

Television is not the only source of the image consciousness that informs everyday life. Giant video screens are now a familiar presence at rock concerts and large rallies, affording mass audi-

ences a better view of the event that is unfolding "before their eyes." In the past, only those watching a baseball game on television could see an instant replay of a home run or a dazzling play in the field. Now the fans at the ballpark can also see the replay, thanks to the video screens that adorn most major-league stadiums. Mega churches also use giant video screens so that the pastors can be seen and heard by the thousands of congregants, and the congregants can see themselves singing and praying on the big screen.

Video consciousness and the play of images within images are familiar themes in popular entertainment and advertising. Madonna's 1991 film *Truth or Dare* was a precursor of the image-conscious sensibility that characterizes today's reality television shows. In the film documentary, Madonna celebrates the pose and denies the distinction between the performer and the person, between the image and the self. Even as a doctor examines her ailing throat, Madonna wants the cameras to roll. Her friend, actor Warren Beatty, questions the "insanity of doing this all on a documentary." Madonna replies, "Why should I stop here?" Beatty chides her. "You don't want to talk off camera. You don't want to live off camera. There's nothing to say off camera. Why would you say something off camera?" Madonna's answer comes later in the song-and-dance number that sums her up. "Don't just stand there, let's get to it. Strike the pose, there's nothing to it. Vogue. Vogue."

The reality television programs that have become so popular in the 2000s incorporate and amplify the photo-op sensibility. Contemporary celebrities such as hotel heiress Paris Hilton, pop singer Britney Spears, and heavy metal rock musician Ozzie Osbourne have gone beyond Madonna. They have developed their own reality television series that take their fans behind the scenes to reveal how they live when they are not performing. In doing so, they frame their own flaws, foibles, and gaffes to create what they hope will be endearing entertainment. Unlike the people who create their own videos for YouTube, the stars have extensive postproduction teams who take the "reality" that unfolds before the camera and edit it into a well-paced show.

*Survivor* and *American Idol*, two of the most popular American reality television shows, work with this same tension between perfecting and puncturing the picture. Front stage is the competition to be the next star singer on *American Idol* or the best at performing the gauntlet of physical challenges in remote exotic locations on *Survivor*. In this sense, both shows tap into the American dream of the ordinary person rising to success and stardom. At the same time, the shows incorporate puncturing the picture as part of the entertainment. *American Idol* does this through the caustic remarks of one of the contest judges, Simon Cowell, who became a star in his own right by bluntly highlighting the flaws of contestants. *Survivor* also plays upon flaws in the many "confessional" interviews. Contestants speak in intimate detail about their "true feelings"—love interests, rivalries, plots, jealousies, and anger directed at members of their own or the opposing "tribe." The choreographing of the real on *Survivor* goes beyond the fact that the isolated locales are littered with handheld video cameras trained on the contestants. Casting directors search for just the right mix of "real people" to appear on the show, aspiring actors try out to be contestants, and editors work to sharpen the drama by crafting the confessional scenes.

The struggle to perfect and puncture the picture in the age of reality television and the Internet has played itself out in interesting ways in the prelude to the 2008 presidential primaries. In 2007, a tour of the presidential candidates' Web sites showed how the candidates used the Internet's multimedia capabilities to control their image. Democrats could tune in to the "Hillcasts" on Hillary Clinton's Web site or "Barack TV" on Barack Obama's Web site. On the Republican side, you could watch "MittTV" on Mitt Romney's Web site or go to the McCain Web site and catch John McCain's announcement video "Live Free or Die," in which McCain said, "Don't change this channel. Put down that remote."[56] On the unofficial Draft Fred Thompson for President '08 Web site, fans of Thompson urged potential supporters "to check out the latest video petitions. . . . Politicians, pundits and pollsters have had their say—now it's your turn. . . . See how to put your voice into action with YourTube4Fred."[57] After Thomp-

son officially announced his candidacy on the *Tonight Show with Jay Leno*, you could tune into "FDTV" on Thompson's Web site and look at a photo gallery of upbeat patriotic pictures reminiscent of Ronald Reagan's campaign ads. Rudy Giuliani's Web site also identified the candidate with Reagan and reminded supporters to put "Rudy on Your Blog" and "Call Talk Radio."

The candidates' Web sites have their own "newsrooms," which feature carefully culled videos of television coverage of their campaigns, blogs, and chat rooms, and links to MySpace, YouTube, Facebook, and Flickr (a popular online photo-sharing site), where you can see more official campaign videos as well as videos made by their supporters. Liberals and conservatives alike make a point of reaching out to the "citizen journalist." John Edwards's Web site urged his supports to "Become a Citizen Journalist," noting that "through blogging, video blogging, and podcasting, citizen journalists provide information and insights from many sources in addition to traditional media sources." John McCain's Web site reiterated the message in a section called Join the Media List: "We want to make sure all members of the media—whether mass media or citizen media—have access to the information they need."

The candidates incorporate carefully crafted videos with perfect lighting and makeup that mimic the intimacy of TV talk shows and videos that have the handheld-camera look of digital and cell phone videos. The same cultivation of the traditional and the cutting edge is evident in the use of still photographs. On Hillary Clinton's Web site you could watch a slide show of Hillary from childhood to the present that has the look and feel of paging through a family album. But the site was also filled with a cascade of photographs taken by supporters. These pictures, unlike the official ones, are "authentic" in a different way. They look like photos from an unedited digital picture file that you'd send a relative or friend—some flattering, others not, but all looking unposed and "real."

The candidates' Web sites cultivate the art of looking real in a way distinctive to our times. In the early days of television, candidates had to learn how to pose for the television camera. Then they mastered the media event. In the wake of YouTube, MySpace,

and Facebook, the best pose is to appear unposed. The idea is to present a continually evolving picture of yourself, and to invite your supporters to take pictures of you. Like friends posting pictures on Facebook, supporters are invited to post pictures as well. Everything is personal and connected. From MyBarackObama .com you could go to "My Blog," "My Friends," "My Messages." On McCain Space you could create your own Web site. It's not that traditional politics or patriotic imagery is left behind. Far from it. The debates, rallies, town meetings, interviews, talk shows, and coffee klatches are all posted on the candidates' Web sites along with plenty of American flags and red, white, and blue logos and graphics.

For all the candidates' efforts to control their images on the Internet, opponents had a heyday puncturing their perfect pictures on YouTube. In the summer of 2007, when I clicked on Hillary Clinton and John Edwards, two leading Democratic contenders for president, the first videos to come up mocked the candidates. One widely watched video showed John Edwards behind the scenes, primping and combing his hair for what seems like an eternity accompanied by the song "I Feel Pretty." A video of Hillary Clinton, which had received over 3 million hits, portrayed her as a Big Brother figure on a giant screen. Clinton's image is smashed by a woman athlete wielding a huge mallet (a send-up of Apple Computer's 1984 Super Bowl commercial). Republican candidates were not spared the image debunking. Rudy Giuliani was spoofed hugging Donald Trump, and John McCain was shown singing "Bomb, bomb, bomb Iran" to the tune of a popular Beach Boys song at a campaign appearance. It should come as no surprise that in the world of YouTube, the first batch of videos on George W. Bush were all spoofs, failed photo ops, and highlights of the president's malapropisms.

## What's Real, What's Not

From their earliest days, movies have made fun of politicians, and well before the current battle for control of the picture on the Internet and on television, movies have made television's power

to fabricate images the subject of their stories. It is almost de rigueur for action-comedies and animated movies to self-consciously call attention to their own image making—sometimes in the form of genre spoofs, and sometimes breaking out of the story to call attention to the movie as a movie.

This self-consciousness in movies is an important strain, but not the dominant one. Most movies do not invite us to see the image as an image. They want us to relax, sit back, and suspend our disbelief. While we do just that, movies tell us stories about our lives. Although the movies do not claim to be presenting facts, people often believe and are moved by what they see, sometimes more so than what they see or hear in schools, lecture halls, or on the evening news.

Movies frame interpretations of the world that are often so offhanded that we are not fully conscious of it at the time. Think back on how television and newspaper reporters covered Bush's "Mission Accomplished" landing on the aircraft carrier. They heightened the drama of the event by featuring comparisons of Bush's tail-hook landing to blockbuster movies like *Top Gun*, *Air Force One*, and *Independence Day*. By bringing in the movies, reporters increased the mythic power of Bush's pictures. "Bush: The TV Movie" was orchestrated by Bush's media team, but the networks filmed it, produced it, and added their own narration.

For his part, Bush took on the mantle of the maverick hero long before the Iraq War. In his campaign for governor of Texas and later president, Bush had shed the image of the Yale-educated patrician son of a president and recast himself as a good old boy from Texas. He chopped wood on his ranch, wore jeans and a cowboy hat, and spoke in the plain patois of a cowboy. Criticized by some in Europe as an American cowboy, Bush was able to ride high at home by tapping into the potent rhetoric and image of the maverick hero.

Bush was suited to play the role by disposition and temperament unlike his father, George Herbert Walker Bush, who as president was very much the patrician and experienced Washington insider. In assuming the role of man of the people, the younger Bush was beholden to a different inheritance—a long lineage of

American presidents from Andrew Jackson to Abraham Lincoln to one of Bush's personal favorites, Teddy Roosevelt, in his role as a Rough Rider charging forward on his horse.

Among modern presidents, Ronald Reagan was the most successful practitioner of the politics of the maverick American hero, and Bush followed the path Reagan had forged. Reagan's ability to move within the story he told made for compelling rhetoric. "Go ahead, make my day," he challenged Congress, borrowing a line from Clint Eastwood's maverick cop, Dirty Harry. More than just an outsider, Reagan stood, like the citizen heroes of Frank Capra movies, as the redeemer of American individualism and idealism.

Reagan instinctively grasped that the American people were left reeling, groping for meaning, in the wake of the trauma and uncertainty after the Vietnam War, Watergate, and the hostage-taking in Iran. The mood of that time was captured in the popular and disturbing film *The Deer Hunter*. Shaken by Vietnam, the characters—young, patriotic working people from a Pennsylvania steel town—try to find their bearings. At the film's end, slowly, tentatively, they begin to sing, "God Bless America."

It was as if Reagan heard the faint strains of the melody and used his voice to make it a swelling song. His speeches drew the public into a ceremony of affirmation. The theme was economic and spiritual renewal. "We're going to make this great nation even greater," Reagan proclaimed. "America will be a rocket of hope shooting to the stars." The audiences became his chorus, chanting, on cue, "U.S.A.!"

Reagan deftly fused the image of the maverick with rhetoric that appealed to religious and moral sentiments. Although neither Catholic nor a born-again Christian, Reagan made the causes of school prayer and antiabortion his own. Here again, Reagan benefited from the ambiguity of his status as insider and outsider. Without being bound to a particular church or doctrine, he succeeded in identifying with religious longings and values. One consequence was that his nonfundamentalist supporters could comfortably dismiss the religious side of his appeal as unthreatening campaign rhetoric; for them it was enough that he was the

president of the economic recovery. For believers, meanwhile, Reagan was the defender of the faith.

It should have come as no surprise that after Reagan's death, both *Time* and *Newsweek* chose to eulogize him on their covers in a photograph portraying him as America's confident cowboy, wearing a blue work shirt and big white cowboy hat. Here was a cowboy who could speak a straightforward moral language in the waning stages of the cold war, not afraid to label the Soviet Union as the "evil empire," or challenge its leader: "Mr. Gorbachev, tear down that wall."

After September 11, Bush drew over and over again from this familiar rhetorical well, vowing "to hunt down, to find, to smoke out of their holes the terrorist organization that is the prime suspect."[58] Referring to Osama bin Laden, Bush declared after a meeting at the Pentagon: "I want justice. . . . And there's an old poster out West I recall, that said, 'Wanted: Dead or Alive.' "[59] Again and again, Bush spoke of bringing "the evildoers to justice," mixing cowboy talk with religious fervor. As the drumbeat for a war with Iraq intensified, Tim Russert, host of the television program *Meet the Press*, asked Vice President Dick Cheney, a prime advocate of the war, about the perception in Europe and around the world of the president "as a cowboy, that he wants to go it alone." Cheney was only too happy to reaffirm Bush's cowboy image: "So the notion that the president is a cowboy . . . a westerner, I think that's not necessarily a bad idea. I think the fact of the matter is he cuts to the chase. He is very direct and I find that very refreshing."[60]

The descent of the Iraq War into chaos, civil war, and insurgent violence did not turn Bush away from his moral certitudes nor did it diminish the appeal of the maverick hero in American culture. In the era of global terrorism, the maverick hero lives in new forms. Just ask Brig. Gen. Patrick Finnegan of the U.S. Military Academy at West Point, who traveled to California in November 2006 to meet the producers of the enormously popular television series *24*. Why? Because the maverick hero of *24*, Jack Bauer,

played by Kiefer Sutherland, presents an attractive view of illegal torture, and this was having a bad influence on the troops.

In Jack Bauer's world, torture works. The fictional world of *24* is populated by terrorists who are on American soil plotting to destroy the nation. With an enemy so bent on evil, torture is positively patriotic. The stakes are always high—a plot to kill the president, a plot to blow up an American city with nuclear weapons—but Jack Bauer always saves the day, usually single-handedly just like the classic mavericks of the American westerns. The only difference (and it is not insignificant) is that torture was not in John Wayne's or Gary Cooper's repertoire. Jack Bauer spares nothing when it comes to spilling blood. The torture scenes are horrific, but always done for a higher good. "I'd like them to stop," General Finnegan said of the producers of *24*. "The kids see it and say, 'If torture is wrong, what about *24*?' "[61] "Everyone wanted to be a Hollywood interrogator," observed Tony Lagouranis, a former U.S. Army interrogator at Abu Ghraib prison who spoke to the creative team of *24*. "That's all people did in Iraq was watch DVDs of television shows and movies. What we learned in military schools did not apply anymore."[62]

The movies also formed a dark reference point in the aftermath of Abu Ghraib. In trying to frame a way of understanding the prison abuse, a member of the military police who served at Abu Ghraib observed that it was "like *Apocalypse Now* meets *The Shining*, except this is real and we're in the middle of it."[63]

## Everyday Pictures

The line between the person and the picture, reality and fiction, is played out in other ways in everyday life. In the old days, people might throw away pictures of ex-husbands and wives, former friends and colleagues. Now they can be digitally discarded or "Photoshopped" out of the picture. The fact that Photoshop is now used as a verb shows how much digital manipulation has become a common coin of conversation. But if we can "Pho-

toshop" our past, how does this transform the meaning of photographs as documents and bearers of memories? How does it transform the very meaning of memory?

Beyond photo manipulation, the digital technology that makes pictures so easy to take and share has transformed how we use pictures in our daily lives. We increasingly experience the world as an occasion for posing. Never has the camera been more ubiquitous, the method of image transmission so quick, the temptation so great to take pictures everywhere. No so long ago we could see the photographer coming—Uncle Harry with his multiple cameras at family events, the tourists with camera bags and cameras strapped around each shoulder, doting parents following their kids with video cameras. Now that digital cameras and cell phone cameras are so small, so easily concealed, and so easy to use, it is hard to know when or where we might become someone's photo opportunity. A recent cover of the *New Yorker* magazine humorously captured this trend. A young child toddles into his parent's bedroom in his pajamas, but he hasn't come to ask for another drink of water or one last hug. He stands at the threshold of the door, cell phone camera in hand, having just taken a picture of his parents, whose startled faces peek up from under the covers.

The use of webcams built into home computers, Internet picture-sharing sites, and reality television programs are the ultimate expression of a picture-driven culture in which all of life can be played out before the camera—waking up and going to bed, talking, sex, love, gossip, crime, courtships, and family fights. We have the capacity to craft our own images for the world to see, but we can also fall prey to the same pitfalls and problems faced by politicians, celebrities, and other media personalities. Who is the self we are broadcasting, and for whose eyes? How will those who view us distinguish the person from the pose? And, for that matter how will we? When everyone with a cell phone is a potential member of the paparazzi, when any picture posted spontaneously among friends can become a part of the permanent record, the line between public and private life dissolves. We are all in the picture now. But like celebrities and politicians, we sometimes lose control of the image.

## What's Real in the Pose

Some, especially those in the media who have to cover one politician's photo op after another, begin to think that the very act of posing makes a picture inauthentic. But criticism of politicians who claim to uphold American ideals cannot rest with simply revealing that they pose for pictures against flattering backdrops. Who in this modern age does not stage events for the camera? The networks, after all, stage their evening newscasts every night with music, backdrops, carefully written scripts, and makeup for their anchors and reporters. The stagecraft of newscasts is far slicker now, but it has always been part of broadcasting the news. A veteran reporter of the 1968 campaign recollects, "we were all sitting around talking, and someone said, 'Nixon is wearing makeup.' I said, 'Look around, guys. Everybody at this table is wearing makeup. Where do we get off criticizing the politicians?' We were in theater, but we didn't like the idea."[64]

To plan or stage an event for the press does not falsify its content, as the history of press coverage of political events amply demonstrates. Before a Vietnamese Buddhist monk burned himself to death in 1963 in protest against his government's policies, his supporters notified the Associated Press, which recorded the event in a famous photograph. Similarly, leaders of the civil rights movement learned to time their demonstrations so that television could carry their message to the nation. Communicating through television images is part of modern discourse.

The distinction between real and pseudo-events must be judged not on the method of presentation but on the content of the event. When an American cardinal visiting Pope John Paul II asked, "if a hometown television crew could film the two together," the pope looked at him, smiled, and said, "If it doesn't happen on television, it doesn't happen." When he assumed the papacy in 1978, John Paul II moved to change the ancient office to become more media savvy. The Rev. Federico Lombardi, head of Vatican radio, observed that "the pope was attuned enough to the media that he held meetings over lunch or dinner with aides

after every trip, dissecting the news coverage." In 1995, the Vatican began a Web site (www.vatican.va), and in 2002 the pope issued a lengthy document on the use of the Internet to further the church's work.[65]

For the pope, the point of all the pictures was not the pose. He cultivated the camera to convey his deeply conservative beliefs about birth control, human sexuality, the celibacy of the priesthood, the role of women, and deference to the church hierarchy. As columnist Andrew Sullivan notes, "the modern-looking stage, the vast crowds . . . the carefully planned photo ops—they all created a series of mirrors focusing back on the man himself. . . . It took a while to realize that this personalization of the Church—and its identification with one man before all others—was more than drama. Wojtyla leveraged this new stardom to reassert a far older idea of the papacy—as the central, unaccountable force in the Church."[66]

The camera-ready pope has left a legacy of camera-ready faithful. In Pope Benedict's campaign to make Pope John Paul II a saint, the media has not been neglected. A necessary step on the pathway to sainthood is proof of a miracle. A French nun, Sister Marie Simon-Pierre, stepped forward to offer evidence: she prayed to Pope John Paul after he died and was cured of Parkinson's disease. A gentle and devout woman, Sister Marie Simon-Pierre had planned to keep her identity secret, but emboldened by the man who provided her miracle cure, she decided to appear at a press conference, noting, "He never shied away from the cameras."[67]

## Why Words Matter

In a book that focuses so much attention on images, I want to reiterate what to me seems obvious: words matter. For all the attention lavished on Bush's landing on the aircraft carrier at the beginning of the Iraq War, it was not the pictures that were his undoing. It was those two fateful words on the banner—mission accomplished. The Bush media advisers tried to tighten their con-

trol of the image by building the words right into the picture, like an ad with a logo or tagline. In one glance you see the message. But, in this case, the media advisers had been too sophisticated for their own good. The words came to define the picture.

Bush never uttered the words *mission accomplished* in the more nuanced speech he delivered about the war that day, but the words on the banner stood out as a declarative statement that could be measured and evaluated by unfolding events. Even before Bush delivered his speech on the deck of the USS *Abraham Lincoln,* reporters questioned the meaning of the "Mission Accomplished" banner. CNN reporter John King, for example, observed, "When we see the president stride across the deck of the *Abraham Lincoln* about thirty minutes from now, he'll walk past two Navy fighter jets and past a banner that says, 'Mission Accomplished.' Now that might raise some eyebrows. . . . Many will question, how can you say mission accomplished when the United States has yet to find any evidence of weapons of mass destruction, the reason Mr. Bush launched this war to begin with?"[68]

The networks marked the one-year anniversary of Bush's landing on the *Lincoln* noting that what was described as the "greatest photo op of all time" was now "the photo opportunity that some Republicans regret," and noted that the "elaborately staged appearance" now "haunts the president."[69] Critics noted the rising death toll of American soldiers, the strength of the Iraqi insurgency, and the uncertainty over whether American goals of bringing democracy to Iraq would succeed. The Democrats had a heyday with "Mission Accomplished" during the midterm elections, incorporating them into campaign ads with a new logo "Mission Not Accomplished." Subsequent anniversaries of America's entry in the Iraq War continued to be marked by references to Bush's "Mission Accomplished" banner.

As my story unfolds, I will argue that image-conscious political reporting fails in two respects. It inflates the importance of the process of image making without adequately assessing the meaning of the images. And calling attention to the image as an image may not be enough to dissolve its hold. The reason is not that images are more powerful than words, but that certain images

resonate with meanings and ideals that run deep in American culture. To fulfill its documentary purpose, political reporting must engage the content of public officials' pictures and words and assess the substance of their claims.

The larger message about the relation of words to images is that pictures make no sense without words, without a story to explain them, without a cultural and political frame of reference. Think about some famous American pictures—Joe Rosenthal's World War II picture of the flag-raising on Iwo Jima, or Eddie Adams's Vietnam-era photograph of the execution of a suspected North Vietnamese fighter on the streets of Saigon. Americans of a certain generation may think they instantly "get" these pictures, but these images have been subjected to various interpretations, controversies, and reinterpretations. They are markers of memories, icons of American culture, but would not have the same resonance for people from other parts of the world where different pictures and other stories form the chronicles of collective life.

In telling the story of the rise of a new image consciousness in American life, my aim is not to explain, in causal terms, the developments I describe. It is rather to explore the expressions and problems of America's photo-op culture, and to consider its consequences for our understanding of ourselves. Since I hope to show that our photo-op culture plays out, in heightened form, tendencies as old as the photograph itself, my story continues with the invention of the photograph over a century and a half ago.

# CHAPTER 1

# Picture Perfect

Just before noon on March 8, 1839, Louis-Jacques-Mandé Daguerre, a French painter and inventor, traveled through the streets of Paris to an appointment with a visitor from America. For over seventeen years, Daguerre had been the proprietor of one of the most popular spectacles in Paris, a theater of illusions called the Diorama.

No actors performed in Daguerre's Diorama theater. It consisted of a revolving floor that presented views of three stages. On each stage was an enormous canvas (72 by 48 feet) with scenes painted on both sides. Through the clever play of light, Daguerre could make one scene dissolve into another. Parisians were treated to the sight of an Alpine village before and after an avalanche, or Midnight Mass from inside and outside the cathedral, accompanied by candles and the smell of incense.

The realism of these illusions was so compelling that an art student once set up an easel and began to paint one of the scenes. Daguerre was quick to set him straight. "Young man, come as often as you want to, but don't work here, because you will be making nothing but a copy of a copy. If you want to study seriously, go out of doors."[1]

The illusions of the Diorama were no doubt far from Daguerre's mind as he walked up the three flights of steps to the apartment where his American colleague was waiting. He had come to see Samuel Morse and his new invention, the telegraph. The two men talked for an hour. As they talked, Daguerre's Diorama was engulfed in flames. It burned to the ground before he returned, destroying years of work.

Fortunately, for Daguerre, all was not lost. He had recently completed work on another invention, already secured beyond the reach of the flames. Two years earlier, in 1837, Daguerre had found a way to preserve, chemically, on silver-plated copper, an image of reality. He had invented the photograph.

## Photography as Document and Artifice

Since the sixteenth century, artists had used a device called a camera obscura to enhance the perspective of their paintings. The camera obscura (literally, dark room) was a box with a lens that formed an image on ground glass that the artist could trace. Daguerre had used this device to draw the lifelike paintings for his theater of illusion.

Many artists had dreamed of preserving the image rather than tracing it, but until the 1830s, no one had succeeded.[2] Daguerre's invention of the photograph—known then as the daguerreotype—would transform the way people saw the world and themselves. But in the day of its invention, the photograph seemed to offer a simpler triumph—of reality over illusion, of accuracy over art.

Photography seemed to promise a picture more perfect than art could produce. At last it would be possible to document the world objectively, free of the vagaries of the artist's eye. They called the photograph "the pencil of nature." Samuel Morse, who became a photographer himself, observed that photographs were not "copies of nature, but portions of nature herself."[3] Oliver Wendell Holmes, father of the noted jurist, called the daguerreotype "the mirror with a memory."[4]

The new photographs were so true to life that people examined them as scientists would examine a specimen. Edgar Allan Poe was struck by the photograph's perfect correspondence to nature. "If we examine a work of ordinary art by means of a powerful microscope, all traces or resemblance to nature will disappear— but the closest scrutiny of the photographic drawing discloses

only a more absolute truth, a more perfect identity of aspect with the thing represented."[5]

Quite apart from its scientific interest, the daguerreotype won instant popularity in America as a means of portraiture. Traditionally, only the wealthy could afford to commission portraits. With the invention of photography, portraiture became democratic. People from every walk of life could afford a photographic portrait. Every town had a portrait studio. Photographers floated down rivers in houseboat studios and traveled in covered wagons through the countryside.

Drawn to photography for its realism, its "absolute truth," Americans soon confronted a puzzling feature of the new invention. Not all daguerreotypes succeeded in capturing the truth of their subjects. Ralph Waldo Emerson, for example, once lauded the photograph for its authenticity. "No man quarrels with his shadow, nor will he with his miniature when the sun was the painter."[6] When he saw his own portraits, however, he was dissatisfied, noting that his family called them "supremely ridiculous."[7]

A successful daguerreotype was more than a mechanically produced representation; it required collaboration between photographer and subject. Since the exposure time was about thirty seconds, the subject had to sit perfectly still, aided by a brace behind him. The photographer had to carefully arrange the light, the lenses, and the composition of the frame. But the best portrait photographers knew that rendering the reality of their subject required more than technical mastery. It demanded of the photographer the insight and imagination to draw the person out, to capture the revealing moment. And it demanded of the subject the art of being natural, of being himself before the camera.

For all their fascination with the realism of the photograph, Americans grasped from the start that portrait photography was an art: the art of rendering an image that tells the truth about its subject. More than mere physical depiction, the daguerreotype sought to express "the subject's internal reality—the spirit of fact that transcends mere appearance."[8] As a nineteenth-century historian of photography observed, "a portrait is worse than worthless if the pictured face does not show the soul of the original—

the individuality of self-hood, which differentiates him from all beings, past, present or future."[9]

The famous Boston daguerreotypist Albert Southworth described the art of making someone look real: "Nature is not at all to be represented as it is, but as it ought to be, and might possibly have been. . . . The aim of the artistic photographer [is] to produce in the likeness the best possible character and finest expression of which the particular face or figure could ever have been capable. But in the result there is to be no departure from truth."[10]

If photography aspired to the "spirit of fact," rather than brute representation, there was always the possibility that the camera could lie. The need to pose, to look good before the camera, meant that even the "pencil of nature" could sometimes deceive. A photograph could fail to do justice to its subject, or could make people look better than they really were. "Hurrah for the camera," said Emerson sarcastically. "The less we are the better we look"; and the novelist N. P. Willis observed, "Some of us know better than others how to put on the best look."[11] Mark Twain poked fun at idealized family portraits for showing people in uncustomary poses, "too much combed, too much fixed up."[12] Nadar, a noted French portrait photographer, could not resist recording the truth about a French police official who looked all too distinguished in the photograph he had taken. On the back of the photo, he wrote "spy, parasite."[13]

Boss Tweed, the corrupt head of the New York City political machine of the 1860s, looked the picture of probity in his official photograph, taken by the famous Civil War photographer Mathew Brady. Tweed, like other politicians of his day, had great control over his photographic image, since the slow shutter speed of cameras prevented any candid photography. The truer pictures of Boss Tweed were the unflattering Thomas Nast cartoon caricatures that appeared in *Harper's Weekly* in the early 1870s. "Stop those damn pictures," Tweed is said to have demanded of his men. "I don't care so much what the papers write about me. My constituents can't read. But damn it, they can see pictures."[14]

Here, then, was a paradox of picture taking that appeared from the start. Despite its promise of the ultimate document, of a pic-

ture more realistic than art could achieve, the camera was also an instrument of artifice and posing, even fakery and deceit. The invention that enabled people to write with the sun would blur the distinction between appearance and reality, between the image and the event. Daguerre's two inventions—photography and the theater of illusions—thus had more in common than at first appeared.

Digital technology has democratized the ability to alter or fake photos in our time, but doctoring photos goes back to the early days of the photograph. Mathew Brady and other famous photographers employed the photo retouching techniques of their day to enhance the portraits they took in their studios. A popular photograph of Abraham Lincoln displayed in public buildings and classrooms after the Civil War combined Lincoln's face with the body of Southern leader John Calhoun. After Lincoln's assassination, a public eager to see an image of their fallen president had their wish fulfilled by an enterprising photographer who took a picture of a Lincoln look-alike posing as the dead president in a coffin.

## Picture This

The era of the unique photographic image, the daguerreotype, ended near the time of the Civil War. New types of photography superseded it based on the use of negatives, allowing the easy reproduction of photographic images. Yet, photographs could not be reproduced in magazines and newspapers, and the photograph was simply used as a model for drawings and etchings. It was not until the turn of the century that photography became a form of mass communication.

Kodak's small, handheld camera, invented in 1888, gave everyone the opportunity to take snapshots. The catchy advertising slogan, "You press the button, we do the rest," boasted of how easy and automatic photography had become. The Kodak became an immediate success, providing a simple way of recording personal and family life. Because of its faster film and ease of use,

Kodak's new camera also made it possible to photograph subjects who had not posed or consented to be photographed.

By 1900, photographs were readily reproduced in newspapers, inaugurating a new era of photojournalism. Pictures also defined the rise of tabloid journalism two decades later. The tabloids read like sensational picture books with huge pictures on the front page and a host of pictures inside. The publisher of the first picture-driven tabloid in 1919, the *Daily News*, declared: "The story told by a picture can be grasped instantly."[15] A story that could not be told in pictures was hardly worth printing, and a picture with a simple caption became news in itself. So eager were tabloids to publish arresting pictures that they were not above fabricating them. The *New York Daily Graphic* invented the "composograph"—a photograph of models reenacting a scene—to solve the problem of picture-poor stories.[16] The photograph became an essential component in the tabloids' serial storytelling of crimes, sex, and disasters—stories that were notorious for hyping reality and blending fiction and fact. As the sociologist Robert Park observed in the late 1920s, the "news story" and the "fiction story" are "now so much alike that it is difficult to distinguish them."[17]

In the movies, fantasy and document were merged right from the start. In 1896 large-screen motion picture projection was invented. Movies were shown in vaudeville theaters appealing to the working and immigrant classes but soon widened their appeal across class lines. During the 1898 war with Spain, audiences craved news from the front, but there was no documentary newsreel footage. That did not prevent Thomas Edison's movie company from fabricating flag raisings against painted backdrops or reenacting executions for a public eager for information.[18]

With the invention of sound, movies became more realistic in presenting their fanciful pictures and more defining of American popular and political culture. Whether mocking social conventions or fueling hopes of social success, movies like *It Happened One Night* (with Clark Gable and Claudette Colbert) and *Top Hat* (with Ginger Rogers and Fred Astaire) shaped the popular imagination during the Depression years. The cultural dominance of movies would extend until the mid-1940s.

Photography began to play a prominent role in advertising by the early 1930s, replacing drawings, graphics, and paintings. Advertisers' newfound infatuation with the photograph was based on its dual power to document and deceive. As historian Roland Marchand points out, advertising firms never tired of talking about the "sincerity" of the photograph—its ability to be accepted as the literal truth. Yet, their art departments had a field day retouching and manipulating photographs to "strengthen their realism" and "dramatize" their "truth."[19] A columnist for a prominent advertising trade journal nicely summed up the ease with which art and artifice were reconciled in the photograph: "To appeal to the reader as genuine and unposed [photographs] should be based on absolute sincerity. Thus the special staging."[20]

The new picture magazines of the late 1930s also exploited the drama inherent in pictures. The first issue of *Life* magazine in 1936 trumpeted its pictures of news events, novelties, human-interest stories, and public-relations stunts. An advertisement for *Time* magazine, carried in *Life*, bore the headline, "There is no drama like reality," succinctly summarizing the blending of drama and documentation in popular picture magazines.

In *Life*'s inaugural issue, its editors introduced two regular features with a wholly unself-conscious enthusiasm for photography. They described "Life on the American Newsfront" as "a selection of the most newsworthy snaps made anywhere in the United States by the mighty picture-taking organization of the U.S. press." The "President's Album" would be a "kind of picture diary—a special focus on the personality center of the nation's life. Luckily for *Life*, it can start its diary with a President [Franklin Roosevelt] who is a marvelous camera actor and is not above demonstrating his art."[21]

For the editors *of Life*, there was little worry about distinguishing the authentic from the staged, the document from the fabrication. *Life* reveled in pictures without the critical edge of today's image-conscious editors. Documentary news shots of the Depression and of the rise of fascism were featured with the same fanfare as novelty shots of a "one-legged man on a mountain," a huge

close-up of Jimmy Durante's nose, and public-relations photographs from the latest movies.

The new medium of television, introduced in the 1940s, was thus the inheritor of a potent visual culture in which the camera played many roles. Like radio in the 1920s and 1930s, television first succeeded as an entertainment medium and then developed strong news divisions, recruiting reporters from print and radio. By the 1950s television became the dominant visual medium, effacing the picture magazines and the movies but incorporating many of their attributes. Comedies like *I Love Lucy,* children's shows like *Howdy Doody* and *The Mickey Mouse Club,* and family fare like *Leave It to Beaver* and *Father Knows Best* drew large audiences in the 1950s. But television offered more: political events broadcast "live" in people's living rooms.

Just as Americans were purchasing their first television sets, an ambitious Tennessee senator, Estes Kefauver, led a special Senate Committee to Investigate Organized Crime in Interstate Commerce. For fifteen months in 1950 and 1951, the Kefauver crime committee traveled from city to city to hold hearings intended to break the back of the powerful crime syndicates that had arisen in the postwar era. In Detroit a local television station bumped *Howdy Doody* to broadcast the senators "grilling mobsters." "When the notorious gambler Frank Costello refused to testify on camera, the committee ordered the TV station not to show his face. The cameras instead focused on the witness's nervously agitated hands, unexpectedly making riveting viewing."[22] The Associated Press reported, "Something big, unbelievably big and emphatic, smashed into the homes of millions of Americans last week when television cameras, cold-eyed and relentless, were trained on the Kefauver Crime hearings."[23] Later congressional inquiries—the Army-McCarthy hearings, Watergate hearings, the Iran-Contra hearings—were broadcast live nationally.

In 1950, only 9 percent of American households had a television set; by 1960, the figure was 87 percent. The news began as only a fifteen-minute program, expanding to the half-hour format in 1963. Television for the first time became the nation's primary news source. It was a fateful year marked by the assassi-

nation of President John F. Kennedy on November 22, 1963. As Americans collectively mourned and watched the Kennedy funeral on television, they also watched in shock as Jack Ruby shot Lee Harvey Oswald on live television. Although the footage of the Kennedy assassination taken by Abraham Zapruder with his home movie camera is what most Americans now remember (almost as if it were live footage), the American public first became aware of the now famous film a week later when still images from the movie were published in *Life* magazine.[24]

If television could bring unfolding reality live into America's living rooms—the Vietnam War and the Apollo moon touchdown—it also brought in its first decades a series of programs that were forerunners of what is now labeled "reality television." A half-century before the hit *American Idol, The Original Amateur Hour* debuted on NBC in 1949 after a stint on the radio. Contestants sang, danced, or performed novelty acts, and the audience voted for their favorite acts by calling the show or sending postcards. Few contestants achieved stardom, but singers Gladys Knight and Pat Boone were television winners, and Frank Sinatra was a winner on the earlier radio version of the show. In the mid-1970s, NBC's *The Gong Show* spoofed variety shows and featured contestants of dubious talent who were evaluated by three celebrity judges who banged a gong to signal that the act had to stop.

Another program that presaged current reality television shows was *An American Family*, which was first aired by PBS in 1972. The program followed the Loud family of Southern California and was designed as a documentary that would reveal the ups and downs of American middle-class family life. With handheld cameras, a film crew followed the family for seven months. With a fly-on-the-wall perspective, viewers watched members of the family eating dinner, engaging in political arguments, taking vacations, attending high school, and later the breakdown of the parents' marriage and the son's move to New York to lead an openly gay life. The program generated the same sort of controversy as reality television programs do today. Was *An American Family* a document or a soap opera, educational or voyeuristic, naturalistic or staged? Or was the program a new hybrid that

incorporated all these qualities? As anthropologist Margaret Mead observed in *TV Guide*, "I do not think that *American Family* should be called a documentary. I think we need a new name for it, a name that would contrast it not only with fiction, but with what we have been exposed to up until now on TV."[25]

The tension between the realism of the television image and its power to fabricate continued to play out as the power of the camera was further enhanced by a series of technological innovations: color, portable cameras, satellite hook-ups, and video. Cable television provides a host of channels and choices of entertainment and news, from reruns of movies and old television shows to round-the-clock news. CNN was established in 1980, MTV in 1981, and the FOX News Channel and MSNBC in 1996. C-SPAN, founded in 1979, provided unedited coverage of both houses of Congress by 1986, and expanded its coverage to include other news events and programs of public interest.[26]

The round-the-clock coverage provided by cable news stations allows them to cover breaking stories of national and international import, but it also intensified the search for arresting and entertaining pictures and stories. In the quest for ratings and profits, television news drifted further toward infotainment, seamlessly interweaving hard news with more lurid tabloid fare—celebrity scandals, murders, and assorted human-interest stories. By the 1990s, cable television's live-action coverage of the Gulf War and the O. J. Simpson trial made the news some of the most exciting entertainment on television. As cultural analyst Neal Gabler observed, "if television made news out of anything that had the rudiments of entertainment, it also made entertainment out of anything that had the rudiments of news." The world became an "endless source of raw material that the medium could process into programming."[27]

The rapid rise of the Internet, digital and wireless technology, blogs, and picture-sharing sites in the first decade of the twenty-first century has expanded the documentary power of the camera and speeded up how pictures real and fabricated can be transmitted. The Internet is an intensely visual medium that breaks down the old boundaries between radio, television, and newspapers. We

no longer simply listen to radio and conjure up pictures in our mind. On Internet radio, we see pictures along with listening to words and sound. During the Iraq War, for example, you could click on a photograph of a soldier on the National Public Radio Web site and be led to a graph titled, "U.S. Troop Fatalities in Iraq since March 2003." You could click again on any date on the bar graph and another photograph came up accompanied by an audio story about the Iraq War.

Similarly, we don't just read newspapers and look at still photos. On the Internet, we listen to a newspaper and watch it like television. The Internet newspaper introduces us to multiple media, front pages that feature large photographs, video reports in the style of traditional television news, photographic slide shows with audio tracks, "photographer's journals," and podcasts. Unlike the print version of papers, the stories and photographs on the home pages of Internet newspapers change multiple times over the course of the day.

Even a newspaper like the *Wall Street Journal*, which has no photographs in its print version, carries photographs and video reports on its Internet site. Like other national newspapers, "Wall Street Journal Video" or its "Best of the Web" selections feature its own reporters and editors in reports that look like television news programs or Sunday morning news talk shows like *Meet the Press*.

Pictures have also assumed greater prominence in the print versions of newspapers. *USA Today* debuted in 1982 as a national paper formatted more like the television screen, with large pictures, news, and entertainment stories. The *New York Times*, for example, once reticent about running pictures on the front page because of the association with tabloid papers, now features outstanding front-page photojournalism.[28] A turning point in the *Times*'s appreciation of the power of pictures came before the era of the Internet and digital photography. In 1987, the marketing department of the *Times* had a hundred readers from diverse backgrounds take a red crayon and mark the way they read the paper. Max Frankel, the executive editor of the *Times* was surprised by the results: "Almost none of our readers read the paper

the way we did, or the way we thought *they* did."[29] People looked at the photographs first and then read the accompanying news story. If the picture was riveting it didn't matter if the story was dull; people still read it. The *Times* absorbed this lesson well in setting up its Internet paper. A way you get to the story is by clicking on the picture.[30]

## Controlling the Picture

As photography, the movies, television, and the Internet became mass forms of image creation, both the promise and the paradox of image making reverberated through American culture. Given the prominence of images in mass democracies, the paradox assumed increasing political importance. Boss Tweed could only complain about those "damn pictures." His successors adopted sophisticated media strategies to control them.

At least since Machiavelli, political consultants have urged politicians to worry more about appearance than reality. "Everyone can see what you appear to be," Machiavelli wrote, "whereas few have direct experience of what you really are."[31] Over four and a half centuries later, American politics is largely a contest for control of television images.

As the American triumph in the 1991 Persian Gulf War became tarnished by the spectacle of abandoned and victimized Kurdish refugees, a Doonesbury cartoon depicted President George H. W. Bush's political predicament. "So what happened? What happened to my perfect little victory?" the president asks. His aides' reply: "We lost control of the pictures, sir. . . . During the war, we killed 100,000 Iraqis, but we controlled the media, so no one saw the bodies. With the Kurds, it's a different situation. Every baby burial makes the evening news. . . . I'm afraid we are just going to have to tough it out. At least until we can get the pictures back on our side."[32]

When the American military landed on the beaches of Somalia to bring food and relief to a war-torn nation, they were prepared for the sniper fire of renegade gunmen in the night. Instead, they

were greeted by the floodlights and television cameras of the American news media. It was as if they had stepped onto a movie set. A political cartoon humorously captured the seamless transformation of life into a photo opportunity: a squadron leader charges up the beach yelling to his men, "Higgins, you take that interview, Johnson, you seize the photo op and the rest of you men, wave to those cameras."

Some years earlier, during the Iran-Contra hearings that made Oliver North a national celebrity, Democrats learned what it meant to "lose control of the pictures." Steven Spielberg, the Hollywood director, was visiting Washington during the televised hearings. As he watched the hearings with some Democratic congressmen, he offered them a lesson in camera angles. "Watch this," Spielberg said, as he turned down the sound and directed the congressmen's attention to North's image on the screen. "The camera on North is shooting up, from about four inches below his eyes. This is the way they shot Gary Cooper in the western, *High Noon*, to make him look like a hero." When the camera panned to the committee members questioning North, Spielberg pointed out, the lighting was dim. Seen at a distance, they looked sinister. Spielberg told the assembled Democrats, "It doesn't matter what Oliver North says. He has already won the battle, because he looks like the hero and everyone else looks like the villain." This realization shocked the congressmen. They knew they could not change the camera angles without being criticized. As one Democratic congressman remarked, "We knew we were in trouble."[33]

A short time later, when it came to the hearings for Supreme Court nominee Robert Bork, Democrats had learned their lesson. This time they focused attention on the setting and stagecraft. The television cameras would look directly at the controversial nominee, not up from the well of the committee room. There would be no more heroic camera angles. As a Democratic political adviser observed, "This time, we wanted to make sure that the playing field was fair."[34] Although ideological and constitutional disputes led to his defeat, Bork did come across badly on television, and failed to win confirmation to the Supreme Court.

The contest for the control of the image is on most vivid display in presidential campaigns. Given the focus on image making in politics and popular culture, it is perhaps unsurprising that politicians draw on their mastery of the medium to project their authority. Early in the 1992 primary season, Democratic presidential candidate Bill Clinton posed for a *Time* magazine photograph sitting on the floor in blue jeans, watching a videotape of one of his campaign commercials on a television screen. The remote-control device in his hands seemed to justify *Time*'s description of Clinton as "the custodian of his own image."[35]

During the 1988 campaign, Republican vice presidential candidate Dan Quayle sought belatedly to assert control over his image. When Quayle was widely labeled in the press as a highly managed candidate, he replied in terms that accepted the notion that image making is the essence of political reality. Instead of rejecting the whole notion of "impression management," he proclaimed his independence from his handlers by resolving publicly to become his own handler and spin doctor: "The so-called handlers story, part of it's true. But there will be no more handlers stories, because I'm the handler and I'll do the spinning. . . . I'm Doctor Spin, and I want you all to report that."[36]

It may seem a strange way for a politician to talk, but not so strange in a media-conscious environment in which authenticity means being master of your own artificiality. Toward the end of the 1988 presidential campaign, Michael Dukakis also tried to bolster his political fortunes by portraying himself as master of his own image. This attempt was best captured in a television commercial in which Dukakis stood beside a television set and snapped off a Bush commercial showing (and ridiculing) his tank ride, and attacking his stand on defense. "I'm fed up with it," Dukakis declared. "Never seen anything like it in twenty-five years of public life. George Bush's negative television ads, distorting my record, full of lies, and he knows it. . . ."

As it appeared in excerpts on the evening news, Dukakis's commercial displayed a quintessentially modern image of artifice upon artifice upon artifice: television news covering a Dukakis commercial containing a Bush commercial containing a Dukakis

media event. In a political world governed by images of images, it seemed almost natural that the authority of the candidate be depicted by his ability to turn off the television set.

By the 2004 presidential campaign, the battle to control the image expanded beyond television to the Internet. In the presidential primaries, Democratic front-runner Howard Dean made effective use of the Internet to raise funds and rally grass-roots support. But it was a television image that upended his Internet-savvy campaign. Dean's campaign went up in flames when an exuberant whoop in a spirited speech to his supporters after a third-place finish in Iowa was endlessly rebroadcast. It came to be known as Dean's "I have a scream" performance, a failed image and visual metaphor as potent as Michael Dukakis's 1988 tank ride or Edmund Muskie's tears in the 1972 New Hampshire primary.

The turn to the photo-op style of coverage—first by the television networks, then in newspapers and on the Internet—is an attempt to avoid manipulation by the campaigns, and wrest control of images from politicians. But it also reflects the emergence of a cultural tendency that had earlier found expression in art and photography: the striving, mostly dormant in the first century of American photography, to draw attention to the image as image, as artifice, as act of construction.

## Soup Cans and Pseudo-Events

In the decades after World War II, artists and photographers began self-consciously to explore their role in the image-making process. For example, in 1970 Lee Friedlander published a photography book of urban images called *Self-Portrait*, in which his own shadow or reflection appeared in every frame. As one critic observed, "by indicating the photographer is also a performer whose hand is impossible to hide, Friedlander set a precedent for disrupting the normal rules of photography."[37]

The pop artist Andy Warhol also explored images of images. Warhol is best known for his paintings of Campbell's soup cans,

Coca-Cola bottles, Marilyn Monroe, and other icons of popular culture. By making copies of familiar images, Warhol changes the way we see them. While an ad for Campbell's soup directs our attention to the product, Warhol's serial reproduction, "200 Soup Cans," directs our attention to the packaging, to the soup can as an image. Similarly, while a glamorous photograph of Marilyn Monroe tempts the viewer to enter into the fantasy she represents, Warhol's silk-screened reproduction of the photograph, titled *Marilyn Six-Pack*, focuses our attention on the merchandising of the image.

Sometimes Warhol begins with the most artificial of images, such as his "paint by numbers" series titled *Do It Yourself*. At other times, Warhol depicts serial images of potent news images—race riots, a mourning Jacqueline Kennedy, car accidents—calling attention to the effects of the television replay.

Warhol's repetition of images from the news, publicity photographs, and commercial products places the viewer in an ambiguous relation to the subject matter. Warhol's art of making pictures of pictures further distances us from the image, inviting our reflections on their meaning and effect. The serial images of celebrities and soup cans can be read as a critique of commercialism. The disaster series illustrates how the constant replays of the modern media—from sports highlights to national traumas—simultaneously transfix us and erode our emotional engagement.

Warhol's reproductions of celebrity portraits and commercial products also play upon and enlarge our engagement with the image. Warhol himself aspired to celebrity status as he engaged in replicating celebrity images. "I love plastic idols," he proclaimed.[38] He became a media personality among media personalities. His reproductions of the celebrity images of Marilyn Monroe, Elvis Presley, and Elizabeth Taylor, far from puncturing the images, may depend for their effect on their enduring appeal. Similarly, in the consumer society people have become accustomed to using advertisements as art—from stacking beer and Coke bottles to decorating dorm rooms to wearing T-shirts with advertising slogans. Warhol's serial images of Coca-Cola bottles and Campbell's soup cans seek a similar effect.

Warhol's pop art anticipates themes that television news would take up two decades later. Warhol once remarked, "I don't know where the artificial stops and the real starts. The artificial fascinates me, the bright and shiny."[39] Reporters and photographers confronting the artifice of the modern campaign might well say the same. They alternate between reporting campaign images as if they are facts and exposing their contrived nature. Like Warhol, whose personality was always a presence in his work, reporters and photographers become part of the campaign theater they cover—as producers, performers, and critics.

A similar shift in emphasis—drawing the viewer's attention away from the event and toward the apparatus of television's coverage of the event—can be seen in the way the networks photograph their anchormen and women on the evening news. In the early days of television news, the images of the candidates or other newsmakers virtually filled the screen, with the anchormen occupying a corner of the screen. Today, the anchors fill the frame. Like the photographer in Lee Friedlander's photos, the television anchor's image becomes a looming presence in the frame, as if inseparable from the event reported.

Social commentators took up the new image-conscious sensibility of the 1950s and 1960s, some with alarm, some with praise. In his book *The Image* (1961), Daniel Boorstin complained that Americans were being increasingly beguiled by "pseudo-events"—scripted performances by corporations and politicians designed to "make news"—rather than engaged in real events. Marshall McLuhan wrote of the power of television to transform reality, and declared that "the medium is the message." And Joe McGinniss described the sophisticated construction of television images by Richard Nixon's 1968 campaign in his book *The Selling of the President* (1969).

*Rowan and Martin's Laugh-In* (1968-73) and *Saturday Night Live* (1975 to the present) featured fast-paced satires of television news coverage. *Laugh-In* had a segment, "Laugh-In Looks at the News," parodying network news and a segment, "News of the Future," which predicted absurd or unlikely news events for comic effect. "Weekend Update" on *Saturday Night Live* makes

fun of newscasters and politicians alike. Chevy Chase portrayed President Ford as a stumbling, bumbling character prone to falling at every turn. Both shows are forerunners of the "fake news" programs popular today like *The Daily Show with Jon Stewart* and *The Colbert Report*, which satirize politicians, puncture photo ops, and make a running joke of the outsized egos and camera-hogging tendencies of television anchors, reporters, and talk show hosts.

The self-conscious attention to image making that has emerged in American popular culture in recent decades is not limited to art and photography, television and film. It also carries consequences for our understanding of ourselves. Much as image-conscious coverage of political campaigns directs our attention away from the substance toward the packaging and stagecraft, recent accounts of identity emphasize the sense in which we construct, even fabricate, ourselves. Traditional notions of fixed selves, defined by character or soul, give way to the modern notion of a centerless self, always in the process of forming or re-forming itself.

Even as Boorstin bemoaned the dominance of images and pseudo-events and Warhol proclaimed his fascination with the artificial, the sociologist Erving Goffman described the fabricated self in his influential book, *The Presentation of Self in Everyday Life* (1958). For Goffman, the self is defined by its "performances," consisting of "fronts," "settings," "dramatic realizations and misrepresentation," and "the art of impression management." Sincerity is no longer a matter of conscience or faithful adherence to one's truest self, but a quality of "individuals who believe in the impression fostered by their own performance."[40]

The fabricated self, like the image-conscious culture it shapes and reflects, takes flight from substance and focuses instead on its own constructed status. Some see this way of viewing ourselves as liberating. If the self is not fixed by a character or soul or historically given identity, it is unburdened by the past, open to a wider range of possibilities. As one defender of the fabricated self has written, "Positing identity as a mutable fabrication rather than a stable 'truth,' is one way to resist the coercive agendas these representations can come to perpetuate."[41]

But there is also a problematic side to the fabricated self, which the modern history of photography vividly portrays. From the time of the daguerreotype to the documentary photography of the 1930s and 1940s, American photography celebrated individuality, and ennobled it. The highest goal of the portrait was to reveal the character and inner life of the subject portrayed. But beginning in the 1950s and 1960s, the individual was no longer presented as distinct and whole.

The photography of Robert Frank explores the perplexities, the dissonances, the moral ambiguity of American life in the 1950s. In Frank's images, we find dark and empty highways, an out-of-focus starlet at a movie premiere, a television set left on in an empty room, a poster of Eisenhower askew in a store window displaying formal wear.

In what was called the new "social landscape" photography of the 1960s, the individual is shown exposed, obscured, fragmented, and deformed. The relation between self and society is askew, oblique. Neither the individual nor the environment that he or she inhabits appears harmonious or whole. The photographer defines the individual by his or her lack of fit. In this new social landscape there is little sense of privacy; even in the private sphere of family and home the individual is exposed.

Diane Arbus, for example, made freaks, deviants, and outcasts the subject of her photographs. Even ordinary people—a baby crying or a child playing in Central Park—are made to look deformed, freakish. In the 1960s, photographers were less concerned with the inner life of their subjects than the incongruities of their outward appearance. Garry Winogrand did a series of photographs of people at the Central Park Zoo in which the people look like the animals. The images are amusing but the individuals are objectified. They have no identity beyond Winogrand's humorous typology.

The pop art of Andy Warhol displays a similar stance toward the self. Warhol had no interest in the soul of his subjects, but was fascinated by the surface. He chose celebrities as his subjects—Marilyn Monroe, Elizabeth Taylor, and Elvis Presley—and reproduced multiple silk-screen images of them drawn from their pub-

licity photographs. When Warhol himself became a celebrity, he deliberately fabricated details of his biography, telling different interviewers different "facts" about his life.

A century earlier, in a whimsical commentary on the new invention of photography, Oliver Wendell Holmes presciently anticipated the new image-conscious sensibility. "Matter as a visible object, is of no great use any longer," Holmes mused,

> except as the mould on which form is shaped. Give us a few negatives of a thing worth seeing, taken from different points of view, and that is all we want of it. ... There is only one Coliseum or Pantheon; but how many millions of negatives have they shed. ... Matter in large masses must always be fixed and dear; form is cheap and transportable. We have got the fruit of creation now, and need not trouble ourselves with the core. Every conceivable object of Nature and Art will soon scale off its surface for us. Men will hunt all curious, beautiful, grand objects, as they hunt the cattle in South America, for their *skins*, and leave the carcasses as of little worth.[42]

As if to confirm Holmes's lament, Warhol titled his multiple reproductions of the Mona Lisa, *Thirty Are Better Than One.*

## Memory, Meaning, and the Digital Document

The transformation in sensibility produced by the rise of the photo-op culture is far from total. Alive as we are to the pose, to the artifice of imagery, we retain, in settings private and public alike, a large measure of the traditional aspiration that the photograph can create an authentic document of our lives.

In everyday life, photographs still serve a documentary ambition apart from the image-conscious sensibility. In wallets and on mantelpieces, in family albums, boxes, envelopes, drawers, digital files, DVDs, on cell phones and computer screens, we show and save pictures. When we look at the photographs that document our lives—baby pictures, wedding pictures, pictures of family re-

unions—we see ourselves in much the same way as our nine-teenth-century forebears did at the time the photograph was invented. Good or bad, in or out of focus, perfect or pedestrian, each photo is a document, a record, a tangible reminder of the way we were, or a way to begin a story and remember the things we actually did.

The power of the photograph to affirm identity is dramatically revealed when lost photographs are recovered, as happened with the lost work of Richard Samuel Roberts. In the 1920s and 1930s, Roberts was the portrait photographer for the black community of Columbia, South Carolina. In large letters outside his studio stood the sign, PERFECT PICTURES. Roberts offered his clients a "true likeness" that he claimed was "just as necessary as every other necessity of life." He chronicled the typical activities of American community life—weddings, graduations, men in business suits and baseball uniforms, mothers and babies, club women, and town leaders.[43]

But these photographs were lost for decades. The town directory of Columbia, South Carolina, for 1920 listed Roberts in the "Colored Dept." as a janitor. The newspapers of the day were likely to recognize blacks only in reporting crimes. The rediscovery of the portraits in 1977 prompted an oral history project to identify the individuals in the photographs. The exhibition in 1986 gave both blacks and whites the opportunity to see the black community as it once saw itself. The photographs were critical documents of lives once lost to public view.

New digital technology has expanded the ability of both professionals and ordinary citizens to reclaim photographs. After Hurricane Katrina, photojournalists David Ellis and Becky Sell of the *Free Lance-Star* in Fredericksburg, Virginia, launched Operation Photo Rescue. Armed with digital cameras and computers they traveled to the storm-devastated town of Pass Christian, Mississippi, to copy and restore as many of the moldy, muddy, and waterlogged family pictures of the town's residents as possible. They harnessed the power of Photoshop not as a form of artificial enhancement but as a means to reclaim the pictures of life's passages, to give people back the markers of memory the hurricane

had destroyed. Given the magnitude of the task, the two photo-journalists communicated with a wider photographic community through their blog, and people from around the country volunteered to restore pictures for the folks in Pass Christian on their own computers.

One of the most moving testimonials to the power of the photograph as a marker of memory is the role photographs play as offerings at memorial sites like the Vietnam Veterans Memorial, the Oklahoma City National Memorial and Museum, and the World Trade Center after September 11. Before an official memorial was built at Oklahoma City, people created a spontaneous one of photographs and other artifacts posted on the chain link fence that surrounded the site. So important was the fence that it was later integrated into the official memorial. Similarly, the fence around the site of the World Trade Center (now torn down) was covered with photographs of those who lost their lives as well as photographs left as remembrances by those they left behind. At these memorial sites, photographs and other artifacts are gathered and archived for future generations.

In a similar spirit, the *New York Times* published photographs of every victim of September 11, along with a short written remembrance, and Internet sites sprung up to memorialize the victims with photographs and testimonials. In the wake of a terrorist bombing in London, a Web site, "We are not afraid," invited people from London and all over the world to post photographs of themselves with a short message affirming that they would not be intimidated by terrorism. Although the Bush administration banned photographs of the coffins of soldiers arriving at Andrews Air Force base during the Iraq War, newspapers and television programs across the nation made a concerted effort to memorialize each fallen soldier with a photographic portrait.

The documentary power of the photograph has been heightened by the widespread use of the video camera. Since the 1980s, the video camera has enabled not only reporters but also ordinary people to document public events, to bear witness to otherwise dark or incredible occurrences, to prove with pictures what words alone seem powerless to prove.

In 1991, when Los Angeles police officers brutally beat a suspect, Rodney King, an amateur photographer recorded it with his video camera. This video document, broadcast on television news programs across the country, led to a public outcry, an indictment of the officers, and an investigation of the department's practices. Although civil-rights lawyers and citizens had long complained of police brutality and mistreatment in the black community, the pictures spoke louder than the complaints. The riots and protests that followed the jury's refusal to convict the defendants stemmed largely from the fact that few believed that any evidence presented in the trial could have contradicted the brutal scene the video document displayed.

Today, cell phone and digital video cameras can make everyone a potential citizen journalist or television reporter. Steve Mann, a pioneer of wearable computing and camera devices, coined the term "sousveillance," playing on the French to mean "to watch from below." At a conference in Seattle titled "Panopticon," after a prison design by eighteenth-century philosopher Jeremy Bentham, Mann suggested that citizens using sousveillance could arm themselves with microcameras, portable video cameras, digital tape recorders, and other wireless devices (even transmitting pictures in real time over the Internet) as a way to defend against police brutality or government or corporate surveillance.[44]

At the 2004 Republican National Convention, protestors used video cameras to document their own behavior and the actions of police. During several days of protest, over 1,800 people were arrested, and the videotapes were collected and catalogued by groups such as the National Lawyers Guild to use in court as evidence. "There is a huge amount of power in these videos in terms of protecting the First Amendment," observed an attorney for the National Lawyers Guild. "Normally it's [the police's] word against the scruffy protester, and the protester loses. This is a new tool to protect the Bill of Rights."[45]

After the Republican convention, the *New York Times* reported that "a sprawling body of visual evidence, made possible by inexpensive, lightweight cameras in the hands of private citizens, volunteer observers, and the police themselves, has shifted the debate

over precisely what happened on the streets during the week of the convention." In the case of some four hundred arrested that week, "video recordings provided evidence that they had not committed a crime or that the charges against them could not be proved, according to defense lawyers and prosecutors."[46] This extensive videotaping saved the day for Alexander Dunlop, who claimed that the police arrested him on the way to pick up sushi. After his trial, in which the police showed their videotape of him, a volunteer film archivist informed Mr. Dunlop that the police tape had been edited in two spots, "removing images that showed Mr. Dunlop behaving peacefully." Once Dunlop's lawyer presented the complete tape, prosecutors "immediately dropped the charges and said that a technician had cut the material by mistake."[47]

As news broke about the terrorist bombings in London, the tsunami in Indonesia, or the mass killings of students at Virginia Tech, participants and witnesses provided live videos to the television networks and a host of pictures posted on the Internet for worldwide viewing. Even as the government struggled to respond to Hurricane Katrina, citizens forged links to mobilize themselves online. As one commentator put it, Katrina was America's first "live-blogged national disaster" in which citizens were at the forefront of information sharing and rescue work.[48]

The documentary power of the camera is much in evidence in the world of sports. Videotaped replays became more than a way of letting television viewers see again a touchdown pass or a stolen base. They also are ways of confirming or refuting the calls of umpires and referees, of getting at the truth. In the 1980s, the National Football League changed its rules to allow referees to consult instant replays to authenticate controversial calls, abandoned the practice for a few years, then brought it back in 1999. The National Basketball Association and the National Hockey League also use some form of instant replay, though Major League Baseball has yet to embrace the practice. Other sports, such as horse racing and track, continue to rely on the camera's eye to determine winners in "photo finishes."

Even home movies and videos, long treasured as part of family memories along with photographs, are now being viewed as important documents in their own right. For many years, museums and archives focused their attention on preserving Hollywood films, art films, and documentaries, but this began to change in the 1990s. In June 2000, the Library of Congress's National Film Preservation Board and the Association of Moving Image Archivists held a two-day conference to discuss the challenges of preserving home videotapes and digital recordings. As historian Thomas Doherty notes, "driver-education films from the 1950s can be as instructive about gender dynamics as about parallel parking," and museum collections of home movies are "the archival equivalent of from-the-bottom-up history."[49]

Implicit in the widespread use of the video camera to bear witness, to render an objective picture of reality, is the traditional conviction, born with the daguerreotype, that the camera does not lie. Even in today's photo-op culture, awash as it is with image making and manipulation, celebrity and contrivance, photo opportunities and media events, the documentary aspiration persists; our search for the authentic document coexists with our self-conscious preoccupation with the image as an image.

Traditional understandings also persist in our view of the selves that images portray. The posing, centerless, fabricated self has not fully displaced our stubborn belief that individual agents can master events and vindicate noble ideals. This can be seen in the difficulty of unraveling or deconstructing the hold that some images, especially mythic or heroic ones, have on our imagination. Popular movies make no claim to being real, yet they embody the "spirit of fact," as surely as the idealized photographs that mark the rituals of our daily lives.

Over a century and a half after its invention, the promise and the paradox of photography are with us still. The modern revolution in the technology of picture making has extended the potential of the camera for authentic documentation but has also created the potential for the image to subvert reality on an un-

precedented scale. We have played out the paradox of the artifice of imagery to a degree unimaginable to those who called the camera the "pencil of nature." They aspired to the perfect picture, and judged the image by its fit with the world. In our image-conscious culture, we seek moments that are picture perfect, and judge the world for its fitness as an image.

# Photo-Op Politics

🦂

## Sound-Bite Democracy

Standing before a campaign rally in Pennsylvania in October 1968, the Democratic vice presidential candidate Edmund Muskie tried to speak, but a group of antiwar protesters drowned him out. Muskie offered the hecklers a deal. He would give the platform to one of their representatives if he could then speak without interruption.

Rick Brody, the students' choice, stepped to the microphone where, cigarette in hand, he delivered an impassioned if disjointed case against the establishment. Those who saw the demonstrators as "commie pinko rads" were wrong. "We're here as Americans." To cheers from the crowd, he denounced the candidates that the 1968 presidential campaign had to offer. "Wallace is no answer. Nixon's no answer and Humphrey's no answer. Sit out this election!"

When Brody finished, Muskie made his case for the Democratic ticket. That night, Muskie's confrontation with the demonstrators played prominently on the network news. NBC showed fifty-seven seconds of Brody's speech and over a minute of Muskie's.

Twenty years later, things had changed. Throughout the entire 1988 campaign, no network allowed either presidential candidate to speak uninterrupted on the evening news for as long as Rick Brody spoke in 1968.

By 1988, television's tolerance for the languid pace of political discourse, never great, had all but vanished. The average length of a sound bite, or block of uninterrupted speech, for presidential

candidates fell from 42.3 seconds to 9.8 seconds. In 1968 almost half of all sound bites were 40 seconds or more, compared to less than 1 percent in 1988. In fact, it was not uncommon in 1968 for candidates to speak uninterrupted for over a minute on the evening news (21 percent of sound bites); in 1988, it never happened.[1]

The 1968 style of coverage enabled not only the candidates but also partisans and advocates from across the political spectrum to speak in their own voice, to develop an argument on the nightly news. Lou Smith, a black activist from Watts, spoke for almost two minutes without interruption on NBC (Chancellor, October 22). Another network newscast aired over two uninterrupted minutes of Chicago Mayor Richard Daley's attack on media coverage of riots outside the Democratic convention. In 1988, George Bush and Michael Dukakis sometimes spoke less in an entire week of sound bites than Lou Smith or Mayor Daley or Rick Brody spoke on a single night in 1968.

While the time the networks devoted to the candidates' words sharply declined between the two elections, the time they devoted to visuals of the candidates unaccompanied by their words increased by over 300 percent.

In 1968, most of the time Americans saw the candidates on the evening news, they also heard them speaking. In 1988, the reverse was true; most of the time the candidates were on television, someone else, usually a reporter, was doing the talking. In a three-week period in the midst of the 1968 campaign, for example, the candidates spoke for 84 percent of the time their images were on the screen. In a comparable three-week period in 1988, the candidates spoke only 37 percent of the time. During the other 63 percent, we saw their pictures—not only posing in media events but also delivering speeches—without hearing their words.

Television's growing impatience with political speech raises serious questions about the democratic prospect in a television age: What becomes of democracy when political discourse is reduced to sound bites, one-liners, and potent visuals? And to what extent is television responsible for this development?

With the decline of political parties and the rise of media-savvy political consultants, presidential campaigns became more adept at conveying their messages through visual images, not only in political commercials but also in elaborately staged media events.[2] By the time of Ronald Reagan, the actor turned president, his media adviser, Michael Deaver, had perfected the techniques of the video presidency.[3]

For television news, the mastery of television imagery by the politicians posed a temptation and a challenge. The temptation was to show the pictures. What network producer could resist the footage of Reagan overlooking a Normandy beach, or of George H. W. Bush on Boston Harbor? Indeed, the networks showed the media events that the campaigns staged and even their commercials. The most striking of these, such as Bush's "revolving door" prison commercial, appeared repeatedly in network newscasts throughout the campaign. At the same time, the networks sought to retain their objectivity by exposing the artifice of the images they showed, by calling constant attention to their self-conscious design.

Preoccupied with the pictures, they often forgot about the facts. Whether the pictures came from media events or political commercials, the networks covered them as news, often with little attempt to correct the distortions they contained. Alerting the viewer to the construction of television images proved no substitute for fact correction, no way back to reality.

A superficial "balance" became the measure of fairness, a balance consisting of equal time for opposing media events, and equal time for opposing commercials. Rather than confront the image with the facts, or with the candidates' actual records on the issue at stake, the networks simply balanced perceptions, setting one contrived image alongside another. Bush posed with his policemen; Dukakis posed with his. The candidates' actual records on crime did not necessarily figure in the story.

To be sure, image-conscious coverage was not the only kind of political reporting to appear on network newscasts in 1988. Some notable "fact correction" pieces, especially following the presidential debates, offered admirable exceptions. But the turn of

television news to the self-conscious attention to image making set the tone of the 1988 coverage, and defined a new and complex relation between politics and the press.

This photo-op style of coverage is now so familiar that it is difficult to recall the transformation it represents. The heightened attention to the construction of images for television, so prominent by 1988, was all but absent only twenty years earlier. Only 6 percent of reports in 1968 were devoted to image-conscious coverage, compared to 52 percent in 1988.

This new relation, between image-conscious coverage and media-driven campaigns, raises with special urgency the deepest danger for politics in our times. This is the danger of the loss of objectivity—not in the sense of bias, but in the literal sense of losing contact with the truth. It is the danger that the politicians and the press could become caught up in a cycle that leaves the substance of politics behind, that takes appearance for reality, perception for fact, the artificial for the actual, the image for the event.

## Media Events

One morning in September 1968, Hubert Humphrey took a walk on the beach in Sea Girt, New Jersey. Shoes off, pants rolled up to avoid the surf, he paused to pluck a shell from the sand and toss it into the ocean. This being a presidential campaign, Humphrey's stroll was no solitary idyll. The candidate was soon surrounded by a swarm of reporters and camera crews, who invited him to hold forth on Nixon, the Supreme Court, crime, and education. Humphrey was happy to oblige.

That night on the evening news, the story played in two different ways. Don Oliver of NBC (September 13) played it straight, as a news conference by the sea. The beach was in the background, but the story was the substance, what Humphrey said. Oliver showed the crowd of reporters and cameras, but made no mention of television's presence.

For David Schoumacher of CBS (September 13), the story was less the substance than the setting. He covered Humphrey's appearance by the sea as an exercise in image making, a way of posing for television. "It used to be kissing babies," Schoumacher began, "now candidates like to have their pictures taken walking alone on the beach. Apparently it is intended to show the subject at peace with himself and in tune with the tides."

In Schoumacher's report, Humphrey's statements scarcely mattered. The story was the media event itself. "Reporters struggled through the sand trying to keep up and hear over the sound of the surf. Hours later they were still comparing notes to figure out what the vice president had said. Mostly they said his campaign was going well."

These two versions of Humphrey's walk on the beach hint at the transformation that network campaign coverage would undergo over the next two decades. Oliver's version, which focused on the candidate and what he said, was traditional political reporting that in 1968 was still the norm for television news. Schoumacher's version, which focused on the construction of images for television, was a novelty in 1968, but an intimation of things to come.

Looking back on his report, Don Oliver recalls that, in 1968, both the campaigns and the reporters were less image driven than today. "I focused on Humphrey's speech because I believed the candidates were still saying things of interest and not merely spouting slogans some advertising man had dreamed up. In 1968 it was still rather innocent. So when a candidate appeared at an event, you didn't really look for who manipulated it."[4]

Reviewing his report, Schoumacher acknowledges, "I was doing some 'show-bizzy' stuff with that piece." He explains that, "in 1968, the campaigns were making their first successful attempts to manipulate reporters, and we were trying to fight as best we could." Not all campaigns were equally adept at the art of manipulating television, Schoumacher recalls. "Although Wallace and Nixon were quite sophisticated, the Humphrey campaign wasn't. They would often stick you in a corner so you wouldn't get in the way of the people who were attending the event. They

never advised us on setting up camera angles. They didn't realize that the people in attendance were a stage set."⁵

The idea that campaign stops were media events, and the participants a stage set, only gradually emerged. The 1968 campaign was just the beginning of the battle to control the pictures that would play on the evening news. The presidential candidates had not yet acquired the habit of speaking in carefully crafted sound bites for easy television consumption. Humphrey's garrulousness was legendary. As reporter Jack Perkins quipped, "It would have been impossible to extract a short sound bite from one of his speeches."

Frank Shakespeare, one of Nixon's media advisers, recalled that Nixon did not speak in explicitly fabricated sound bites either. Given the style of reporting, such speech was not required as a condition of coverage on the network news. Despite the Nixon campaign's worries about press hostility to their candidate, Shakespeare observed, "We were always confident that if Nixon broke new ground or addressed an issue in a serious way, you had a reasonable shot of getting a direct portrayal on television."⁶

By the 1970s, the campaigns and the networks had grown more sophisticated in the creation and use of television images. Still, the networks were ambivalent about making television itself the focus of political coverage. This ambivalence was reflected in a 1976 dispute between Walter Cronkite and Roger Mudd over whether to air a piece focusing on candidates' attempts to manipulate television news.

During the primary campaign, Mudd and producer Brian Healy prepared a report revealing how Senator Frank Church, Governor Edmund G. Brown Jr., and Ronald Reagan used media events in California. The five-minute report was an extended piece of image-conscious coverage, designed to highlight the growing ability of the campaigns to contrive events to play on television. "Reagan had spent three hours and five minutes talking to not more than 2,000 people in the flesh," Mudd reported. "He took no new positions, he broke no new ground; but that night in Los Angeles's three early-evening newscasts, he was seen by an audience of 1,071,000 people for five minutes and fifty-one

seconds. And that night on the three network newscasts, he was seen for four minutes, four seconds by 37 million people." At the end of the segment, a political consultant commented, "The return is very small in terms of astute judgments on the candidate. The return is high in terms of just plain exposure. I like it the way it is because it makes my job easier. But I'm not sure the voters are getting a straight deal on it."[7]

Walter Cronkite refused to air the piece on the *CBS Evening News*, fearing it cast television news in a negative light for allowing itself to be manipulated. Mudd's report, which ran the next day on the *CBS Morning News*, was a hard-hitting version of the image-conscious reporting that would soon become standard fare. Mudd now thinks such reporting is overdone. "When we did the piece in 1976, we thought we were being very courageous. That kind of reporting was not a staple in the 1970s. By the 1980s, those were standard pieces to put on the plate. By 1988, we had had too much."[8]

Presidential campaigns had become adept at crafting images for television, and the networks covered them with frequent reference to this fact. They often portrayed the candidates as rival image makers, competing to control the picture of the campaign that would play on the evening news. The traditional focus on the candidates' statements and strategies gave way to a style of reporting that focused on the candidates' success or failure at constructing images for television.

When Bush kicked off his 1988 campaign with a Labor Day appearance at Disneyland, the networks covered the event as a performance for television. "In the war of the Labor Day visuals," Bob Schieffer reported (CBS, September 5), "George Bush pulled out the heavy artillery. A Disneyland backdrop and lots of pictures with the Disney Gang." Dukakis's appearance that day in a Philadelphia neighborhood did not play as well. His maneuver in the "war of the Labor Day visuals" was marred by a squealing microphone, an incident highlighted in the image-conscious coverage of all three networks.

Likewise, when Bruce Morton (CBS, September 13) showed Dukakis riding in a tank, the image was the story. "In the trade

of politics, it's called a visual," Morton observed. "The idea is pictures are symbols that tell the voter important things about the candidate. If your candidate is seen in the polls as weak on defense, put him in a tank." Even when Morton turned to the speech that followed the ride, it was with an eye to the television image the candidate sought to project. "Dukakis, against a backdrop of tanks and flags, used the word 'strong' eight times."

In 1988, the networks covered even the presidential debates as occasions for television image making. Two days before the first debate, Peter Jennings (September 23) began ABC's coverage by noting, "Today, Bush and Dukakis have been preparing, read rehearsing." There followed a report by Brit Hume, describing a Bush meeting with Soviet Foreign Minister Eduard Shevardnadze as "unquestionably a campaign photo opportunity." Hume alerted his viewers to listen as the television microphones picked up the sound of Bush whispering to Shevardnadze, "Shall we turn around and get one of those pictures in?"

Jennings then announced that Dukakis too had found time for "a carefully staged photo opportunity." In the report that followed, Sam Donaldson drove home the point again. Showing Dukakis playing catch with a Boston Red Sox outfielder, Donaldson described the event as "this mornings' made-for-television, predebate photo opportunity."

The hyperconsciousness of television image making on the part of networks and campaigns alike, so pervasive in 1988, was scarcely present only twenty years earlier. While Nixon and Humphrey both sought to use television to their advantage in 1968—Nixon with considerable sophistication—their media events consisted for the most part of traditional rallies, parades, and press conferences. The networks rarely drew attention to the image-making apparatus of "visuals" or "backdrops."

By 1988, the politicians, assisted by a growing legion of media advisers, had become more sophisticated at producing pictures that would play on television. The networks, meanwhile, were unable to resist the temptation to show the pictures. Vivid visuals made good television, and besides, some network producers argued that if the candidate goes to Disneyland or rides in a tank,

does not covering the campaign mean covering those events? "We were dying to deal with the issues," complained one network producer. "We were pleading with these guys to do more substance, to give us the opportunity to do more substantive pieces. In the end, we just covered what was out there. If what is out there is theater, then that is what we cover."[9]

Even as they taped the media events and showed them on the evening news, however, television journalists acknowledged the danger of falling prey to manipulation, of becoming accessories to the candidates' stagecraft. One way of distancing themselves from the scenes they showed was to turn to photo-op coverage, to comment on the scenes as a performance made for television, to lay bare the artifice behind the images.

Given limited access to the candidates, image making becomes one of the few subjects of coverage available. "The press plane was the decoy, where they took all the reporters off and fed them pablum," observed Tom Bettag, executive producer of the CBS evening news during the 1988 campaign. "The manipulation is the only thing the reporters were allowed to get their hands on, and the image making became one legitimate way of looking at the candidates."[10] CBS producer Susan Zirinsky added that revealing the artifice is one way that journalists try to avoid being manipulated. "I think very often when you feel snookered you feel you've done a service if you point it out. It's your own moral conscience as a journalist speaking. You say, 'Hey, we did not just go and cover this event. There is more to this. You wouldn't believe what happened.' "[11]

However critical its intent, image-conscious coverage often has the opposite effect. One of the problems with the photo-op style of coverage is that it involves showing the potent visuals the campaigns contrive. Reporters become conduits for the very images they criticize. Lisa Myers's report on Bush's use of television (NBC, September 19) is a case in point. "It is a campaign of carefully staged events and carefully crafted images," Myers began. A sequence of Bush images then appeared on the scene: "George Bush; friend of the working man" (Bush wearing a hard hat); "Bush the

patriot" (Bush saying the Pledge of Allegiance); "Bush the peace-maker" (Bush watching the Pershing missile destruction).

Even as Myers described the artifice of Bush's political theater, she provided additional airtime for some of his most flattering images. Furthermore, the political message the pictures were intended to convey was presented uncritically. Myers focused on the effectiveness, not the truthfulness of the images. The photo of Bush in a hard hat, for example, was simply presented as a testimonial to Bush's image-making skill. There was no mention of the fact that Bush's labor policies were unpopular with workers, or that he had been booed by workers at an earlier campaign stop, as all three networks reported at the time (September 6).

Myers concluded by observing that the Bush campaign, by limiting reporters' access and "carefully scripting each event" was skillfully "managing the news." But in giving Bush's "carefully crafted images" another television run, her own report fell prey to the manipulation she documented.

In the hands of network producers, the campaigns' media events generated visuals as flattering as paid political advertisements. It is no wonder that even sophisticated observers could fail to distinguish them. When Leonard Garment, Nixon's media director in 1968, was shown a videotape of Myers's report, he asked in genuine confusion, "Is this a Bush commercial?"[12] By 1988, it was hard to tell the difference.

"In 1988, the media events turned out to look like paid ads," comments Joe Napolitan, who in 1968 was in charge of Humphrey's media. "The press let the campaigns structure 'commercials,' and they produced them and ran them on the evening news."[13]

Some reporters acknowledge that their attempts to be critical of campaign contrivances may sometimes be lost on the viewer. Reviewing his report on Bush's campaign kickoff in Disneyland, CBS correspondent Bob Schieffer was unsure the piece came across the way he had intended. "When I used the phrase, 'the war of the Labor Day visuals,' I was being satirical. It just reminds me that you can't be too subtle on television. I thought it was ridiculous. Here Bush is with the balloons, Snow White, and

Goofy. I was doing it to show how hollow it was, but I'm not sure it came across that way."[14]

Jeff Greenfield, an ABC correspondent, suggested that image-conscious coverage could be a distraction from genuinely critical reporting. Reporters "become stylistically skeptical, but not substantively. You score great points if you show how the campaigns move a tree to make the picture look better. But frankly, it's the frustration of feeling so manipulated."[15]

Although photo-op coverage seeks to alert the viewer to the artifice of the images that the campaigns contrive, even critical versions of image-conscious coverage can fail to puncture the pictures they show. When Bush visited a flag factory in hopes of making patriotism a campaign issue, Brit Hume (ABC, September 20) reported with some cynicism that Bush was wrapping himself in the flag. "This campaign strives to match its pictures with its points. Today and for much of the past week, the pictures have been of George Bush with the American flag. If the point wasn't to make an issue of patriotism, then the question arises, what was it?"

Although he showed Bush's potent visuals, Hume reminded viewers that Bush's purpose was implicitly to question the patriotism of Dukakis, who had vetoed a law mandating the Pledge of Allegiance. But the very pictures that Hume tried to debunk would live to run again on the evening news, as file footage, or stock imagery illustrating Bush's campaign.

Only three days later, the staged image of Bush at the flag factory appeared without comment as background footage for a report (ABC, September 23) on independent voters in New Jersey. The media event that Hume reported with derision was quickly transformed into a visual document of Bush. The criticism forgotten, the image played on.

## Political Ads as News

In the final week of the 1968 campaign, the Nixon campaign aired a television commercial showing a smiling Hubert Humphrey su-

perimposed on scenes of war and riots. The Democrats cried foul, and the Nixon campaign agreed to withdraw the ad. The next night on the evening news, Walter Cronkite (CBS, October 29) and Chet Huntley (NBC) reported briefly on the withdrawal, though neither showed any part of the ad.

It was one of the few times that a political commercial received even passing mention on the network news that year. Political ads were not considered news in 1968. Although both Nixon and Humphrey spent heavily on television commercials, only two clips from paid political ads appeared on the evening news, both from a staged Nixon "panel show" in which the candidate answered questions from a preselected group of citizens.[16] Not once did the network newscasts run excerpts from the candidates' thirty- or sixty-second commercials.

Twenty years later, political commercials were a staple of television news campaign coverage. Network newscasts showed 125 excerpts of campaign commercials in 1988, and ran some so repeatedly that they became visual motifs, recurring video stand-ins for the candidates.

The attention the networks gave political ads in 1988 illustrates their growing preoccupation with imagery made for television. As with their coverage of media events, so with political ads, the danger is that reporters become unwitting conduits of the television images the campaigns dispense. No matter how critical the narrative, to show commercials on the news runs the risk of giving free time to paid media, of letting the visuals send the message they were designed to convey.

Most of the time, the narrative was not critical. For all their use of commercial footage, the networks rarely corrected the distortions or misstatements the ads contained. The reporter addressed the veracity of the commercials' claims less than 8 percent of the time. The few cases in which reporters corrected the facts illustrate how the networks might have covered political commercials but rarely did. When Richard Threlkeld (ABC, October 19) ran excerpts from a Bush ad attacking Dukakis's defense stand, he froze the frame at each mistaken or distorted claim.

BUSH AD: Michael Dukakis has opposed virtually every defense system we've developed.

THRELKELD: In fact, he supports a range of new weapons systems, including the Trident 2 missile.

BUSH AD: He opposed antisatellite weapons.

THRELKELD: In fact, Dukakis would ban those weapons only if the Soviets did the same. The same principle is incorporated in the INF Treaty which George Bush supports.

BUSH AD: He opposed four missile systems including the Pershing 2 missile deployment.

THRELKELD: In fact, Dukakis opposes not four missile systems but two as expensive and impractical and never opposed deploying Pershing 2s.

In another notable case of fact correction, Lesley Stahl (CBS, October 25) corrected a deceptive statistic in Bush's revolving-door furlough ad. The ad showed criminals entering and leaving a prison through a revolving door as the narrator said: "[Dukakis's] revolving-door prison policy gave weekend passes to first-degree murderers not eligible for parole." The words "268 escaped" then appeared on the screen.

Stahl pointed out that "part of the ad is false. . . . 268 murderers did not escape. . . . The truth is only four first-degree murderers escaped while on parole." She concluded by observing, "Dukakis left the Bush attack ads unanswered for six weeks. Today campaign aides are engaged in a round of finger pointing at who is to blame."

But the networks were also guilty of letting the Bush commercial run without challenge or correction. Only four days earlier, Stahl's CBS colleague Bruce Morton had shown the revolving-door ad and the deceptive statistic without correction. Even after her report, CBS and ABC ran excerpts of the ad without correction, just days before the election. In all, network newscasts ran excerpts from the revolving door ad ten times throughout the campaign, only once correcting the deceptive statistic.

It might be argued, in defense of the networks, that it is up to the candidate to reply to his opponent's charges, not the press.

But this argument is open to two objections. First, if the job of the press is to report the truth, then airing misleading commercials without challenge or correction does not amount to objective reporting. Second, the networks' frequent use of political ads on the evening news creates a strong disincentive for a candidate to challenge his opponent's ads. As Dukakis found to his misfortune, to attack a television ad as unfair or untrue is to invite the networks to run it again.

Two weeks before the election, the Dukakis campaign accused the Republicans of lying about his record on defense, and of using racist tactics in ads featuring Willie Horton, a black convict who committed rape and murder while on furlough from a Massachusetts prison. In reporting Dukakis's complaint, all three networks ran excerpts of the ads in question, including the highly charged pictures of Horton and the revolving door of convicts. Dukakis's response thus gave Bush's potent visuals another free run on the evening news.

As they appeared on the evening news, the Bush ads on crime enjoyed a heightened impact due to the networks' readiness to combine them with material from the Willie Horton ad produced by a group not formally tied to the Bush campaign. This link was so seamless that many viewers thought the revolving-door furlough commercial featured Willie Horton, when in fact it never mentioned him. Bruce Morton (CBS, October 21), for example, showed the pictures of the revolving-door furlough ad while recalling the Horton story as a voiceover. "The Bush campaign has scored big on television ads on crime, especially on the Massachusetts furlough program under which Willie Horton on furlough committed rape and assault."

Even as he reported the Bush campaign's disavowal of the Horton ad, Brit Hume (ABC, October 25) highlighted the racial dimension of the Horton story as images from the revolving-door ad filled the screen. "They also denied any racial intent in television spots about black murder convict Willie Horton who raped a Maryland woman and stabbed her husband, both white, while on prison furlough from Massachusetts." Likewise, a special report by Jackie Judd on crime (ABC, September 22) opened with

a photograph of Willie Horton filling the screen. Even though her report tried to provide some perspective on the furlough issue, her images reinforced the Willie Horton ad.

Although Bush campaign ads never showed him, Willie Horton's picture appeared nine times on the evening news, five times in juxtaposition to official Bush commercials. Horton's victims also were shown holding a press conference by all three networks (October 7) in addition to their appearances in commercials broadcast on the evening news on other occasions. In these ways, the networks contributed to the massive media exposure of Willie Horton.

The networks' coverage of campaign commercials reached its greatest intensity on October 25, when Dukakis attacked Bush's negative ads, and Bush replied. That night on the evening news, the networks not only reported the candidates' charges and countercharges, but also showed no fewer than twenty excerpts of campaign commercials to dramatize the dispute. Although the story of the day concerned competing claims about the veracity of the ads, the networks focused on the effectiveness, not the truthfulness, of the ads they showed.

In defense of their ads, Bush campaign officials called a press conference that day to offer evidence to back their claims. All three networks covered the press conference, but none bothered to assess or even to report any of the evidence the Bush campaign offered. Instead, they treated the press conference as one more media event, with sound bites from John Sununu, "The data speaks for itself," and Dan Quayle, "Every statement is accurate and can be documented," and supporting charts and documents as backdrops to yet another exercise in image making.

The networks became in effect electronic billboards for the candidates. Not only were Bush's furlough ads featured, but also so were Dukakis's "handlers ads," attacking Bush as a packaged candidate. Political commercials that were not even aired on network television nonetheless reached a national audience via the evening news. The Willie Horton ad, for example, was shown on cable television but not on the networks, according to its producer, Larry McCarthy.

"In 1968, reporters just did not think ads were the story,"[17] noted Joseph Napolitan, Humphrey's media director. Frank Shakespeare, Nixon's media adviser, agreed. "The press was not interested in somebody making a commercial. That was like going into a newspaper and asking if you could go into the print shop. An ad can be very effective, but it is peripheral. What's central is the candidate, what he says, what he stands for."[18]

Reporters who covered the Humphrey-Nixon campaign were hard put to recall any of the 1968 commercials. According to Roger Ailes, who had made commercials for Republicans from Nixon to Bush, campaign ads have not suddenly become more important in presidential politics, or more effective. He attributes the current preoccupation with ads to a decline in journalistic standards, and a shift in emphasis from political substance to compelling pictures. "I'm sure somebody suggested showing ads in 1968, and someone said, 'Why would we want to give them free air time?' Reporters then were busy trying to figure out what the campaign was about from an issues standpoint and report it. I think they were actually still doing journalism in those days. Today people build their whole newscast around these ads because they haven't done any real reporting."[19]

Network producers offer different explanations for the increased attention to political ads in campaign coverage. CBS producer Jill Rosenbaum argued, "To ask us not to use [political commercials] is to ignore a huge part of the political environment. You can't make a distinction in the campaign between what's on television because it's news and what's on television because it's a commercial."[20]

Yet it was precisely this blurring of the distinction between news and commercials that the campaigns exploited. By 1988, the campaigns actively promoted upcoming commercials to network producers and reporters. "It used to be that we would struggle to get a copy of an ad," noted Andy Franklin, director of political coverage for NBC during the 1988 campaign. "Now, if you want an ad, you get it, sometimes before the stations that are going to air them as commercials."[21] Brian Healy, who directed CBS's 1988 campaign coverage, added that campaigns now actively promote

upcoming ads to network reporters and producers. "They'll say, 'We are going to start running some ads next week that are going to be devastating.' They can put it into a computer and knock it over to you. And you look at it and decide whether it will fit into the stories you're doing. It's that easy."[22]

Campaigns eased access to political commercials as they limited access to the candidates. Presidential campaigns now call press conferences in which the candidate does not appear, but a video presentation of new television ads does. Sanford Socolow, senior producer for the *CBS Evening News* with Walter Cronkite in 1968, was scornful of the networks' widespread use of political commercials. "In 1988, an ad agency staging a glamorous opening was enough to get their political ads on the evening news. In 1968, we would have turned our backs on it."[23]

Ted Koppel, who covered Nixon's campaign in 1968 for ABC, did one of the few reports that year to focus on political advertising. Koppel's report, on Nixon's staged "man in the arena" citizen panel show, was an early instance of image-conscious coverage that differs in some ways from the photo-op coverage now prevalent in campaign reporting. The piece begins by revealing the artifice of Nixon's staged television show. A polished master of ceremonies is shown warming up the audience, urging them to applaud on cue, to "sound like ten thousand people." Koppel reports, "Across the country . . . the same jovial emcee warms up one studio audience after another for the most successful television personality since Ronald Regan washed his hands of 'Twenty Mule Team Borax.' In 1960, television was a prime factor in defeating Nixon. This year it may be his most effective vehicle on the road to the White House" (ABC, September 25, 1968).

Koppel's coverage of the Nixon commercial differed from the 1988 style of ad coverage in that the commercial never fills the screen. We see it only from afar, displayed on television monitors as people are shown watching it in different settings. Far from giving free airtime to the Nixon ad, the report focuses on how the images were made and what Nixon was trying to achieve. A telling image in the Koppel report is a picture of reporters isolated in a screening room, barred not only from the panel of question-

ers but even from the studio audience. This isolation of the press was a harbinger of things to come.

Agreeing in part with Ailes, Koppel thinks the current prominence of ads as news has something to do with television's appetite for gripping visuals. "Part of the problem is that we are becoming trapped again and again by enhanced production values." He also suggested that the preoccupation with ads in 1988 reflected the emptiness of the campaign. "In 1968 you had two very interesting candidates facing major issues. In 1988 you had two very boring candidates. The television ads were it in 1988."[24]

Reuven Frank, former president of NBC news, was the producer who guided the *Huntley-Brinkley Report* in the 1960s. He offered the traditionalist's objection to broadcasting commercials as news. "The trap is making the ad the story by showing it on the news." Frank opposed showing even Lyndon Johnson's famous "daisy ad" on the evening news during the 1964 presidential campaign. The ad, now part of the lore of negative campaign advertising, implied that Barry Goldwater, Johnson's Republican opponent, might be quick to use nuclear weapons. It never mentioned Goldwater by name; instead, it showed a little girl pulling petals off a daisy. Her voice merged with a countdown for an atomic explosion that then filled the screen.

The Democrats withdrew the ad after one showing. "It was not a story. It was not news," Frank insisted. "But one of the networks showed the ad and that inflated its importance. It made the ad the story. That's the trap."[25]

By 1988, the networks had succumbed to the trap that Frank describes. The campaigns, meanwhile, had become highly adept at generating controversies about ads to attract network coverage. As Larry McCarthy, producer of the Willie Horton ad, observed, "I have known campaigns that have made ads and only bought one spot, but released them in major press conferences to get it into the news. It's become a fairly common tactic."[26]

And controversy or not, by repeatedly showing ads, the networks risked being conduits for the campaigns' contrivances. Oddly enough, the networks were alive to this danger when confronted with the question of whether to air the videos the cam-

paigns produced for their conventions. "I am not into tone poems," said Lane Venardos, the executive producer in charge of convention coverage at CBS. "We are not in the business of being propaganda arms of the political parties."[27] But they seemed blind to the same danger during the campaign.

The networks' use of commercial footage on the evening news was not restricted to days when ads were an issue in the campaign. From Labor Day to Election Day, network newscasts drew freely on commercial images to illustrate an issue or to represent the candidates. Commercial images became part of television's stock of background visuals, or file footage, aired interchangeably with news footage of the candidates. As CBS producer Bill Crawford explained, "Television is a picture medium. When you are 'picture poor'—and that's a term—you go back to your reels of good pictures. That's the nature of the business."[28]

To illustrate the candidates' appeals to Hispanic voters, for example, Peter Jennings (ABC, October 28) juxtaposed a clip of Dukakis speaking to a Hispanic audience in Texas with an excerpt from a commercial showing Bush with his Hispanic grandchildren. A John Cochran (NBC, October 18) report comparing Bush's and Dukakis's foreign policy stands included sound bites from the presidential debates along with an image from a commercial showing Bush shaking hands with Gorbachev.

Tom Brokaw (NBC, September 30), reporting on the political leanings of blue-collar workers in the industrial Midwest, interspersed interviews with actual workers with an excerpt from a Dukakis commercial showing actors playing workers saying, "I voted for the Republicans but that doesn't make me a Republican." Following the sound bite from the workers in the ad, and while the images from the Dukakis ad were still on the screen, Brokaw reported, "They blame the administration for the loss of more than half the steel jobs in the district." Whether "they" referred to the actual workers or the ones depicted in the ad seemed almost beside the point, so seamless was the movement between real speech and commercial image.

So successful was the Bush campaign at getting free time for its ads on the evening news that, after the campaign, commercial

advertisers adopted a similar strategy. In 1989, a pharmaceutical company used unauthorized footage of presidents Bush and Gorbachev to advertise a cold medication. "In the new year," the slogan ran, "may the only cold war in the world be the one being fought by us." Although two of the three networks refused to carry the commercial, dozens of network and local television news programs showed excerpts from the ad, generating millions of dollars of free airtime.

"I realized I started a trend," said Bush media consultant Roger Ailes. "Now guys are out there trying to produce commercials for the evening news."[29] When Humphrey and Nixon hired Madison Avenue experts to help in their campaigns, thoughtful observers worried that, in the television age, presidents would be sold like products. Little did they imagine that, twenty years later, products would be sold like presidents.

## Media Advisers as Celebrities

As a young reporter covering the Nixon campaign in 1968, Ted Koppel always kept a copy of Theodore White's *The Making of the President*, 1960, by his side. It was the book that revolutionized presidential campaign reporting. Before White, reporters focused on political speeches, parades, and rallies. White took the public behind the scenes, revealing the strategies and struggles that traditional political reporters had missed.

In 1968, Joe McGinniss took behind-the-scenes reporting one step further. While White had valorized politics, McGinniss debunked it. In *The Selling of the President*, published shortly after the 1968 campaign, he demystified politics in the television age, showing how public-relations people and ad-men sold presidents like soap and cigarettes. Koppel recalled its impact on reporters. "All of a sudden everybody said, 'Oh I get it. They're trying to sell candidates the way they sell soap.' And from that moment on, we had emerged from the Garden of Eden. We were never able to see candidates or campaigns quite the same way again."[30]

Twenty years later, television reporters had learned the lessons of McGinniss too well. Along with the attention to stagecraft in 1988 came an unprecedented focus on the stage managers, the "media gurus," "handlers," and "spin-control artists." The media advisers McGinniss exposed with a critical eye became celebrities on the evening news.

A week before the first 1988 presidential debate, ABC led its nightly newscast with a story about the 1984 campaign. The network had acquired an audiotape of a meeting of Reagan's image makers, and though the tape contained no significant revelations, ABC made it the lead story of the day.

Noting that the 1988 campaign consisted of "carefully crafted speeches, staged events, and expensive commercials," anchor Barry Serafin (September 19) announced, "Tonight we have a rare look behind the scenes, where the image shaping begins." The story that followed played audio excerpts of a meeting four years earlier, in which Reagan media advisers cynically discussed the dearth of ideas coming from the White House, their hopes for a small audience for the presidential debates, and Reagan's ability to run against government. "He just believes that he's above it all," said one participant to general laughter. "He believes it, that's why they believe it. I can't believe it but they do."

Although the report contained scarcely any news, its prominent place on the evening news aptly reflected the networks' preoccupation with image making. In 1968, neither political advertisements nor the men who made them were news. There were a few references to "advance men," fewer still to "communications experts," and reporters rarely interviewed them or sought their "expert" opinion on the campaign. Only three reports featured media advisers in 1968, compared to twenty-six in 1988.

In addition, the stance reporters took toward media advisers had changed dramatically. In *The Selling of the President*, McGinniss exposed the growing role of media advisers with a sense of disillusion and outrage. By 1988, television reporters covered image makers with deference, even admiration. Media advisers and advertising professionals, some partisan, some independent, frequently appeared on the evening news as authorities in their

own right. Sought out by reporters to analyze the effectiveness of campaign commercials, they became "media gurus" not only for the candidates but for the networks as well.

By 1988, Roger Ailes, as media adviser to Bush, was a featured figure on the news, credited with crafting Bush's television image. One flattering report, for example, showed Ailes watching Bush on a television set as Lisa Myers (NBC, September 23) reported that the celebrated "media guru" supplied Bush his best one-liners.

As if reveling in the spotlight, the media advisers dispensed with the traditional pretense of concealing their role. In one of the rare 1968 reports on television image making, Nixon television adviser Frank Shakespeare denied managing his candidate's image. "We don't advise him at all what to do. We put the cameras on him close and that's it" (Kaplow, NBC, October 25).

In 1988, by contrast, media experts described their manipulative craft without embarrassment or evasion. Before the first presidential debate, Republican consultant Ed Rollins told Lesley Stahl (CBS, September 23), "These are very staged events, and anyone who says they're not is kidding themselves." He told Lisa Myers (NBC, September 23), "I think the image and how he [Bush] looks is as important as the words he says." Recalling the preparations for Walter Mondale's debate with Reagan, Democrat Bob Beckel told Stahl, "We spent more time talking about ties than East-West relations."

Like the reporting of media events and political commercials, coverage of media advisers focused on theater over politics, perceptions over facts. Rather than correct the facts in the political ads they showed, reporters sometimes solicited the "testimony" of rival media advisers instead. For example, Jim Wooten (ABC, October 10) did an entire report on negative campaign advertising without ever assessing the veracity of the commercials. Instead, he interviewed media advisers from both sides who insisted their ads were accurate. In a practice unheard of twenty years before, reporters also aired the opinions of media experts not associated with either campaign to evaluate the candidates' political ads. Wooten (ABC, October 10) reported that the Dukakis

commercials had not "impressed the advertising community." Stan Bernard (NBC, October 25) interviewed an "impartial" advertising professional who testified that Dukakis was a "crybaby" for complaining about negative ads, and that his advertising campaign in general left voters "totally confused and totally turned off." Another media expert pronounced Dukakis's "advertising ineptitude almost unparalleled," and suggested this was a reason to doubt his ability to "manage the country" if elected.

So prominently did media advisers figure in network campaign coverage that their role became the subject of interviews with the candidates. Interviewing Dukakis, Dan Rather (CBS, October 27) wanted to know which image maker was to blame for arranging a media event that backfired. "Governor, who put that helmet on you and put you in that army tank?" When Dukakis sought to deflect the query, Rather persisted. "But who put you in?" Dukakis replied, "Michael Dukakis put me in."

Even as the press bemoaned the influence of media advisers, it made celebrities of them. A *Time* magazine cover story proclaimed 1988 the "Year of the Handlers." The story condemned the candidates for their "passive and uncritical acceptance of the premises of modern political manipulation. Bush flogs patriotism at a flag factory, the far more restrained Dukakis joyrides in a tank, and neither seems embarrassed by the prearranged artifice. There is a cynical edge to it all, as the backstage puppeteers pull the strings, and Bush and Dukakis dangle before the TV cameras obediently reciting their memorized themes for the day." But even as it criticized the media-managed campaigns, *Time* celebrated the handlers, featuring Republican James Baker and Democrat John Sasso on the cover of the magazine.[31]

Political and media advisers argue that their newfound celebrity is misplaced. Speaking of his appearance on the cover of *Time*, Sasso said, "My family was thrilled, but I thought it was absurd. I refused to be interviewed. What I thought or said was not that important. It was irrelevant to the everyday concerns of people. The press's obsession with handlers distorts the political process."[32]

In 1968, Roger Ailes labored in obscurity as Nixon's media man; his name was never mentioned on the evening news. By 1988, he was a celebrity. "We have grown too big because the media has focused laser-like attention on us for six or eight years," Ailes observed. "It's always the story of 'What is the commercial?' On one commercial alone, I turned down about 85 percent of the requests from the press for interviews. I could be out in the public eye far more than I am."[33]

Among those critical of the amount of coverage now devoted to media advisers and spin doctors is former CBS anchorman Walter Cronkite. "I was dumbfounded at the attention given to them after the [1988 presidential] debates," Cronkite stated.

> I was amazed at the time they gave to it. I thought it was ridiculous to listen to those fellows for any great length of time. It was interesting to find out how really far out they would reach to try to make their point on how poorly the opposition did each time. It had a kind of fascination, like a snake coming up out of a basket. I was not offended by the way the correspondents handled those things; I was offended by the amount of time they gave to it.[34]

In addition to devoting airtime to the testimony of media advisers and spin doctors, the networks focused sometimes admiring attention on their manipulative craft. For example, in an exchange with CBS anchor Dan Rather on Bush's debate performance, correspondent Lesley Stahl lavished praise on the techniques of Bush's media advisers:

> DAN RATHER: What about this perception, the extraordinary jump in the perception that George Bush has very human qualities?
>
> LESLEY STAHL: Well, last night in the debate that was a very calculated tactic and strategy on the part of his handlers. They told him not to look into the camera. [*She gestures toward the camera as she speaks.*] You know when you look directly into a camera you are cold, apparently they have determined.

RATHER [*laughing*]: Bad news for anchormen I'd say.

STAHL: We have a lot to learn from this. They told him to relate to the questioner, to relate to the audience if he could get an opportunity to deal with them, to relate to the opponent. And that would warm him up. Michael Dukakis kept talking right into the camera. [*Stahl talks directly into her own camera to demonstrate.*] And according to the Bush people that makes you look programmed, Dan [*Stahl laughs*]. And they're very adept at these television symbols and television imagery. And according to our poll it worked.

RATHER: Do you believe it?

STAHL: Yes, I think I do actually.

The celebrity status of media and political consultants reflected something the public could not see—a new and disturbingly close relationship between the press and the political consultants. The press was increasingly depending on consultants as its primary sources. As David Broder, political columnist for the *Washington Post*, observed, "You put two things together—reporting the campaigns from the inside, and the emergence of a new set of inside players, who are devoid of any responsibility for government past or future—and you change the definition of political reporting."[35]

"It was a deal with the devil," stated a network producer. "If you can't talk to George Bush, then you talk to Roger Ailes and Bob Teeter. And if they are giving you information, then you protect them. Roger Ailes is a vindictive man, and you have to say good things about him in order for him to continue to feed you information. The public has no idea how much reporters depend on handlers as sources."[36]

## Gaffes and Gutter Balls: Failed Images as News

Early in the 1988 campaign, George Bush delivered a speech to a sympathetic audience of the American Legion, attacking his opponent's defense policies. In a momentary slip, he referred to

September 7, rather than December 7, as the anniversary of Pearl Harbor. Murmurs and chuckles from the audience alerted him to his error, and he quickly corrected himself.

The audience was forgiving but the networks were not. Despite the irrelevance of the slip to the contest for the presidency, all three network anchors highlighted it on the evening news. Dan Rather introduced CBS's report on Bush by declaring solemnly: "Bush's talk to audiences in Louisville was overshadowed by a strange happening." On NBC, Tom Brokaw reported: "he departed from his prepared script and left his listeners mystified." Peter Jennings introduced ABC's report by mentioning Bush's attack on Dukakis, adding, "What's more likely to be remembered about today's speech is a slip of the tongue."

So hypersensitive were the networks to television image making in 1988 that minor mishaps—gaffes, slips of the tongue, even faulty microphones and flat tires—became big news. In all, no less than twenty-nine reports made mention of failed images. The networks' disproportionate attention to incidental campaign slips reflects the more general turn to photo-op coverage. Their heavy focus on the construction of images for television led naturally to a focus on images that went awry.

In 1968, before the preoccupation with failed photo ops had taken hold, the minor mishaps of politicians were rarely considered newsworthy. Only once in 1968 did a network insert a flawed photo op into a report unrelated to the content of the campaign, when David Schoumacher (CBS, September 13) noted that Humphrey lost a foot race on the beach "to an out-of-shape reporter."

Yet it was hardly the case that politicians were without mishaps in 1968. Rather, the trivial slips they made did not count as news. For example, vice presidential candidate Spiro Agnew, addressing a Washington press conference, made a slip at least as embarrassing as Bush's Pearl Harbor remark. Accusing the Democrats of being soft on defense, Agnew accidentally attacked his own running mate, saying, "Mr. Nixon is trying to cast himself in the role of a Neville Chamberlain." Like Bush, Agnew quickly corrected himself, saying that it was Humphrey who reminded him

of Chamberlain. "Mr. Nixon, of course, would play the opposite role, that of Winston Churchill."

On the evening news that night, Agnew's slip of the tongue went without mention. The networks showed his remarks, including his misstatement and correction, but focused on the substance of his attack on the Democrats. None of the anchors or reporters made the slip itself the story, nor for that matter, even took note of it.

Some of the slips the networks highlighted in 1988 were not even verbal gaffes or misstatements, but simply failures on the part of candidates to cater to the cameras. In a report on the travails of the Dukakis campaign, Sam Donaldson (ABC, October 17) seized on Dukakis's failure to play to ABC's television camera as evidence of his campaign's ineffectiveness. Showing Dukakis playing a trumpet with a marching band, Donaldson chided, "He played the trumpet with his back to the camera." As Dukakis played "Happy Days Are Here Again," Donaldson's voice was heard from off camera calling, "We're over here, Governor." Donaldson completed the picture of futility by showing Dukakis at a bowling alley throwing a gutter ball.

Interestingly, the other networks also covered the bowling alley, but without showing the gutter ball. Chris Wallace (NBC, October 17) showed a more successful Dukakis ball, greeted by cheers from the crowd. "In these tough times," he concluded, "it's the kind of encouragement that keeps the candidate going." Bruce Morton's (October 17) report for CBS split the difference. "When you're losing, everything is a symbol," he said, "whether you throw a gutter ball or knock down some pins."

The campaigns and the networks blame each other for the atmosphere that rivets media attention on gaffes. Roger Ailes observed, "Let's face it, there are three things that the media are interested in: pictures, mistakes, and attacks. It's my orchestra-pit theory of politics. If you have two guys on a stage and one guy says, 'I have a solution to the Middle East problem,' and the other guy falls in the orchestra pit, who do you think is going to be on the evening news?"[37]

Andrew Savitz, a Dukakis campaign aide in 1988, argued that the media's focus on gaffes forces candidates to avoid spontaneity and the risks that go with it. "Nobody does anything spontaneously with a bunch of cameras around now. One of the real driving forces is a sense of fear. A mistake made before the national cameras is a mistake forever."[38] Even the most careful attempts by candidates to present a favorable image for the cameras can go wrong. Political adviser John Sasso recalled a photo opportunity in which Dukakis played catch with a Boston Red Sox baseball player: "Dukakis threw twenty balls and dropped one, and that's what ended up on television."[39]

Reporters and producers argue that a gutter ball or a muffed catch can serve as a visual metaphor of an inept campaign. They also point out that modern media-driven campaigns invite the focus on gaffes. "In 1988, the campaigns were so highly crafted, so manipulative, so much trying to control the coverage, that when a mistake was made, it really stood out," observed NBC producer Bill Wheatley. "We would be less than human in not reporting it."[40]

Richard Salant, former president of CBS news, attributes television's coverage of gaffes and slips to the growing influence of entertainment values in network news. He recalled the repeated pictures of President Ford stumbling on the steps while getting off airplanes. "They used to do this in vaudeville with banana peels. It runs very deep in the nature of entertainment. People bought televisions not to watch the news but to see Milton Berle."[41]

Perhaps the most memorable media event that failed in 1988 was Dukakis's tank ride. In one form or another, the much-ridiculed image of Dukakis in an M-1 tank appeared eighteen times on network newscasts during the 1988 campaign. It appeared so often that it became a symbol of Dukakis's failure to be the master of his image as a presidential candidate—so much so that the Bush campaign even used it in one of its own campaign commercials.

Memorable though the tank ride became as a media event that backfired, it is striking to recall that initial television coverage of the event was not wholly negative. Both Bruce Morton (CBS, September 13) and Chris Wallace (NBC, September 13) covered

the event with lighthearted humor. "Biff, bang, powee!" Morton began, over pictures of a helmeted Dukakis riding in the tank. "It's not a bird. It's not a plane. It's presidential candidate Michael Dukakis in an M-1 tank as staff and reporters whoop it up [*From off camera come voices calling, 'Go Duke!' 'That a boy, Duke!'*]." On NBC, Chris Wallace began, "Don't call Michael Dukakis soft on defense. Today he rolled across the Michigan plains like General Patton on his way to Berlin."

Only eight days later, in another report, Morton (CBS, September 21) aired the visual of Dukakis in the tank again, this time portraying it as a failed photo op. "Sometimes, even in sophisticated 1988, the visuals fail. Reporters hooted when Dukakis drove up in a tank." The picture was the same, but the interpretation had changed. So had the audio track. This time, sounds of laughter accompanied the visuals of the tank ride, replacing the cheers that were heard the first time the event was aired.

Several days later, a CBS report on an unrelated issue aired the Dukakis tank ride again, also with a negative audio track. Reporting the candidate's views on the budget deficit, Bill Whitaker (September 27) opened with a shot of Dukakis in the tank, accompanied by a barely audible voice saying, "Put 'em up!" followed by laughter. As the treatment of the tank ride illustrates, the networks' focus on failed photo ops not only exaggerates trivial aspects of the campaign; it also invites editorializing with images.

Campaign officials from both sides see in this tendency an unhealthy entanglement between politicians and the press. "The press is fascinated by the frequency of faux pas," noted Kathryn Murphy, director of communications for the Republican Party during the campaign. "The response of the campaigns is to minimize mistakes. Then reporters complain that the campaigns are too tightly controlled."[42] Dayton Duncan, press secretary to Dukakis, agreed. "Public officials have to be error-free actors. Many reporters view an interview as their chance to have a politician make a mistake. A mistake is viewed as one way of stripping away the artifice."[43]

## Balancing Pictures and Perceptions:
## The Problem of False Symmetry

The focus of television news on media events, political commercials, media advisers, and failed imagery did not succeed in avoiding manipulation by the campaigns. Instead, it shifted attention from the substance to the stagecraft of politics, and eroded the objectivity of political reporting.

Rather than report the facts, or the actual records of the candidates, there was a tendency simply to balance perceptions, or to air an opposing image. Fairness came to mean equal time for media events, equal time for political commercials. But this left the media hostage to the play of perceptions that the campaigns dispensed.

The problem is best defined by those few instances when reporters went beyond the play of perceptions to refer to the record or report the facts. For example, Robert Bazell, reporting on the issue of the environment (NBC, October 21), began by showing how Bush and Dukakis used media events and contrived backdrops to portray themselves as ardent environmentalists. Rather than simply juxtaposing pictures of Bush riding a boat in Boston Harbor and Dukakis posing against backdrops of mountains and beaches, Bazell related their actual records and positions on such issues as global warming, acid rain, offshore drilling, and pesticide use.

In another notable example, ABC's Jim Wooten (September 26), assessed the validity of each candidate's claims in the first presidential debate. He interspersed clips of the candidates' statements with a correction of their facts:

DUKAKIS: I was a leader in the civil rights movement in my state and in my legislature.

WOOTEN: Well, he did propose an antidiscrimination commission once, but that was about it.

BUSH: I want to be the one to banish chemical and biological weapons from the face of the earth.

WOOTEN: But he was the man who cast three tie-breaking Senate votes for new chemical weapons.

BUSH: The governor raised taxes five different times.

WOOTEN: The governor also cut taxes eight times, and people in thirty-three other states pay a greater part of their income in taxes than citizens of Massachusetts.

BUSH: I am proud to have been part of an administration that passed the first catastrophic health bill.

WOOTEN: In fact, the administration opposed some of the key provisions in that bill, and the president signed it reluctantly.

Unlike Wooten's reports after the first and subsequent debates, most coverage did not attempt to assess or correct the facts, but rested instead with the play of perceptions. In setting the pictures or the claims of each campaign side by side, the networks sought fairness in balance, without breaking through the images to report the facts.

After ABC (September 22) showed a Bush media event with Boston police, Peter Jennings made explicit what the networks often did reflexively, equating fairness with a balancing of images. "In the interest of fairness," he announced, viewers would now see a scene of Dukakis posing with police officers too. In the piece that followed, Sam Donaldson reported that Dukakis "surrounded himself with his own sea of blue today . . . in a made-for-television appearance." To its credit, ABC followed this juxtaposition of media events with an issue-oriented report on the candidates' positions on crime. Much of the time, however, the networks settled for only a balance of campaign imagery.

The most flagrant instance of this tendency was in the presentation of the candidates' political ads. Reports were balanced in that they showed commercials from both sides. But setting the candidates' ads side by side, however balanced, does not necessarily make for objective reporting. It simply trades off the images the campaigns dispense. This leaves the viewer victim to the distortions the images may contain.

Furthermore, even when the reports did make some attempt to evaluate the candidates' rhetoric and imagery, the concern for "balance" (in the sense of not taking sides) led reporters to equate different orders of distortions or mistakes. In the name of balance, the reports created a false symmetry. For example, in the final weeks of the 1988 campaign, the nightly newscasts often cast both campaigns as "dirty," even though the false accusations and smear tactics they actually reported were mostly perpetrated by Republicans (including some not formally tied to the Bush campaign). By showing excerpts from commercials such as the Willie Horton ad, the networks gave national exposure to inflammatory ads produced by local Republican groups, ads the Bush campaign could claim to renounce.

When Dukakis attacked these ads, the networks treated his attacks as one more chapter in a dirty campaign, as if Dukakis's criticisms were on a par with the smears. "We begin with a presidential campaign that is going through an especially mean phase," said Peter Jennings (October 24), opening an ABC newscast. Tom Brokaw (October 24) began NBC's *Nightly News* in a similar vein: "Election day, two weeks from tomorrow, and it's getting very nasty again." The next night, Jennings (October 25) declared, "It's becoming difficult in this campaign to keep abreast of the accusations. . . . There are certainly some who wonder what all this has to do with running the country in the 1990s, but whatever happens, this kind of charge and countercharge is the hallmark of the campaigns at this point."

Introducing one newscast that week, Brokaw (October 25) seemed to promise the kind of reporting that would examine the content of the accusations and sort fact from falsehood: "Campaign commercial wars: Who's lying and who's not?" But the coverage that followed failed to answer this question. It focused instead on the effectiveness of the candidates' ads, and on the way voters and media experts perceived them.

In 1968, by contrast, fairness took a different form. Rather than seek symmetry within each broadcast, the networks sought fairness over the course of the campaign by covering a wide range of views and allowing people to speak for themselves in sustained

segments. This was true not only for candidates but also for critics drawn from across the political spectrum.

When a candidate made a major statement, the networks showed his opponent's reply. For example, when Humphrey gave an important speech on Vietnam, the networks aired Nixon's response. But they showed no similar compulsion to balance media events and images. When Humphrey took a walk on the beach, or when Nixon rode a hydroplane, the networks made no effort to show a rival image. Often, they ignored the gimmick altogether. And since they did not show excerpts from political commercials, the problem of balancing advertising images did not arise. They avoided entanglement with the candidates' image making, and so avoided the need to "balance" coverage of their respective gimmicks.

## The Blurring of Commentary and Political Reporting

It might seem that reporters' reluctance to answer Brokaw's question, "Who's lying and who's not?" reflected a healthy instinct for the sidelines, a refusal to take sides. But notwithstanding their penchant for "balance" in 1988, reporters intervened more frequently in the stories they covered, and injected their opinions more freely, than did their predecessors twenty years earlier.

In 1968, reporters on the whole allowed the candidates and their critics to speak for themselves. The newscasts distinguished sharply between reporting and commentary. Looking back twenty years later at the 1968 coverage, one is struck by how detached and dispassionate anchormen and reporters alike were in presenting the daily story. Coverage still partook of an unadorned "wire service" style of reporting, emphasizing description not interpretation. Opinions and analysis were reserved for explicitly designated commentary segments, which resembled spoken op-ed pieces. Two of the three networks offered campaign commentary in 1968, with Eric Sevareid on CBS, and Frank Reynolds and various guest commentators on ABC. In all, the networks

broadcast some fifty-seven political commentaries during the general election campaign.

In this way, the treatment of fact and opinion reflected the practice of print journalism, with news and editorials at least nominally on separate pages. This demarcation had the effect of enhancing the credibility of the television journalist in both realms. In the role of reporter, the journalist enjoyed the credibility that goes with detached, straightforward reporting. In the role of commentator, the journalist was able to offer analysis and opinion at sufficient length to develop an argument, as in a traditional newspaper column or op-ed piece.

In 1988, by contrast, explicit political commentary had all but vanished from the networks' evening newscasts. In 1988, only eight commentary segments appeared, all by John Chancellor of NBC.

Of course, the rarity of explicit commentary in 1988 did not mean that anchors and reporters refrained from offering their views—far from it. They inserted them freely in their reporting, blurring the line between fact and opinion. This in turn diminished their authority, in two ways. On the one hand, their reliability as witnesses diminished as they departed from the unadorned narrative style of traditional reporting. On the other hand, their impact as commentators was blunted as their occasion for commentary became cramped, reduced to a kind of sniping at the sidelines. In 1968, commentary segments averaged two minutes in length; by 1988, the shift from explicit to injected commentary had reduced the reporter's critical voice to a tagline, a passing snide remark. The compressed pace of 1988 coverage forced not only the candidates but also the reporters to deliver their opinions in sound bites and one-liners.

In 1968, for example, Frank Reynolds devoted two minutes and fifteen seconds to a hard-hitting commentary on how Nixon, Humphrey, and Wallace were all exploiting the theme of "law and order." When, twenty years later, Brit Hume sought to make a similar point, he was reduced to a twelve-second tagline at the end of a report on a Bush campaign stop in New York: "Bush is running for president, not sheriff, but some days it is hard to tell.

His polls show he's hurt Dukakis on crime. And if he can use the issue to hurt him in a state Dukakis once thought was his, so much the better."

The explicit commentaries of 1968 typically addressed large themes—the Vietnam War, protest and dissent, law and order, the condition of American cities. The "injected commentaries" of 1988, by contrast, compressed as they were into a few seconds in the daily story, often amounted to little more than fleeting jibes or ad hominem remarks.

For example, after covering a speech in which Dukakis attacked his opponent in strong terms, Sam Donaldson shifted suddenly from reporting Dukakis's words to undercutting them. "Unless you're Harry Truman—and Dukakis is not—the strategy of giving them hell runs the risk of sounding shrill and unpresidential. But Dukakis figures Bush started it, and he has no choice but to join in" (ABC, September 12). Ten days later, Donaldson (September 20) criticized Dukakis again in a tagline commentary, this time for sticking to the issues: "Thirty-six years ago, Adlai Stevenson insisted he was talking sense to the American people, and Ike won in a landslide."

## Words and Images at War

In 1968, the reporter spoke from the sidelines, allowing the candidates time to tell their story. By 1988, the narrative structure of political reporting had become more complex, consisting of a tension, even a struggle, between the stories the campaigns and the reporters sought to tell.

The candidates sought to construct their story through the use of media events and catchy one-liners. The networks used their own juxtaposition of images, sound bites, and reporting. On both sides, the staccato language of sound bites and fast-paced visuals had replaced the familiar pace of ordinary speech. As a result, the presidential campaign on the nightly news came to look and sound less like traditional political discourse and more like commercial advertising.

This change can be seen in the contrast between Charles Quinn's report on Muskie's encounter with antiwar demonstrators in 1968 (NBC, October 25) and Bruce Morton's coverage of Dukakis's similar encounter with antiabortion demonstrators in 1988 (CBS, September 9).

In Quinn's coverage, there are few cuts in either the pictures or the words. Quinn speaks only at the beginning and end of the report, briefly and offscreen. He sets the context for the drama— "It was the worst heckling Senator Muskie has faced so far in the campaign"—then backs off to show it unfold. The camera lingers at a medium distance on both Muskie and the demonstrators, later moving in for close-ups of Muskie and student spokesman Rick Brody. The words of candidate and protester are the heart of the story. Over half of the report is devoted to Muskie's or Brody's speech.

In the case of Dukakis and the antiabortion protesters, by contrast, the story on the evening news was not about what the candidate or the protesters said, but about the television image the confrontation produced. "Most of what candidates do is aimed at your television screen," began Bruce Morton in his report on the confrontation. "The Dukakis campaign would have liked to have these pictures of his appearance before a mostly Polish audience today, but there were these pictures too." As Morton speaks, the report cuts quickly from favorable pictures of Dukakis to a woman sitting on the floor with her children, yelling, "Do we have to destroy our children?"

In contrast to the coverage of the Muskie-Brody confrontation, the focus of Morton's report was not political speech, but the disruption of speech, and the television image the disruption created. Dukakis was relegated to a two-second sound bite addressing the protesters, and a seven-second sound bite delivering his economic message. An antiabortion demonstrator shouted for four seconds, and a national Right to Life representative interviewed later spoke for seven. Morton concluded the report by talking about television, and the balance of images that television conveyed: "What happened today was that the camera saw both realities: The few demonstrators with their issue, the vast majority

of the crowd applauding Dukakis." But the "reality" the camera "saw" was one in which no one spoke for more than nine seconds. It was a "reality" consisting of fast-moving images but little political discourse.

The same could be said of the 1988 coverage as a whole. The 9.8-second sound bite was one measure of this change. The decline of total candidate speaking time was another. The speaking time of presidential candidates on the nightly news was 56 percent greater in 1968 than in 1988, even without counting third-party candidate George Wallace.

The tendency to detach the candidates' pictures from their words is a characteristic feature of the photo-op style of reporting. While this style of coverage might seem to give the reporter the upper hand in the contest for control of television words and images, it does not always work this way.

In order to play the role of theater critic, the reporter has to show the theater, to put the potent images on television. Moreover, reporters are put in the paradoxical position of criticizing the very theater they help produce. The campaigns stage the media events, but the networks take the pictures—and the more dramatic the pictures, the more likely the story will run on the evening news. Reporters thus have a stake in the power of the visuals they go on to criticize.

Campaign coverage under these conditions is beset by conflicting impulses. This conflict is reflected in a tension between the visual and the narrative elements of the report. The visuals offer the most arresting images the campaigns dispense, while the narrative attempts to deconstruct these images, to reveal their artifice. This sets the reporter's narrative in competition with the campaign pictures, a competition the pictures are likely to win.

This competition was illustrated in a 1984 piece on Ronald Reagan by Lesley Stahl (CBS, October 4), which criticized at length Reagan's manipulation of television imagery during the campaign. Stahl was surprised to find that the Reagan White House loved the story. Grateful that the piece included almost five minutes of potent Reagan visuals, a presidential aide seemed oblivious to Stahl's critical narrative. "They don't listen to you if

you are contradicting great pictures," the aide told Stahl. "They don't hear what you are saying if the pictures are saying something different."[44]

Stahl concluded from her experience that television images swamp words; that pictures speak louder than the reporter's critical voice. But Stahl's lament, which is often recited in complaints about the 1988 campaign, overlooks a deeper lesson about the use of words and images in political reporting.

Like many examples of photo-op coverage, Stahl's words often reinforced the images she intended to undercut. The opening of her piece was a paean to Reagan's image-making skills: "How does Ronald Reagan use television? Brilliantly." Aside from a few instances of fact correction, most of Stahl's report illustrated her opening statement. Far from being critical, her words were captions for the images she showed.

Stahl's conclusion, like her opening, was less critical than congratulatory. "President Reagan is accused of running a campaign in which he highlights the images and hides from the issues. But there is no evidence that the charge will hurt him, because when people see the president on television, he makes them feel good, about America, about themselves, and about him."

Unlike most examples of photo-op coverage, Stahl's report did, to its credit, make some attempt to confront Reagan's imagery with his record. In this respect, her narrative offered a critical counterpoint to his pictures. But her counterpoint lacked force because it spoke in no images of its own. While Stahl noted that Reagan used backdrops that contradicted his own policies on aid to the disabled and elderly, she showed no pictures depicting the consequences, only Reagan's visuals. Similarly, while she observed that Reagan distracted public attention from the bombing of the U.S. Marine headquarters in Beirut by offering patriotic images of the Grenada invasion, Stahl showed no images of Beirut, focusing instead on Reagan's pictures celebrating Grenada.

It might be argued that for reporters to use pictures to dramatize their points risks violating the line between reporting and editorializing. But this argument ignores the visual language of television, a language the campaigns have mastered to a highly

sophisticated degree. It also ignores what is already a familiar practice in television reporting. Some of the best reporting on the facts and issues of the 1988 campaign—Jim Wooten's fact-correction pieces after the debates, Robert Bazell's report on the environment, and Lesley Stahl's piece on the forgotten issue of homelessness—made effective use of counterimages, illustrating discrepancies between candidates' rhetoric and records in ways that words alone might not have conveyed.

Most of the time, reporters rested with the campaigns' pictures. They revealed the artifice behind the images, but reproduced them nonetheless. So skillful were they in documenting the theater that it became difficult to distinguish the play from the real thing.

CHAPTER 3

# Contesting Control of the Picture

🌾

## Picture-Perfect News: For and Against

Some of the most thoughtful critics of the change in network coverage of presidential campaigns were found at the networks themselves. Bill Wheatley was in charge of NBC's campaign coverage for 1992. In 1988, he was the executive producer of the *NBC Nightly News*. He spent much of the time in between thinking of ways to overcome such problems as manipulation by campaign image makers and the compression of speech on the evening news.

Wheatley viewed the turn to photo-op coverage in the 1970s and 1980s as an attempt by reporters to reveal the campaigns' manipulation of images for television. Given the traditional obligation to report what happened on the campaign trail, the networks found themselves reporting constantly on their own manipulation. How could the networks break out of this pattern? "At some point," stated Wheatley, "we need to say that the fact that we're being manipulated is no longer news. And at some point, we should do something to stop being victims. We should stop and say, 'Let's get rid of the manipulation and concentrate more on the themes.' "[1]

One way of doing this, Wheatley suggested, was to stop the practice of airing excerpts from campaign commercials as general file footage. Only when the story focuses on the ads should the commercial video appear on the screen. "I think we fell into a trap with the ads in 1988. We used them too often, and as general

footage. Not using the ads as part of general coverage would cut down on the candidates' ability to manipulate us."[2]

Wheatley was also critical of the trend toward short sound bites that appear at a rapid-fire pace. Reviewing taped excerpts of his network's 1988 coverage, Wheatley observed "discombobulated sound bites, sound bites that come out of nowhere. There is no setup, no introduction of the person who is about to speak." Identification of the speaker by a superimposed label at the bottom of the screen, Wheatley commented, was often insufficient. He pointed out that the bewildering pace was a symptom of the attempt to pack reports with as much information as possible, sometimes more than the viewer can absorb.[3]

At CBS, Bob Schieffer, who at the time was a senior political correspondent, reiterated: "We are all agreed that we have squeezed sound bites too short." The reason is that "we have tried to put too many elements into our pieces," which has "often resulted in pieces that are superficial at best and often downright frivolous. This is a problem we can change by making the simple declaration, 'we are going to stop doing it that way,' and then sticking to it."

Schieffer also recommended returning to a more traditional style of reporting, using pictures to document events rather than to grab and hold viewers' attention. In his view, network newscasts should strive to become "information-driven rather than picture-driven. This is not to say that we should stop using pictures. But we should use the pictures to impart information." Schieffer argued that a piece for the evening news should "be judged on what information it imparts, not on how it 'looks.' "[4]

Ted Koppel, long-time anchor of ABC's *Nightline*, was also critical of picture-driven network newscasts. The enhanced production values have made it more difficult, he believed, for reporters and politicians to convey substance on television. Looking back on his own coverage of Nixon in the 1968 campaign, Koppel was struck by the contrast.

There is a real irony when I look at the 1968 coverage. The real paradox is I got to say a lot more and got to be more

analytical in those pieces precisely because the pictures were lousy. . . .

The brilliance of our production values today, the extraordinary technological leaps that we have made since 1968, are our own biggest hurdle. They are our biggest handicap. We have become so good at making it look slick, we have become so good at enhancing the visual elements, that you would have to be Robert Lowell, Mark Twain, or Thomas Jefferson to say something that is going to get through all that television noise. No one is that good. Nothing anyone says is profound enough to get past the hurdle of extraordinary production values we have put in our path.[5]

Some of those responsible for the evening news in the 1960s see today's fast-paced, picture-driven coverage as a product of pressures for ratings that they did not confront. Sanford Socolow, executive producer for the *CBS Evening News* with Walter Cronkite, described the unwritten rules on pacing that now govern network newscasts.

Producers and reporters are charged with getting an exciting, enticing piece on the air, even if it means breaking up the candidate's train of thought. The correspondent is not allowed to talk more than twelve or fifteen seconds before there is some intermediate sound. It's called pacing. If in the heat of the battle to get on the air, if the substance gets in the way of the pace of the piece, then damn the substance.[6]

Walter Cronkite recalled that in his day, entertainment values did not play a part in campaign coverage.

We never thought that way at all. We were out after substance. We did not go for "sound bites." I think there were nights when [the candidates spoke] for forty seconds, and I was disappointed that we didn't have more. . . . We were not under the pressure to make everything as short as possible. The attitude today is that you have to hold them every second of that half-hour that you're on the air. We were not under that pressure. Part of that was because there were only

two competitive networks—ABC wasn't that important. People hung in there. Maybe they didn't want to watch what they were watching, but they didn't turn us off.

Cronkite faulted the current picture-driven style of coverage for crowding out speech. "The problem today is this absolute fear of having the anchor or a correspondent on the air as opposed to having pictures. It's the reason for the sound bite being as short as it is. It's just the form of television news today. It's the attitude of the producers, it's the entire ethic of the business."[7]

Shad Northshield, who in 1968 produced NBC's *Huntley-Brinkley Report*, thought the quality of network coverage had declined because of the intense pressure for ratings. "I think the political coverage in 1988 was basically not as good as the political coverage in 1968. It wasn't as good journalistically. It was much better technically, of course. But that's all it was." Today's network producers have turned to short sound bites and attention-grabbing visuals because of pressures imposed by the corporations which now own the networks. "They are doing it because of this goddamn, evil, bottom-line mentality. This business is a business. Television news is more television than news."[8]

Some of those responsible for coverage of the 1988 presidential campaign offered a spirited rejoinder to their critics inside and outside television news. They argued that the quality of coverage had improved, not declined, since 1968. More sophisticated technology enables faster, more flexible editing of pictures and words. And more sophisticated, image-conscious reporting does more to pierce the veil of campaign manipulation.

Tom Bettag was the executive producer of Dan Rather's *CBS Evening News* during the 1988 campaign. The 1968 campaign was before his time. Hearing of criticisms by his predecessors of the 1988 coverage, Bettag offered a vigorous reply. He argued that there is something to be said for the image-conscious turn of television news, and also for its faster pace. "I think that in 1968 the networks were remarkably naive about the images they put on. With time, we became more sophisticated in realizing that we were being used in the images. I think that is a positive

step. Maybe it's not being done right. But the packaging is important, and Joe McGinniss's book was the first time a lot of us thought about that. What you're seeing is people still coming to grips with it."

Bettag resented what he saw as the old-timers denigrating the present to enhance the past. "I don't think the past was that good. I think there is a glorification of '68. One of the problems in '68 was that it was the 'just-the-facts-ma'am' wire service reporting. The time was very different. I would attribute the [longer sound bites] to the idea that they were trying to fill up a broadcast. The problem at that time was how to fill up a half-hour broadcast."

Far from being a model of objectivity, the 1968 style of coverage "was a sterility," Bettag argued. "It just laid out what the politicians said. It was a broadcast dominated by reports from beat correspondents in and around Washington. So much of the agenda was just filling it up with Washington stuff. You could let sound bites run for two minutes because it helped fill out the broadcast."

Today "the problem is one of massive compression," Bettag continued. "You're trying to stuff in more information from many other places. The compression [is an attempt] to give viewers as much information as they can quickly absorb. You get a much broader feel for what's going on." Bettag maintained that the faster pace of television news is a reflection of viewers' expectations. "People became used to a much faster pace of information. Madison Avenue was much slower paced in '68 than in '88. People's ability to receive visual information has speeded up. Just because television news has speeded up doesn't mean it's all bad. It means the people have changed. It's not just that television news has gone showbiz. Politics has changed too."[9]

Bill Crawford, a senior producer for CBS in 1988, was a field producer during the 1968 campaign. He attributed shorter sound bites to improved editing techniques. Like Bettag, Crawford claimed that the politicians' speeches ran longer in the old days because the networks lacked the technical means to cut it easily, and in any case needed to fill airtime. "I think '88 sound bites

were too short. Everybody in the business does; that's kind of a given. I also think that in '68 they were way too long and self-indulgent and done to fill the time. It was also the result of the kind of editing we had to do then."

Reviewing videotapes of the 1968 coverage, Crawford commented that, given the generous time devoted to the candidates' speeches, "these pieces have a nice, musty, antique feel about them." This was due, he suggested, to the difficulty of editing film, which was used in 1968, compared to the ease of editing videotape, which by the 1980s had replaced film in television news. "That's why the sound bites [in 1968] were so long, because you didn't have the ability to go 'pop, pop, pop.' The mechanics drove it then, as the mechanics drive it now."

Like Bettag, Susan Zirinsky was not yet in television in 1968. By the 1980s, she was one of CBS's leading political producers, covering the Reagan presidency and the 1988 campaign. She argued that modern video editing techniques have improved coverage by enabling producers to package pictures and words from different campaigns and different events in a single report. "As the technology changed, I think the product got better, not worse. You can give people things later, meet deadlines with greater proficiency, and [have] a greater hand editorially. The candidates and the process may have become warped. I don't think our technical expertise warped it."

Zirinsky did not defend the short sound bites of 1988. "Yes, I think sound got too short. Absolutely. We're moving the other way now." But she argued that those who complain about short snippets of political speech often confuse two different things— sound bites and "natural sound." Natural sound, she explained, is an editing technique that employs a few words of a candidate's speech without intending to convey information.

> It's an effective editing tool when you're cutting a piece and want to break up the pacing or want to hear the candidate just for his rhythm and his mood or whatever you're trying to achieve. It's not really a sound bite. It is just a burst of natural sound.

It's part of the editing. It breaks the track up and gives pacing to a piece. It's a television technique. Everybody I've read misconstrues sound bites as averaging four seconds. Of course they are, if you take these bursts of sound that aren't really sound bites. If you showed me three scripts, I could tell you, "that's a sound bite, that's a sound bite, that's a burst of natural sound."[10]

Dan Rather, then anchor of the *CBS Evening News*, made a similar point. He did not defend the short sound bite the networks now employ, stating, "I am firmly committed to lengthening sound bites, extending them to at least twenty to twenty-five seconds." But like Zirinsky, he worried that "researchers count 'natural sound' as sound bites and thus their statistics are wrong. . . . A producer or reporter may show a candidate speaking for three or four seconds and use it as an opener and consider it natural sound." Rather acknowledged, however, that "the public might not see it that way. When people see the candidate they may expect they are going to hear part of his speech. . . . The natural undertow in this business is detrimental to length. I think a lot of this is wrong."[11]

That not all snippets of candidates' speech are genuine sound bites is small comfort to those concerned with the devaluation of political discourse on television news. That the networks sometimes use the words of presidential candidates as "bursts of natural sound" to improve the pacing of reports is further evidence of the growing emphasis on production values. In any case, the fact remains that Bush and Dukakis got to speak for thirty seconds or more only fifteen times during the 1988 general election campaign, compared to 162 times for Nixon and Humphrey in 1968.

As for the argument that the networks ran long sound bites in 1968 because they needed to fill airtime, Walter Cronkite insisted that it was simply untrue.

That's personal revisionism on the part of people who weren't there. I don't think any of the old-timers would tell you that. Its true, of course, that we didn't have as much material available, but it's not true at all that we couldn't

have filled up the broadcast. There was never any problem of not having material for a broadcast, never. We were in a terrible time bind from the very beginning of getting in everything that was important.[12]

While no one would dispute the notion that video is easier to edit than film, the change in technology was not a sufficient explanation for the change in the style of political coverage. The ease of editing videotape did not by itself dictate short sound bites. Mechanics drives the coverage only to the extent that reporters and producers use technology to achieve the effects they want. What effects do they want? Given pressures to win ratings by holding audiences all too ready to change the channel, the networks have used new technology to produce fast-paced, visually arresting newscasts that are strong on pictures, short on words.

Some argued that even as a way of winning high ratings the 1988 style of campaign coverage was misconceived. Don Hewitt was no stranger to high ratings. Not only had he been executive producer of the popular newsmagazine *60 Minutes*, but Hewitt had also been in television news since 1948. He spoke bluntly and disdainfully of the fast-paced style of network newscasts. Hewitt noted that producers began to worry about the pace of the broadcast in the 1980s. "By that time, the news had become so much a part of the entertainment business and razzle-dazzle. It wasn't just politics. Everything got charged up and there was no chance to think about anything."

But Hewitt thought that the "razzle-dazzle" production techniques the producers had adopted were the wrong way to hold an audience. "Most of the people who work in television news are misguided. They don't understand." The key to the enormous success of *60 Minutes*, he argued, is not pictures but words.

I don't use sound bites. I'd fire anybody who talks about sound bites. . . . *60 Minutes*, which is one of the most popular broadcasts in the history of television, lives on talking heads and on people getting a chance to say what they have to say.

What [most network news producers] don't know is that you use your ear more than your eye. Your ear keeps you focused on the television set. I believe that. That's how I built this broadcast. They just don't know how to do it. We've been on the air since 1968. We're the longest-running show on television because words are sacred to us. What we say is much more important than what we show you. We don't show you that much anyway, but we tell you a lot.

The success of this broadcast is built on audio and words. I can live with an out-of-focus picture, but I can't live with an out-of-focus sentence. What I don't want, in the middle of a *60 Minutes* story, is for some guy to say, "Hey Mildred, do you understand what that guy is saying?"[13]

For good or ill, the last quarter century had witnessed a transformation in the way television news covers presidential politics. Those who welcomed it and those who deplored it agreed that the transformation was due to changes in politics, economics, and technology. With the rise of media consultants, campaigns improved their ability to manipulate images for television. Reporters, seeking to resist manipulation, focused increasing attention on the image-making apparatus of the campaigns. Meanwhile, mounting pressures on network news divisions to boost ratings led to fast-paced, visually compelling broadcasts, which heightened the networks' appetites for the pictures the campaigns dispensed. Reporters and producers sought the best possible picture, whether from media events or political ads, then tried to puncture the picture by revealing its artifice, by highlighting its contrived nature. Finally, the technologies of video editing enabled the networks to deliver the perfect pictures and the reporting that would expose them in a slickly packaged collage of fast-moving images and words.

But the significance of this transformation goes beyond the political, commercial, and technological factors that brought it about. The new interplay of television and politics brought with it a growing public disillusion with the media and the politicians

alike. This disillusion, which found widespread expression in the aftermath of the 1988 campaign, was directed both at the campaign and at the coverage of the campaign. In ways that defied a precise fixing of blame, both the campaigns and the networks seemed entangled in a politics of imagery and artifice that left the substance of politics behind.

Some of the frustration may have been connected to the failure of the democratic promise of television. On the one hand, television news promised a kind of ultimate document. Like photography, but with greater boldness, television offered—indeed at moments still offers—a direct access to reality, the tantalizing prospect of being there, of seeing the person or the event with our own eyes, of judging for ourselves. On the other hand, as campaign coverage amply illustrates, television is also a powerful instrument of artifice, at once victim and accomplice of the sophisticated illusions that politicians and their media experts are able to spin.

For all that is new in the way television covers presidential politics, its predicament might best be understood as the modern expression of a paradox as old as the camera. By considering some earlier contests for the control of political images, we can shed light on the struggle that television news still confronts. The "picture perfect" mentality that informs television coverage of presidential politics plays out, in heightened form, tensions that have been present in photography from the start. Does the camera document reality or subvert it by promising realism but producing a pose? When politicians are doing the posing, the stakes have always been high. When the camera became a television lens, the stakes grew higher still.

Not all that is troubling about "picture perfect" presidential campaigns is without precedent in American politics. Long before television, journalists struggled with the realism and the artifice that pictures convey. And from the earliest days of the republic, politicians have engaged in image making while critics have bemoaned the triumph of appearance over reality, of style over substance.

## Presidential Image Making: Past and Present

Political image making and the "selling of the president" have a history almost as old as that of the republic itself. "A man will soon, without the imputation of indelicacy, be able to hawk himself in the highways as an excellent candidate for the highest promotion," declared Federalist Thomas Dwight in 1789, "with as much freedom and vociferation as your market men now cry codfish and lobsters."[14] Two years later, after losing the election of 1800 to Jefferson, Federalists blamed their opponents' skillful if scurrilous use of a new medium of communication that threatened to debase politics—the press. "The newspapers are an overmatch for any government," wrote Federalist Fisher Ames. "They will first overawe and then usurp it. This has been done, and the jacobins owe their triumph to the unceasing use of this engine."[15]

Federalists of the old school resisted the notion of popular electioneering, and opposed recourse to the printing press. "We can do infinitely more by private letters than by newspaper publications," argued one.[16] But in time, they had little choice but to take up the techniques of their opponents. In an age when newspapers and journals were published and written to win political adherents, the Federalists began newspapers of their own. Before long, Federalist electioneering sheets abandoned traditional scruples and appealed without embarrassment to popular sentiment. In the first stirrings of sound-bite democracy, "much was made of slogans and catchwords. . . . Intricate issues were summarized in a few phrases or reduced to a line of wretched verse. . . . Political problems which might have stymied Solomon were resolved in a pun or an epigram. . . . Editors ran the same cant words and phrases in their columns over and over again," as Federalists learned "to rely upon the effect of repetition."[17]

At least where the presidency was concerned, however, the new techniques of electioneering were held in check. As historian Gil Troy has written, the founders thought that presidential candidates should stand, not run, for office. While seekers of lesser offices might engage in the fray of campaigning, presidential can-

didates, true to the republican ideal of disinterested public service, would remain aloof and stand on their character and record. John Adams and Thomas Jefferson spent the 1796 and 1800 campaigns away from public view on their respective farms.[18] Prior to his 1832 reelection campaign, Andrew Jackson declared: "I meddle not with elections. I leave the people to make their own President."[19]

By 1840, the Whig and Democratic parties organized the masses with songs, slogans, and revival-like meetings in the first popular presidential campaign. Still, William Henry Harrison, the Whig candidate for president, presented himself as the humble embodiment of republican restraint. In his letter of acceptance to the Whig nominating convention, he stated that he would not "declare the principles upon which the Administration would be conducted." Stating a view of the presidency similar to today's view of Supreme Court justices, Harrison argued that the Constitution made the president an "impartial umpire" who should not make promises or policy statements as a condition of election. He decried the tendency of ambition to make "men of the fairest characters" act like "auctioneers selling . . . linen."[20]

As party politics displaced the eighteenth-century ideal of disinterested politics, the dignified silence of presidential candidates became less an expression of republican virtue and more a strategy of political caution. Democratic opponents charged that Harrison's silence was a pose, a way of avoiding the issues. They attacked the "correspondence committee" that answered his mail as a group of handlers in effect, dubbing it "General Harrison's Thinking Committee." The Democrats "dismissed 'General Mum' as a 'caged' simpleton forced to rely on his 'conscience keepers.'"[21]

Four years later, the Democrats urged the strategy of silence upon their own candidate, the obscure James Polk. "If you could avoid reading or speaking or writing from now until the election, our success would be certain," a friend advised him. His opponent, Henry Clay, observed no such restraint. Although declaring that the people "should be free, impartial and wholly unbiased by the conduct of a candidate himself," Clay did not hesitate to

pronounce upon a wide range of controversial issues. Refusing to heed the advice of handlers who insisted that he be "caged," Clay lost the election.[22]

Today, political handlers and media advisers have become celebrities in their own right. But they are engaged in a practice that has fueled controversy and outrage for over a century. An 1852 political cartoon titled "Managing the Candidate" offers an early instance of an attack on handlers and image makers. The cartoon shows the Whig nominee, Gen. Winfield Scott, trying to step over a controversial plank in the Whig's platform ratifying the Great Compromise of 1850 between the North and the South. Perched on Scott's shoulders, the Whig politician William Henry Seward covers Scott's mouth and holds his arm, preventing him from speaking or writing. "Never mind your tongue or your pen, I'll manage them," Seward says. "But . . . stretch your legs, as I do my conscience, and you can get over anything."[23]

The mass-communications revolution of the early twentieth century brought two new instruments of political image making—public relations and radio. As Republicans mounted a sleek advertising campaign to sell Warren Harding to the American people in 1920, critics protested the artifice of the modern campaign. "There is interposed between the voter and his final judgment the whole mechanism of modern publicity," wrote the *New Republic*. Another commentator worried that in this "new age of publicity," the publicity man had become the "president maker." The young Democrat named Franklin Roosevelt criticized Harding's campaign of contrived photo opportunities. "Photographs and carefully rehearsed moving picture films do not necessarily convey the truth."[24]

This did not prevent Calvin Coolidge, a man of few words, from making up for his taciturnity by "performing" for the cameras as tree chopper, hay pitcher, or host at the White House to such visitors as Henry Ford and Thomas Edison.[25] In 1932, Franklin Roosevelt easily prevailed over Herbert Hoover in that year's version of "the war of the Labor Day visuals." Roosevelt projected a "picture personality," the *New York Sun* observed, while Hoover looked unhappy even when photographed fishing.[26]

The 1936 campaign between Roosevelt and Republican Alfred E. Landon was the first to be professionally choreographed for radio. The Republicans hired a voice coach for Landon, and Roosevelt adopted a calmer, more intimate speaking voice, even when addressing a live audience, in deference to his radio listeners. As with television a generation later, the new medium inspired politicians to dramatize their message to hold the attention of a mass audience.[27]

At first, the broadcasting companies refused on principle to mix politics with entertainment. When the Republicans produced a dramatic skit portraying the dire effects of the New Deal on an average American couple, the networks refused to air the program. Edward Klauber, a CBS official, explained that if the networks aired political dramatizations, "the turn of national issues might well depend on the skill of warring dramatists rather than on the merits of the issues debated."[28]

The nominating conventions of that year were the first to be staged for radio. The proceedings were reduced in length, Roosevelt's speech was moved to the evening for prime listening time, and applause was abbreviated to "short staccato cheers that ended quickly so that no word would be lost."[29] Analyzing the 1968 presidential campaign, Eric Sevareid would observe, "The important figure in the crowd is the television cameraman. He provides the significant audience."[30] A delegate to the 1936 Democratic convention said much the same of the new mass medium of his day: The "real presiding officer was the microphone."[31]

As the parties perfected the image-making techniques of advertising and radio, the 1936 campaign added new fuel to the long-standing fear that salesmanship and showmanship would crowd out the substance of democratic politics. *Newsweek* wrote that the radio professionals would sell the Republican line as if it were "toothpaste or tomato juice."[32] Offering a different litany of commodities, another reporter wrote that the advertising men would sell Landon and "tax phobia as they have automobiles, shaving soap, [and] cigarettes."[33] Attacking Roosevelt's facility with radio, William Randolph Hearst's *San Francisco Examiner* exclaimed, "Do we want a showman or a statesman?" Decades before Mi-

chael Deaver and Ronald Reagan would perfect the video presidency, the journalist Marquis Childs concluded that campaigning in this "era of the news reel and the radio calls for a technique as deliberate as that of a Hollywood star."[34]

## The Problem with Pictures: Past and Present

Like the longstanding worry about political image making, concerns about picture-centered journalism found expression long before the age of television. For well over a century, Americans have vacillated between celebrating pictures and worrying about their contrived nature, their association with commercialism, and their tendency to crowd out words. In the mid-nineteenth century, journalists thought of pictures "as clutter on the page and a waste of space." As late as the 1880s, some reporters still protested that "pictorial reporting" or "illustrated journalism," as they called it, "betrayed us into making our eyes do the work of our brains."[35]

Prior to the 1880s, newspapers even resisted pictures in paid advertisements, penalizing advertisers who used illustrations. James Gordon Bennett, founder and editor of the *New York Herald*, "held that the advertiser should gain advantage from what he said, but not from how the advertisement was printed or displayed."[36]

Beginning in the 1880s, however, the relationship between newspapers and advertisers changed. As press historian Michael Schudson points out, advertisements, which before this time had occupied less than a third of newspaper space, began to take up half the paper or more.[37] At about the same time, the development of the halftone engraving process enabled American newspapers, magazines, and books to reproduce photographs on the same paper that accepted type.[38] Photographs and words could now appear together on the printed page; spectacle, entertainment, and advertising would henceforth commingle with the news.

The mass reproduction of photographic images in newspapers and magazines led Americans living between 1885 and 1910 to experience a "visual reorientation" that historian Neil Harris compares to the transformation brought by the invention of the printing press four centuries earlier. For good and ill, the visual reorientation of the late nineteenth century anticipated the one brought by television and the Internet in our time.

The printing of photographs in mass publications offered viewers a direct contact with reality, unmediated (or so it seemed) by the mind and hand of an artist. For the first time, Americans could actually see what important people, such as presidential candidates, looked like. The lack of such pictures explains the intense public interest in the mass-produced prints of Abraham Lincoln in the 1860s. In 1864, after Ulysses S. Grant's victories had made him the highest-ranking general officer in the army, even the Washington press corps did not know what he looked like. "The identification of the hero at Union Station was made on the basis of one man's memory of a faded photograph that had shown a corner of the general's face."[39]

In the halftone photograph as in television and the Internet, the documentary promise coexisted with the dangers of distortion, fabrication, and simplification. Social critics of the late nineteenth and early twentieth centuries, responding to the sudden prominence of mass-produced pictures and photographs, gave early expression to many of the worries voiced about the media today. Writing of the "decadence of illustration," a critic wrote in 1899 that "illustrators of fiction were exaggerating the purely pictorial aspects of stories and failing to supplement the plots."[40] Another critic argued that deceptive and misleading illustrations of nonfiction should be subject to the same critical assessment as words. In a complaint similar to recent worries about media events and political ads on the evening news, C. F. Tucker Brooker wrote in 1911: "Has not the time come to demand that the pictures introduced into works on social and cultural conditions be subjected to the same investigation which is given to other testimony?" In virtue of their capacity to command attention, "pictures irresponsibly selected, and inserted without adequate inves-

tigation, can easily lead to more serious misapprehension than would result from glaring error in the letter-press."[41]

Critics also argued that pictures threatened to overwhelm words, to crowd out serious reflection with titillation, sensation, and distraction. In 1893, the *Nation* wrote that newspaper pictures had come to prominence as words lost their significance. "The childish view of the world is, so to speak, 'on top.' "[42] A 1911 editorial in *Harper's Weekly* railed against "over-illustration." "We can scarce get the sense of what we read for the pictures," the editorial argued. "We can't see the ideas for the illustrations. Our world is simply flooded with them. They lurk in almost every form of printed matter." Properly subordinated, illustrations aided thought, but improperly used, they became "a mental drug" that posed a threat to the development of young minds. "[I]t would be safe to say that a young mind, overfed pictorially, will scarcely be likely to do any original thinking."[43]

As the critics feared, the growing prominence of pictures coincided with pressures for the compression of speech. Bemoaning the eight-second sound bite of the 1990s, Walter Cronkite stated that "distortion by compression may be the single biggest problem with television news." He called on network news departments to "show a little more responsibility by dropping the contrived photo opportunities and the planted sound bites in favor of longer interviews and statements by the politicians dealing with the issues."[44] The shrinking sound bite that Cronkite decried, however, is the ultimate expression of tendencies in American culture that appeared early in the twentieth century.

The founding of the *Reader's Digest* in 1922 ushered in what historian Daniel Boorstin called "a new era of abridgments." When the magazine's founder, DeWitt Wallace, went to his dubious father to borrow money for the new venture, he confidently told him, "We are living in a fast-moving world. People are anxious to get at the nub of matters."[45] Wallace produced his first issue by going to the New York Public Library and copying by hand from other magazines abridged versions of their articles. Most of the editors of the original magazines gave Wallace permission to reprint the articles, thinking it would bring them free publicity.[46]

Wallace's digest soon outsold all the magazines it digested. In time, it published more copies than the Bible. As one testimonial featured in the *Reader's Digest* put it, "I don't have time to read *all* the magazines, so I just read the best from all of them in the little magazine that fits right into my pocket."[47]

At about the same time, the modern impulse to compress found expression halfway across the globe, where the Russian novelist Evgeny Zamyatin glimpsed the sensibility that would later issue in the sound bite. "The old, slow, soporific descriptions are no more. The order of the day is laconicism—but every word must be supercharged, high voltage. Into one second must be compressed what formerly went into a sixty-second mixture."[48]

In America, the quickened pace of life formed the premise of the burgeoning advertising business of the 1920s and 1930s. A columnist for an advertising publication declared that speed had become an imperative of everyday life: "Quick lunches at soda fountains . . . quick cooking recipes . . . quick tabloid newspapers . . . quick news summaries." Another writer told of a "new American tempo" that gave American life "the turbulence of shallow water." Advertisers had to be quick to spot trends and change with them to keep pace with the American public.[49]

Like the publishers and advertisers, politicians also learned to compress their speech to keep pace with the public. Even in the days of the campaign whistle-stop, long before the advent of the thirty-second television spot, candidates chafed at the need to compress their message. "I have tried discussing the big questions of this campaign from the rear end of a train," Woodrow Wilson complained in 1912. "It can't be done. They are too big. . . . By the time you get started and begin to explain yourself the train moves off."[50]

The advent of radio as a campaign device imposed further pressures on politicians to compress their speech, though in retrospect the constraints hardly seem severe. Radio coverage of the 1932 campaign brought complaints from listeners and broadcasters, who objected that the speeches were too long and tedious. The radio editor of the *New York Times* explained that henceforth, politicians would have to reduce their speech to keep their audi-

ence. "It requires a highly interesting speaker and a sparkling topic to hold an invisible audience [for fifteen minutes] . . . [candidates] must learn to discard hour-and-a-half speeches and condense their thoughts to fit in a half-hour at the most."[51]

The 1930s also brought the birth of the popular picture magazines, such as *Life* and *Look*, which critics thought would contribute to the modern tendency of pictures to crowd out words. Walter Lippmann, for example, wrote of the "rivulet of text" that trickled between the imposing advertising photographs of the new magazines.[52]

In their lavish use of pictures, the new magazines were not burdened by worries about the fate of words or the risk of blurring news and entertainment, document and drama. For *Life* magazine, pictures were a means of revealing the drama in events. Its unabashed celebration of photojournalism was uncomplicated by the image-conscious sensibility of today's television news. News was entertainment, and entertainment was news.

The same merging of documentation and drama, of news and spectacle, characterized *Time* magazine's advertisements during this period. An ad for *Time* in 1936 promised would-be readers access to "The Greatest Show of All."

> In all the world there is no drama like reality . . . no spectacle so great and stirring as the tremendous, marching pageant of news. In the year to come . . . great actors like Mussolini and Hitler will march across the stage before you in what may prove their farewell appearance. New players, today unknown, will spring into fame. . . . Millions of people will never see more than the sideshows, never get to understand what the tremendous show is all about. To them all this is wasted, for they will lose the best lines and miss the plot. *Time* can make sure you get the full drama of every worthwhile act.[53]

The 1930s also gave powerful expression to the documentary impulse in photography, most notably in photographers such as Walker Evans and Dorothea Lange, who were employed by the Farm Security Administration. Their classic photos of the ravages

of the Depression were not vehicles of spectacle and entertainment, but a form of witness and record. Photographs such as Lange's memorable "Migrant Mother" acknowledged the drama in the document, not for the sake of spectacle but for the sake of presenting in vivid terms the reality of American life in the Depression. Likewise, the photographs in Paul Taylor and Dorothea Lange's *An American Exodus* constituted a compelling documentary record of the victims of the dust bowls.

Television news in its formative years took up the documentary tradition and aspired to bring out the drama in the news without lapsing into spectacle or entertainment. When network newscasts went from fifteen minutes to a half-hour format in 1963, Reuven Frank, executive producer of NBC's *Huntley-Brinkley Report*, wrote a long memorandum on television news as a guide for his staff, many of whom had experience with newspapers or radio but not television.

Frank's memo was a revealing meditation on the use of pictures in television. He acknowledged that the camera does not merely record reality, but conveys reality by dramatizing it. Still, the drama would be for the sake of conveying reality, not for the sake of entertainment.

> Every news story should, without any sacrifice of probity or responsibility, display attributes of fiction, of drama. It should have structure and conflict, problem and denouement, rising action and falling action, a beginning, a middle and an end. These are not only the essentials of drama; they are the essentials of narrative. We are in the business of narrative because we are in the business of communications.

Frank acknowledged the impact of television pictures, but sought to deploy that impact, for the sake of informing, not amusing the public. "There will be no tricks to gain or hold audiences we do not want."[54]

The documentary ambition of television news also found expression in emphatic rules against the "staging" of events for the camera, rules still invoked by network reporters and producers. A CBS code written during the 1970s states, "Staging is prohibited.

...We report the facts exactly as they occur. We do not create or change them."[55]

Charles Quinn, a reporter for NBC in the 1960s, recalls emphatically resisting an attempt to improve the picture during a civil rights march. "Toward the end of the Selma March, they wanted me to do a stand-up [report] in front of the statehouse, where it was all a mess. A guy comes along bringing extra placards and said they wanted more rubble around my feet. He said he was the producer, and I told him to get that crap out of there. I said, 'This ain't Hollywood.' "[56]

But even the principled resolve to avoid staging, to eschew entertainment, to convey a reality independent of the camera's eye, could not fully overcome the problem of the pose, endemic to photography and heightened by television. From its earliest days, television learned that its presence altered the event. Where political coverage was at stake, this alteration drew the networks and the politicians into a contest for the control of television images, a contest played out with increasing intensity in the age of the Internet.

The power of television to alter the event first appeared when television began to cover the national political conventions. Don Hewitt, executive producer of *60 Minutes*, recalled the innocence about the image that prevailed, when television covered its first conventions. "When I went for the first time, we were sort of there as observers. It was exciting. You'd get a good credentials committee fight going or a platform committee fight. A good fight today is if NBC has their sign an inch bigger than CBS's, now there's a fight! Political conventions today are true media events, programmed for the media."[57]

At first, Hewitt recalled, the politicians were naive about the ways of television, so CBS ran a class for politicians about how to act during a convention. He feared that inducing image consciousness would spoil the spontaneity. "I remember telling CBS news executive Sig Michelson, 'You're going to ruin the convention if you tell them not to fall asleep or pick their nose, because that's half the fun of the damn thing.' " Hewitt remembers an earnest inquiry from Frank Clement, the keynote speaker at the

1956 Democratic convention. "Clement was governor of Tennessee, and he walked into the CBS facility with his Aunt Ida. He said, 'I've got a problem. When I speak I like to do that (he raised his arms in jubilation), and when I do that my tie jumps up. Is it okay to do that if my tie jumps up?' It was like something out of Li'l Abner."[58]

As Hewitt pointed out, television changed the event by being there. "We began to realize that the convention was a television show, and these guys were the extras. Walter Cronkite was the star, and all those guys on the floor and at the rostrum were the extras."[59]

It did not take long for the politicians to learn the consequences of television's powerful presence. Walter Cronkite told of a problem that arose while he was covering Estes Kefauver's 1956 campaign for the Democratic presidential nomination. "There were only four of us on his bus. He was such a dark horse, he would stop at even the smallest crossroads. I'd get off the bus, and the people would surround me rather than the candidate. Kefauver finally said, 'Walter, would you please get off the bus last so the people at least have a chance to meet me?' "[60]

The televised debates between John Kennedy and Richard Nixon in 1960 marked a fateful moment in the advent of image-conscious politics. Theodore White reported that the candidates fared about equally well among those who listened to the first debate on radio, but that among television viewers, Kennedy was the clear winner over Nixon. Where Kennedy appeared rested and fit, Nixon, who refused to wear makeup, appeared drawn and ill shaved. "It was the picture image that had done it," White concluded, "and in 1960 television had won the nation away from sound to images, and that was that."[61]

Daniel Boorstin saw the Kennedy-Nixon debates as part of a growing tendency for imagery to displace reality in American life. In his 1961 book *The Image*, Boorstin detected in the debates, and in their public reception, elements of the photo-op sensibility that has since come to dominate coverage of presidential campaigns. "Public interest centered around the pseudo-event itself: the lighting, make-up, ground rules, whether notes would be al-

lowed, etc. Far more interest was shown in the performance than in what was said."[62]

Although the politics of media events and photo opportunities was only in its infancy, Boorstin glimpsed the allure of arresting visuals that would come to grip television news. "The pseudo-events which flood our consciousness are neither true nor false in the old familiar senses. The very same advances which have made them possible have also made the images—however planned, contrived, or distorted—more vivid, more attractive, more impressive, and more persuasive than reality itself."[63]

Reflecting on his defeat, Richard Nixon faulted himself for failing to adapt to the imperatives of television image making. "I spent too much time in the last campaign on substance and too little time on appearance," Nixon concluded. "I paid too much attention to what I was going to say and too little on how I would look. . . . One bad camera angle on television can have far more effect on the election outcome than a major mistake in writing a speech."[64]

In 1968, Nixon and his advisers resolved not to repeat their mistakes of 1960. This time, they would mount a made-for-television campaign. "For the first time, a really sophisticated group of broadcast people came around a candidate, and did it for television," recalled Frank Shakespeare, one of Nixon's media advisers. "We didn't even care what Scottie Reston said [in his syndicated column for the *New York Times*]. We never even read it. That was minor heresy then, for most of the journalists were print journalists. They did not realize what we knew. We were talking to millions of Americans."[65]

But even Nixon's media-managed campaign was innocent by the standards of today's campaigns. While the campaign succeeded at staging confined events, like the televised programs showing Nixon answering questions from a "citizens'" panel, most of the media events were traditional rallies and speeches, and the campaign was not yet adept at matching a "message of the day" with a carefully contrived visual image. "We were much less attentive to the backdrops, staging, and settings of events that would play on network evening newscasts than now," Shake-

speare commented. "In a highly structured event like the convention, we were very conscious of it, because in a convention you can design the set and time the event. But when we thought of a photo opportunity, we were still thinking in terms of newspaper photographs, making sure Nixon was positioned well."[66]

For their part, the networks devoted little coverage to the politics of image making. With a few exceptions—Ted Koppel's report on Nixon's use of television, John Hart's piece on the advertising and media experts working for Nixon, David Schoumacher on Humphrey's press conference by the sea—television news did not report on the construction of images for television. Only about one report in twenty involved image-conscious coverage during the 1968 campaign, compared to over half of all reports two decades later.

Looking back, Russ Bensley, a producer for the *CBS Evening News* in 1968, thought the networks should have paid greater attention than they did to political image making. "A Madison Avenue campaign was largely beyond our experience. We missed the boat. We should have covered it more fully. It was a sea change in our politics."[67]

CBS reporter John Hart thought there was something larger at stake. "It was not a conscious choice" to emphasize politics rather than photo ops, Hart explained. "That was the tradition we were in. It wouldn't have occurred to us to do a lot of self-conscious stuff. We would have been embarrassed to do it. It wasn't that we were especially wonderful. It was just that we believed the world happens for its own sake, not for television."[68]

Through the 1970s and 1980s, the networks began covering presidential campaigns as though they happened for the sake of television, which increasingly they did. By 1972, the networks began labeling appearances contrived for television as "media events," which then had a derisive tone that has faded with familiarity. When George McGovern's campaign took the press to a Midwest farm so the candidate could make a statement about the wheat scandal against a backdrop of grain silos, NBC's Cassie Mackin protested. "This is a Presidential campaign and we don't need pretty pictures to get on the air," she complained. "Why

can't they just run their campaign and let us take the responsibility of finding something interesting to say about it? It would be fine with me if they did nothing for the media."[69]

Before long, however, the contrived "pretty pictures" that Mackin disdained would become a staple of television coverage of presidential campaigns. This was due primarily to two developments that coincided in the early 1980s. With the coming of Ronald Reagan and media masters such as Michael Deaver and Roger Ailes, the campaigns (and the White House) became highly adept at producing compelling pictures for television. At the same time, a heightened concern with ratings and profits increased the networks' desire to show entertaining visuals on the evening news.

"We absolutely thought of ourselves when we got into the national campaigns as producers," said Michael Deaver. "We tried to create the most entertaining, visually attractive scene to fill that box, so that the cameras from the networks would have to use it. It would be so good that they'd say, 'Boy, this is going to make our show tonight.' . . . We became Hollywood producers."[70]

Richard Cohen, a senior political producer at CBS during Reagan's presidency, testified to Deaver's success. "Do you know who was the real executive producer of the television network news? Michael Deaver was the executive producer of the evening news broadcasts. Michael Deaver decided what would be on the evening news each night. He laid it out there. I mean, he knew exactly who we were, what we went for. He suckered us."[71]

In an earlier era, when network news divisions were insulated from pressures for ratings and profits, reporters and producers would have been less tempted by arresting images unrelated to genuine news. Richard Salant, president of CBS News during the 1960s and 1970s, stated the traditional ethic in an introduction to the *CBS News Standards* handbook. Catering to viewers' interests and tastes was the role of entertainment programs like *The Beverly Hillbillies*, where "it is entirely proper to give most of the people what most of them want most of the time," Salant wrote. "But we in broadcast journalism cannot, should not, and will not

base our judgments on what we think the viewers and listeners are 'most interested' in."[72]

In a story well chronicled in works by Ken Auletta, Peter Boyer, Ben Bagdikian, and others, changes in the structure and economics of network news in the 1980s eroded the traditional distinction between news and entertainment. Network news operations came to be seen as profit centers for the large corporations that owned them, run by people drawn less from journalism than from advertising and entertainment backgrounds. As the media analyst Edwin Diamond observed, "The ABC, CBS, and NBC news organizations are now recasting themselves—not, as in the past, because of the imperatives of journalism, . . . but because the network's new owners demand it."[73]

In the early days of television, Edward R. Murrow described broadcast journalism as an "incompatible combination of show business, advertising and news."[74] But through the 1960s and 1970s, the competitive pressure for ratings was scarcely felt in the day-to-day life of network reporters and producers. Shad Northshield, who succeeded Reuven Frank as executive producer of the *Huntley-Brinkley Report*, recalled, "We had been out of first place [displaced by CBS] for eleven weeks before anybody mentioned it. Today, you cannot have any fluctuations in ratings without having someone scream at you."[75]

Today, ratings consciousness permeates the networks. Former NBC producer John Ellis remarked, "Even as late as 1979 or 1980, it would have been inconceivable for the executive producer of the nightly news to discuss ratings. Then it got to where our executive producer had to explain to the press why NBC was in the position we were in the ratings."[76]

Commercialization led to further emphasis on entertainment values, which heightened the need for the dramatic visuals the campaigns contrived. Given new technological means to achieve these effects—portable video cameras, satellite hookups, and sophisticated video editing equipment—the networks were not only disposed but also equipped to capture the staged media events of the campaigns. Reporters became more oriented to performance. As Peter Boyer writes, "In the new CBS News, correspondents

were told that it was no longer just what they said that mattered, but the way they said it; they were part of the message—performers, in a sense—and they were encouraged to affect a more casual and relaxed style."[77]

Long-time CBS political correspondent Bob Schieffer, who opposed the turn to entertainment values in network news, noted that the networks "made a market" for the contrived images the campaigns dispense. "Perhaps it is time to realize that while we have been criticizing the candidates for trivializing the campaigns, our desire for more and more pictures and our willingness to use them has encouraged these silly photo sessions that have become the staple of the modern campaign."[78]

Those most successful at supplying the networks' demand for arresting visuals were keenly aware of the new focus on entertainment on the evening news. Michael Deaver noted that his job peddling flattering images of Ronald Reagan was made easy by the fact that "the media, while they won't admit it, are not in the news business; they're in entertainment."[79]

Roger Ailes saw an analogy between his aim as a media adviser and the aim of network producers.

> We're all worried about arithmetic. They're worried about their ratings; I'm worried about the number of voters that are going to vote for my guy. [Network journalists know that] if everybody else is covering the jets flying overhead or the guy falling in a mud puddle then they'd better have that shot too. Because if they start talking to him about ethics and the Middle East problem, and the other networks show Ford falling down a flight of stairs, people are going to switch channels.[80]

Ailes has since switched roles, moving from media adviser to the head of FOX News. In his old role, he argued that, just as his commercials were designed to maximize votes, network newscasts were designed to maximize ratings:

> My only concern about them is their piousness in pretending that they're doing something else. They're trying to

make their newscast the most exciting and visual and the least wordy and thoughtful. If they can do that they may get the highest ratings. There's nothing wrong with that, just admit it.

Just say, "Folks, we're in show business and these candidates are in show business. You are the audience, and everybody is trying to get to you and entertain you. We'll give you whatever you want, because we're all in the business of selling." The thing that I object to is these journalists running around saying that Roger Ailes is doing something different from what they're doing. We're all in the same business.[81]

## Perfecting and Puncturing the Picture

The shift from the traditional CBS news broadcast of the Cronkite era to the present was not simply a shift from a hard-news emphasis to an entertainment-oriented one. It was also a shift from one understanding of pictures to another. On the traditional *CBS Evening News*, which aspired to be the "broadcast of record," pictures served a documentary function. "For the correspondent and producer, the principal challenge was to capture on film the quote that figured to be in the lead paragraph of the wire service story."[82] This meant that news film typically consisted of government officials or politicians speaking.

Today, pictures play a different role on the evening news. They function less as documents of news events than as a rapid succession of visually arresting images. Lesley Stahl aptly described this phenomenon in a late 1980s interview with Bill Moyers.

> STAHL: As a reporter, I like to be able to wallpaper, as we say in television, my pieces.
> MOYERS: Wallpaper?
> STAHL: Wallpaper. Put pretty pictures up while I'm talking behind it. Pretty, interesting pictures, pictures with movement. Pictures that will capture the audience eye. I

shouldn't want that, because I know that it's deceptive and the audience won't really hear what I'm saying. But I still like it. I like my pieces to have energy.[83]

The networks' use of pictures as "wallpaper," as images designed to capture and hold the viewer's attention, recalls the use of photos by picture magazines like *Life* a half-century ago. Like the networks today, *Life* in the 1930s and 1940s used photography as both document and spectacle. Then as now, if the picture was compelling, it mattered little whether the subject was weighty or trivial, spontaneous or staged. Images of Hitler, Churchill, and Roosevelt coexisted with public relations and novelty shots.

The difference is that *Life* celebrated pictures without embarrassment, without concern about their constructed character, whereas the photo-op style of coverage that has set the tone of political reporting since 1988 is born of the conflicting imperatives that network journalists confront. The "picture perfect" impulse prompts reporters and producers to seek the best pictures they can possibly get, even if this requires a certain complicity with the advance men and image makers who stage the media events. Meanwhile, the journalistic impulse prompts the same reporters and producers to expose as artifice the pictures they have helped produce. Since the picture no longer documents reality but distorts it, reality depends on the words that puncture the picture, that draw attention to the image as an image.

The first impulse, the need for the best possible picture, compels network producers to collaborate closely with the campaigns. Lesley Stahl explained that during the Reagan presidency, "The White House would get together with CBS producers to line up shots so the president would look good, and there would be balloons and flags. They sort of get together with our producers and say, 'What kind of an angle would you like to have?' "[84]

This collaboration continued during the 1988 presidential campaign. Thomas Rosenstiel of the *Los Angeles Times* reported that toward the end of a Bush campaign speech, a campaign advance man would take network camera crews to an area specially arranged behind the podium. "On cue, Bush knows to turn

around to the cameras so that he can be shot with balloons falling into the crowd behind him, a splendid shot."[85]

Susan Zirinsky, a senior producer at CBS News recalled the picture-poor days of the Carter administration, "when you couldn't even find out what time an event was being held." Reagan's media-conscious team made life easy by comparison. "During the [Reagan] campaign, pictures that I used to ask for all the time, such as a helicopter shot of the motorcade, suddenly became possible."[86]

In an interview with Martin Schram, Zirinsky reflected on the collaboration between network producers and the politicians' image makers.

> In a funny way, the [White House] advance men and I have the same thing at heart—we want the piece to look as good as [it] possibly can. . . . That's their job and that's my job. . . . I mean, I'm looking for the best pictures, but I can't help it if the audiences that show up, or that are grouped together by the Reagan campaign, look so good. I can't think of that. I can't factor that out of the piece. I show whatever is there. I show who shows up. I can't help it if they're great-looking people and it looks like a commercial.[87]

Zirinsky protested that this quote, taken alone, makes it seem as though she was in cahoots with the image makers, a suggestion she emphatically rejects. Although she shared their interest in producing the best possible picture for the evening news, she noted she has the further job of "countering" the pictures. "The way you counter it is editorially—with script, with extra interviews, with extra sound bites," and above all by alerting viewers to the contrivance the pictures represent. Here Zirinsky voices the second impulse, the impulse to puncture the pictures she had worked so hard to get. "If you merely present the picture as the day, the event, you are playing into their hands. If you stop and say to the audience, 'This event was so orchestrated that they even cleared an entire field so that the press could take a picture,' you hope the public gains some understanding of the machinations involved. It's your own moral conscience as a journalist speaking."[88]

Those responsible for network coverage in the 1960s maintain that it was different in their day. When television pictures functioned more as documents than as visually compelling images, there was less need for complicity with the campaigns, and also less need to puncture the pictures. Shad Northshield, executive producer of the *Huntley-Brinkley Report* during the 1968 campaign, recalled, "Of course, we were always interested in pictures. Pictures were the stuff of what happened that day. As to pressuring reporters to come up with better pictures, no, I didn't do it." Northshield attributes the current demand for arresting visuals on the evening news to the "pervasive and destructive and pernicious and terrible" effect of the "bottom-line mentality" on network news.[89]

Frank Shakespeare, Nixon's media adviser, maintained that in 1968 the networks would have resented any attempt by the campaigns to collaborate on dramatic camera angles or backdrops. "They didn't want to be used. . . . If you tried to say, 'This would be interesting to film rather than that,' or 'Get your camera over here rather than there,' . . . no, no, no. We didn't do that. There was a church-and-state line then. We were the politicians and they were the reporters. And we weren't in bed together."[90] Likewise, Sanford Socolow, senior producer of the *CBS Evening News* with Walter Cronkite in 1968, stated bluntly that network complicity in campaign stagecraft was scorned in those days. "If someone caught you doing that in 1968, you would have been fired."[91]

Tom Bettag, who produced Dan Rather's newscast in 1988, argued that the traditionalists "remember those times as being better than they actually were." He maintained that the complicity Susan Zirinsky describes is nothing new. Reporters and camera crews have always tried for the best possible picture. "They want their pictures to look good, and the [campaign] people are trying to get their person to look good. There is an inherent complicity on both sides that has always been there." Bettag saw no alternative to seeking interesting and exciting visuals. "Either you pay attention to making it look good or you don't. If you don't, that's a conscious decision too. It will become a mess on the screen.

Anything I shoot I try to make look as good and as visually interesting and exciting as I possibly can."[92]

Walter Cronkite, not tempted by the photo-op mentality of modern television news, disagreed. "Our interest is not in getting the best possible picture of the candidate. Our interest is in covering the event as journalists. We hope to have a nice clean picture of the candidate. But if we're asked to shoot him so that you see his arms wave, or see him holding an American flag or something like that, to heck with that. That's not our problem. That's not our duty at all."[93]

Some of the early failures of photo-op coverage have been corrected since the 1988 presidential campaign. In 1992, the networks, inspired by the "ad watches" developed by print journalists, began systematically checking the veracity of candidates' commercials, instead of using them as illustrations of campaign image making. As the Internet has become a bigger factor in campaigns, newspapers and the networks are doing "Net watches" as well.

In the wake of the 1988 presidential campaign, the networks tried to swear off sound bites. ABC's *World News Tonight* announced that it would "avoid sound bites that are designed exclusively for TV news consumption." The *CBS Evening News* declared that it would run no sound bite of a presidential candidate less than thirty seconds in length. NBC sought to break with the syndrome of short sound bites by airing three-and-a-half-minute excerpts of the candidates' stump speeches.[94] *Newsweek* magazine, in full-page newspaper ads touting its convention coverage, promised, "No sound bites. No stories driven by photo ops. No 'in depth' reporting in 90 seconds."[95]

Despite the networks' promises, however, the shrinking sound bite continued to shrink. The average sound bite was only 8.4 seconds in the 1992 general election and dropped to a scant 7.8 by 2004.[96]

The 1992 campaign signaled an end to television campaigns waged primarily on the network evening newscasts. Seeking more sustained television exposure than the nightly newscasts afforded, the campaigns began to make frequent use of other television

venues, including talk shows and quasi-news programs such as *Larry King Live* (CNN), *Oprah* (syndicated), *Arsenio Hall* (syndicated), *Today* (NBC), *Good Morning America* (ABC), *This Morning* (CBS), the *Tonight Show* (NBC), the *David Letterman Show* (CBS), *Saturday Night Live* (NBC), and MTV. On some of these programs, the candidates were able to answer questions for one or two hours of unedited airtime, making possible a return to a more extended form of political discourse.

Talk shows and late night comedy shows continue to be favorite venues for presidential candidates, and a number of presidential hopefuls have announced their candidacies on late night talk and comedy shows. In 2004, John Edwards declared his candidacy on *The Daily Show with Jon Stewart*, John Kerry rode a motorcycle on the set of the *Tonight Show* to show that he was not a stiff patrician but a regular guy, and Howard Dean did a self-deprecatory "Top Ten" list on David Letterman's *Late Show* trying to limit the damage of his much-derided Iowa "scream." By 2008, Republican presidential candidates followed suit. Fred Thompson announced his bid for the presidency on the *Tonight Show with Jay Leno*, John McCain chose the *Late Show with David Letterman*, and Rudy Giuliani confirmed his candidacy on *Larry King Live.*

Critics of this development, including some networks and print journalists, complain that the candidates' emphasis on talk shows and "infotainment" programs is a way of circumventing professional journalists; answering questions from viewers or talk-show hosts offers the benefits of favorable television exposure without the challenge of probing, critical questions from hard-news reporters.

But this objection, while valid in principle, overlooks the extent to which the network evening newscasts have already abandoned sustained attention to hard news in favor of entertainment-driven stories. The fast pacing and quick cutting, the stylish pictures and short sound bites, the shift in emphasis from political coverage to soft-news, lifestyle, and human-interest stories, has hardly left the network newscasts a bastion of sobriety and substance. It is not clear that the public learns less watching presidential candidates on a talk show or comedy show than watching the slickly

produced packages of images and words that the evening news presents. In an intriguing 2007 study, titled "No Joke," telecommunications scholar Julia R. Fox and her colleagues discovered that the popular "fake" news program *The Daily Show with Jon Stewart* had as much substantive news coverage of the 2004 presidential election as network newscasts.[97]

In the film *The Wizard of Oz*, Dorothy's dog Toto pulls back the curtain to reveal that the "great and powerful Oz" is no wizard after all, but an illusion created by a man pulling levers. "Pay no attention to that man behind the curtain," the man thunders through his machine. But once the artifice is exposed, the wizard's authority is dissolved.

Photo-op news coverage does not always work that way. The unmasking of an image as an image often serves only to heighten its appeal. What Daniel Boorstin wrote several decades ago has proven all too true of today's self-conscious attention to image making. "We are frustrated by our very efforts publicly to unmask the pseudo-event. Whenever we describe the lighting, the make-up, the studio setting, the rehearsals, etc., we simply arouse more interest. . . . Information about the staging of a pseudo-event simply adds to its fascination."[98]

One example of an illusion that is enhanced rather than diminished by the revelation of its artifice is Disney World and its popular attraction Disney/MGM Studios, which takes visitors behind the scenes of the movies. The architecture critic Robert Campbell described the image-conscious aspect of Disney World in terms that could also be a commentary on television's image-conscious coverage of presidential campaigns.

> I'd never understood why people seemed to be so fascinated by the things Disney World ostensibly presents—all those stagey rides in the Magic Kingdom, all those very obviously fake European villages at Epcot Center. . . . But now I think I understand. Disney World isn't really about the displays it seems to be about. Instead, it's about how those displays are created. . . .

Frontstage Disney World is kind of a bore, but backstage Disney World is fascinating. And we're always being given tantalizing glimpses of that backstage. Those glimpses are what we love. . . . What's interesting is the machinery that makes the illusion work. On display at Disney World is the machinery of illusion—not illusion itself.[99]

At Disney/MGM, they have "made the backstage frontstage." A whole city neighborhood appears to be made of streets and buildings. But "you can walk around behind these 'buildings' and see that they are nothing but painted plywood facades. . . . The fact of fakery—that's the essence of the Disney World experience."[100]

Similar assumptions inform today's coverage of presidential campaigns. It, too, makes "the fact of fakery" a central theme. The front stage—the speeches, the issues, the position papers— is important, but the backstage—the staging, the backdrops, the spin control—is fascinating. Network reporters and producers think that covering the construction of images for television will alert viewers to the contrivance of those images, and so expose the artifice of the campaigns. They think that revealing the media advisers and handlers and spin-control artists manipulating the levers of illusion will dissolve the illusion and replace it with reality. But it does not work that way. Unlike *The Wizard of Oz*, revealing the man behind the curtain does not diminish the hold of the image. The effect is instead like that of Disney/ MGM studios. Revealing the painted plywood facade leaves the allure of the city intact.

CHAPTER 4

# Exposed Images

🌿

The annual portrait of the justices of the Supreme Court is not usually worthy of note, but Stephen Crowley's 1995 front-page photograph in the *New York Times* was no ordinary picture. Instead of the traditional dignified pose, readers of the paper saw the trappings of a photo session laid bare: the justices are viewed from a distance, framed by a large curtained backdrop in a room that has been rearranged and lit for the camera. They are caught unaware in the act of posing. Almost a decade later, the *Times* ran a similar Crowley photograph inside the Sunday paper on the occasion of Justice Sandra Day O'Connor's retirement. This time the camera pulled farther back to reveal a line of unattended still cameras on tripods pointed at the justices.

Even as television news struggled to overcome its preoccupation with image making, the photo-op mentality found a new home in the pages of the *New York Times*. The pictures of the Supreme Court justices represent a major shift in the way the *Times* covered public figures and politicians from the 1990s to the present.

## Photographing Photo Ops

Television reporters and producers were not the only ones facing the dilemma of how to take pictures of increasingly media-managed campaigns. Newspaper photographers were in the same boat. How could they cover campaigns without being conduits for the politicians' photo ops? To see how newspapers grappled

with this problem, I looked at all the *New York Times*'s front-page presidential campaign coverage from the Nixon-Humphrey-Wallace race in 1968 through the Bush-Kerry race in 2004, as well as hundreds of other photographs on the front page and inside the paper.[1]

In 1968, the *Times* covered the presidential race in much the same way as the network evening newscasts. Politicians had not yet perfected the photo op, and front-page pictures in the *Times* documented the rallies, parades, and speeches that still characterized the presidential campaign. The pictures of the Republican and Democratic conventions, for example, capture their celebratory spirit. The Republican convention in Miami went off without a hitch. Under the banner headline, "Nixon Nominated on First Ballot," the *Times* photograph is a long shot showing a jubilant Richard Nixon in a convention hall filled with signs and banners. The celebratory aspect of the Democratic convention, however, was marred by antiwar demonstrators: the *Times* captured this in two juxtaposed front-page photos, one labeled "At Convention," showed cheering delegates, the other labeled "In Street," showed police clashing with demonstrators. Whether it was a big front-page picture of vice presidential candidate Edmund Muskie with his family or a photo of a Nixon parade with the banner "Nixon's the One," the *Times* photos hewed to a straight documentary style—no exposure of the image-making apparatus, no presence of a cluster of news photographers in the frame, no attempts to puncture the picture by showing the behind-the-scenes action.[2]

The only hint of image-conscious coverage came in a front-page story by R. W. Apple Jr. on September 15 titled "Political Advance Man: Plan and Fret." Under a documentary photo of Hubert Humphrey spontaneously marching in a parade in Philadelphia, Apple takes his readers behind the scene and chronicles the ups and downs of Humphrey's lead advance man, a peripatetic thirty-eight-year-old named Kingsley H. Murphy Jr. Apple begins his piece by noting that Murphy was none too pleased with Humphrey jumping into the parade, because if "you don't have the sex appeal of a Kennedy . . . sometimes it's better if you don't try for dazzling crowds . . . you reach more people more effi-

ciently with television." Apple then lays out for his readers how in the new era of the "media campaign" candidates were timing their events to play on the evening news and choreographing their photographs to make sure the lighting and background were just right for the news photographers.

During the subsequent four presidential campaigns neither the crafting of images for television nor the machinations of media advisers became the subject of front-page photographs, with one exception. Near the end of the 1980 presidential race between Carter and Reagan, the *Times* ran a front-page photo of Gerald Rafshoon, President Carter's media adviser, supervising the installation of a debate lectern. As I paged through the front-page photographs of the 1972, 1976, 1980, and 1984 presidential campaigns, I got a sense of the sweep of historical events—the Vietnam War, the reelection of Richard Nixon, the victorious campaign of Jimmy Carter, the hostage crisis in Iran, Ronald Reagan's two successful bids for the presidency—all depicted in the *Times*'s traditional documentary style.

What did change is that the photographs of the candidates (as well as other people in the news) moved from the long and medium shots that characterized the 1968 coverage to close-ups, portraits, and more intimate scenes of two or three people grouped together. This style of photography had the effect (whether intended or unintended) of eliminating the staging, backdrops, logos, and signs of the candidates from many of the front-page photographs. It wasn't that the candidates stopped staging pictures, but the pictures in the *Times* focused on the person, and the telephoto shots often blurred whatever background remained within the frame. When the frame of the photograph widened to reveal the backdrop, the *Times* ran the photo op straight. In 1972, for example, the *Times* ran a front-page picture of Richard and Pat Nixon standing in front of the Statue of Liberty near the end of the campaign.

Far from calling attention to the photo op, the *Times* on occasion even helped explain the symbolism. A caption of a photo of Jimmy Carter waving aboard a ship during the 1976 presidential campaign informs the readers that the ship was similar to one

Carter served on in World War II. The close-up photographs did not poke fun but simply showed the standard poses of politicians. In 1976, for example, the *Times* juxtaposed front-page pictures of Jimmy Carter and Betty Ford holding and kissing babies. In 1980 Ronald Reagan and an actor friend were featured on the front page smiling and waving their cowboy hats the day after the presidential debate. Throughout the Reagan era, the *Times* continued its traditional style of photojournalism. In 1984, the *Times* juxtaposed dignified portraits of Reagan and Mondale behind the lecterns at the presidential debates, and later showed a jubilant image of Nancy and Ronald Reagan when Reagan was reelected.

Although things began to change subtly during the 1988 presidential campaign between George H. W. Bush and Michael Dukakis, this change was nothing comparable to the dramatic shift that occurred in television news coverage. The *Times* covered the campaign that was unfolding on television with interest, but also continued with its standard news reporting. The photographs of the candidates did not change in style. The only front-page photograph to call attention to the artifice of image making was a small photo of Lloyd Bentsen, Dukakis's running mate, having makeup applied before a television appearance, and this was part of a photo montage of more traditional images of the Democratic and Republican candidates.

The *Times* provided examples of the candidates' television ads on the front page for the first time in 1988, but with considerable restraint compared to the television networks. Of the some fifty front-page campaign pictures that ran during the 1988 presidential campaign, only two showed ads, compared to 125 ad excerpts shown on the network evening newscasts that year. On October 19, the *Times* ran a montage of Dukakis's ads accompanied by an article critical of Dukakis's television ad campaign. Near the end of the campaign, on November 3, the *Times* ran an image of the inflammatory and controversial Willie Horton ad with an accompanying article, "Bush, His Disavowed Backers and a Very Potent Ad."

Even as the photography of politicians remained largely unchanged, the reporting and news headlines gradually became more image conscious. Michael Oreskes wrote a front-page story titled "Dukakis Faces Powerful Foe in Camera Hogging Hurricane" on September 16, 1988. The photograph of Dukakis accompanying the article was a standard close-up of the candidate with a fire-ravaged Yellowstone Park in the distant background, but Oreskes's article focused on how the battle for control of the image was being fought on television with "photo opportunities," "theme weeks," and "photogenic events" timed to play on the evening news. He noted that television correspondents "made fun on the air" of Dukakis's "most carefully planned photo opportunity"—his tank ride in Michigan. Oreskes even inserted his own image-conscious commentary: "On *CBS News* there were pictures of Mr. Dukakis, looking like a Cub Scout on an outing to an army base, as Bruce Morton said: 'Biff, bang, powee . . . If your candidate is seen in the polls as weak on defense, put him in a tank.' "

Yet Oreskes, along with other *Times* reporters, mostly kept a critical distance from the television news coverage and its photo-op style of coverage. They tried to give their readers a perspective on the nature and problems of the media-managed campaigns. On September 18, for example, E. J. Dionne Jr. wrote a front-page piece titled "Race Reflects Voter Concern with Image over Substance," in which he cast a wary eye on what he described as the new role of "spin control" by campaign operatives: "A decade ago campaign staff members were evicted from the press rooms for interfering with reporters at work on debate stories. But tonight they were quickly surrounded by reporters, cameramen and photographers recording their views."

The presidential campaign of 1988 was a watershed of sorts for reporters and photographers. After the campaign, Arthur Grace, veteran political photographer for *Newsweek,* published a book titled *Choose Me: Portraits of a Presidential Race* in 1988. In the foreword, ABC news correspondent Sam Donaldson outlined the dilemma facing photojournalists:

There was a time that photographers photographed events that occurred naturally. There is John F. Kennedy leaning on his desk in lonely repose. . . . There is Richard Nixon at the helicopter door, crooking his arm in a twisted farewell to his presidency. . . . Those pictures are powerful. But it's getting harder and harder for all of us who cover politicians to get hold of the "real McCoy." Political campaigns are now carefully staged for the picture media. They are scripted, choreographed and sanitized. Access to reality has been severely limited. Today politicians still want the cameras to project their messages but they want it done on their terms and almost never in a natural, spontaneous way. . . . There was a time when we all went along on campaigns and politicians did what they wanted to do . . . they played to crowds and we took pictures of them playing to crowds. We watched events as they unfolded. Now, instead of just talking to people, the only time they talk to people is so they can be photographed talking to people. They simply use the medium for its own sake.[3]

The photographs in Arthur Grace's book pointed the way to a new style of photojournalism—a style that began to appear inside the pages of the New York Times in the 1990s and only later came to be featured on the front page. As Sam Donaldson noted in his foreword to Choose Me, Grace had "moved around the roped-off media pens where we are all made to stand and gotten inside the campaign of 1988. He's done it through enterprise, hard work, and an eye for an interesting picture. He's done it also by earning the trust of the candidates. . . . In short, in this age of media staging, Grace has managed to give us a fascinating glimpse of reality."[4] Grace captured many pensive moments in his beautifully rendered black-and-white images, but the "reality" he captured was what media events looked like from behind the scenes. He shows the press photographers as performers in the frame photographing the candidates; he takes us into the television studios to see how the candidates are being made up or how they wait in isolation before going on air; and he has an eye for odd and awk-

ward moments or the times when the candidates look slightly absurd—Michael Dukakis dwarfed by a podium or George Bush delivering a speech with his eyes shut. Amid all the hoopla, Grace framed scenes that punctured the pose.

## A Lonesome Trail It Wasn't:
## Photographers in the Frame

In the summer of 1995, Bill Clinton took a trip to Montana. He put on a cowboy hat and mounted a white horse. The press was there to take the picture, but the image was not of a rugged cowboy in the Ronald Reagan mode. That's because nine members of the press appear in the picture with their television cameras, boom mikes, notepads, tape recorders, and still cameras. "A lonesome trail it wasn't," noted the caption to the Associated Press picture, which ran on the front page of the *Times* on June 2, 1995.

The presence of photographers pressing into the frame is now so commonplace we forget what a change it represents. The presidential campaign of 1992 marked the first time that the *New York Times* ran a front-page photograph with news photographers in the frame. It is a picture of Bill Clinton leaving Calvary Baptist Church in New York City on July 12, the day before the opening of the Democratic National Convention. Two newspaper photographers are poised in the foreground corner of the frame taking pictures of the candidate. A handful of other front-page pictures during the 1992, 1996, and 2000 presidential campaigns showed the presence of photographers in the frame, though these pictures began to appear with greater frequency inside the paper.

One could argue that the presence of the photographers enhances the celebrity of the candidate as do paparazzi photographs of movie stars and other celebrities. But most of the photographs don't read that way. They bear more of a kinship with Clinton on horseback in "A lonesome trail it wasn't"—the presence of the photographer exposes the constructed nature of the photo op. A photograph of Senator Robert Dole that appeared in the Novem-

ber 1994 pages of the *Times*, for example, reveals the self-conscious choreography of press and politicians. Dole sits with his hands purposefully clasped posing for a photographer crouched on the floor. Despite Dole's attempt to control his image, the *Times* photograph makes his office look like a set, framed by the photographer's curtain.

Even as the photographic captions note politicians' attempts to "control the campaign coverage" or "blitz the media," the presence of the photographers in the frame accents the artifice of the pose.[5] And when the captions speak of substantive issues, the photographs can still reveal the contrivances of the politician's media events. "Mr. Bush 'won't face the truth about Iraq,' " notes a caption to a photograph of Senator John Kerry on October 8 during the 2004 presidential campaign. But the wide-angle photograph of Kerry by Stephen Crowley reveals a media event in the middle of nowhere. Kerry stands at the edge of a small platform in a large field pointing to someone outside the frame. Meanwhile, photographers in the background tinker with their cameras, lights, and equipment. Are they striking the set or setting up? It is hard to tell, but two things are clear. They are not focused on Kerry, and there is not a member of the public in sight.

In earlier decades, *Times* photographers moved in for close-ups of candidates and their supporters, but in the era of "scripted, choreographed, and sanitized" media events, the wide-angle shot has become a far more effective technique. A *Times* caption of a July 1993 photograph of President Clinton exposes his intent to use "the White House stage to promote the earned-income credit." Shot from an extreme low angle with a wide-angle lens, Clinton looms like a giant over the families seated on the stage. The accompanying news report reiterates the photograph's message: "The flowers were fake, the books borrowed and the stiff poses could have been borrowed from *Family Feud*. But the faux-homey set on a White House stage had a real political purpose." This "purpose," however, is not the point of the photograph. The picture is a visual pun on the media event.

Wide-angle shots that show photographers in the frame are a way for the press to accept the dance card of the politicians, and

then, like a reluctant partner, roll its eyes and call attention to its awkward position. They are a way to fulfill the assignment and subtly wink at the same time. And they are a way to escape from the "roped-off media pens" and take a more interesting picture. "At least one photographer strayed from his group yesterday as the leaders of the Group of 8 arrived to pose in the resort town of Heiligendamm," notes the caption to a large color photo on the front page of the *Times* on June 8, 2007.[6] The photograph by Guido Bergmann does not present an ennobling portrait of the world leaders. In fact, it does not even show their faces. Instead we see them from behind, at a distance, walking on a long stretch of lawns toward a horde of photographers gathered in the distance.

## Television in the Frame

The importance of television in the new media-managed campaigns was noted by reporters since 1968, but not until the 2000 presidential campaign did the *Times* show television images of the candidates on the front page. Bush and Gore are shown in nine different TV images. But the deeper change in photojournalism is how photographers brought the television image into the frame as another way of exposing the photo ops and deflating the politicians' images.

When Lamar Alexander announced his bid for the presidency in 1995, the *Times* photo caption notes that he "summoned the media to Maryville, Tennessee." But the response to the summons might not have been the photo op the candidate had hoped for. Alexander is but a blurry image as he stands at the podium in the background of the *Times* photograph. Dominating the foreground of the frame is a silhouetted television camera whose lens obscures most of Alexander's campaign sign, which now reads "Lam." All we see of Alexander is a small round image in the television camera's viewfinder.

Similarly, when Governor Christine Todd Whitman of New Jersey prepared to deliver the Republicans' response to President Clinton's State of the Union message, she is shown twice—first,

out of focus in the background as she sits in the television studio, and second, in sharper focus as she appears on the television monitor. A more recent example of this motif is a Doug Mills *Times* photograph of Congressman Rahm Emanuel speaking before the press on the Democrat's position on the war in Iraq. The photo caption begins "A TV camera viewfinder caught Representative Rahm Emanuel." It might have been a traditional documentary shot (Emanuel stands at the podium in clear focus with Senator Charles Schumer by his side), except on the small round TV camera's viewfinder in the foreground we see an extreme close-up of Emanuel's face, which looks as distorted and strange as an image in a fun house mirror or the face of movie actor Jim Carrey in *The Mask*.

By placing the television camera in the frame and showing the politician's image in the viewfinder, the photographers achieve a visual double entendre. We see a picture of a politician getting his picture taken on television. A variation on this theme is a photo taken by Fred R. Conrad that appeared in the aftermath of the Democratic 2004 convention on the front page of the "Week in Review" on August 1. The colorful balloons, confetti, and convention hoopla are in the background. In the foreground we see a close-up image of John Kerry on a small isolated monitor next to a darkened laptop computer screen strewn with confetti. Far from a commanding presence, Kerry is reduced to an image on a screen, his face caught in an awkward expression.

Meanwhile, like the television reporters, print journalists became theater critics commenting on how well or poorly candidates performed on television. Reporting on a 1992 Illinois rally for Bill Clinton and Al Gore, Don Terry of the *New York Times* described the campaign's efforts to gather a good crowd and then observed, "It looks so much better on the evening news when the heartland is crowded."[7] Another *Times* story was reported by Gwen Ifill on the Democratic ticket's appearance at a town meeting in West Virginia, where a statue of John Kennedy "loomed behind the men as they spoke, an irresistible television shot."[8] Under the headline "Playing Diplomat on Television," a *New York Times* story by Richard L. Berke on George H. W. Bush's cam-

paign noted, "The President's media consultants could hardly have scripted a better picture than the sight over the weekend of George Bush as Commander in Chief, an American flag draped behind him and the Presidential seal in front of him."[9]

Political candidates, sensing the disenchantment of the public with photo-op politics, explicitly renounced the use of sound bites and contrived images. Independent candidate Ross Perot found that to an electorate wary of artifice, campaigning as the earnest citizen and political outsider was a promising political strategy. He publicly resolved that he would be a candidate without handlers, and in a much-reported sound bite, deflected questions about details of his economic policy by saying, "I am not going to sound-bite it." Candidates focused more on town meetings and the homey conversational style that daytime and evening talk shows welcomed.

By the 2000 campaign, the *Times* took note of the new trend in front-page photographs. A photo by Stephen Crowley captioned "Confessions of a Peanut Butter Eater" showed Governor George W. Bush sharing a laugh with Oprah Winfrey.[10] Three weeks later the *Times* ran a front-page image from NBC's *Saturday Night Live* broadcast with a less flattering caption about Bush's Democratic rival Al Gore: "Al Gore was shown the 'Saturday Night Live' satire of the first debate as a reminder to keep his cool." The accompanying article by Richard L. Berke and Kevin Sack explains how Gore's media advisers wanted their candidate to lighten up and not come across as "the overbearing know-it-all" featured in the *Saturday Night Live* skit.[11]

By 2006, the *Times* did their own riff on late night talk shows in a front-page news headline that read: "Here's Donny! In His Defense, a Show Is Born," The April 16, 2006 headline played on the line used by Ed McMahon to introduce NBC icon Johnny Carson on the *Tonight Show*. Below the headline are three large photos of Secretary of Defense Donald H. Rumsfeld—first laughing, then serious, then with his hand to his head. The accompanying article highlights Bush's support of Rumsfeld even as his Iraq war strategy seemed to be failing.

## The Easter Bunny and Other
## Characters Enter the Picture

Photographers have found other techniques to sidestep the photo op for a more interesting picture. Instead of showing the actual event, they take backstage pictures before the event occurs or focus the camera's eye on figures peripheral to the main story. In a Stephen Crowley *Times* 1997 photo titled "Waiting for Clinton," we see a secret service agent wearing a trench coat and sunglasses on one side of the frame and on the other side we see a person in an Easter Bunny outfit, wearing giant glasses and a dark vest.[12] The secret service agent's vigilant eyes are trained away from the camera, but the Easter Bunny stands on a carpet rolled out for the event, and his wide eyes are looking straight at the camera. A security guard stands against a building, a background figure to the unlikely duo. The caption reads, "A Secret Service agent and an Easter Bunny waited for President Clinton yesterday, before the 119th White House Easter Egg Roll. Lines of children for the egg rolling stations stretched halfway down the South Lawn."[13]

In a 1996 *Times* photo by Amy Toensing titled "House Freshmen Say, 'Cheese,' " a similar effect is achieved by relegating the ostensible subjects of the picture—the new members of Congress—to the background, and plucking out a background figure—a security guard—to play a starring role in the photo. To add to the effect, neither the security guard nor the members of Congress are looking at the *Times* photographer. The House members appear in sharp focus, but their eyes are directed toward an official photographer who stands outside the frame. Meanwhile, the security guard in the foreground is slightly out of focus, and he's looking off to the side. The text of the caption reads: "Members of the 105th Congress posing for their class portrait . . . as a guard also struck a pose."[14] Of course, the security guard was not posing at all, but was simply caught in the frame. Both the picture and the caption underscored the point that the *Times* was not really running a photo of the new members of Congress, but rather a photo of them posing for a photo.

One of the most popular radio shows of all time was called "The Shadow," and the opening lines are so famous they are still remembered today: "Who knows what evil lurks in the hearts of men? The Shadow knows!" The Shadow was an "invincible crime fighter, never seen, only heard."[15] Sometimes the *Times* photographers imported their own "shadows" to disrupt the conventional pictures of politicians. In Stephen Crowley's front-page photograph of John Kerry taking part in an "economic summit" during the 2004 presidential campaign, the camera peeks over the shoulders of three shadowed figures to picture Kerry at a distance, exchanging a laugh with a summit delegate. The shadow figures loom larger in Andrew Councill's 2007 *Times* photograph of Senator John McCain addressing cadets at the Virginia Military Institute on the war in Iraq. Who knows what the shadow knows? The shadow is certainly a bigger presence in the frame than McCain at the podium.

The pictures taken by *Times* photographers reflect a style first seen in art photography and in the movies. As soon as television began to have a significant impact as a means of mass communication, movie directors probed the new medium's vulnerability to artifice, fabrication, and deceit. Even as Walter Cronkite and Chet Huntley and David Brinkley presided over the more traditional documentary-style television news, art photographers explored such themes as the image as an image, the picture as a performance, and the flaw that reveals the artifice of the pose.

## Taking Pictures of Pictures

The image-conscious photography that has recently become prominent in newspapers is not without precedent. In 1960, art photographer Garry Winogrand took a photograph that uncannily anticipated the photo-op style of coverage that television news would adopt in the 1980s and photojournalism in the 1990s. The photo shows John Kennedy addressing the Democratic National Convention, and it portrays politics in the age of television as an array of images of images. Shot from behind the

podium, it does not show Kennedy's face or the reaction of the delegates below. Instead, it shows Kennedy's back, and on the platform behind him, a portable television showing him delivering his speech.

From behind the scenes, Winogrand exposes the layers of images that constitute the political event. In the foreground of the photograph is the television; in the middle is the candidate gesturing to the crowd. In the background, out of focus, is the platform that holds the television cameras that are recording the image that appears on the screen.

Winogrand directs our attention from politics to the pose, from the political event to the irony of political form. Winogrand is not interested in the meaning of the event as experienced by its participants but in the meaning of the scene as a picture about pictures.

Winogrand's picture of Kennedy signaled a departure from the traditional ambitions of both art and documentary photography. As art photography sought to interpret reality, documentary photography sought to record it, but both directed the viewer's attention to a reality beyond the photograph. The art photographers of the 1950s and 1960s undertook a different project.

Just as modernist drama denied the audience the suspension of disbelief and made us aware of the play as a play, the new photography made us aware of the frame as a frame. As modern playwrights had decades earlier made the scenery, scripting, and staging subjects of dramatic discourse, photographers of the postwar period took pictures that called attention to the conventions of photography—the camera angle, lens type, and depth of focus. They directed attention to the picture itself, to the image as an image.

This new photographic sensibility arose in conjunction with the rise of television. During the 1950s and 60s, when television began to become a potent form for documentation and entertainment, it also became a powerful influence on the work of artists. Photographers began to photograph the television set as part of the social landscape. Artists began to explore and criticize the conventional ways in which the media invite us to see the world.

The idealized visions of television, movies, advertising, and fashion became the subjects of pictures.

The first stirrings of the new image-conscious photography had appeared in the work of the great documentary photographers of the Depression era. Even as they fulfilled their assignments for the Farm Security Administration, documenting conditions of poverty across the country, they subverted conventional images by taking pictures of pictures. Among the earliest ironic pictures of pictures were their photographs juxtaposing the promotional media of their day—movie posters, advertisements, and promotional billboards—and the impoverished American landscape.

In Atlanta, Walker Evans photographed a series of movie billboards, stretching like a large strip of film, in front of two bleak frame houses. The glamorous face of Carole Lombard in her new movie *Love before Breakfast* is defaced by a blackened eye. In a photograph taken on Cape Cod, Evans shows an extreme close-up of a torn movie poster of a man protectively embracing a woman. By magnifying the tear and the wrinkles of paste underneath the poster, Evans exposes the very materials of its creation as they fall apart, and subverts its intended meaning. The paste marks extending from the corners of the man's and woman's eyes look like fallen tears. A large rip forms a violent gash down the woman's forehead. The movie image has lost its power, and instead, Evans shows the drama within the drama of an image in decay.

Driving down the roadways of America, the photographers of the Depression captured the absurdity of American boosterism. A billboard that appears in several photographs shows a happy family driving their car, with the slogan, "There is no way like the American way." Arthur Rothstein shows the billboard in a desolate part of Alabama. It reappears in a Russell Lee photograph of a barren stretch of American highway.

Unlike the disengaged stance of art photography in the 1960s, the Depression-era "pictures of pictures" were made in the service of social criticism. The same was true of the work of another forerunner of modern image-conscious photography, the Swiss

photographer Robert Frank. During the 1950s, Frank traveled through America taking photographs. His book *The Americans*, first published in 1958, revealed a truth that the idealized American images of the postwar era concealed. Watching a parade in Hoboken, New Jersey, Frank turned his camera away from the flags and festivities to photograph the onlookers. The camera looks up at a dingy brick building as two women watch the parade below, framed by the bleak, bare windows. A large American flag appears not as a vibrant patriotic symbol but as part of a mournful landscape. It is displayed between the windows, obscuring the face of one of the women. The other woman's face is barely visible in the darkened room.

Another picture in *The Americans*, "Restaurant—U.S. 1 Leaving Columbia, South Carolina," shows a television left on in an empty restaurant. A man in a suit, perhaps a politician, pontificates on the screen. But there is no life in the room, no response to the image. The artificial light of the television image coexists with the window light and the empty table. The face on Frank's television screen is not a compelling image, but an eerie electronic form.

In "Television Studio," Frank portrays a smiling young woman sitting on a chair on a small stage in a television studio in Burbank, California. Although the young woman is at ease posing for the television camera, Frank focuses on the staging of the picture. The studio lights, the cables on the floor, and the two-tiered stage where the woman sits are all visible. The young woman is in the background and off-center in the frame, her body half obscured by the elbow of a man standing in the foreground. Off at an angle we see her bright, smiling face on a studio monitor. In Frank's photo, the woman's smile seems less real than the studio equipment that transmits the image.

Brilliant in their dark documentation, Frank's photographs were a prelude to the new image-conscious photography of the next decades. The art photographers of the 1960s, admiring though they were of Walker Evans and Robert Frank, rejected social criticism in favor of a distant, dispassionate stance toward the world they photographed. Their pictures about pictures directed attention away from the subject matter and

toward the medium of photography. As Winogrand explained, "I photograph to find out what something will look like when photographed."[16]

A characteristic example of this distance is a photograph by Michael Ciavolino, dating from 1962, that shows a group of young people gathered around a table drinking beer. It looks like a typical snapshot except for the fact that the photographer printed the photograph encased within the contact sheet. We see the sprocket holes, the numbered frame, a portion of the image in the next frame, and the word designating the film type, "Panchromatic," all vividly on display.

The stress on the photograph as image comes out strongly in the work of Ken Josephson, who developed the theme of pictures of pictures by showing a hand jutting into the frame, holding a photograph or picture postcard of the scene being viewed, such as the Washington Monument or a Michigan beach.

Photographers began to use windows, mirrors, reflections, and the frame of the photograph itself to heighten the viewer's awareness of looking at images of images. In Lee Friedlander's book *Self-Portrait*, the photographer appears in every frame as an intruding shadow or reflection. One photograph shows a public building with a photograph of John Kennedy in the window. Friedlander, his image reflected in the window as he takes the photograph, is standing outside looking in. Kennedy's face is obscured by a sign we cannot read, which obscures the face of the photographer.

In other photographs, Friedlander's shadow intrudes on familiar images in a way that undermines their conventional meanings. Our view of a hometown parade in Lafayette, Louisiana, is humorously disrupted by the shadow of Friedlander's head on a post in the foreground of the frame. The post disrupts the picture by dividing it in two. To the right of the post, the drum majorette, in shimmering body suit and white boots, casts her own shadow before her as she marches up the street, oblivious to the photographer's presence. In another photograph, the shadow seems to stalk its subject, appearing on the back of a blond woman wearing a fur coat walking down a New York City street.

A photograph taken from a car in New York state shows a reflection of Friedlander taking the picture in the car's side mirror. The image of Friedlander occupies the side of the frame with the mirror and car window dividing the frame. Across the street, we see a roadside chapel with a cross and the words "God Bless America" on the roof, which in Friedlander's photo take on an ironic meaning.

Through the presence of his shadow or reflection, Friedlander refuses us the traditional documentary understanding of the photograph. Friedlander intentionally employs the "mistakes" of amateur photographers—shadows, reflections, and distracting objects in the frame—to explore the photographer's role in making the picture.

Like Robert Frank in *The Americans*, Friedlander questions and disrupts images that are central to American cultural identity. But unlike Frank, who asked the viewer to enter the reality his photographs depicted, Friedlander, by his very presence, holds us back from entering another reality. He makes us aware of the picture as a picture, asking us to question the conventional way we see.

Photographers of the 1960s also explored the camera's potential for realism and fabrication by taking pictures of television sets. Like Robert Frank, they portrayed the television image in a way that heightened its artifice and subverted its power. A Diane Arbus photograph shows a Christmas tree and presents in an empty living room in Levittown, Long Island, in 1963. Everything is orderly. Alongside the tree is a lamp, the shade still covered with plastic. In the other corner is a television set. All the artifacts of suburban life are realistically portrayed but drained of their usual meanings. The television, like the tree, is a testimonial to the artificiality of everyday life.

In his book *Suburbia* (1972), photographer Bill Owens shows a similar Christmas living-room scene. The large television set, the top decorated with fake cotton snow and Christmas figures, is the focus of the picture. Ronald Reagan appears on the screen in an old movie, but no one is there to see him. He exists only as an amiable living-room fiction, an image within an image. In

another Owens photograph, a family poses on their couch with the television tuned to a football game. The picture could have evoked the warm familiarity of a family snapshot, but Owens's wide-angle black-and-white image creates an ironic distance from his subjects' familiar engagement with the television set.

Lee Friedlander did a series of photographs of television sets turned on in empty rooms. Each photograph features a close-up of a televised face, a portrait oddly situated in the austere furnishings of what appear to be empty motel rooms. In one photograph, a baby's face appears on a small TV set at the foot of an empty bed. The blurred image of the child framed by two darkened doorways is an eerie, indecipherable presence, a simulation of selfhood.

## Pictures as Performances

In Friedlander's self-portraits, the presence of his own image in the frame calls attention to the picture as a picture. In this respect it does for photography what Pirandello's modernist play *Six Characters in Search of an Author* does for drama. In Pirandello's play, the actors address the audience and speak of their roles, calling into question the tenuous line between appearance and reality, theater and life. The photographer's presence in the picture frame achieves a similar effect.

Even when Friedlander's image is not present in the photograph, his use of poles, mirrors, and other objects to disrupt the frame is "another reminder of the artifice and illusion at work in an otherwise very 'real-looking' two-dimensional picture," observes the critic Rod Slemmons. "Suddenly the proscenium arch appears."[17] The audience becomes aware of the play as a play.

Friedlander performed in the pictures he took, sometimes as shadow or reflection, sometimes as subject, but always as a kind of alien, dislocated presence. "Friedlander put himself in all these strange environments where he wasn't known, where he was a stranger, where he was wandering," observes the art photographer Barbara Norfleet. This ironic mode of self-portraiture had

the effect of heightening the pose, the self-distance of the subject. As Norfleet notes, Friedlander's photographs, which depict him as "this lonely wanderer, this homeless person, present in different environments that bear his reflection," show him "not as himself, but as a simulation of himself."[18] His self-portraits do not really portray the person of the photographer but rather an image of the person.

The theme of the photographer as performer is carried a bold step further in the work of Cindy Sherman. In the late 1970s, Sherman did a series of photographs called "Untitled Film Stills." Each photograph pictures a woman in a typical pose from a film. Sophisticated and naive, dominating and vulnerable, glamorous and plain, the women are caught by the camera in various dramatic poses. A young blond woman looks at her reflection in the mirror. The cool vulnerability of her gaze reminds us of Grace Kelly or Marilyn Monroe. A dark-haired woman, simply dressed, stands defiantly in a doorway evoking the gritty sensuality of Sophia Loren in an Italian movie. A tough-looking brunette sitting in a chair smoking a cigarette resembles Joan Crawford. Still another, viewed from a low angle against a sharply etched background of city buildings, looks like a heroine from a Hitchcock film.

For all their various looks, settings, and genres, the photographs have one thing in common. Each is a self-portrait. Cindy Sherman poses in every frame. The photographer is the sole subject of the photographs she takes, and yet no two photographs look alike. In each picture, she dons a different persona, a different disguise. The different looks and roles assure that, despite her presence in every frame, Cindy Sherman herself—the person as distinct from the pose—never actually appears.

As with Warhol, the repetition of images is essential to Sherman's art. Her photographs depend for their impact on being viewed as a series. And like Warhol's images, Sherman's pictures are copies of copies, illusions of illusions. But in Sherman, the self-referential aspect implicit in Warhol and explicit in Friedlander finds its ultimate expression, as she photographs herself posing as movie stars posing for photographs.

In a series of color photographs Sherman took in the 1980s, she poses as ordinary women fantasizing about the glamorous life, perhaps imagining themselves as movie stars. In each photograph, a young woman is seen staring, waiting, imagining. In one, a girl lies on a kitchen floor, holding a crumpled piece of paper. In another, a young woman waits by the phone in her nightgown. In these pictures, Sherman seeks to document the reality of fantasy. "There is a stereotype of a girl who dreams all her life of being a movie star," Sherman once explained in an interview. "She tries to make it to the stage in films and either succeeds or fails. I was more interested in the types of characters that fail. Maybe I related to that. Why should I try to do it myself? I'd rather look at the reality of these kinds of fantasies, the fantasy of going away and becoming a star."[19]

Sherman's work explores the many roles that women play, but leaves ambiguous her own stance toward those roles. Does she mean to celebrate or criticize the stereotypes she portrays? On the one hand, she never offers an alternative to the female stereotypes she depicts, never offers a vision of women unbound from the roles they occupy in her pictures. On the other hand, her self-conscious emphasis on the constructed status of women's roles may suggest an attempt to loosen their hold, to free women from their grip. As one commentator writes, "What raises Cindy Sherman's photos above the stereotype . . . is that she obviously knows quite well what's what with the women she is representing, and takes her distance from the self that she wraps herself in."[20]

## Failed Images: Framing the Flaw

The focus on the failed image that reveals the artifice of the pose is yet another aspect of the photo-op mentality that the art photographers of the 1960s and 1970s had already explored. The most explicit treatment can be found in a series of photographs on media events by Garry Winogrand published under the title *Public Relations* (1977). With a background in both photojournalism and commercial photography, Winogrand had a keen eye for the

artifice in media events. He focused on the show behind the show—the staging, the lighting, and the role of the media in the drama of politics in the age of television.

Winogrand shows, with an ironic eye, the entanglement of the media and the politicians. A photograph of presidential aspirant Edmund Muskie shows him at an outdoor rally during the 1972 primary campaign. Neither the candidate nor the reporters and photographers who surround him are in control of the jumbled scene. Winogrand captures the chaotic choreography of the media jostling for position, pointing microphones and cameras, their faces displaying the odd off-guard expressions of people caught unawares.

Winogrand makes the candidate and the background setting look out of kilter; the statehouse behind Muskie appears to lean over, and Muskie's podium tilts toward the crowd of reporters. By tilting his camera in a low-angle shot, Winogrand accentuates the way the candidate is "framed," undermined, foiled by the camera.

The double meaning of being "framed" suggests the tendency of image-conscious photography to puncture the pose by reframing the event to expose the flaws. Winogrand shows how the camera forms and deforms the events it covers in a photograph of an Eliot Richardson press conference in 1973. Sitting at a small table strewn with microphones, dressed in a suit with a handkerchief in his pocket, hands folded calmly before him, Richardson would look the picture of poise in a standard news photo shot from the chest up. But Winogrand's wide-angle shot makes Richardson look oddly isolated in a strangely empty room, a vast white wall looming behind him, with two incongruous house plants to either side.

The lifelessness of the scene is accentuated by the absence of anyone responding or listening to Richardson. The presence of the press is represented only by the microphones on the table, connected by wires to a clutter of small portable cassette recorders on the floor. The symmetry of this odd scene is upset only by a woman poking her head into the side of the frame to adjust her tape recorder.

Like Friedlander, Winogrand uses what would be considered mistakes in conventional photographs to artistic advantage. The misplacement of the central figure, heads and bodies poking into the frame, figures obscuring other figures, people caught in odd poses or with their eyes shut, are all used to subvert the perfect picture. At a protest demonstration in Washington, DC, following the Kent State shooting in 1971, the central drama is the odd juxtaposition of the press and protestors in the frame. A young woman is speaking in the center of the frame, but like Muskie, she is not the center of attention. A boom mic held by an unseen hand disrupts the frame. The television crews wearing gas masks look like alien beings in contrast to the students who are dressed in casual summer clothes.

Winogrand shows with irony and humor the way not only politicians but also ordinary people are part of the photo-op society. The frontispiece of *Public Relations* is a wide-angle photograph of people taking photographs at an observation area at the Kennedy Space Center in 1969. They are all striking slightly different poses as they aim their handheld cameras, oblivious to the photographer framing them in his picture.

In *Public Relations*, Winogrand emphasizes what the press tries so hard to deny, that they too are part of the performance. As artist and onlooker, Winogrand is not caught up in the contradiction of the press, who first seek the best possible picture of the politician, then try in their reporting to undermine it. When network reporters are criticized for collaborating with the advance teams of presidents or candidates, they insist that such collaboration is necessary to get a good picture. "What we're trying to do is make sure that we can see the president and what he does," explained Brit Hume in defense of network producers working with the Reagan White House to set up the shots. "All kinds of things can go wrong. You can have the president or the other candidate back lighted, for example, which means that he can barely be seen by the camera or, because of the placement of people, the shot is blocked. We're trying to make sure our access to the story is not cut off."[21]

Like the photojournalists who adopted this style in the 1990s, Winogrand does not seek the "perfect picture" in the first place. He is able to expose the artifice of media events without it. For Winogrand, the "technical" requirements of the shot are not reasons to collaborate with the image makers but conventions to be resisted and renounced. In Winogrand's photographs, not only the politicians but also members of the press are participants in the theater of contrivance.

The fact that picture after picture in *Public Relations* is about people taking pictures vividly illustrates how the line between authenticity and artifice, between document and fiction is crossed and recrossed. The focus on images that fail to meet conventional expectations is a way of jarring us into seeing in a different way.

This was precisely the effect of Walker Evans's photograph of the gashed and peeling movie poster in the 1930s, and of Robert Frank's photograph of the television set turned on in an empty highway restaurant. By placing billboards within a wider frame, photographers since the Depression have let the life outside the billboards provide ironic commentary on the idealized images they project. Lee Friedlander provides a variation on this theme by using his shadow or reflection to create a flaw in an otherwise conventional scene or to deface a studio portrait or political poster. In each case, photographers transform an idealized image into an artifact that lacks the potency it might otherwise hold.

## The Self Deformed

The eye for the flaw that deconstructs the pose is also an eye that deforms the self. The photo-op mentality, alive as it is to the constructed character of events and persons, suggests a view of the self that is at once liberating and disempowering. "You see someone on the street and essentially what you notice is the flaw," observed Diane Arbus. "It's just extraordinary that we should have been given these peculiarities. . . . If you scrutinize reality closely enough, if in some way you really, really get to it, it becomes fantastic. . . . Something is ironic in the world and it has

to do with the fact that what you intend never comes out the way you intend it."[22]

Along with Winogrand and Friedlander, Diane Arbus was featured in a 1967 Museum of Modern Art exhibition titled *New Documents*. Her photographs in this and later exhibitions drew large crowds and considerable critical attention. Trained as a fashion photographer, Arbus specialized in portraits that accentuated the deformities and abnormalities in the commonplace. One commentator has aptly described her work as "fashion portraiture gone horribly wrong."[23]

The sharp focus of Arbus's large-format camera transformed its subjects into strange caricatures of themselves. In a photograph labeled "Boy with a Straw Hat Waiting to March in a Pro-War Parade, N.Y.C. 1967," a young man stares at the camera with a deadpan expression, dressed primly in a bow tie, jacket, and patriotic buttons. Arbus's use of the photographic flash does not so much illuminate and document the person as introduce an air of unreality. It makes the natural look unnatural, magnifying every physical imperfection and making symbols—like the American flag—look like props.

In Arbus's hands, the boy's pose is made to mock his ideals, and he becomes an unwitting participant in his own self-caricature. A photograph labeled simply "Patriotic Young Man with a Flag" goes a step further and makes the young demonstrator look like an escapee from a mental institution. Again, the use of the flash is a vehicle for bringing out the deformity in his expression. His eyes look upward, he smiles, he holds the flag, and it all seems like a dark form of madness.

The mundane subjects of family snapshots and photo albums—babies, children, and family groupings—fare no better under Arbus's scrutinizing gaze. In Arbus's sharp-focus close-ups, babies are not smiling but crying, their faces contorted and grotesque. A flower girl posed in front of a foggy landscape looks like an actor in a surreal drama. A little boy holding a toy hand grenade in Central Park is caught in a pose so contorted that it looks at once like the spasm of a nervous disorder and a gesture of barely contained violence.

Arbus's photographs are an assault on normalcy. In this assault, she, like Winogrand and Friedlander, makes high art out of the photographic mistakes and oddities that would end up in the reject pile of the amateur or fashion photographer. But Arbus also consciously sought out freaks, deviants, and the physically deformed. Freaks made her feel "a mixture of shame and awe." Arbus noted, "Most people go through life dreading they'll have a traumatic experience. Freaks are born with the trauma. They've already passed their test in life. They're aristocrats."[24]

But the "aristocrats" of Arbus's photography, like her "normal" subjects, do not escape the indignity of exposure, the estrangement in the pose. In a photograph labeled "Mexican Dwarf in His Hotel Room," Arbus shows a man wearing only a hat and a towel covering his lower torso, staring with composure at the camera. Our eyes are directed to the deformities. The label of the photograph itself, "Mexican Dwarf," suggests that these two categories define his being. And so the inner life intimated in his smile is subsumed by his categorization as a "freak."

Another photograph, "A Jewish Giant at Home with His Parents in the Bronx," shows how her labeling underscores the depersonalization of her subjects, her insistence on directing our attention to the odd violations of social categories and expectations. Beyond the labels, Arbus sets up an equivalency between the normal and the abnormal, between those like the "Tattooed Man" who choose their deformity and those like the "Woman with a Veil on Fifth Avenue," whose deformity is bestowed by Arbus through the distorting power of her camera lens. Twins in their party dresses posing for the camera look as surreal as another photograph of two mentally retarded women posing in party hats. In the end, we cannot determine to what extent the deformity we see is constructed by the distortion of Arbus's camera. If selfhood is constructed then so are its deformities. On what grounds can we distinguish, Arbus seems to ask darkly, between real deformities and artificially imposed ones?

Although less relentless in the pursuit of the grotesque than Arbus, Winogrand also features the self, deformed. In contrast to Arbus, his subjects rarely pose for the camera. Instead, Wino-

grand shows the self, deformed in the urban landscape. An oblique-angle photograph shows an outstretched arm protruding into the frame, giving money to a destitute man. The arm of the giver disassociated from his body is as alien an object as the boom microphones thrust into the frame in Winogrand's shots of media events. Other photographs show the self decentered by tilting the camera to make an otherwise normal-looking activity look out of kilter.

As the critic Jonathan Green notes, "There is no private world in Winogrand's photographs. . . . Winogrand's tragicomic world emphasizes extreme human types and situations. He constantly juxtaposes the well formed and the misshapen, the ordinary and the extraordinary. His viewpoint exaggerates the peculiarities of visual form and character, almost but not quite turning his subjects into caricatures."[25]

Sometimes Winogrand's pictures show people with physical disabilities, but unlike Arbus he does not make them the subject of fascination and awe. Winogrand widens the frame to show how the so-called normal people are implicated in a deeper deformity—the failure to relate to the life around them. Through the framing of the shot, he asks us to reflect on the formlessness of mass society, in which the problem is "not the number of people involved," as the philosopher Hannah Arendt observed, "but the fact that the world between them has lost its power to gather them together, to relate and to separate them."[26]

A Winogrand photograph shot outside an American Legion convention shows how people pass by on the street ignoring a legless man near the center of the frame. In another wide-angle shot we see women walking down a Los Angeles boulevard, their figures defined by the sharp play of light and shadow cast by the sun. Other people wait for a bus. All are oblivious to a young man in a wheelchair who sits in the shadow of a building, his head drooped over his body.

Winogrand's view of life was deeply pessimistic. He did not believe with the traditional documentary photographers that exposure would lead to social reform. To expose was an end in itself, a logical and formalistic consequence of the camera's ability to

expose images. "I look at the pictures I have done up to now," he wrote in an application for a Guggenheim grant, "and they make me feel that who we are and what we feel and what is to become of us just doesn't matter. Our aspirations and successes have become cheap and petty. I read the newspapers, the columnists, some books. I look at magazines (our press). They all deal in illusions and fantasies. I can only conclude we have lost ourselves."[27]

## Television in the Movies

Movies about television were among the early instances of pictures about pictures. Since the inception of television, filmmakers have explored the consequences of the new medium for politics and selfhood. As early as 1948, Frank Capra's *State of the Union* dealt with television as a tool of political image making. Grant Matthews, an idealistic presidential candidate played by Spencer Tracy, begins his campaign as a crusader for social reform. Supported by his wife Mary (Katharine Hepburn), Matthews at first resists the manipulation of his advisers and remains true to his ideals. But soon the politicos and special-interest brokers prevail, and Matthews compromises his principles in hopes of victory.

Matthews agrees to deliver a script that the politicians have ghostwritten in a national broadcast to be televised from his home. His wife objects, imploring him to stand by his principles, to no avail. "That won't be Grant Matthews you'll hear in there tonight," she tells him. "It will be a shadow, a ghost, a stooge mouthing words that aren't your own."[28]

When the moment comes for Matthews to speak, he has a change of heart and throws away the script. As he begins to denounce the politicians and the image makers, the political operatives order the sound shut off. But Matthews, breaking through the artifice, asserts his mastery of the event. "Don't you shut me off," he demands. "I'm paying for this broadcast." He proceeds to lay bare the deceit of his campaign and to expose the contrivance of the broadcast itself. "This was no simple fireside broadcast, paid for by your dollars and dimes. This is an elaborately

staged professional affair." At the last moment, Capra's hero struggles free of the image-making apparatus that surrounds him and asserts his integrity, his true self.

Subsequent heroes would not escape their entanglement with the television image so easily. In films of the 1950s and 1960s, television becomes a source of disempowerment and estrangement.

Elia Kazan's *A Face in the Crowd* (1957) is a parable of television's potential for power and duplicity. The public, which in Capra's film hungers for the genuine candidate, is present only as the crowd, the gullible audience yearning to believe but easily duped. The film chronicles the rise and fall of Lonesome Rhodes, an Arkansas drifter (played by Andy Griffith), who rises to national prominence as a folksy television personality, political kingmaker, and demagogue.[29]

Discovered by a woman from a local radio station, Marcia (Patricia Neal), who falls in love with him and promotes his career, Rhodes begins his radio career as a voice of the common man, genuine and unadorned, poking fun at the establishment. Before long he rises to stardom on national television, retaining his populist persona even as he becomes a Madison Avenue flack for his sponsor's product, "Vitajex pills."

Once authentic, Rhodes's folksy style becomes a wildly successful performance, magnified by his mastery of the medium. So adept does he become at television image making that he is enlisted to provide some "Madison Avenue coaching" for a senator with presidential ambitions. "Senator, I'm a professional and I have to look at the image on that screen the same as I would a performer on my show. And I have to say he'll never get over to my audience. Not the 65 million people who welcome me into their living rooms each week." After some resistance, the senator accedes to constructing a new television image so that he too can be sold to the public as successfully as Vitajex pills. One of the senator's powerful backers explains the need to change with the times. "Politics has entered a new stage—the television stage. Instead of longwinded public debates, the people want capsule slogans . . . punch lines and glamour."

Unlike Capra's film, Kazan's offers its hero no redemption from television's politics of deceit, no moment when the authentic self vindicates itself and rises above the image. Unlike Grant Matthews, Lonesome Rhodes does not puncture his own pose. Infatuated with his own image and television fame, Rhodes becomes demagogic in his will to power, as manipulative and disdainful of those close to him as he is of his viewers.

In the climactic scene, Rhodes's performance is finally punctured by the disillusioned Marcia, who uses television to expose him. After a show, Rhodes, thinking he is off the air, ridicules the stupidity of his audience. Marcia switches on his microphone, allowing the viewers to hear their hero's disdain for them. The audience is outraged and disillusioned, and Rhodes's image is destroyed. So is Rhodes, who at the end of the film is left ranting and raving to the accompaniment of an applause machine.

Films of the 1960s and 70s continued to explore how politics and selfhood are formed and deformed, constructed and deconstructed by the power of television. In *Medium Cool* (1969), by Haskell Wexler, the television image does more than empower or entangle an individual like Grant Matthews or Lonesome Rhodes; it comes to define social reality as a whole. The film deals with a television news cameraman (Robert Forster), who thinks of himself as neutral and detached, but finds himself implicated in the events he covers and, by his presence, transforms.

In the opening sequence, we see him callously filming an injured victim of a traffic wreck; only when his film is safely in the can does he call for an ambulance. In subsequent conversations, he and his colleagues reply to criticism of the media by insisting that they just "cover" reality that the camera merely "records," that the soundman is but "an elongated tape recorder." But the events of the film, which unfold against the tumultuous backdrop of the violence and confrontation of 1968, erode the cameraman's claim to neutrality. Those he covers forcefully deny the innocence of the camera's eye.

Pursuing a human-interest story, the cameraman seeks out a black cab driver who found and returned a large sum of money. But the cab driver just wants to be left alone. His friends

are hostile. They berate the cameraman for exploiting blacks, yet they crave the attention of his camera. They, too, want to be on television.

A friend of the cab driver, an angry young black man, rages against the artifice and power of television images. A "nobody" who shoots someone draws television coverage, the young man explains. "Then the cat lives, man. He really lives. A hundred million people see the cat on the tube, man, and they say, 'ooo, the former invisible man lives.' Everybody knows where he went to school. Everybody knows about his wife and kids and everything. . . . The tube is life. . . . You make him a TV star on the six, the ten, and the twelve o'clock news."

The slogan "the tube is life" restates for the television age the old paradox of the camera. The pictures that look so real can be false and misleading, but people do not feel real unless they are in the television picture. Television is powerful because it confers a celebrity that has become a surrogate for identity and true recognition.

*Medium Cool* shows that neither the cameraman nor the public he films can escape their entanglement with television images. The cameraman finally overcomes his disengagement by falling in love with a woman from Appalachia (Verna Bloom), and befriending her son. But in the end, he, too, becomes an object before the television camera. As he drives with his woman friend to find her son, their car crashes. The film ends, as it began, with the crash being filmed—this time by a camera that turns toward the audience as the movie ends.

Like *State of the Union*, *The Candidate* (1972) tells the tale of a reform-minded candidate who is stripped of his ideals by professional image makers. When a young liberal lawyer, Bill McKay (Robert Redford), agrees to run for the U.S. Senate, the political advisers promise he can be his own man, since he has no chance of winning anyhow. But when victory appears within grasp, the handlers take over, reconstructing the candidate's identity along with his political beliefs. The cynical image making that *A Face in the Crowd* depicts with dark satire appears here as a routine aspect of the modern campaign.

In an early speech, McKay, still speaking in his own voice, declares, "Our lives are more and more determined by forces that overwhelm the individual." He soon finds himself a victim of the very forces he describes, as he loses control of his campaign and his identity as well. McKay, who was once critical of political image making, now watches images of himself on television.

Unlike Grant Matthews in *State of the Union*, the candidate of the 1970s never breaks through the artifice to reassert his true self. When he wins the election, his disempowerment is complete. Surrounded by an enthusiastic crowd applauding the "people's candidate," McKay pulls his campaign manager aside and into a service elevator. His manager turns to him, "We've got sixty seconds of privacy. . . . What's on your mind, Senator?" McKay responds, "Marvin, what do we do now?"

Sidney Lumet's *Network* (1976), one of the most popular movies about the power and artifice of television images, depicts a television world driven by ratings pressures and entertainment values. The old news values of straight reporting are pushed aside in order to accommodate the glamour and glitz of entertainment shows. The tension between the camera as recorder of reality and instrument of artifice is gone. Artifice becomes the organizing principle for the reality television presents. People and events are constructed and contrived to be compelling television images.

The film begins with news anchorman Howard Beale (Peter Finch) being fired due to poor ratings. In despair, he becomes unhinged. Appearing on the air, he delivers a diatribe against the ills of the world and announces that he plans to blow his brains out the next week. In an absurd twist, ratings soar in response to Beale's mad ravings. His reward is his own show under the auspices of the entertainment division.

The new *Howard Beale Show*, which features Beale's tirades, a soothsayer, and a TV gossip columnist, is an instant success. It rises on the wave of popular anger and exploits for entertainment purposes viewers' love-hate relationship with television (just as the movie itself plays to those same emotions in its audience). Beale builds his popularity by warning against television's power and artifice. "The only truth you know is what you get out of

this tube. . . . We're in the boredom-killing business. . . . You're never going to get the truth from us. . . . You're beginning to think that the tube is reality and that your real lives are unreal. . . . You people are the real thing. We are the illusion. So turn off your television sets."

Paradoxically, the television audience applauds the message and ratings soar further. Beale's plea to "turn off your TV sets" is less a call to action than a form of entertainment. Television thus reduces words to media events, part of the seductive appeal that keeps people watching. As the hard-driving producer (Faye Dunaway) tells her boss, "He's articulating a popular rage. . . . I want that show."

The network gives Beale complete freedom of speech until he threatens the economic interests of the corporation that owns the network by urging his audience to send telegrams to the White House to protest an upcoming business deal. The head of the corporation decides that instead of taking Beale off the air, he will convert him by teaching him of the larger forces that render protest futile. In a dimly lit corporate boardroom he solemnly tells Beale, "You have meddled with the primal forces of nature. . . . You get on your little twenty-one-inch screen and howl about America and democracy. There is no America. There is no democracy. There is only IBM, ITT and AT&T. . . . The world is a collage of corporations inexorably determined by the immutable bylaws of business."

After Beale's encounter with the corporate executive, he preaches a prophecy of doom, telling his audience that "the individual is finished." His ratings fall and the network executives decide to have him assassinated on his own show. After a moment of stunned silence, the audience applauds this too. The movie ends with the narrator observing, "It is the first time in history a man was killed for having lousy ratings."

In contrast to the high emotion and dark satire of *Network*, another satire of television, *Being There* (1979), achieves its effect through the absence of emotion. Directed by Hal Ashby (based on a screenplay by the author of the original novel, Jerzy Kosinski), the movie is about the life of Chance (Peter Sellers), a gar-

dener who has lived his life totally isolated from society, raised in effect by a television set. Television provides Chance with his only way of knowing the world.

The opening sequence shows Chance waking up in the morning to television images. Television sets are everywhere, even outside in the garden. When Chance learns from the housekeeper that his employer has died, he receives the news impassively as he continues to watch television at the kitchen table.

Chance's life after leaving his employer's home is a sequence of absurd incidents based on his attempts to deal with life as if it were television. Walking through a run-down neighborhood, he is confronted by a young tough who pulls a knife on him. Chance tries to turn aside the tough by pushing the button on the remote control device he still carries in his hand. Wandering the streets of Washington, he cannot tell the difference between real things and their television images. Surprised to see his own image on the video monitor in a store window, he backs up and is hit by a rich woman's car. Fearing a lawsuit, the woman (Shirley MacLaine) befriends Chance and invites him to her home. Amiable and disconnected from life, Chance's first request is: "May I watch television please?"

Dressed in the dated but expensive clothes of his former employer, Chance appears to be a man of independent means. When he identifies himself as "Chance the gardener," the woman mistakenly hears "Chauncy Gardner." Chance becomes the houseguest of the woman and her husband (Melvyn Douglas), an aged business tycoon, and is swept into their lives of high finance and political influence. Without an identity of his own, Chance is the perfect receptacle for people's projections. They take his simpleminded homilies about gardening to be subtle metaphors of economic analysis. They interpret his innocence and emptiness as a refreshing clarity and directness. The dying businessman tells Chance: "You have the gift of being natural."

Through no doing of his own, Chance moves into ever-higher circles of power. His words are taken as economic insights by his patron and incorporated in a presidential address to the nation.

Chance becomes a television authority in his own right, inter-
viewed before a national audience.

The final scene of the movie is at the funeral for Chance's busi-
nessman friend, attended by the president and the pillars of gov-
ernment and high finance. The pallbearers are power brokers who
discuss in hushed tones the need to find a new candidate for
president. "What about Chauncy Gardner?" suggests one of the
pallbearers. "But what do we know of the man?" asks another.

> "Absolutely nothing. We don't have an inkling of his past."
>
> "Correct. That could be an asset."
>
> "A man's past cripples him. His background turns into a
> swamp and invites scrutiny."
>
> "Up until this time he hasn't said anything that could be
> held against him."
>
> "The mail and telephone response from his appearance
> on that Burns show was the highest they've ever had, and it
> was 95 percent pro. . . ."
>
> "I do believe, gentlemen, that if we want to hold on to the
> presidency our one and only chance is Chauncy Gardner."

Chance's weightlessness makes him the perfect candidate for a
world governed by the ephemeral images emitted by the televi-
sion screen. Unlike candidates whose identity must be remade by
the image makers, Chance has no identity in need of reconstruc-
tion. A pure image, he is utterly selfless, without ambitions or
interests of his own, and without an identity to resist the con-
struction others place on his words and being.

Television as an object of satire, sometimes dark, sometimes
surreal, gives way to lighter comic treatment in *Broadcast News*
(1987). The long-standing worry about the authenticity versus the
artificiality of the television image remains. It animates the work
relations and even the personal relations of Jane Craig (Holly
Hunter), a hard-driving young news producer, and Tom Grunick
(William Hurt), the handsome but ill-informed news anchor.

Unlike earlier films about television, however, *Broadcast News*
makes its peace with artifice. For the young producer, the line
between authenticity and artifice is a matter of great conviction,

but in practice the distinction proves elusive. Early in the film she delivers a harangue to her fellow broadcasters defending traditional news values: "We are being increasingly influenced by the star system. . . . Our profession is endangered. . . . We are being pressured to take a loyalty oath to profit and economy. . . . We are all secretly terrified by what is happening." Her bored audience files out one by one until she finds herself speaking to an empty room. Only Tom Grunick, the handsome but empty young anchorman, lingers to praise her. Although romantically appealing to Jane, he represents everything she stands against.

But Craig herself is entangled in the artifice of television, even as she rails against it. While covering Central American insurgents preparing to engage in combat, she berates a network cameraman for asking them to lace up their boots for the camera. "We are not here to stage the news," she admonishes. As the camera crew stands poised for the shot, one of the soldiers momentarily stops lacing his boots. "You do whatever you want," Craig sternly instructs him. "You are free to choose for yourself." Perplexed, he shrugs and continues to lace his boots. The "authenticity" of the moment vindicated, the cameras roll.

For all her unwitting accommodation to the artifice of her profession, Craig still clings to the scarcely credible distinction between news and entertainment. The dramatic turning point in the movie is when Craig discovers that Grunick faked a tear in an emotional report that won high praise at the network. Outraged that her reporter friend was "acting," she breaks off her budding romance with him. "I know you acted your reaction to the interview. It made me ill. . . . It's amazing. You commit this amazing breach of ethics and you act like it's nothing."

Jane's romance with Tom is over, but not their professional partnership. Some years later, she agrees to be his managing editor when he is named anchorman of the evening news. Unlike earlier films that rail against the pose, the deceit, and the emptiness of television imagery, *Broadcast News* casts the poser (anchorman Grunick) as a winsome character, appealingly self-effacing. An anchorman for the age of Ronald Reagan, he is hollow but decent, comfortable with the artifice that surrounds him.

By the 1990s, movies such as *Bob Roberts* (1992), *Wag the Dog* (1997), *Bulworth* (1998), and *Primary Colors* (1998) exposed the machinations of politicians and the blurred line between politics, news, and entertainment with a sharper, often satirical edge. As an investigative reporter declares in *Bob Roberts* (directed by and starring Tim Robbins), "There are no Mr. Smiths in Washington. Mr. Smith has been bought." In *Wag the Dog* (directed by Barry Levinson), a president running for reelection hires a media adviser who fabricates a war in order to distract the public from a sexual scandal involving the president that breaks two weeks before the election. When the president's media advisor, Conrad Brean (Robert De Niro), first goes to Hollywood producer Stanley Motss (Dustin Hoffman) to help him stage a trumped up, fictional war with Albania, the producer asks: "I'm in show business. Yes? Why come to me?" Without missing a beat, the media adviser reminds the producer of the power of slogans and pictures: "You remember the picture fifty years from now, you've forgotten the war. . . . War is show business, Mr. Motss. That's why we're here." Sure enough, the deception works. The opposition candidate tries to expose the artifice, to no avail. Television news stations are more interested in ratings than investigative reporting. The president's media adviser is even able to convince the CIA to go along with the fabrication.

Political idealism is compromised by the media manipulations of modern campaigns in *Primary Colors* (directed by Mike Nichols and based on Joe Klein's best-selling novel) a story about a southern Democratic governor (loosely based on Bill Clinton) running for president in 1996. Two of the main characters are deputy campaign manager Henry Burton (Adrian Lester) and savvy, wisecracking troubleshooter Libby Holden (Kathy Bates). Both believe in the political vision of Jack Stanton (John Travolta), but Stanton turns out to have many flaws, including reckless sexual infidelities and the willingness to use information about a rival's private life to ruin him. The satire and humor of the film turns bleak when Libby Holden commits suicide after becoming disillusioned with Stanton's craven efforts to win. Before she kills herself, Libby threatens to expose Stanton: "I will

destroy this village in order to save it." Flawed though Stanton is, Libby is unable to follow through with her threat. As she confides to Henry shortly before her suicide, "I lived my life drawing light and warmth from them [Stanton and his politically pragmatic wife]. Without them, I'm bleak and cold and airless for eternity."

The loss of self is a theme, or at least an intimation, that has haunted the image-conscious turn of art, photography, film, and television in the last quarter-century. In different ways, each of these media challenged the distinction between the event and the image, between the person and the pose. But what began as an impulse to unmask artifice, to expose the image makers, to deconstruct conventions that wrongly claimed the authority of nature, may have ended by denying the possibility of a self that is more than the poses it strikes or the roles it plays. As Andy Warhol ironically remarked, "If you want to know all about Andy Warhol, just look at the surface of my paintings and films . . . and there I am. There's nothing behind it."[30]

Andrew Niccol's *S1m0ne* (2002) updates Warhol with a digital-era version of the Pygmalion story. The lead character, a movie director named Viktor Taransky (played by Al Pacino) decides to create a beautiful movie star digitally and pass her off as real. "A star is digitized," Taransky gleefully proclaims. "You know what this means, we have stepped into a new dimension. Our ability to manufacture fraud now exceeds our ability to detect it."

Sitting at a high-tech computer panel developed by a computer whiz, Taransky is a master of manipulation. As Taransky starts formulating the face of his picture-perfect star, she says at one point with a flat tone: "I am the death of the real." Taransky has more tinkering to do before he gets her voice and looks to his liking. He punches in a blend of famous American actresses—a little Meryl Streep, some Lauren Bacall, and then Audrey Hepburn. When he gets Simone to speak in Audrey Hepburn's voice, Taransky exclaims with delight, "Perfect, Simone, perfect!"

Since Taransky has entirely fabricated his star, he must use every trick in a publicist's book to keep her at a distance from the public. He does all Simone's interviews through video conferencing and creates the mystique of a warm but reclusive star. In one

of his more grandiose moments, Taransky has Simone tell an interviewer: "I'm considering a career in politics." Sometimes Taransky speaks to Simone as if she were real: "I'm so relaxed around you. I'm so myself." Mostly he works overtime to rationalize the deception he has perpetrated on the public: "What's real anymore?" he muses in one of his many "dialogues" with Simone. "Most actors these days have digital work done to them. It's a gray area. The only real truth is the work. I'm going to tell the truth about you after your next picture."

Taransky solves the dilemma of his deception by faking the death of Simone and burying her in a fake funeral. His crazy machinations draw a police investigation, but when the police arrive at the funeral and open the casket, they find only a cardboard figure. Taransky, accused of murder, has a lot of explaining to do, but manages to get out of the fix. When he is reunited with his family at the film's end, one of his kids articulates the movie's tongue-in-cheek morality tale: "We're fine with fake as long as you don't lie about it."

*The Truman Show* (1998), directed by Peter Weir and written by Andrew Niccol, explores how far fakery can go under the guise of presenting reality. With wit, humor, and satire the movie presents a prescient critique of the current craze for reality television shows by taking their aspirations to the farthest extreme. An entire world is created within a giant, domed television studio. Everything is fake: a fake town, Seahaven; fake nature—the sun, moon, rain, and stars can be summoned at will; and fake people—the entire town is populated by actors. All of this is for the sake of producing a popular reality television program, *The Truman Show*, which airs live, worldwide, twenty-four hours a day, seven days a week without commercial interruption (the staggering revenues from the show are generated by product placement). The only person innocent of the camera's eye is the show's star, Truman Burbank (Jim Carrey). Truman has no idea that his life is a television show and that his every movement is recorded by some 5,000 hidden television cameras and watched by more than a billion viewers.

The dramatic tension in the movie revolves around Truman's attempts to break through to reality. The movie opens with the director and actors firmly in control. In interview snippets they speak in a glib, self-assured patter about how they are bringing their audience something really "real" despite the elaborate fabrications. "While the world he inhabits is in some respects counterfeit, there's nothing fake about Truman himself," proclaims the show's director, Christof (Ed Harris). The actress who plays Truman's wife Meryl Burbank (Laura Linney), sits confidently on a balcony in a 1950s-style dress, and tells the television audience: "You know for me there is no difference between a private life and a public life. My life is my life on *The Truman Show*." The actor playing Truman's best friend Marlon (Noah Emmerich), observes, "It's all true, it's all real. . . . Nothing you see on the show is fake. It's merely controlled."

For all the talk about control, for all the careful choreography that makes Truman's life one extended photo op, the fabrications begin to fall apart, and Truman, who has lived for thirty years on a television set, begins to see that his normal life is not so normal. First a klieg light mysteriously falls from the "sky" as Truman greets neighbors on the street. Later, as Truman sits alone on the beach, a chute of rain falls on his head, but nowhere else. The actor who played Truman's father (supposedly dead from a drowning accident in Truman's youth) breaks onto the set dressed as a street person, and Truman calls out plaintively, "Dad?" The show thwarts Truman's effort to pursue his father by choreographing the traffic and the extras so that the rogue actor is whisked onto a bus. Earlier, the show concocted a drama to convince Truman that the actress who played his college girlfriend, Lauren, was schizophrenic when she tried to warn him: "They're pretending, Truman. Do you understand? . . . This is fake. It's all for you . . . it's a show." The turning point comes when Truman rushes into a building, pushes the elevator button, and discovers startled members of the production crew eating their lunch.

The facade finally exposed, Truman begins to work his way back to reality—no easy task when everyone in his life is an actor

who lies to keep the illusion going. Truman has little patience for his wife, whose dialogue is heavily laced with product promotions and who plays her role like a 1950s sitcom mom, a June Cleaver on amphetamines. The person he most trusts is his best friend Marlon, who he believes is the one anchor in a universe of deceptions. In a moving scene, Marlon sits alone with Truman on a pier as Truman confides that everyone is faking it. Marlon reassures Truman: "The last thing I would ever do is lie to you. Think about it, Truman, if everybody is in on it, I'd be in on it too." Meantime, the intimacy is betrayed as every line Marlon utters is being fed to him by the director, Christof, through a concealed earpiece.

Throughout the movie the hubris of Christof, the image creator, is contrasted with the humor and ingenuity of his creation, Truman. Carrey plays Truman with just the right blend of antic humor and authenticity. He captures the upbeat breezy TV talk that Truman speaks. Having been born on TV, he knows no other language. Truman's perpetually happy face and amiable demeanor also reflect his identity as a 1950s-style sitcom character. But Carrey never lets us forget that Truman is a person fighting his way out of a facade.

In a bid to break free from his scripted life, Truman dreams of going to Fiji, where he believes Lauren lives. Although the show enlists a full team of actors to keep him within the boundaries of Seahaven with one subterfuge after another, Truman finally outwits the cameras and one night slips from view. The television transmission is cut for the first time in the show's thirty-year history. The moon is turned into a searchlight, and cast and crew walk through Seahaven with locked arms searching for Truman.

Frustrated by the futile search, yet still master of his universe, Christof orders the technicians to "Cue the Sun." When he discovers Truman sailing a boat on the harbor (and thus overcoming the fear of water the show had instilled in him), Christof orders the television transmission resumed. Then like a mad Prospero of the digital age, Christof orders a violent storm to pummel Truman's boat in order to heighten the drama for the television audience. In horror, one of his assistants exclaims, "For God sakes,

Christof. The whole world is watching. We can't let him die in front of a live audience." As Truman is near death from drowning, Christof relents and calms the sea.

The final showdown comes when Truman's sailboat crashes into the facade of the set. At first Truman beats his fists in agony against the painted sky, but then his spunk returns and he ascends the steps along the outermost wall of the set. In close-up we see Christof looking at Truman's image on his laptop computer. Truman stands outside against the light of the fabricated sky. With the artifice exposed, Christof and Truman have their first conversation. At this moment, the movie displays the polarities of the photo-op culture: the man behind the camera who thinks that because he is taking the picture, he owns and controls the subject, and the subject who finally asserts a will and life of his own:

> CHRISTOF: You can speak. I can hear you.
> TRUMAN: Who are you?
> CHRISTOF: I am the creator of a television show . . .
> TRUMAN: Then who am I?
> CHRISTOF: You're the star.
> TRUMAN: Was nothing real?
> CHRISTOF: You were real. That's what's made you so good to watch. Listen, Truman. There is no more truth out there than there is in the world I created for you . . . the same lies, the same deceit, but in my world you have nothing to fear. I know you better than you know yourself.
> TRUMAN: You never had a camera in my head.
> CHRISTOF: You're afraid. That's why you can't leave. It's okay, Truman. I understand.

Like a proud father, Christof reminisces about all the moments he witnessed as Truman grew up. Swept up in his sentimental musings, he suddenly realizes that Truman is not responding. Furious, he blurts out: "Well say something, God damn it. You're on television. You're live to the whole world." After a long pause, Truman responds with a favorite line from his former happy patter: "Good Afternoon. Good Evening. And Good Night." This time the line signals his liberation. He takes a bow, opens the

stage door and disappears from the set. The television audience goes wild and cheers.

The movie's satire, however, does not let the television audience off the hook. They too are complicit in the charade. They know the show is fake, but they cannot resist watching (and the movie includes many humorous snippets of their reactions). For the audience of *The Truman Show*, it's enough that it looks and feels real. In a final satirical jab at the television audience, the movie ends with a shot of two security guards, who as fans of Truman are momentarily at a loss when static fills the screen and the show's transmission ends. "What else is on?" one asks the other. "Where's the *TV Guide*?"

In *Lost in Translation* (2003), director Sophia Coppola explores the line between the fake and the real, the person and the pose, with an observant eye. The story chronicles a romantic encounter between a fading, middle-aged action hero from the movies, Bob Harris (Bill Murray), and Charlotte (Scarlett Johansson), the young wife of a twenty-something, self-centered celebrity photographer. The setting is Tokyo, Japan, where Harris has come to shoot a commercial for Suntory whiskey. Coppola makes the city, with its media-saturated landscape, an actor in its own right in the film. In the opening sequence, the camera picks up the pulse of Tokyo as it cuts back and forth from the flashing neon lights, the ads, the looming buildings, the rush of cars, to Harris, blurry-eyed from jet lag, staring out of the window as the city scrolls by. With a world-weary look, he catches sight of himself posing for a Suntory whiskey ad on a giant billboard.

Harris cannot escape the pose, the feeling that he is living within someone else's picture, no matter where he turns. As he sits at the hotel bar and tries to blend into the background, two American businessmen observe him from a distance. "You see that guy? You know who that is?" one asks the other. "It looks like him, but it's not him," his friend responds. The men go over to banter with Harris, but, like typical fans, they can barely distinguish the man from the movie star.

In a world where nothing seems quite real, Bob and Charlotte search for real intimacy and find it amid the bright fabrications

of karaoke bars and video arcades, camera flashbulbs and fawning fans, and the postmodern pastiche of the city streets. Like the movie classic *A Brief Encounter*, their romance is never consummated, but Coppola, with the able talents of Bill Murray, interjects a lot of deadpan humor to punctuate the poignancy. Nowhere is this humor more evident than in the shooting sequences for the Suntory commercials. Harris has to sit in a chair, act the sophisticate, and hold up a glass of Suntory whiskey. The Japanese director and photographer can barely speak English, and toss out a shifting set of cues—"passionate," "like an old friend," "mysterious face," "more tension"—punctuated by a litany of references to American pop icons, whose personas Harris is asked to inhabit—Humphrey Bogart, Frank Sinatra, Roger Moore—but whose names the Japanese keep mispronouncing.

The camera keeps clicking; Harris keeps posing, but he keeps his distance through his droll repartees. When the photographer says "007," Harris responds dryly, "He drinks martinis, but okay." For Harris, a man caught in the photo op, irony is the only way he can reclaim his identity. His position is not unlike the one television networks and newspapers face. If you must report on the photo op, at least come back with an ironic rejoinder. It's never a complete liberation, either for the journalists or for the movie's hero. Harris mocks his own image, but never lifts himself into a new life. After a gallant parting with Charlotte at the film's end, he is reabsorbed in the media landscape as he walks back into the mass of people and neon lights of the Tokyo streets.

For all its prominence in the photo-op culture, the fabricated self is not the only way we see ourselves. Tempted as we are to equate the person with the pose, we still believe in the power of pictures to capture the essence of an individual. This belief goes back to photography's traditional aim of revealing the inner truth of its subject, the "spirit of fact" that transcends appearance. It recalls the insistence of Marcus Aurelius Root, the first photographic historian, that a portrait must "show the soul of the original—the individuality of selfhood which differentiates him from all beings, past, present or future."[31]

Closely related to the "spirit of fact" of the traditional da-
guerreotype is the notion of persons as embodiments of larger
meanings and high ideals. The daguerreotypist Mathew Brady
had this in mind when in the 1840s he undertook a "Gallery of
Illustrious Americans." The public figures in his portrait gallery
would give expression to a distinctly American identity that cele-
brated both individuality and national purpose. This idealized,
ennobling vision of the American self was carried into the twenti-
eth century in the urban and industrial images of Jacob Riis and
Lewis Hine, and in the portraits of dignity amid depression by
Dorothea Lange and Walker Evans.

This vision persisted in popular movies. Heroic figures, from
Gary Cooper in *High Noon* to Sylvester Stallone in *Rocky* to Tom
Hanks in *Saving Private Ryan*, assert their individuality even as
they vindicate ideals larger than themselves. The heroes of Ameri-
can movies from the 1940s to the present stand in sharp contrast
to the disempowered, centerless selves represented elsewhere in
the culture. Confronted with corrupt institutions; bumbling bu-
reaucracies; or vast, impersonal structures of power, they launch
out on their own, empowered despite their circumstances.

This cultural counterpoint provides the setting for contempo-
rary political discourse. Ronald Reagan drew readily from the he-
roic images of the movies, as when he borrowed Spencer Tracy's
line from *State of the Union* to great effect during a debate in the
1980 New Hampshire primary: "I paid for this microphone,
Mr. Green!" For his part, George W. Bush tried to identify
himself with the maverick heroes of the movies in his "Mission
Accomplished" moment and in his continued stalwart defense of
the Iraq War.

The persistence of the heroic image of the American self
helps us understand the limits of photo-op coverage as a mode
of political critique. When Ronald Reagan stood on the bluff
of a Normandy beach and recalled the heroic sacrifice of the
"boys of Pointe du Hoc," it was artifice of the highest order, a
carefully staged media event in which the president's practiced
voice cracked with emotion at just the right moment. Yet no
amount of attention to these facts could dissolve the power of the

image. The reason is not simply that pictures overpower words. Reagan's words, after all, were a crucial part of the drama he created. The image resisted deconstruction because the pictures and the words taken together—for all their staging, for all their politically motivated design—spoke to something potent in American culture, a heroic ideal that is celebrated time and again in American movies.

CHAPTER 5

# Mythic Pictures and Movie Heroes

By most accounts, 1968 was a year of unraveling certitude and faith. Thousands of American soldiers had been killed or wounded in Vietnam. Thousands more returned home to a nation that did not recognize them as heroes. The Tet Offensive gave the lie to the government's confident promise of victory against the North Vietnamese. Eugene McCarthy scored a stunning victory against Lyndon Johnson in the New Hampshire primary, prompting the incumbent president to withdraw from the race. Not only liberal politicians but even Walter Cronkite also came out against the war. Along with the assassinations of Robert Kennedy and Martin Luther King Jr., and the riots in the inner cities, these tumultuous events called into question America's self-image as master of its destiny and force for good in the world. It was as if American life was finally playing out, in terms too obvious to deny, the dissonant, disempowered self-image that art photographers of the 1960s had already glimpsed.

Even as events seemed to conspire against the traditional image of American mastery and virtue, Americans flocked to see *The Green Berets* (1968, directed by John Wayne and Ray Kellogg), with its patriotic theme song: "Fighting soldiers from the sky, fearless men who jump and die. / Men who mean just what they say, the brave men of the Green Berets." In 1968, the movie was a top-ten box-office hit. The popularity of the movie at a time of turmoil and doubt might be explained in a number of ways. Perhaps some, such as those Richard Nixon called "the silent majority," liked the movie because they supported the war and approved of the movie's message. Others may simply have enjoyed

the movie as entertainment. But the appeal of popular movies is not limited to the ideologies they convey or the entertainment they provide.

Popular movies derive their appeal by engaging us in familiar narratives. For all the different stories they tell, they often reiterate certain myths and ideals that resonate with our collective self-understanding. What Erik Erikson observed about the enduring power of myth holds true for the myths that American popular movies convey: "It is useless to try to show that it has no basis in fact, or to claim it is fiction, and in fact nonsense. A myth blends historical fact and fiction in such a way that it 'rings true' to an era."[1]

As bearers of mythic pictures, American popular movies display a stance toward images that is different from that found in other realms of our culture. The image-conscious sensibility, so pronounced in art photography, television news coverage, and even photojournalism takes a different form in popular film. While movies from *A Face in the Crowd* (1957) to *Network* (1976) to *The Truman Show* (1998) have addressed issues of image creation and image manipulation in modern society, most popular movies do not seek to unravel or expose the myths that pictures convey. Unlike image-conscious photography and television news coverage, which focus attention on the image as a way of puncturing the picture and dissolving its hold on us, most popular movies invite us to believe in the pictures we see. They ask us to enter the imaginary worlds they present, to be moved and engaged by them.[2]

One of the most potent mythic images that American movies carry is the maverick hero, a self-reliant individual who does things his own way, often outside established institutions, but who triumphs in the end, vindicating noble ideals. The maverick hero has a long history in the American imagination, reaching back to Natty Bumppo, the frontier hero of James Fenimore Cooper's early nineteenth-century novels, and finding classic expression in the cowboy heroes of western novels and movies of the first half of the twentieth century. In popular movies from the 1960s to the present, the maverick hero has assumed new

forms. In contrast to the disempowered, centerless self that modern fiction, art photography, and some movies represent, the maverick hero persists as a free and active agent, capable of exercising mastery even in the face of circumstances that seem to defy human control.

From frontiersmen to cowboys, soldiers to policemen, ordinary citizens to comic-book heroes of superhuman powers, American mavericks display several characteristic qualities. First, they typically prove their strength through one-on-one combat with their adversaries, most often in fistfights or shoot-outs. Drawing on his own strength and wits, the hero defeats the villain without depending on institutional support or technological advantages. Second, the maverick neither hungers for battle nor aspires to power. He is drawn into service reluctantly, and when his mission is done, he leaves the scene.[3] Finally, despite his fierce individualism, the maverick acts not for himself but on behalf of a community worthy of his efforts. He is at once an insider and an outsider—an insider in that he shares the highest ideals of the nation or community he serves; an outsider in that he is no organization man. He typically distrusts or disdains the officials with whom he must deal; more often than not, the institutions and organizations he encounters either corrupt the ideals he seeks to vindicate or simply get in his way.

This insider-outsider quality made it easy to adapt the archetype of the maverick hero to a period of deep disenchantment with American politics and institutions. In the wake of the Vietnam War and Watergate, for example, popular movies often presented a dark vision of big business, the military, and government bureaucracies. As Americans began increasingly to fear that vast structures of power defied individual control, the movies portrayed powerful corporations ruthlessly pursuing profits, security agencies abusing power in the name of questionable goals, law enforcement agencies engaging in corruption, foreign nations victimizing Americans, and supernatural forces exercising mysterious control over individuals.

The maverick hero could survive this loss of faith in institutions because he was not fully identified with institutions in the

first place. His identity depended instead on a mythic marginality. As an insider-outsider, he had always vindicated American ideals while rebelling against institutional constraints. The modern maverick hero was not vulnerable to the erosion of institutional authority; as a self-reliant individual, he always stood apart from the institutions he served.

John Wayne's Colonel Kirby, the hero of *The Green Berets*, is one in a long line of maverick heroes, a soldier with the soul of a cowboy. Over the Green Beret camp in the jungles of Vietnam hangs the sign, "Dodge City." When a skeptical newspaper reporter confronts Kirby about the brutal way Americans interrogate the enemy, he retorts cowboy style: "Out there, due process is a bullet." Kirby is tough but kind, strong but sentimental. Like the classic cowboy, he defends a community too weak to defend itself. In the last scene of the movie, Kirby places a Green Beret's cap on the head of an orphaned Vietnamese boy, telling him, "You're what this is all about."

None of the Vietnam movies to follow played out the theme of the maverick hero with full confidence in the goodness of the fight. In *The Deer Hunter* (1978), *Apocalypse Now* (1979), and *Platoon* (1986), no hero would enjoy the moral certitude of Wayne's Colonel Kirby or emerge unscarred by the war.

At the same time, the image of the noble cowboy gave way to morally ambiguous variations. In the American westerns of the late 1960s, the heroes were motivated more by money or adventure than by high ideals.[4] A year after *The Green Berets*, John Wayne played against type as the crude, drunken, one-eyed marshal Rooster Cogburn in the box-office hit, *True Grit* (1969). The dark side of the cowboy myth was painfully revealed in another big movie of 1969, *Midnight Cowboy* (directed by John Schlesinger). Early in the movie, the hero, Joe Buck (Jon Voight), sings a cowboy song in the shower. He hopes to find his fortune by dressing up as a cowboy and becoming a hustler, catering to rich women in New York City. But his naive faith in the allure of the cowboy image brings him only poverty and failure. His seedy sidekick (Dustin Hoffman) tells him that even in the hustler's world, "no one wants that cowboy crap." As the failed hustler

wanders the streets of Manhattan, he is surrounded by billboards displaying Madison Avenue's images of the good life, images that serve as ironic commentary on Joe's inability to live the myth.

The empty drive-in movie theater that opens the movie, and the bleak figure of the failed hero adrift in the urban landscape, evoke the photography of Robert Frank, Lee Friedlander, and Garry Winogrand. But even as the image consciousness of the art photography of the 1960s and 1970s reverberated in movies like *Midnight Cowboy*, the maverick hero did not die. Although westerns waned in popularity and Vietnam War movies became filled with painful ambiguities, the American maverick survived by adapting to changed social circumstances. In order to see how the maverick hero survived the coming of a new, more iconoclastic age of image making, it is important to establish the archetypes from which he is derived: the cowboy heroes of *Shane* (1953) and *High Noon* (1952), the citizen hero of Frank Capra's *Mr. Smith Goes to Washington* (1939), and the urban maverick represented by Humphrey Bogart in *Casablanca* (1942).

## Classic Maverick Heroes

The movie western goes back to the days of silent films, but finds its fullest expression in two classics of the 1950s, *Shane* (1953, directed by George Stevens), and *High Noon* (1952, directed by Fred Zinnemann).

*Shane* is a Technicolor fable of fast action and moral certitudes. The hero, Shane (Alan Ladd), embodies the paradoxes and the triumphs of the maverick hero. He is a loner whose origins and full name are never revealed, yet his sense of selfhood and moral bearings are secure. He moves from place to place, the very embodiment of the rugged individualist of the frontier, yet assumes the identity of a homesteader in order to defend a community of farmers against a ruthless cattle baron. He is a gunfighter who can triumph in a lawless world, but who fights for a society of law and order.

Within the parable of the western, the hero is a man with sure moral bearings who plays the role of the enforcer only in the absence of law enforcement. Shane enters the lives of a homesteader family, Joe Starrett (Van Heflin), his wife Marian (Jean Arthur), and their son Joey (Brandon De Wilde), asking only for permission to cross their property and to stop for water. But he soon becomes involved in their conflict with the villains, a powerful cattle rancher named Ryker (Emile Meyer) and his gang.

The selfish individualism of Ryker, who exploits both the land and its people, is contrasted with the selfless individualism of Shane. "What are you looking for?" Ryker asks Shane after failing to win him over to his side with a job offer. "Nothing," replies Shane. The laconic hero never articulates his principles but acts to defend justice in a world without legal institutions. He takes up his gun only to defend those too weak to defend themselves. "A gun is a tool," he tells Marian Starrett. "No better, no worse than any other tool, an axe, a shovel, or anything. A gun is as good or bad as the man using it."

The later part of the movie illustrates just this point. Shane refuses to let the family man, Starrett, sacrifice himself in a fight against Wilson (Jack Palance), Ryker's hired gun. He knocks out his friend and goes into town alone to confront and kill the gunfighter. Once this deed is done, the hero reinforces Marian Starrett's view that guns don't belong in the community. He tells young Joey Starrett that now that the gunfighter has been defeated, "I've got to be going on." "Why, Shane?" asks Joey. The reply is classic maverick, bringing to closure a moral parable that seamlessly reconciles self-reliance and community obligation. "A man has to be what he is. You can't break the law. I tried it and it didn't work for me. . . . There's no living with a killing. . . . Right or wrong, it's a brand. . . . Now you run home to your mother and tell her everything is all right. There ain't any more guns in the valley."

In contrast to the bright tones of *Shane*, *High Noon* is a prelude to the morally ambiguous world that many modern heroes occupy. Although the movie celebrates self-reliance and individual agency, the film has the dissonant feel of a Robert Frank photo-

graph. The world that should look bright is murky; the central figure in the story—Gary Cooper's sheriff, Will Kane—is not securely situated, but distanced from the community.

Unlike the outsider Shane, the hero of *High Noon* begins as the insider who wants to move out, the sheriff who "cleaned up" the town and now wants to retire, marry, and settle down in a new community. Although Kane does not begin as a loner, circumstances soon force him to become one. As he prepares to leave town with his bride, Amy Fowler (Grace Kelly), he learns that Frank Miller, the feared gunfighter whom he sent to prison for murder, has been released and is returning on the noon train to kill him. Three members of Miller's old gang have already arrived in town to help their old boss get his revenge.

Like Shane, Kane is a reluctant hero. He does not look for trouble, but he stands firm in the face of it. Kane's friends urge him to leave town with Amy as planned. At first Kane agrees, but out on the prairie he stops and turns the buggy back to town. "It's no good. I've got to go back," he tells his puzzled wife. "They're making me run. I never run from anybody before." Back in town Amy urges her husband, "Don't be a hero. You don't have to be a hero—not for me." But Kane loses his temper. "I'm not trying to be a hero. If you think I like this, you're crazy. . . . This is my town. I've got friends here. I'll swear in a bunch of special deputies. With a posse behind, maybe there won't be any trouble."

Unlike the homesteaders in *Shane*, who are virtuous but weak compared to the powerful rancher, the townspeople of *High Noon* lack moral fortitude. As the clock ticks down dramatically to high noon, the townspeople desert Kane one by one, offering one excuse after another. Finally, as the noon train arrives, even Amy rides out of town, because she is a Quaker and cannot condone violence. But Kane does not leave. Like Shane, he is willing to stand alone and fight for what he believes.

In *Shane* the mythic individualism of the hero is magnified by the western landscape, but in *High Noon* the hero is isolated in the enclosed world of the small town. Yet, he becomes a looming presence in the stark landscape, the embodiment of individual agency in a fallen world. In the dramatic climax of *High Noon*,

Kane defeats the villains in a protracted gunfight, aided at the last moment by his wife Amy, who breaks with her Quaker teachings and returns to take up a gun by her husband's side.

After Kane and Amy defeat the villains, the townspeople emerge from their hiding places and gather around the couple. In one of the most memorable scenes in American movies, Kane pulls off his badge and throws it down in the dust. Without speaking to anyone, he gets in a buggy with his bride and rides out of town. He shows disdain for the cowardice of his community, but he has fulfilled his obligations to them and to himself. *High Noon* is a variant of the parable of *Shane*: self-reliance is distinguished from pure self-interest. It is ennobled by a higher calling to defend the rights of the individual and the community, even when the community is weak and wayward.

In contrast to the classic cowboys, the citizen heroes of Frank Capra's movies of the 1930s and 1940s are typically rooted in their communities but cast in conflict with the corrupt forces of the modern world. Although we often associate Capra with an idealistic vision of American institutions, his movies actually combine a deep cynicism about politics and big institutions with a redemptive vision of the citizen hero. In Capra's movies, the villains are greedy capitalists, corrupt politicians, and power-hungry newspaper moguls. In relation to the powers that be, the citizen hero is a virtuous outsider. He seeks neither fame nor glory, but he is called by circumstance to assume civic responsibilities and reaffirm democratic ideals.

In *Mr. Smith Goes to Washington* (1939), Jefferson Smith (James Stewart), the popular head of a boys' club, is appointed by the governor to a vacant Senate seat. The party bosses figure that an idealistic "young patriot" who "recites Lincoln and Jefferson" will be the perfect cover for the special-interest land deal they hope to enact. They assume that young Smith is too naive to thwart their plans. At a banquet given to celebrate Smith's departure for Washington, the astonished hero exclaims, "I can't help feeling there's a mistake somehow."

Like the cowboy heroes, Smith is called to a mission he does not seek. At first, those who should be his supporters doubt him.

Smith's savvy, world-weary secretary Clarissa Saunders (Jean Arthur), mocks him behind his back, calling him "Daniel Boone," "Honest Abe," and "Don Quixote Smith." Yet, Smith proves that his patriotism is genuine, and that he has the strength and conviction to take on the Washington establishment. Taunted by reporters who claim that he is not a real senator but "an honorary stooge," Smith resolves to prove his mettle and proposes legislation to establish a national boys' camp to be funded by small contributions from individuals.

By sheer coincidence, the site of the proposed camp is the exact location coveted by the party bosses for their real-estate scheme. When the bosses fail to dissuade Smith from pursuing his proposal, they try viciously to destroy his reputation. They enlist Joe Paine (Claude Rains), the senior senator from Smith's state, to accuse Smith falsely of trying to profit from the land the boys' camp would occupy. The party machine assembles a host of false witnesses and forged documents to incriminate him. Smith's fellow citizens, believing the charges, turn against him. Even the admiring boys from his club lose faith in their fallen leader. In despair, Smith packs his bags and decides to leave Washington.

This dark vision of Washington corruption is juxtaposed with Capra's mythic vision of the city, seen in his heroic shots of the monuments and buildings that both inspire Smith and provide the setting for his ultimate triumph. Saunders finds the defeated Smith sitting beneath the Lincoln Memorial. Once cynical, she has grown to love and respect Smith. She inspires him to stand up for his ideals and fight the political machine. "You didn't just have faith in Paine," she tells Smith. "You had faith in something bigger than that."

Once fortified, Smith returns to take on the establishment. Coached by Saunders, he uses Senate procedures to gain access to the floor. In plain and honest language, he exposes the corruption, graft, and deceit. Holding the Senate floor in an arduous but earnest filibuster, Smith reads from the Declaration of Independence and the Constitution. The national press that once ridiculed him now lauds him as a citizen hero. CBS Radio reports that the gallery is packed with people who have "come to see what

they couldn't see at home, democracy in action." The people of Smith's state rally to him. The boys at the club print and distribute their own small newspaper to counter the lies the party bosses have printed in the newspapers they control throughout the state.

Smith's status as insider and outsider is now fully played out. He stands alone inside the Senate chambers and affirms American ideals, yet he speaks as the loyal outsider, the man who refuses politics as usual. Smith is vindicated in the end by the man who betrayed him, his mentor, Senator Paine. The consummate insider is finally moved by the moral suasion of the civic hero. Paine dramatically vindicates Smith before the assembled Senate. The movie ends to the strains of "My Country 'tis of Thee."

Capra's openhearted idealists represent one side of the American archetype of the citizen hero. Humphrey Bogart's Rick Blaine in *Casablanca* (1942, directed by Michael Curtiz) represents another. Rick is a sophisticated urban hero without the innocence or naïveté of the classic western maverick or Capra's common man. He is the insider-outsider who makes a virtue of his marginality. Although he poses as a cynic, he is an idealist at heart. He feigns indifference to politics, yet fights for noble political causes. He appears selfish, but like Capra's heroes and the classic cowboys, acts selflessly to affirm social ideals.

Bogart's Rick has a hold on the popular imagination that goes beyond the film's engaging plot. He is the most stylized and modern of all the heroes, a consummate performer who never loses himself in his role. He cultivates his identity as a marginal man as a way of exerting his agency in an uncertain world. Unlike the cowboy, who scarcely speaks at all, and unlike Capra's plainspoken idealists, Rick's mastery of the situation is defined in good part by his memorable repartees: "And what in heaven's name brought you to Casablanca?" asks his friendly rival, the Vichy police Captain Renault (Claude Rains). "My health," Rick coolly replies. "I came to Casablanca for the waters." "What waters?" Renault replies. "We're in the desert." Rick responds with deadpan irony, "I was misinformed."

Part of the enduring appeal of *Casablanca* is its artful blending of sophistication and sentimentality, of self-distance and ardent

passion, of modernism with classic American mythology. At his nightclub, Rick's Café Américain, the hero creates a modern American identity in which style and panache are the defining qualities of selfhood. Yet, from the beginning of the film, Rick's café is situated within a larger mythic landscape. Casablanca is the last stop on the refugees' path to "the new world," "the freedom of the Americas." Through the interventions of the hero, Rick's café becomes the portal to a new life.

While Rick cultivates the stance of the neutral onlooker and political cynic, he is actually a highly principled man. "I suspect underneath that cynical shell, you're at heart a sentimentalist," Renault tells Rick. "Oh, laugh at it if you will, but I am familiar with your record." Renault then recites how Rick fought with the Spanish Loyalists and ran guns to Ethiopia. Although his credentials as a hero are impressive, Rick keeps them hidden. "The problems of the world are not my department," he tells the famous resistance fighter, Victor Laszlo (Paul Henreid), when Laszlo seeks his help in leaving Casablanca. Laszlo responds by evoking Rick's record, "Isn't it strange that you always happen to fight on the side of the underdog?"

Rick's nobility, hidden beneath a cynical exterior, is one of the defining characteristics of the urban maverick. He looks after his own staff, helps a young woman's husband win at gambling so that she will not have to compromise herself with Renault to get exit papers, and in the end makes the ultimate sacrifice by giving up the woman he loves in order to aid the cause of the resistance. "I'm no good at being noble," he tells Ilsa Lund (Ingrid Bergman). "But it doesn't take much to see that the problems of three little people don't amount to a hill of beans in this crazy world. Someday you'll understand that." The last shot of the movie shows Rick walking off with Captain Renault into the fog of the small Casablanca airport, after the plane carrying Ilsa and Laszlo to freedom has departed.

The classic American heroes did not die out in the 1940s and 1950s, but lived on in a world less innocent and credulous than the world of their origin. Even in today's photo-op culture accustomed to irony, deconstructing myths, and unraveling rituals,

Americans still are moved and engaged by the movies of the past. More than this, the heroic archetypes those movies defined are continually recreated in the movies and find their way, in new forms, into our cultural and political imagination. Politicians and presidential candidates campaign with movie stars, and some—like Ronald Reagan, Arnold Schwarzenegger, and Fred D. Thompson—come to politics via the movies and television. But it is not simply coming from the movies or quoting the movies—as George W. Bush did after September 11—that enhances the appeal of politicians.

Far more potent is when politicians cast themselves within familiar movie narratives—as mavericks against the establishment, as defenders of law and order, and as virtuous citizens who will redeem American ideals. To the degree that politicians can successfully inhabit these roles, identification with a heroic archetype can confer a certain immunity to political criticism and to attempts by the media to puncture their images.

Five such heroic archetypes—the cop, the soldier, the superhero, the action hero, and the citizen hero—provide cultural scripts that shed light on American political image making. The movies, after all, do not make up their heroes out of whole cloth. They draw from a cultural well that goes back to the Puritan faith in America as God's new Israel, the myth of the frontier, and the celebration of American individualism. Following these five heroic types is like following different threads in a cultural tapestry that is constantly being woven. The threads criss-cross and blend with one another. A cluster of symbols, themes, and values create a recurring patriotic tableau with the American flag an omnipresent icon.

## Law and Order: The Maverick Cop

By the 1970s, the lawless frontier had not disappeared but moved to the crime-ridden city, calling forth such gritty cop heroes as Clint Eastwood's Dirty Harry. Eastwood's maverick police detective, Harry Callahan, is at once an insider and an outsider. He

fights for law and order, but also has to fight his own boss, the bungling police department, the downtown bureaucrats, and the lawyers who care more about the rights of criminals than of their victims. He gets the criminals in the end by breaking with the bureaucrats and drawing on his own resources.

Like other movies featuring cops and criminals, the camera work in Eastwood's Dirty Harry movies conveys a sense of both enclosure and exposure to danger in the urban environment: snipers shoot victims from tall buildings, gunmen hold passengers hostage on subways, individuals are lost in crowds or cornered in alleyways. The individual is exposed and abstracted in a pattern of buildings, streets, and traffic. Yet, even in an urban landscape that becomes alien and hostile, the hero of the movie exerts his mastery.

The underlying paradox of the Dirty Harry movies is that in order to enforce the law, the hero has to break the rules. In the first movie of the series, *Dirty Harry* (Warner Brothers, 1971, directed by Don Siegel), the district attorney is more concerned with protecting the rights of a psychopathic killer than those of his victims, smugly reminding Harry, "It's the law." Harry angrily retorts, "Then the law is crazy." In spite of the obstacles presented by his own department, Harry, through a series of daring feats, captures the killer. But he is so frustrated with the incompetence of the law enforcement bureaucracy that at the end of the movie he throws away his badge in disgust, just as Gary Cooper's righteous sheriff did in *High Noon.*

But in the next Dirty Harry movie, *Magnum Force* (1973, directed by Ted Post), the hero is wearing the badge again. The criminal justice system has not changed, but Harry has resigned himself to working within it, though he still insists on doing it on his own terms. This time he fights against a secret vigilante group of police officers within his own department, which kills criminals who might elude arrest and punishment. As the plot unfolds, Harry and his partner attempt to identify the sources of the conspiracy. In the climactic scene, Harry discovers that his own lieutenant is a member of the vigilante organization and exclaims in dismay, "When police become our executioners, when

will it end?" Harry's boss cynically retorts, "You had your chance to join, but you preferred to stick with the system." In a line that defines the insider-outsider status of the maverick hero, Harry responds, "I hate the damn system, but until someone makes some good changes, I'll stick with it."

Still, Dirty Harry remains a maverick, disgusted by the failure of society to live by its ideals—ideals that he himself, though rough-hewn, hardened, and cynical, fights fiercely to defend. In *Sudden Impact* (1983, directed by Clint Eastwood), a beautiful woman artist (Sondra Locke) invites Harry to join her at an outdoor cafe. "What makes you think I'm a cop?" he asks. "I saw the commotion here the other day," she responds. "You're either a cop or public enemy number one." Harry answers, "Some people might say both."

> ARTIST: Really, who?
> HARRY: Oh, bozos with big brass nameplates on their desks and asses the shape of the seats of their chairs.
> ARTIST: Why?
> HARRY: Oh, it's a question of methods. Everybody wants results, but nobody wants to do what they have to do to get it done.
> ARTIST: And you do?
> HARRY: I do what I have to do.
> ARTIST: I'm glad, Callahan. But you know you're an endangered species. This is the age of lapsed responsibilities and defeated justice.

Like Harry Callahan, the self-reliant hero of *Die Hard* (Twentieth Century Fox, 1988, directed by John McTiernan) thrives on being the man on the margin, resisting conventions yet redeeming society. The main elements of the plot are classic western. The hero is an outsider who comes into town and discovers that the bad guys have taken over. Overcoming great odds, he defeats them single-handedly. Once the job is done, he moves on. But the old story is overlaid with the most modern trappings. Far from being the classic loner, the hero of *Die Hard*, John McClane (Bruce Willis), is a man beset by marital problems. He is a New

York City police detective who does not want to leave his job. His wife, Holly Gennaro (Bonnie Bedelia), has relocated to Los Angeles with their children to work as a high-powered executive at a Japanese-owned corporation. As the movie begins, McClane arrives in Los Angeles in hopes of saving their marriage.

But even on vacation he is ready for duty, his gun concealed in a shoulder holster underneath his casual clothes. It isn't long before he needs it. A heavily armed gang of international thieves breaks into the office party at his wife's corporation and takes everyone hostage. Alone and unseen, McClane reaches for his gun. The world has suddenly become uncivilized and brutal. Barefoot and in his undershirt, the maverick cop moves down the back stairs of the building.

The tension between the hero's role as insider and outsider becomes a central dramatic theme. McClane desperately tries to communicate with the outside world with a radiophone he has commandeered from the thieves, but he is foiled at every turn by the forces that are supposed to help him. Isolated inside the building, he cries, "Come on, come on. Where's the fucking cavalry?" But when the modern cavalry arrives they fall flat on their faces. The police, SWAT team, and FBI forge their plans by the book and only succeed in playing into the thieves' hands, further endangering the hostages.

Caught in the crossfire between criminals and cops, the maverick cop is forced to wage his battle alone. The criminals try to kill him. The cops ignore him and refuse his advice. The thieves have superior technology, but they too play by the book, methodically proceeding with their plans. This is just the opening the maverick hero needs, because he is not playing by anyone's rules. Like Dirty Harry, he does what he has to do, even if it violates police procedures: "You won't hurt me, because you're a policeman," a cornered machine-gun-toting thief challenges McClane. "There are rules for policemen." McClane wryly responds, "Oh, yeah. That's what my captain keeps telling me."

In an exchange over the radiophone, the hero serves warning to Hans Gruber (Alan Rickman), the cold-blooded head of the international band of thieves, that he has "waxed" one of his men,

and he will pursue the rest. But the arrogant foreigner has nothing but disdain for the hero and Americans in general:

> GRUBER: You know my name, but who are you? Just another American who saw too many movies as a child. Another orphan of a bankrupt culture who thinks he's John Wayne, Rambo, Marshal Dillon.
>
> McCLANE: I was always partial to Roy Rogers. Actually, I really liked those sequined shirts.
>
> GRUBER: Do you really think you have a chance against us, cowboy?
>
> McCLANE: Yippee Ki-Ay, motherfucker.

Unlike modern art photography or television news reporting, the self-conscious references to American movies are not a means of calling attention to the image as an image, but to the image as a myth with real import. McClane, after all, is the genuine article. He lives the myth and embodies the culture the thieves disdain. Like other cop movies, *Die Hard* contrasts the urbanity and sophistication of the criminals with the unadorned and simple lifestyle of the hero.

Just as Dirty Harry challenges a criminal holding a gun to a hostage's head with the deadpan remark, "Make my day," McClane asserts his control through a mastery of one-liners. Near the end of the movie, when the evil Gruber is about to kill McClane, Gruber again taunts him: "Well, this time John Wayne does not walk off into the sunset with Grace Kelly." McClane coolly corrects him, "It's Gary Cooper. Asshole." Before the beaten Gruber falls to his death, McClane bids him farewell with Roy Rogers's classic sign-off, "Happy trails."

In confronting the thieves, the maverick hero confronts the forces in modern society that keep the ordinary citizen, the little guy, down: privileged corporate types, criminals with their superior weapons, arrogant rule-bound cops, and the media who treat the heroes' desperate battle to save the hostages as just another dramatic event to be exploited.

Gritty heroes like John McClane and Dirty Harry are just one variation of the maverick cop. In *Beverly Hills Cop* (1984, directed

by Martin Brest) and *Beverly Hills Cop 2* (1987, directed by Tony Scott), the same themes are played out as comedy. Like the hero of *Die Hard*, police detective Axel Foley (Eddie Murphy) is the outsider who comes to town and solves an important crime before returning home. Like other mavericks, he mocks authority and circumvents the rules at every turn.

In a comic variation on the insider-outsider theme, Axel dons disguises, fabricates identities, plays with roles, and moves between social worlds. A freewheeling black undercover cop from Detroit, he solves cases that are beyond the police in posh Beverly Hills. With comic flair and unfailing confidence, he pursues the criminals, effortlessly moving among various poses. In *Beverly Hills Cop*, Axel poses as an authoritative city building inspector and dismisses a construction crew renovating a fancy home, claiming they have committed code violations. Later, he occupies the same home while the owners (and the construction crews) are away. In another scene, Axel gains access to a private club by posing as a flamboyant gay man who has had a liaison with one of the members. The discreet maitre d' waves him in for fear he will make a scene. He then breaks out of his pose to confront the criminal maverick style, one on one. For the maverick hero, the pose or disguise is a means of exercising his agency, of tricking fate, of overcoming social obstacles. Alex improvises his way to successfully catching the criminals and winning over his partners from the Beverly Hills police force, and, in the sequel, even their go-by-the-book boss.

The maverick cop as master improviser and comedian is an equally prominent theme in *Rush Hour* (1998), *Rush Hour 2* (2001), and *Rush Hour 3* (2007), all directed by Brett Ratner. But there is a clever cultural twist. Two apparently mismatched mavericks—free-wheeling, fast-talking, black Los Angeles police detective James Carter (Chris Tucker) and the outwardly more sober Chinese detective and martial arts expert Chief Inspector Lee (Jackie Chan)—come together and engage in some good-natured collaboration and culture swapping to get the job done. At the film's beginning, both are used to doing things their own way. Carter is the cocky, bad boy of the LAPD, clever at apprehending

criminals but constantly on the brink of suspension due to the mayhem he creates. "I work alone. I don't need no partners," he proclaims to one of his colleagues. Lee does not seek a partner either. He has come to America to help his long-time friend and boss, Consul Han, whose daughter has been kidnapped by gangsters demanding millions of dollars in exchange for her return.

True to the plot of many movies featuring maverick heroes, the FBI agents handling the case are arrogant, incompetent bumblers. They try to keep both Carter and Lee out of the loop by assigning Carter to be Lee's minder, which makes for much initial tiffing and one-upmanship before the men decide to buddy up. Carter and Lee riff on each other's cultures, don different disguises, and choreograph moves together, but each also has moments when he confronts one of the villains one on one. The two mavericks out-maneuver the FBI at every turn, rescue each other from innumerable jams, and get the criminals in the end with a timely assist from the female bomb expert on the LAPD. The last scene of the movie shows the repentant FBI agents telling Carter that when he comes back from vacation "there's gonna be an FBI badge waiting for you." "You serious?" replies Carter, feigning pleasure and surprise. "Come on man, don't be playing. I don't know what to say. It's like a dream come true. I got an idea, though. Why don't y'all take that badge—and shove it up your ass?" This cocky bantering is light years from the way Gary Cooper's sheriff spoke in *High Noon* or the laconic speech of Clint Eastwood's Dirty Harry, but the sentiment's the same. The maverick hero fights the good fight, but refuses to play by the book. He has disdain for shallow conformity, cowardice, and conventional rules. When trouble comes, he improvises.

## The Military Hero

The stars and stripes of the American flag fill the screen. Gen. George Patton (George C. Scott) walks up and stands in the center of the screen backed by the massive flag. Strident, confident, sure of his country, he speaks:

Men, all this stuff you've heard about America not wanting to fight, wanting to stay out of war is a lot of horse dung. Americans traditionally love to fight. . . . Americans love a winner and will not tolerate a loser. Americans play to win all the time. I wouldn't give a hoot in hell for a man who lost and laughed. That's why Americans have never lost, and will never lose a war, because the thought of losing is hateful to Americans.

The maverick's role as insider and outsider presupposes a secure place to stand. As a maverick hero fighting in the Second World War, Patton had such a place. The ideals he fought for were as unassailable as those of the maverick cops. The institutions these mavericks worked within were basically intact, though, in the case of the cops, usually flawed by bureaucratic incompetence and, sometimes, corruption. But the corruption was not all pervasive. Most cops were good cops, just as most soldiers were good soldiers. Both cops and soldiers fought the good war. The enemy was clear and the cause just. If the maverick cop or soldier bent or broke the rules, it was in the context of principles that were being enforced. If he went too far, he was set straight. The institutional order remained secure.

The Vietnam War presented a test of how the military hero could be adapted. Aside from *The Green Berets*, popular movies about Vietnam showed how the agency of the maverick was eroded as he entered a violent and chaotic world, bereft of a larger moral meaning that could vindicate the violence and provide the foundation for his actions. With no firm place to stand, no clear enemy to fight, no secure bearings, the struggle for individual agency was fought on other terms. The triumph of the citizen-soldier became survival itself, the ability to live with the tragedies and moral ambiguities of the war, the ability to return home intact.

In 1970, the second year of the Nixon administration, three of the top ten movies—*Patton*, *M\*A\*S\*H*, and *Catch-22*—were war films. Although none was about Vietnam, the making and reception of each was shaped by the Vietnam experience.

*Patton* (Twentieth Century Fox, 1969, directed by Franklin J. Schaffner) takes place during the Second World War, but the movie plays to the ambivalent feelings of the American public during the Vietnam War. By presenting Patton as a maverick, the filmmakers could make his character appealing to an American public deeply divided about war during the Vietnam era. Keenly aware of the mixed feelings of the American public, Francis Ford Coppola, one of the screenwriters, portrayed Patton as a quixotic figure, a "man out of his time." In this way, "people who wanted to see him as a bad guy could say, 'He was crazy, he loved war.' The people who wanted to see him as a hero could say, 'We need a man like that now.' "[5] The movie lets the audience draw its own conclusions about Patton's character by romanticizing his self-reliance and spunk in taking on the military bureaucracy—the movie's subtitle is "Salute to a Rebel"—while simultaneously showing that he went too far, that he was an autocrat, not a democrat.

Like the maverick cops, Patton incorporates many elements of the classic cowboy and frontier hero. He is a self-reliant loner who has the daring to fight against great odds. Like other mavericks, Patton rejects the rationalized and technological methods used by big institutions in favor of fighting one on one. During a news conference, a reporter asks him what he thinks of "super weapons," and Patton responds, "There's no honor or glory in it." In an early sequence, Patton rushes into the street during an air raid and fires a pistol at the oncoming planes. In a later scene, he takes off in a jeep without informing the other generals on the staff, in an impulsive single-handed attempt to confront Hitler and the German command. When a foot soldier asks where he is going, Patton responds, "Berlin. I'm going to personally shoot that paperhanging son of a bitch."

For all the failings of its hero, *Patton* presents a positive and patriotic vision of America's mission in the Second World War. In *M\*A\*S\*H* (directed by Robert Altman), the satire combines a sense of the absurdity of war with a celebration of the maverick hero. Korea is portrayed as a woebegone frontier, where the cause is not clear and the cavalry has become a big military bureaucracy.

The heroes, "Hawkeye" Pierce (Donald Sutherland) and "Trapper" John McIntyre (Elliott Gould), are surgeons in a Mobile Army Surgical Hospital. Cocky and self-conscious though they are, their nicknames hark back to the classic heroes of the American frontier.

Hawkeye and Trapper are dedicated doctors but rebel against the regimentation of army life. They move in and out of their roles as professionals and renegades, purists and hedonists, idealists and cynics, asserting their mastery by healing the wounded, while circumventing the army bureaucracy at every opportunity. In the opening sequence, Hawkeye successfully steals an army jeep and drives himself to his unit. Later in the movie, Hawkeye and Trapper arrive at a military hospital, dressed in civilian clothes and carrying golf clubs, to operate on a general's son. In a confrontation at the hospital, they knock out a superior officer who tries to prevent them on procedural grounds from operating on an Asian baby. The heroes' foils are their sanctimonious co-workers, Major Houlihan (Sally Kellerman), the sexy head nurse, and Major Burns (Robert Duvall), a bumbling doctor, who appear ridiculous in their reverence for military protocol.

As a modern comedy, *M\*A\*S\*H*, like other comedies of recent decades, is laden with image-conscious irony, poking fun throughout at the way the camp gathers to watch World War II movies. But even as *M\*A\*S\*H* calls attention to itself as a movie, it sustains the myth of the maverick hero. In the final scene, as Hawkeye prepares to leave, the chaplain blesses the jeep that will take him away as everyone gathers to say goodbye. Over the camp's loudspeaker, a voice announces, "Tonight's movie has been *M\*A\*S\*H*." Despite this self-conscious gesture, the moral of the tale is more old-fashioned than postmodern. Although *M\*A\*S\*H* mocks the myth that America only fights good and noble wars, it celebrates another—that the maverick hero, equipped with skill, irreverence, and panache, can assert his individuality even in the face of the military bureaucracy, and ride off in triumph in the end.

In contrast to *M\*A\*S\*H*, *The Deer Hunter* (1978, directed by Michael Cimino) portrays a more patriotic America even as it

reveals the trials of the Vietnam War. Unlike other Vietnam War movies such as *Coming Home* (1978) or *Apocalypse Now* (1979), *The Deer Hunter* does not criticize the war or the military. Nor does it show the Americans as perpetrators of violence. Instead, it presents in heightened form a tale of the victimization of the ordinary man who is stripped of his innocence by the war, yet is extraordinary by virtue of his ability to survive the experience without losing his sense of purpose. This theme is developed by comparing the different fates of three friends who go to Vietnam. Only one becomes the agent of his own destiny; the other two are victims of the furies of war.

The first hour of the movie is infused with a quiet patriotism and commitment to the American way of life. In rich evocative detail we learn about the lives of the three central characters, Mike (Robert De Niro), Nick (Christopher Walken), and Steve (John Savage), young men who have come of age in a Pennsylvania steel town, and who are about to serve in Vietnam. The camera celebrates their hard work in the steel mill, their deer hunting, and the bonds they have with the community as they prepare for Steve's wedding. The Russian Orthodox wedding takes place in the American Legion hall. Huge photographs of young men who fought in Vietnam are draped with American flags. The sign on the stage where the musicians perform reads "Serving God and Country Proudly."

The Vietnam War is portrayed as an inexplicable horror, which is contrasted with the familiar routines and bonds of community life back home. The last sequence in Pennsylvania shows Mike, Nick, and Steve carousing in a local tavern with their friends, squirting each other with beer and drunkenly singing a spiritual. The mood shifts as one of the friends who will remain at home plays a classical piece on the piano. The camera slowly pans to each of their faces. The playing stops and there is silence.

The transition to Vietnam is sudden and violent. Mike, Nick, and Steve meet again amid chaotic fighting with bombs falling around them. The three friends experience the cruelty and sense-lessness of the war: the difficulty of distinguishing friend from foe, the atrocities committed by the enemy, and the perils of cap-

ture by the North Vietnamese. Among the three, Mike emerges as the leader, but he cannot lead them out of the hell they are in. The men are soon separated and their fates are profoundly different. Steve is severely injured and returns home disabled for life. Nick is driven mad by the war, and commits suicide. Only Mike emerges as a hero. He does not challenge institutions or break the rules, but he exhibits the self-reliance, diffidence, and cool rationality in the face of crisis that are characteristic of the maverick. "You are a maniac. A control freak," Nick goads him as they talk about deer hunting before leaving for Vietnam. But it is precisely his self-control and inner discipline that allow Mike to endure his brutal sojourn in Vietnam. Like the classic frontiersman, cowboy, and soldier, Mike is a quiet man, a natural leader, whether hunting deer with his friends in the forests of America or fighting in the jungles of Vietnam. His friends panic and fall apart, but Mike goes on. Like the frontier hero, he finds the path home because he is never truly lost. He is guided by an inner strength and conviction that even Vietnam cannot destroy. After Nick's funeral back home, those who fought and those who remained spontaneously sing "God Bless America."

*Platoon* (1986, directed by Oliver Stone) also focuses on the theme of redemption in survival. The young hero Chris Taylor (Charlie Sheen), like Mike in *The Deer Hunter*, is a patriot who has chosen to go to Vietnam but discovers there is no honor or glory there. But, unlike *The Deer Hunter*, in which the war is abstracted into an indefinable hell, *Platoon* examines the configurations of this hell with an unsparing eye. We see in much greater detail not only the brutality of the enemy, but also the violence and lawlessness among the American troops, and their victimization of the Vietnamese people.

The young hero's gift and the measure of his heroism is that he bears witness to the dissolution of order, yet does not lose his faith or conviction. He affirms the democratic vision of America, even as he endures the hardships of Vietnam. He comes to Vietnam innocent of violence, and leaves knowing the darker side of his soul, yet he returns home strengthened by his trials.

The struggle within Chris's soul is represented by two author-ity figures, sergeants Elias (Willem Dafoe) and Barnes (Tom Be-renger). Both are seasoned veterans of Vietnam combat, but their characters are radically different. Sergeant Elias is a compassion-ate leader and protector of his men. Although skilled in jungle warfare, he is Christ-like in his compassion and fundamental pac-ifism. Off the battlefield, he is a child of the counterculture, lis-tening to rock music and smoking pot with his men. Sergeant Barnes is the polar opposite. He is the incarnation of the violence and brutality of the war, a soldier whose only goal is survival, a man who sees himself as beyond common morality.

The dramatic turning point in the movie comes when Chris discovers that Barnes has murdered Elias under cover of battle. Since no one witnessed the crime, it appears that Barnes will get away with it. Confronted with the breakdown of morality and order, Chris wants to step outside the law himself and kill Barnes. "Let military justice do the job on him," a friend counters. "Fuck military justice," responds Chris, now speaking the familiar lan-guage of the maverick cop. "Whose story are they going to be-lieve?" But unlike many modern maverick heroes, Chris has no position of authority, no freedom to move in and out of the insti-tution he serves. The army is now embodied in the cruel authority of one man. "I am reality," Barnes taunts Chris and the other young soldiers. But Chris refuses to submit. He confronts Barnes on his own terms, never descending to the brutality of his foe.

Like the citizen hero, classic cowboy, or maverick cop, Chris is the bearer of a common morality, which he departs from only when pushed to the extreme. It is only when Barnes tries to kill Chris (as he did Sergeant Elias) under cover of battle, that Chris is finally forced to mete out his own justice. When he meets up with Barnes once again in the chaos of battle, he kills Barnes in cold blood, even though Barnes is wounded and defenseless.

This fateful act of violence, which is a radical departure from the ethic of the classic cowboy and soldier, is the last test Chris faces. The violence he metes out and the suffering he has endured, however, bring forth a deeper knowledge: "I think now, looking back, we did not fight the enemy," Chris reflects in a letter home.

"We fought ourselves. The enemy was us. The war is over for me now. But it will always be there for the rest of my days. . . . Those of us who did make it through have an obligation to build again, to teach others what we know, and to find goodness and meaning in this life."

*Platoon* reiterates an American parable as old as the Puritans. For the Puritan, America represented a wilderness that tested the soul of man and of the community. The individual and the band of congregants often fell from the path. But they were exhorted and inspired to face their flaws and to redeem their virtue by a higher calling, a moral and civic purpose they were destined to fulfill. Vietnam is a similar wilderness through which the hero passes before returning home to reaffirm the true meaning of America.

In *Rambo: First Blood Part II* (1985, directed by George Pan Cosmatos) the maverick hero reemerges with a vengeance. John Rambo (Sylvester Stallone) is John Wayne's cowboy-soldier recast as primal man, the maverick as noble savage rising from the mud of Vietnam to redeem his honor. The archetypical maverick themes are boldly drawn—the individual against the institution, the vindication of patriotic ideals against political corruption and indifference, the affirmation of instinct and nature over civilization and technology, the celebration of self-reliance and one-on-one combat over modern warfare. In this post-Vietnam-era fable, the Vietnam veteran is no longer victim, but righteous avenger.

In the prologue of the film, the hero is introduced as the outcast who is the true idealist and patriot, the outsider who is asked to come back to tackle a task too difficult and dangerous for others. In the first scene we see Rambo on a prison work crew. We first hear his name when a guard calls out to him. Rambo's former commanding officer, Colonel Trautman (Richard Crenna) of the Green Berets, has come to the prison to ask Rambo to help rescue prisoners of war still in Vietnam. Rambo has the perfect credentials for the mission. He is a decorated Vietnam veteran and himself an escapee from a POW camp. "Sir, do we get to win this time?" asks Rambo. "This time it's up to you," responds Trautman.

Fired up by his commitment to the cause, Rambo finds that he is foiled by the institution he serves. He soon learns that his trusted Green Beret commander, Colonel Trautman, will not lead the mission. Instead, an arrogant congressman, Murdock (Charles Napier), is running the show. Much to his surprise, Rambo is ordered only to locate the POWs and take pictures. The rescue operation will be left to others. "Don't try the blood and guts routine," Rambo is admonished. "Let technology do the work." Rambo responds with the classic self-reliance of the maverick hero, "I've always believed the mind is the best weapon."

The movie's parable is that the natural instincts of the hero are far superior to the modern military technology the organization commands. Like other mavericks, Rambo has a single symbolic weapon, in this case a large knife, which he carefully sharpens in preparation for the mission. In a series of quick cuts, close-ups of Rambo's knife and his bare muscles are contrasted with medium shots of the high-tech equipment being readied. Once Rambo is airborne, the fancy equipment fails immediately. As he attempts to parachute out of a plane, he becomes entangled in the ropes and is left dangling in the air. About to die before he has even begun, Rambo cuts himself free with his knife.

Liberated from the encumbrances of modern technology, Rambo moves through the jungles of Vietnam with the ease of an American frontiersman in virgin woods. In contrast to the heroes of Vietnam War movies, he is undaunted by the dangers the jungle presents. The hero of *Platoon* cringes at the sight of snakes; Rambo picks one up and confidently tosses it aside. Armed with only his knife and a bow and arrow, Rambo is in complete command, just like the mythic frontier heroes who have come before him. He knows that men like Murdock consider him expendable, but in the jungle he is a free man, free to carry out the mission on his own terms.

Rambo attains this freedom, paradoxically, when the corrupt congressman, Murdock, orders a helicopter support mission aborted and abandons him in the forest. Deserted, Rambo becomes empowered. On his own, he successfully takes on the forces of two superpowers—the American forces who have betrayed him and the Russians who support the North Vietnam-

ese—relying on instinct and artful sabotage. In a series of daring exploits he outwits Vietnamese soldiers and their heavily armed Russian counterparts. In each encounter he works with his primitive weapons or skillfully uses the superior technology of his enemies against them. Rambo's final coup is commandeering a Russian helicopter to transport all the POWs back to the American camp in the forest.

The drama of the maverick as the bearer of justice against corrupt institutions is vividly portrayed in Rambo's final confrontation with Congressman Murdock. After Rambo returns to base with the freed American prisoners, he goes into the high-tech control room and machine-guns all the equipment. He then confronts Murdock, who still hides behind his institutional role: "Rambo, I don't make the orders. I take them like you." Rambo pulls out his large knife, threatening Murdock. "You know there are more men out there. You know who they are. Find them or I'll find you."

Like the cowboy and the maverick cop, Rambo walks off alone in the end. Having righted the wrongs, he is ready to leave. Like John Wayne's Davy Crockett in *The Alamo* (1960), Rambo does not want medals or accolades. He brushes off Colonel Trautman's remark that he should get a second Medal of Honor for his service on the mission. "You should give it to them [the POWs]. They deserve it more." Like Wayne's Green Beret hero, Colonel Kirby, Rambo is a homespun patriot, a man of few words but deep convictions. His rage is directed at the betrayal of ideals, but he honors the ideals themselves. "Hate [my country]? I'd die for it. . . . I want what every other guy who came over here and spilled his guts wants—for our country to love us as much as we love it."

## Patriotic Heroes after Vietnam:
## When Presidents Become Mavericks

Love of country and patriotic ideals also infuse movies about the military that are set in the post-Vietnam era. *Top Gun* (1986, directed by Tony Scott), for example, is a modern replay of a John

Wayne movie, free of the doubts and ambiguities characteristic of so many movies of the Vietnam era. The hero is a gifted young Navy pilot, Pete Mitchell (Tom Cruise), who goes by the name Maverick. The story takes place at the elite Navy training school for fighter pilots, nicknamed "Top Gun," where men learn the "lost art of aerial combat" and become "the top fighter pilots in the world."

The movie unselfconsciously praises what movies about Vietnam so often questioned: selfless obedience to orders. "We don't make policy. . . . We are the instruments of that policy," instructs their commanding officer. The "best of the best" carry out their duty with pride, and the movie celebrates them in sequence after sequence of breathtaking aerial photography.

True to his nickname, Maverick is a misfit. He is praised as "a hell of an instinctive pilot," but his superiors worry that he is a "wild card" who may be unreliable in combat. His playful antics give them further cause for concern. He buzzes the control tower, making a superior officer spill his coffee. He flies upside down and takes a photograph at the same time. His prowess defies the books, and he is not afraid to challenge his teachers. Off duty, Maverick is freewheeling and fun-loving. As one instructor tells him, "Son, your ego is writing checks your body can't cash."

But, unlike many maverick heroes of the 1970s, the hero's conflict is not with a corrupt or ineffective institution. The military is exemplary in every respect. The elite fighter training school represents a chance to be the best he can be. The conflict lies, rather, in Maverick himself. In the quiet interludes between the flying sequences we learn that his wildness and rule breaking are associated with the death of his father, also a star Navy pilot, whose plane was shot down under ambiguous circumstances during the Vietnam War.

Maverick has an older instructor who provides him with guidance, in the father-figure role assumed by John Wayne in World War II movies. Maverick's instructor tells him that his father was a great hero, but that the circumstances of his death were kept classified because he had crossed over "the wrong line" in aerial combat. Maverick's faith in his father is restored, but he is still

haunted by the loss of his flying partner in an accident, and he remains unsure whether he can fly under the pressure of combat.

The hero's final test and triumph comes after he graduates from Top Gun and his squadron is in battle over the Indian Ocean. He overcomes a moment of panic and engages the enemy, outwitting and destroying their planes against great odds. After his successful mission, he returns to his ship to buzz the control room in a flyby, once again making a controller spill his coffee. But despite the antics, Maverick is fundamentally a hero who is integrated with his organization. He is the outsider who has come all the way in, a John Wayne–style hero for the 1980s, wholly at ease with the institution he serves.

As *Top Gun* shows, the maverick can be a loyal insider or, as *Rambo* illustrates, a loyal outsider who walks away from the institution once the job is done. Through the maverick hero, rugged individualism can be reconciled with institutional affiliation, self-reliance with social obligation. The maverick hero enables the movies to absorb the critique of institutions while retaining the mythic resources that empower the hero. Most important of all, individual agency and power can be affirmed in a modern world where (outside the movies) the individual often feels powerless and diminished.

By the late 1990s, two box-office hits, *Independence Day* (1996, directed by Roland Emmerich) and *Air Force One* (1997, directed by Wolfgang Petersen), go beyond *Top Gun*'s portrayal of the maverick as loyal insider and cast the president of the United States as a maverick hero and military pilot. What is interesting about this new plot development is that movies do the work that presidents and presidential candidates have long aspired to do— identify themselves with mythic American heroes. In *Independence Day*, President Thomas J. Whitmore (Bill Pullman) is a former Gulf War pilot who unites the world to fight off alien invaders bent on destroying the earth. From start to finish the president is his own man, often rejecting the more cautious advice of those around him. When the military first detect the approach of the aliens, the president refuses to leave the White House. Later, against the advice of his military advisers, the president decides

to fly one of the planes in the critical air battle against the alien invaders. In a speech delivered with a bullhorn to the assembled crews, he strikes a new tone of patriotism for the global era: "Should we win the day, the 4th of July will no longer be known as an American holiday, but as the day when the world declared in one voice, 'We will not go quietly into the night. We will not vanish without a fight. We're going to live on. . . . Today we celebrate our Independence Day.' "

In the final battle, the president fires the first missile at the alien spacecraft. The generals try to call the battle off when the aliens repel the president's missile. But the president once again overrules the military and shoots off another missile. It hits its target and the battle begins. For all his virtue and aplomb, however, the president is not the star maverick of the movie. That role is occupied by the quick-witted and cocky Air Force captain, Steven Hiller (Will Smith). But the president has the imagination and independence to support Hiller and others who come up with innovative ways to defeat the alien enemies. In fact, *Independence Day* shows how multiple mavericks—the president, Hiller, a computer whiz, and an old feisty pilot and Vietnam vet—collaborate to win the day.

In *Independence Day*, the president as maverick plays a supporting role. In *Air Force One*, the president is the star. When Russian terrorists posing as journalists commandeer Air Force One, President James Marshall (Harrison Ford) refuses the Secret Service's offer to help him escape from the plane in an evacuation pod. Instead, he hides in the bottom of the plane and plots how to defeat the terrorists. For most of the film, the terrorists do not know he is there. Cold blooded and confident, their leader tells the frightened passengers held hostage: "He's fled. The coward chose to save himself." On the ground, the vice president (Glenn Close) and military leaders fear the president is dead, although one general says, "Let's not bury him yet. Let's not forget this president is a Medal of Honor winner. In Vietnam, he flew more helicopter missions than any man in my command. He knows how to fight."

Indeed he does. With grit, determination, and ingenuity, the president foils the terrorists, picking them off one by one, using their own weapons against them, improvising as he goes along. Multilingual, he tricks one of the terrorists by speaking in Russian and feigning that he is a member of their team. When the president is captured by the terrorists, and their leader holds a gun to his head, he temporarily complies with their requests, then cuts free from his bonds with a shard of broken glass and tackles the terrorists. Near the end of the movie, the president pushes the leader of the terrorists off Air Force One, saying, maverick style: "Get off my plane." He then runs upstairs to make a call to the White House that prevents the rogue general and self-proclaimed leader of Kazakhstan Ivan Radek (whom the terrorist have been bargaining for) from being released from prison. After the terrorists are dispensed with, the president even manages to fly Air Force One and fend off an enemy attack before he is finally rescued by the U.S. military and resumes command of the country.

## Superheroes and Action Heroes:
## Ordinary-Extraordinary Men

A variation on the insider-outsider role of the maverick is the hero with a double identity—now the common man, now the superhero. Unlike the maverick, the superhero usually does not rebel against the methods and practices of the institutions he serves. He works cooperatively with organizations, defending their goals and respecting their practices. In *Superman* (1978, directed by Richard Donner), the hero's mission is to fight for "truth, justice, and the American way." Superman (Christopher Reeve) upholds these ideals both in the role of Clark Kent, the shy, bumbling, bespectacled newspaper reporter, and when he dons his costume and becomes a superhero. Superman represents the fantasy of immense individual power, always exercised on behalf of the community.

The Superman movies replay the law-and-order theme, without the social and moral ambiguities that beset the maverick cop. Superman never has to do dirty work, fire a gun, or endure the disdain of his superiors. He is the all-American cosmic enforcer who flies above the fray. His identity as a common man is both a contrast and a complement to his identity as superhero. In the persona of Clark Kent he is a laughable if well-intentioned wimp, whose idea of confronting a gun-toting mugger is to sermonize, "You can't solve society's problems with a gun." As Superman, no criminal is a match for him. He can catch bullets in his bare hand, prop up the president's plane when an engine fails, divert a nuclear warhead from its target, and even bring the dead back to life. But Clark Kent represents an essential aspect of Superman's character. He is a nonviolent hero, a modest man who never seeks fame or glory.

Superman's dual identity as ordinary citizen and extraordinary being is distinctively American. In marked contrast to the Nietzschean conception of a superman characterized by a will to power and a disdain for common morality, Superman is a self-effacing team player. When he brings the crooks back to prison at the conclusion of the first movie, the grateful warden says, "This country is safe thanks to you." "Don't thank me, warden," replies Superman. "We're all part of the same team." Like James Stewart's citizen hero in *Mr. Smith Goes to Washington*, Superman is an unabashed patriot, a believer in the American ideals of family, community, and individual service. He embodies the distinctly American paradox of being the uncommon common man.

This paradox has been part of the Superman myth ever since he made his comic-strip debut in 1938. But unlike the earlier comic strips, the Superman movies (1978, 1980, 1983, 1987, 2006) incorporate a double message. On the one hand, they play the story straight, reveling in the hero's feats, celebrating his homey virtues, and elaborating on the cosmic nature of his calling. The first movie, for example, is interspersed with mythic sequences in which Superman goes into outer space where his dead father from Krypton (Marlon Brando) instructs and guides him in the use of his powers. But even as the movie moves within the

myth, it also steps outside it, self-consciously calling attention to the story's form, and winking to the audience in a series of inside jokes. On the way to rescue Lois Lane (Margot Kidder), for example, Superman looks longingly at a phone booth (the classic place for quick changes in the comic-book versions of the story); but it is a modern booth, open to the elements rather than enclosed, so he must change in a hotel. In romantic and rescue scenes, the tone often shifts from sentimental to satirical, always drawing on the audience's awareness of how the new version of the story departs from the old.

However, this self-conscious attention to the story's plot and form does not unravel the mythic elements of the movie. By vacillating from the cosmic to the satirical, the movie widens its appeal to include sophisticates and believers, parents and children. Underlying all the Superman sagas—the satire, the simple plot, the stereotypic characters, and the extraordinary special effects— is a parable of individual agency rooted in commitment to the community.

*Batman* (Warner Brothers, 1989, directed by Tim Burton), and its popular sequels (1992, 1995, 1997, 2005), is also based on a comic-strip character and is another variation on the Superman theme. The tone of the movie, however, is darker. Batman's (Michael Keaton) double identity has a different cast, too. Unlike the mild-mannered Clark Kent, who comes from the middle-American heartland, Batman's other self, Bruce Wayne, is a rich, self-assured millionaire, who lives in a grand house with a butler. Like Superman, he has lost his parents at an early age, but the cause of their death strikes much closer to home, evoking a deeply shared anxiety in the audience: his parents were murdered by muggers in a city alleyway as young Bruce watched in helpless horror. The plot is further tied together by the revelation, toward the end of the movie, that Batman's evil adversary, the Joker (Jack Nicholson), was the mugger who killed his parents years before.

Although the setting of Batman is fantastic, the themes of urban lawlessness and disorder, crime and retribution closely parallel movies like *Dirty Harry* and *Die Hard.* The hero is a lone fighter against crime who bails out a well intentioned but weak

police department. "The police have got it wrong," Batman tells Vicki Vale (Kim Basinger), the ace photographer who is covering his exploits. Through a masterly analysis of the clues, Batman has determined that the Joker has poisoned hundreds of chemicals that go into cosmetic products, and urges Vale to take the information to the press. But she hesitates:

VALE: A lot of people think you're as dangerous as the Joker.
BATMAN: He's psychotic.
VALE: Some people say the same thing about you.
BATMAN: What people?
VALE: Well, let's face it. You're not exactly normal, are you?
BATMAN: It's not exactly a normal world.

In contrast to Superman, Batman is a superhero who still must prove himself. Like Dirty Harry, Batman is scorned and doubted by the people he serves. Undaunted by the doubts of others, Batman proves himself in feat after daring feat. Yet with all his powers, he is decent and self-effacing. He only becomes Batman as a last resort. He would much rather lead a normal life.

In the popular Spider-Man movies (2002, 2004, 2007, directed by Sam Raimi and starring Tobey Maguire) the superhero is brought into the age of the photo op. Unlike earlier superheroes, Spider-Man's double identity gives him the power to be the creator and guardian of his own image. He is not just the Marvel comic-book hero soaring through the air to rescue people aided by his web. In his other identity, as sweet, nerdy, science student Peter Parker, he is the freelance photographer of Spider-Man. The double identity of hero and photographer is played out in an old-fashioned way in *Spider-Man 1*—through the use and misuse of tabloid newspaper photos—but the sensibility the movie and its sequels capture is the self-conscious attention to picture making characteristic of today's generation of kids growing up with Facebook, YouTube, and MySpace.

From the start of the Spider-Man saga, photography is connected to the superhero's destiny. In *Spider-Man 1*, Peter Parker gets bitten on the finger by a genetically designed red and blue superspider while taking photographs for his high school newspa-

per on a school field trip to a science lab. The next morning Peter discovers that he no longer needs his glasses and admires his new-found muscles as he looks in the mirror. In an altercation with a bully in the school cafeteria, Peter discovers his web powers. After defeating his foe, he begins to create his own superhero image, sketching Spider-Man costume designs in his school notebook (which replicate the familiar Marvel comic-book design).

Part of the movie's parable is that being master of your image is not easy, and it is not the same thing as being master of your destiny. Early in the film, Peter's beloved Uncle Ben is killed by a fleeing robber who Peter, in his newfound role as Spider-Man, lets escape from the scene of a crime. The marvels of genetic engineering that result in an accidental spider bite that transforms Peter Parker into a superhero also transform an ambitious scientist, Norman Osborn, into a supervillain. Osborn invents a serum for "Human Performance Enhancers," and, in a moment of hubris, drinks the green serum, straps himself into a special machine, and emerges as the violent and vengeful Green Goblin who terrorizes the city and becomes Spider-Man's nemesis.

The ensuing fight between good and evil, and the daring last-minute rescues of innocent victims in New York City, are standard fare for superhero movies. What's new is how the movie develops the theme of a young, intensely media-conscious superhero. One way the movie does this is by making the media's obsession with inflating and puncturing pictures a central feature of the story. Once Spider-Man appears on the scene, the press runs banner headlines celebrating his exploits, but J. Jonah Jameson (J. K. Simmons), the cynical, hard-bitten editor of the city's biggest tabloid, the *Daily Bugle*, doubts Spider-Man's heroic credentials. "Who is Spider-Man?" Jameson grumbles. "He's a criminal, that's who he is. A vigilante, a public menace. What's he doing on my front page?"

Throughout the Spider-Man movies, the tabloid editor will be one of Spider-Man's foils, even as Peter Parker works for him as a freelance photographer producing heroic shots of Spider-Man. *Spider-Man 1* established how Peter Parker assumes this double role. The *Daily Bugle* runs a front-page ad: "Reward! For Photos

of Spider-Man," and Peter Parker, a recent high school graduate, decides to answer it, knowing that he is uniquely qualified for the job. In order to assemble a picture portfolio to present to the *Daily Bugle*, the wily Parker rigs up a camera in a web that automatically take pictures when he is Spider-Man and swings in to foil a robbery. After dispensing with the criminals, Spider-Man looks up at the camera, poses for his photo op, and says, "Cheese!"

Peter soon learns that the battle for control of the picture is more complex than having an inside track on getting great photos. He must continually battle the lurid tabloid headlines Jameson constructs to frame Peter's pictures and besmirch Spider-Man's image. "That's slander," Peter tells Jameson after he sees a *Daily Bugle* headline that suggests that Spider-Man has joined the Green Goblin in attacking the city. "Spider-Man wasn't attacking the city, he was trying to save it!" But in the tabloid world, the unscrupulous Jameson commands the captions. "I resent that," he confidently retorts. "Slander is spoken. In print, it's libel." Peter has to put up with the fact that Spider-Man's feats have no bearing on the stories Jameson constructs.

In *Spider-Man 3* (2007) the self-conscious attention to image making is further heightened. The movie opens by reprising images from past Spider-Man movies, which are contained within a series of photographs in a giant web. After we see Spider-Man swinging through the city's buildings, we meet Peter Parker on the streets of New York, now a confident master of his own image. It is no wonder, because the city has branded itself with Spider-Man. A huge sign proclaims: "The New York Travel Bureau Welcomes You to Manhattan HOME OF SPIDER-MAN." The Times Square electronic bulletin trumpets "NY Loves Spider-Man." The newsstand tabloids are awash in praise: "What a Catch!" "What a Man! Giant television screens feature the hero's exploits as children breathlessly look on.

In a voice-over narration, Peter Parker has become cocky and self-important as he admires himself in the multiple Spider-Man images: "It's me, Peter Parker, your friendly neighborhood—you know—I've come along way from being the boy who was bit by

a spider. Then nothing seemed to go right for me. Now, people like me! People really like me" (an inside reference to Sally Field's much-mocked line in an Academy Award acceptance speech).

But if one side of the photo-op culture is inflating the image, another is finding a way to frame the flaw that punctures the pose. This becomes a key part of the story in *Spider-Man 3*, played out with a twist that involves digital manipulation. The editor of the *Daily Bugle*, still bent on showing that Spider-Man is a "fake" and a "two-bit criminal," challenges Peter Parker and a new young freelance photographer, Eddie Brock (Topher Grace), to expose Spider-Man. The one who catches Spider-Man in the act of committing a crime will get a permanent job as a staff photographer. Because the superhero is virtuous, Brock can find no evidence, so he digitally manipulates a photograph to make Spider-Man look like a thief. The exposé photograph gets huge media play, and Peter becomes aware of it as he walks down the street and hears people expressing their disillusionment with Spider-Man. Peter goes to the *Daily Bugle* office and has a showdown with Brock in front of the editor and the entire staff who have gathered to celebrate Brock's scoop. The editor fires Brock and prints an apology and retraction: "Sorry Spidey, Bugle Drops Charges" and "Faker Fired."

The *Spider-Man 3* plot also features the classic form of image-consciousness—Peter's intense infatuation with his own image. In his incarnation as Spider-Man, Peter does battle with an array of new supervillains: the Sandman, the New Goblin, and Venom. His virtuous character, however, is hollowed out by out-of-control egotism and an obsession with performing for the camera (in the fantasy landscape of the movie, this flaw is magnified when cosmic black goo mysteriously appears and attaches itself to Peter). Through a good part of the movie, Peter makes a fool of himself strutting around town in a black Spider-Man suit on a testosterone high, mugging for the cameras, and taking pictures of beautiful girls. All this reveling in the photo-op culture comes to an end when Peter is brought back to the basic decency and homey virtues by his Aunt May (who looks and speaks just like Aunt Em in the *Wizard of Oz*). Peter sheds the black Spider-Man

suit and returns to his true self. The photo-op mentality is absorbed into a familiar script. The parable of the virtuous ordinary-extraordinary man reasserts itself. So does the patriotic tableau that forms such an integral part of American movies. *Spider-Man 3* ends, just like the first Spider-Man movie, with the superhero backed by a giant billowing American flag.

## Action Heroes

Another popular version of the hero with a double identity is the action-adventure hero. We already met Harrison Ford in his role as president in *Air Force One*, but his credentials as maverick hero were established in earlier roles. One prominent role was as Indiana Jones of Steven Spielberg's mythic adventure films, *Raiders of the Lost Ark* (1981), *Indiana Jones and the Temple of Doom* (1984), and *Indiana Jones and the Last Crusade* (1989). The hero is two people in one. In one part of his life he is Dr. Jones, dedicated academic and archaeologist, the picture of convention in his staid suit and glasses, a man whose passion is facts and footnotes. But in the other, more expansive part of his life, he is Indiana Jones, archaeologist-adventurer, world traveler, and maverick hero, who thinks nothing of climbing out the window to escape his clamoring students.

Like the classic maverick hero, Indiana does not initiate his missions but is called upon by others who need his special skills, yet they often end up disparaging or betraying him. The rich American businessman who hires Indiana to search for the Holy Grail in *Indiana Jones and the Last Crusade* turns out to be a Nazi. Although good guys (American army intelligence officers) hire Indiana Jones in *Raiders of the Lost Ark*, they too foil him in the end. After Indiana locates the Ark, they thank him and pay him handsomely, but they will not let him have access to it. "We have top men working on it," they claim. "Who?" asks Jones, who is, together with his partner Marcus (Denholm Elliott), among the top men in the field. "Top men," the intelligence officer stonewalls. "Fools, bureaucratic fools," Jones grumbles to his partner

and lover Marion (Karen Allen). The last scene of the movie shows that the officer has lied; the sacred Ark is filed away and forgotten in a cavernous government warehouse in a box marked "top secret."

Aside from this dramatic example of bureaucratic betrayal, Indiana's adventures are set comfortably in the past, free of the moral and political ambiguities that plague contemporary maverick cops and soldiers. The good and bad guys are defined with comic-book clarity, and Indiana pursues them with the earnest dedication of the young Spider-Man or a boy-hero from an adventure book. "Nazis, I hate these guys," he says to himself looking up at an Austrian castle with the self-assured innocence of Tom Sawyer or the Hardy Boys. Like other mavericks from the movies, Indiana thwarts his technologically superior foes using simple old-fashioned methods. Instead of carrying a gun, Indiana has a special whip, which he uses like a cowboy's lasso to disarm his enemies. In *Raiders of the Lost Ark* he chases a Nazi while riding a white horse. In *Indiana Jones and the Last Crusade* he rides on horseback against a rocket-shooting Nazi tank, leaps from his horse to the tank, picks off the Nazis one by one, and frees his father (Sean Connery), also an archaeologist, held captive inside. He pursues his enemies across the world and masters modern technology with ease.

Despite his special gifts, Indiana is never portrayed as a grand figure. Like many American heroes, he is "revered" with irreverence. He is at once larger than life and continually cut down to size. Indiana's father orders him around and calls him "Junior" when they work together to find the Holy Grail in *Indiana Jones and the Last Crusade*. Indiana's partner and lover, Marion, in *Raiders of the Lost Ark*, is a feisty maverick in her own right. When he first visits her in Nepal she punches him for neglecting her for so long and forces him to take her along on his mission because he owes her money. The irreverent attitude toward the hero is also conveyed through self-conscious parody of the genre. In one episode, Indiana confronts a huge Egyptian brandishing an enormous sword. Instead of going one on one in heroic combat, whip

against sword, Indiana nonchalantly pulls out a gun and shoots his enemy instead.

Through the character of Indiana Jones, Spielberg's movies are able to both mock and sustain their mythic elements. Like many maverick heroes, Indiana is a skeptic when it comes to grand ideals and myths. "We cannot take mythology at face value," he lectures his students near the beginning of *Indiana Jones and the Last Crusade.* "Archaeology is the search for facts, not the truth." When others, including his father and his older colleague Marcus, speak of the extraordinary spiritual powers of the Holy Grail, Indiana pooh-poohs this as a "bedtime story."

Once the Nazis capture his father, however, Indiana temporarily sheds his modern skepticism and becomes a believer. After his father is shot by the Nazis near the place where the Holy Grail is hidden, Indiana learns that only the healing power of the Grail can save him. Following his father's instructions and using his inner resources, Indiana recovers the Grail and heals his father. Once his mission is accomplished, the tone of the movie quickly shifts from spiritual to earthy, from classic myth to the homegrown American kind, in which irreverence is mixed with reverence, humor with homage. "What did you find, Dad?" Indiana asks his father. "Illumination," his father responds. "And what did you find, Junior?" The wry paternal condescension breaks the mood at once. But as they ride off, Indiana's father good-naturedly defers to his son. "After you Junior," he says teasingly. As the camera lingers affectionately on the departing figures, we are suddenly back to the landscape of American mythology, with father and son riding off into the sunset like cowboys in a western epic.

Like the Indiana Jones movies, George Lucas's mythic space adventures, *Star Wars* (1977), *The Empire Strikes Back* (1980), and *Return of the Jedi* (1983), and the popular Star Wars prequel trilogy, *The Phantom Menace* (1999), *Attack of the Clones* (2002), and *Revenge of the Sith* (2005), fuse classical and contemporary myths through the pairing of contrasting heroes. In the first Star Wars movies, Luke Skywalker (Mark Hamill) is a virtuous, idealistic, young Jedi knight who learns to use the power of good, "the Force" to overcome the imperial foes. His partner and friend,

Han Solo (Harrison Ford), is a crude but endearing maverick who lives the myth in irreverent opposition to it; who does not espouse ideals, yet redeems the ideals in the end; who appears at first as a mercenary, but ends by nobly sacrificing his own interests for the sake of the virtuous band of rebels.

Early in the saga, Han Solo dismisses the spiritual teachings of the Jedi knights: "I've been from one side of the galaxy to another. I don't believe in a mystical force." He is not even willing to help rescue the captured Princess Leia until Luke Skywalker suggests there will be a reward. In contrast, Luke Skywalker believes in the cause of the rebels, and aspires to be a virtuous knight. Through his character, the Star Wars movies can give full expression to their classical mythic elements. In the climactic scene of *Star Wars*, as the rebels begin their attack on the space station of Darth Vader, the leader of the imperial forces, Luke hears the voice of his mentor telling him "the Force will be with you always." Luke turns off the fancy computer in his spacecraft and flies into the enemy stronghold, trusting his deeper instincts. Along with Han Solo and the other rebels, he destroys the space station in this mythic version of a classic war movie.

This type of scene also replays, with more explicit mythic import, the confrontations of maverick cops with their technologically superior foes. In *Die Hard* the cop hero has nothing but instinct and intuition to rely on as he faces the heavily armed terrorist-thieves. "Think, think," he tells himself when he realizes he must go it alone. In *Sudden Impact*, Harry Callahan makes constant, though self-deprecating, references to being "psychic" and "intuitive" when it comes to outwitting criminals. This reliance on intuition is shared by Luke Skywalker's maverick partner, Han Solo, as well.

Most American heroes are self-effacing, more likely to believe in intuition and instinct than grand ideals, more likely to be called to the cause than to be initiators of the struggle. They fight on the right side, but not always with the right attitude. Sometimes they are idealists like John Wayne's Davy Crockett and Colonel Kirby, but often they are skeptics or cynics like Humphrey Bogart's Rick Blaine, Clint Eastwood's Harry Callahan, Bruce Wil-

lis's John McClane, or Leonardo DiCaprio's undercover cop, Billy Costigan, in Martin Scorsese's 2006 Academy-award-winning movie *The Departed*. The cynicism of the heroes, however, masks a deeper idealism. They are willing to sacrifice for the good of others, even as they are foiled by the institutions they serve.

The typical mythic structure sets the hero apart from the institution he serves. John Wayne movies make this point by showing that the hero can be a self-reliant maverick who calls his own shots while working within institutions. Clint Eastwood movies make the point by setting the hero against the law enforcement bureaucrats. *Star Wars* makes the point by drawing the lines between the institution and the individual in bold mythic strokes— good versus evil, the individual against the empire. Since part of the American way is to resist institutional conformity, to rebel against authority, the maverick as insider-outsider or as the bearer of a double identity is well suited to sustaining the myth. Social criticism and the celebration of institutions easily coexist.

The distinctive qualities of American maverick heroes are thrown in relief when compared to the early movie portrayals of British Secret Service agent James Bond by Sean Connery (1962– 67, 1971) and Roger Moore (1973–85). From the first James Bond movie, *Dr. No* (1962), to the present, these spy-adventure films have been consistent blockbusters in America and worldwide.

In American movies of the early Bond period, the hero is rarely a government spy. The FBI and CIA are more likely to be portrayed as arrogant bureaucracies that foil the hero, or worse, as rogue organizations, immoral and conspiratorial, that threaten the hero's life. In *Three Days of the Condor* (1975), the CIA is depicted as a violent organization that kills its own members in interdepartmental power struggles. In *Marathon Man* (1976), the hero is hunted by "the Division," a secret government organization that "fills in the gap between the FBI and CIA," that rationalizes collaboration with Nazi war criminals by telling the hero, "We cut both ways." In *The Eiger Sanction* (1975), Clint Eastwood plays a cynical hired assassin who joins the CIA to do some good for his country, but quickly learns that there is little difference between the CIA and the enemies they fight. This portrayal of

the CIA is reiterated in many contemporary movies, prominent among them the films featuring the rebellious and reflective CIA assassin Jason Bourne (Matt Damon).

By contrast, the officials of the British Secret Service are not cold and brutal bureaucrats, but witty, charming, and highly competent. In the early Bond films, the hero is a sophisticated professional whose work demands a high degree of self-reliance and the ability to engage in one-on-one combat. But unlike the typical American maverick, Bond's relationship with his superiors is unproblematic and the secret organization he serves is presented in a glowing light. They support the hero on his dangerous missions with an impressive array of state-of-the-art technology. If Bond falls off a cliff, a parachute suddenly pops out to bring him safely to the ground. If an enemy corners him, a concealed weapon pops out to foil his foe.

In the early Bond films, James Bond is presented as the "Renaissance man" of the global age, a master at moving in and out of roles and poses, a man at ease in many cultures. There is no tension between nature and civilization, self and society. He is not the New-World hero who has to define himself against society, but the Old-World hero, already comfortably civilized, the ultimate insider.

In other respects, though, the early Bond resembles the American maverick. He is backed up by technology, but he is not a technocrat. He works cooperatively within a highly rationalized organization, but he is not an organization man. He is supremely independent, versatile, and innovative. The fancy gadgets of the Secret Service get Bond into the enemies' strongholds, but once inside, he is on his own to face the vast technology of his foes.

Like the American maverick, James Bond expresses his agency and command through the laconic remark, the pun that shows that he can say the right thing when words would fail the ordinary person. The classic Bond, however, is a much more self-conscious and self-satisfied hero. He does not have to fight abuse and disdain like Dirty Harry and his fellow maverick cops. Nor does Bond display any of the homespun idealism of Superman and Spider-Man. In Bond's stylized realm, questions of ideology are

beside the point. There is no tension between his roles as insider and as outsider; he is the consummate insider with an outward gaze, a performer with a self-conscious appreciation of his own act. "I hope you enjoyed the show," he remarks to his Russian partner, the beautiful Triple X in *The Spy Who Loved Me* (1977), after he has fought off several villains in front of some Egyptian tombs.

Although James Bond is from the outset an image-conscious hero, with every plot combining fast action and tongue-in-cheek humor, by the 1970s another element is added to the image consciousness—winking references to American movies. In *The Spy Who Loved Me*, for example, the villain's henchman is a hulk with metal teeth and braces, named "Jaws," who at one point kills a shark by gripping it in his powerful mouth. In *Moonraker* (1979), Bond smashes a bad guy against a piano and says, "Play it again, Sam." When Bond rides with others across a plain, all dressed as gauchos, the theme from a popular television western, *Bonanza*, plays. When Bond cracks a secret scientific code, the background music mimics that of another Steven Spielberg hit movie, *Close Encounters of the Third Kind* (1977).

The image consciousness and winking allusions parallel the style of the hero himself and enhance the stylish, tongue-in-cheek quality of the films. Just as Bond's puns and one-liners prove his mastery over every situation, so the references to movies and other icons of American popular culture prove once again the ability of blockbuster movies both to mock and magnify their own myths.

Neither mockery nor mastery characterize the James Bond of the more recent *Casino Royale*, the twenty-first official Bond film (2006, directed by Martin Campbell and starring Daniel Craig), which casts Bond as a rough-hewn rebel and hard-driving action hero. The story takes place at the beginning of Bond's career, before he becomes a sophisticated spy. In a departure from the classic Bond of Sean Connery and Roger Moore, the new Bond is a maverick hero as gritty as Clint Eastwood's Dirty Harry. As Bond pursues the villain, Le Chiffre (Mads Mikkelsen), a financier who sponsors terrorists, he gets bloodied, bruised, and tor-

tured in a way his suave Bond predecessors never did. Far from an organization man, the new Bond disobeys orders and rebels against his coolly efficient superior, M (Judi Dench), just like the maverick cops in *Die Hard, Rush Hour,* and *Bad Boys.*

Like other maverick cops and action heroes, this Bond does a lot of running and leaping. The very act of running is an act of agency, an adrenalin rush, a demonstration of prowess and command. Yet for all the running, physical command, and perfect physique, Daniel Craig's Bond is hauntingly alone in the world. He is detached from community and wary of his own backers in the British Secret Service. When he utters the famous line, "Bond, James Bond" at the film's end, dressed for the first time in a tuxedo, he assumes the pose but lacks the joie de vivre or irreverent mastery of his predecessors. He has no idyll with a pretty woman at the film's end. The woman he loves is dead. Stripped of his moorings, the new Bond resembles an action figure from a video game, occupying a world that is hyperreal and yet hollowed out. In other ways he is the self-assured postmodern man, without flourishes or illusions, whose victory—like the renegade hero Jason Bourne played by Matt Damon in the blockbuster action movies *The Bourne Identity* (2002), *The Bourne Supremacy* (2004), and *The Bourne Ultimatum* (2007)—is survival in a hostile and uncertain world.

## Citizen Heroes: Triumphs of the Common Man

One of the persistently optimistic strands in American movies is the story of the triumph of the ordinary person. This strand of the American myth is what politicians are most likely to incorporate. Nowhere is this American fable more directly told than in *Rocky* (1976) and its many successful sequels (1979, 1982, 1985, 1990, 2006). *Rocky* (directed by and starring Sylvester Stallone) is the story of an Italian boxer, Rocky Balboa, a nobody who becomes a somebody, an underdog who becomes a champion. Like the heroes of Frank Capra's movies, Rocky is a common man of uncommon character.

The first movie in the series, *Rocky*, is a simple story of a boxer who makes good on his own terms. This modern Horatio Alger story chronicles the hero's rise from loser to national hero. But the deeper story of *Rocky* reiterates a core theme running through Capra's movies—the virtue and incorruptibility of the ordinary citizen.

Like so many American heroes, Rocky finds his life changed by a stroke of fate. Apollo Creed, America's champion boxer, is looking for a new challenger for a fight on the Fourth of July. Apollo comes up with a scheme that will boost attendance and hype the fight. "Give a local boy a shot on this country's birthday," he tells his inner circle. "I like it," responds his manager. "It's very American." "No," says Apollo smiling, "it's very smart." After looking at film footage of various boxers, he decides on Rocky. Apollo, who is black, wants a "snow-white contender," and Rocky fits the part. "Apollo Creed meets the Italian Stallion," Apollo laughs, ever the self-conscious performer. "It sounds like a monster movie."

Like Capra's Jefferson Smith or John Doe, Rocky is cast in a role by the established powers who want to use him for their scheme. Like Capra's heroes, Rocky remains true to himself amid the phoniness and the hype. He is the self-reliant hero without pride or overreaching ambition. For Rocky the fight represents his opportunity to prove himself. Without fancy equipment or staff, he trains in his neighborhood gym and runs every morning at dawn down the streets and back alleys of the city. For Rocky, the fight is not a show but a personal quest. He sets his own goal, not to win but to go the distance and to be standing after fifteen rounds.

Apollo, in contrast, is the consummate performer, a prideful champion who sees patriotism as merely something to exploit in a media event in which he will star. He enters the fight dressed as Uncle Sam and throws silver dollars to the crowd. By contrast, Rocky quietly prays in preparation for the fight and appears without fanfare. Rocky succeeds in lasting the fifteen rounds and proves his heart and skill as a fighter.

In the sequels to *Rocky*, the hero returns to the ring and continues to display the virtues of self-reliance, patriotism, and faith. The simplicity and authenticity of the hero are continually contrasted with the false and fabricated images the media creates. In *Rocky II*, for example, the hero is cajoled into making television commercials, at which he miserably fails. He must constantly resist attempts to refashion and glamorize his image.

*Rocky IV* casts the Rocky story within a broader mythic framework. This late cold war parable pits Rocky against the monstrous Russian fighter Drago. Drago is presented as an automaton, the powerful embodiment of Russian technology and totalitarianism. Rocky's erstwhile opponent Apollo, now a friend, takes on Drago against Rocky's advice, and in a bloody battle is killed.

Rocky then decides to fight Drago to avenge the death of his friend. As he prepares for the fight, Rocky assumes the mantle of the classic citizen hero. He is the natural man, while Drago is a creature of technology and steroids. When he goes to Russia to fight Drago, Rocky recreates the American frontier on Russian soil and finds his strength there. He lives in a simple cabin, "no sparring, no TV." He trains alone in the snow—loading rocks, pulling sleds, carrying huge logs, scaling the lonely mountains—with only his trainer and brother-in-law providing moral support. When his wife joins him in his lonely outpost his rejuvenation is complete. He is ready to take on the seemingly invincible Russian.

Fighting on foreign territory in front of a hostile crowd, Rocky once again wins the hearts of his detractors. The hero is pummeled by his Russian foe, but refuses to give in. Somehow he finds the strength to fight his way to victory, and the Russians who once booed him now chant his name. The movie ends with the victorious Rocky draped in an American flag, being carried aloft by ordinary Russians in defiance of the party officials.

In *Forrest Gump* (1994, directed by Robert Zemeckis and starring Tom Hanks), the triumph of the citizen hero is played out against a wide swath of history that stretches from the 1960s through the early 1990s. The movie deals with trauma and conflict, and blends fact and fiction, documentary footage, and simu-

lated scenes. But far from exploring a dark conspiracy in American history, the movie tames history and turns it into parable and fable. The parable is about the triumph of simple virtues—goodness, decency, and fellow feeling; love and loyalty to friends, family, and community. The fable is that a simple person, without pretence, guile, or intellect, can become a force in the world, moving among leading historical figures and shaping the course of American politics and culture.

Forrest Gump is different from other citizen heroes of the movies in that he is literally simple, with an IQ of only 75. In one sense this widens the gulf between the hero and the world. In another sense, the movie portrays Forrest as liberated by his simplicity. Unlike Chance Gardener in *Being There*, Forrest is not a cipher, a man so vacant that people can read anything they want into him. Forrest's simplicity is a form of integrity. He remains true to himself, even when he appears ridiculous. The mismatch of perceptions between the hero and the political and cultural leaders he encounters allows the movie to poke fun at the powerful and add an element of whimsy to the political events and iconic, often disturbing pictures that mark history in the age of the modern media.

In real life, politicians hope to be photographed with their famous forebears. Bill Clinton, for example, repeatedly used the picture of himself as a young man shaking hands with President Kennedy as part of his campaign imagery. When Forrest Gump meets Kennedy as a member of the All-American Football team, and the president asks him how he feels, all Forrest can say (after drinking numerous bottles of soda at the reception) is "I gotta pee." Later, when Forrest meets Richard Nixon as a member of the U.S. Ping-Pong team, Nixon offers to put him up in a better hotel, which turns out to be the Watergate. Forrest sees the flashlights of the Watergate burglars and alerts the front desk about the break in. By quirk of fate, Forrest is also the source of a host of pop culture innovations ranging from Elvis Presley's gyrations to the smiley-face logo.

The parable of the wise fool runs through fairy tales, Shakespeare, and the novel (reaching back to Cervantes' *Don Quixote*

and Dostoyevsky's *Idiot* to Harper Lee's *To Kill a Mockingbird*). Through the vehicle of the idiot or fool, the author casts a critical eye on the certitudes of civilization and the pretenses of society. Beyond these literary parallels, Forrest Gump embodies many qualities of the American hero, which are presented in a simpler, purer form. Forrest is the underdog who makes good, a compassionate civic actor who, even though he is named after a Southern Civil War hero, stands on the right side of the civil rights movement. Like the maverick and action heroes, running is one of the ways Forrest makes his mark in the world. Simple-minded though he is, Forrest's talent as a runner leads him to be a high school and college football star, a hero in Vietnam (where he rushes to carry the wounded from the battlefield), and later a folk hero who runs back and forth across the country for three years inspiring other citizens to join in. "Run, Forrest, run," are the words his childhood friend Jenny uses to spark him to run away from bullies as child, but running becomes a life force, the means by which Forrest transcends his circumstances.

Forrest is also the narrator of his story, and this gives him a sense of command that belies his simplicity. As he sits on a park bench and talks to different people, the movie shows his life in flashbacks, with Forrest's narration as a voice-over. His stories reprise themes we have seen in other movies, such as the citizen-soldier and virtuous veteran of the Vietnam era. When Forrest is sent to Vietnam, he observes, "Now I don't know much about anything, but I think some of America's finest best young men served in this war." Forrest earns a Medal of Honor in Vietnam, but like most war heroes from the movies, he does not prize medals, but cares only about the deeper bonds he has forged with his fellow soldiers.

Another central theme of American movies reiterated in *Forrest Gump* is the nostalgic portrayal of home. Just as in *It's a Wonderful Life* and *The Wizard of Oz*, home is a haven. As an American everyman, Forrest must leave home, but the return home is an essential component of the American myth. It answers the often-elusive yearning for a sense of place in a rootless, often alien society. Before Forrest's best friend Bubba dies in Vietnam, he tells

Forrest: "I want to go home." Later in the movie, when Forrest decides to stop his cross-country runs, he says to his motley band of followers, "I'm pretty tired. Think I'll go home now."

The idealization of motherhood parallels the idealization of home. Forrest comes from a loving home, and, after his mother dies, Forrest recreates a loving home by marrying his sick and wayward childhood sweetheart Jenny and raising their son. The meaning of home comes full circle as Forrest waits for the yellow school bus and watches his son get on board just as his mother did for him when he was a boy. The pure unabashed expression of sentiment and feeling and the unapologetic embrace of home as an anchor of identity in *Forrest Gump* illustrate how effectively movies are a counterpoint to the coolly detached, intensely self-conscious stance of the photo-op mentality and its unmoored sense of selfhood.

The nostalgia for home is also a central theme in *Saving Private Ryan* (1998, directed by Steven Spielberg), with Tom Hanks once again playing the leading role, this time as a noble citizen soldier, Capt. John Miller. After D-Day, Miller's mission is to lead a small group of soldiers to search for and help bring home Private Ryan (Matt Damon), whom the military believes is the sole surviving brother among four who enlisted to fight in World War II. The mission is difficult and dangerous because Captain Miller and his men must risk their lives traversing battlefields across the Normandy countryside to save a man whose location is unknown, whom they do not know, and who may not be alive. After several of Miller's men are killed and their efforts to find Ryan seem futile, Miller's troops rebel and want to abandon the mission.

Miller rallies them to the cause by evoking the image of home. The men have only known Miller as a tough, brave, and resourceful soldier who led his troops up Omaha Beach (the horror and bloodshed, the enormous loss of life in the D-Day landing, is presented by director Steven Spielberg in unsparing, searing, and graphic detail). Miller's men know nothing about Miller's background and amuse themselves by creating a betting pool, guessing what he does back home. In revealing his identity,

Miller connects the men to the reason they are fighting the war, and his speech reconnects the film's audience to the virtues of the plainspoken citizen hero in the tradition of Jimmy Stewart and Gary Cooper:

> I'm a schoolteacher. I teach English composition in this little town called Addley, Pennsylvania. The last eleven years, I've been at Thomas Alva Edison High School. I was the coach of the baseball team in the springtime. Back home I tell people what I do for a living, and they think, well, that figures, but over here it's a big mystery. So I guess I've changed some. Sometimes I wonder if I've changed so much that my wife is even going to recognize me whenever it is that I get back to her—how I'll ever be able to tell her about days like today. Ryan, I don't know anything about Ryan, I don't care. The man means nothing to me; it's just a name. But if going to Ramelle and finding him so he can go home, if that earns me the right to get back to my wife then, that's my mission . . . just know that every man I kill, the farther away from home I feel.

Home is a simple yet resonant symbol. It is not just a place but also a way of being in the world that the war has torn asunder. As the men renew their quest for Private Ryan, the movie takes us closer and closer to the memory of home as the touchstone for goodness and decency. Once they find Ryan, Ryan refuses to go home and insists on staying with his unit (the only "brothers" he has now) to defend a bridge in an upcoming battle. Captain Miller and his confidant Sergeant Horvath deliberate what to do, and Horvath reflects: "Some day we might look back on this and decide that saving Private Ryan was the one decent thing we were able to pull out of this whole God-awful shitty mess. . . . Like you said Captain, if we do that, we all earn the right to go home."

The idea of "earning the right to go home" suggests that home stands for a set of virtues that are the measure of one's life, virtues that must be reclaimed. When Ryan tells Miller he is having trouble remembering his brother's faces, Miller evokes the simple

poetry of everyday life: "When I think of home I think of something specific. I think of my hammock in the backyard or my wife pruning the rose bushes in a pair of my old work gloves." This gets Ryan to begin to reminisce and laugh about the antics of his brothers, but as the time of battle approaches, Ryan tries to get Miller to talk again about home: "Tell me about your wife and those rose bushes?" Miller answers, "No. No that one I save just for me."

Miller, who embodies all the virtues of the citizen soldier, does not get to return home. As he is dying, he draws Private Ryan close to him, and says, "James. Earn this. Earn it." This dialogue reveals how closely connected the citizen hero is to the portrayal of patriotism in American movies. Through the portrayal of the self-effacing citizen hero, patriotism does not call attention to itself or call itself by name. It unfolds in the stories of particular individuals. The home front and the battlefront are connected because acts of courage on the battlefield are connected to acts of goodness in everyday life. Spielberg makes this connection clear by beginning and ending *Saving Private Ryan* with the elderly Ryan visiting Miller's grave at Normandy accompanied by his family. As Ryan stands at Miller's gravesite, he tearfully asks his wife if he has been a good man and lived up to what Miller hoped for him. The camera then moves in for a close-up of the simple white cross that marks Miller's grave. The last image of the movie, like the first, is an American flag filling the screen. The flag is at once part of the memorial for the fallen and a symbol of courage and redemption.

World War II provided the movies with a noble cause from which to cast their heroes. Today, the Iraq War and the "war on terror" present new challenges for the movies and other media. The popular television series *24* (created by Joel Surnow and Robert Cochran and starring Kiefer Sutherland as Jack Bauer) provides a dramatic example of how the maverick hero is brought into the age of terrorism, transcending political controversies and drawing in audiences from across the political spectrum.

## The Hero in the Age of Global Terror

As Frank Capra's Jefferson Smith brought an earnest idealism to combat political corruption, Jack Bauer brings the dark arts of counterterrorism to combat enemies of the United States bent on its destruction. Despite his grim methods, Jack Bauer is an appealing hero. That might seem like a strange thing to say about a guy who doesn't flinch from hacking off the head of a dead terrorist, or tormenting another with a video image of his young son being killed, or knocking out his bosses when they question the brutality and legality of his techniques. But to understand Jack Bauer, we have to separate the methods from the man.

Jack Bauer has many of the virtues of the citizen hero, the military hero, the cop hero, and even the superhero. He's John Wayne's cowboy, Clint Eastwood's cop, Tom Hanks's noble soldier, and Daniel Craig's coolly stoic James Bond all rolled into one. Despite his toughness and grit, Jack Bauer has a lot of heart and sensitivity. Like Harrison Ford in *Air Force One* and Tom Hanks in *Saving Private Ryan,* Jack is a devoted family man. But Jack's family life plays out in episode after episode, year after year as an intimate television drama with many unexpected and agonizing twists.

In the world of *24*, the sensitive Jack is a counterpoint to Jack the counterterrorist. Yes, Jack Bauer uses torture, and it works. The terrorists' plots are foiled, Jack's methods are vindicated, and he dares to take risks no one else does. Torture also works because the producers of *24* have created a likable and contemporary hero, a man who is not summed up by what he is forced to do. Jack Bauer is portrayed as a good man who has to use violent techniques, a family man whose job often takes over, and a noble man ready to sacrifice for his country. He is the quintessential maverick for the age of global terror with a backstory a lot of people can relate to.

In the first season of *24*, the audience is introduced to Jack as a concerned father and loving husband who faces the same prob-

lems everybody else does. We see him in his modest suburban home wearing a t-shirt and playing chess with his teenage daughter Kim (Elisha Cuthbert). The scene establishes that he had been separated from his family, but is now back in the fold. When Kim says something snippy to her mother, Jack supports his wife Teri (Leslie Hope). After Kim goes to bed, Jack kisses Teri's head and massages her shoulders. When Teri complains that Jack lets Kim manipulate him, he listens attentively. "Hey. Maybe you're right," he quickly concedes, and follows with words that would win instant approval from Oprah or Dr. Phil. "Maybe we should talk to her right now. Tell her not to play us off each other, and that if she's insulting you, she's insulting me too."

This being the world of *24*, high drama trumps domestic bliss. The home life Jack cherishes is soon torn asunder when terrorists kidnap his wife and daughter and his wife is later killed by co-worker Nina Myers (Sarah Clarke), who is collaborating with the terrorists. The crisscrossing of Jack Bauer's role as maverick, citizen hero, and family man continues as the story unfolds. In the second season, for example, a terrorist plot to blow up Los Angeles with a nuclear bomb is foiled, but the nuclear device cannot be defused. Jack assures the president by phone that he has a few volunteers for a suicide mission to drop the bomb over the desert. Jack's colleague George Mason (Xander Berkeley) remarks, "Funny, I don't see any volunteers. When was the last time you flew a plane?" Jack responds in the laconic can-do style of the classic maverick hero, "I can get it in the air and put it down where it needs to go, George."

All the trappings of the mythic mission of the maverick come into play. Jack is the lone hero in a small propeller plane taking off from the airport, the music swells, the camera cuts away to the president not yet aware that his go-to man is preparing to sacrifice his life. But Jack Bauer is not the typical loner, the maverick who defends the community but lacks a family of his own. Jack is a modern dad who wants to stay in touch with his kid, and so an essential part of the drama is Jack's emotional conversation with his daughter Kim by phone from the plane:

JACK: Sweetheart, there's something I've got to tell you. it's gonna be hard for you to hear, I need you to stick with me, okay.

KIM: Wha—uh—

JACK: We found the bomb. It was wired in a way that made it impossible to defuse it. We needed someone to fly it over the desert so when the bomb exploded nobody would get killed. That someone turned out to be me.

KIM: How are you getting off the plane?

JACK: I'm not, sweetheart. The bomb has to be dropped in a very specific area. There was no other choice. I'm sorry.

KIM [with tears in her eyes then spilling down her cheeks as she sobs]: But—Dad—but but—No! No you can't do this to me!

The parable of the tale is that he will not do this to her. At the eleventh hour his colleague George Mason steps in. Mason, who is going to die soon from radiation poisoning, has stolen aboard the plane, and he comes out from hiding to argue that Jack should parachute out and let him fly the last part of the mission. He convinces Jack to abandon the role of the classic hero by delivering a homily about the family values a modern hero should embrace:

Come on Jack. You've had a death wish ever since Teri died. The way things have been going for you the past year and a half this probably doesn't look like such a bad idea. Get to go out in a blaze of glory, one of the greatest heroes of all time, leave your troubles behind. This could be the easy way out, huh? You've still got a life, Jack. You want to be a real hero? Here's what you do. You get back down there and you put the pieces together. You find a way to forgive yourself for what happened to your wife. You make things right with your daughter, and you go on serving your country. That'd take some real guts.

Jack Bauer lives to fight another day, and 24 continues to weave a taut drama of virtue and violence that make the scenes of tor-

ture palatable, even forgivable. The uncompromising, tough-on-terror stance of the show's maverick hero is a satisfying fantasy in a world in which Americans seldom see their government catching terrorists, much less with such verve. The satisfaction of the fantasy is deepened because the show seamlessly incorporates so many core American values—individualism, patriotism, love of family, and defense of home and country. These values are part of the deeper cultural script that I described at the beginning of this chapter—a script that explains why Americans see themselves as the good guys and not (as other nations sometimes do) as an overbearing superpower.

# CHAPTER 6

# The Person and the Pose

Today we are aware, as never before, of the artifice that constitutes the pose. We are as fascinated by how images are made as we are by what they mean. In popular culture, politics, and everyday life we have elevated the image-making process to a subject in its own right. In some moods we are connoisseurs of the slickly produced image, whether in political ads, celebrity photos, or popular movies. In other moods we are outraged by the distortions and deceits that images purvey.

Fascinated though we are with the process of image making, another side of us believes in the images we see. This belief stems from the fact that images are bearers of meanings, enduring carriers of ideals and myths. It also stems from our continuing confidence in the camera's ability to reveal a deeper truth, to move beyond the surface, to record reality and document facts.

America's photo-op culture plays out in heightened form the tension between the person and the pose, between the claims of the subject and meanings attached to the photograph by the photographer and viewers. But beyond photo ops, this tension is part of every photograph. The photograph converts the subject from an active state to stillness. A photograph is even called a still. Although the person may of course have been in movement, she or he is caught in a moment of time, and will be forever. The word *pose* is connected to repose, to be at rest.

The pose is not necessarily what the person in the photo is doing. A person may be running, working, fighting, talking to friends, mourning, pausing to reflect, or staring off into space. The photograph takes all this free play of movement and feeling

and freezes it. In this sense, the pose converts the person into a captive. The capture can be captivating and transcendent or it can be a trap. The caption of the photograph is another form of capture. It too can be illuminating or like putting up a sign on the cage of an animal in the zoo.

If the opposite of capture is freedom, the act of taking photographs can impinge on the freedom of the subject. What freedom is at stake? It is not the freedom of movement; the subject can keep moving through the world. It is the freedom to interpret one's own action and being. What the photograph captures by freezing the frame is an interpretation, an interpretation that the subject of the photograph may or may not share.

What's really at stake in the contest for the control of the image is the ability to interpret the meaning of the person or moment captured in the frame. We use the word frame in relation to photographs, but we also use it to describe framing a question, an argument, or debate. To frame an issue is to exercise some interpretive power. Being framed is having an interpretation placed on your action that might be false—like being framed for a crime you did not commit. But it need not be false in this respect. It is a way of seeing that can convey great affection, as when Humphrey Bogart says to Ingrid Bergman in *Casablanca*: "Here's looking at you, kid."

Once you are in the frame, once you exist in a photograph, you are subject to the gaze of others, who may or may not know you, understand you, or be sympathetic to you. That's why the public-private divide is so delicate and elusive when it comes to photographs. Some photographs capture the very essence of a family member or friend so deeply that we share them only with intimates. Roland Barthes gives a powerful testimonial to this view of the photograph in his book *Camera Lucida*. Barthes includes a number of photographs, but there is one photograph he does not show, and that is the one he treasures most. Its discovery is an epiphany:

> There I was, alone in the apartment where she had died, looking at these pictures of my mother, one by one, under

the lamp, gradually moving back in time with her, looking for the truth of the face I had loved. And I found it.

The photograph was very old. The corners were blunted from having been pasted into an album, the sepia print had faded, and the picture just managed to show two children standing together at the end of a little wooden bridge in a glassed-in conservatory, what was called a Winter Garden in those days. My mother was five at the time (1898) her brother seven . . . you could tell that the photographer had said, "Step forward a little so we can see you"; . . .

I studied the little girl and at last rediscovered my mother. The distinctness of her face, the naïve attitude of her hands, the place she had docilely taken without either showing or hiding herself, and finally her expression, which distinguished her . . . all this had transformed the photographic pose into that untenable paradox which she had nonetheless maintained all her life: the assertion of gentleness. In this little girl's image I saw the kindness which had formed her being immediately and forever, without her having inherited it from anyone. . . . my grief wanted a just image, an image which would be both justice and accuracy . . . [the other photographs] were merely analogical, provoking only her identity, not her truth; but the Winter Garden Photograph was indeed essential, it achieved for me . . . *the impossible science of the unique being.* . . . a radiant irreducible core . . . the grace of being an individual soul.[1]

Barthes does not share the photograph with his readers, because he says, "For you, it would be nothing but an indifferent picture, one of the thousand manifestations of the 'ordinary,'" perhaps interesting for the "period" and "clothes" but it would have no deeper meaning.[2] Each of us makes similar decisions about where we draw the line between public and private in how we share and display our family pictures. For some, all pictures are front-room pictures. They are displayed for everybody to see—the plumber, the dishwasher repairman, relatives, or close friends. For others, special family photographs are reserved for

the rooms where family and friends gather—dens, studies, family rooms, bedrooms, or the hallways or stairways away from general view. The family album is not for everyone. The treasured pose has a very private meaning.

The intimacy inherent in every portrait, the knowledge that there is a person in the pose, however obvious, is easy to forget. When we look at photographs—especially photographs displayed for public view in newspapers, magazines, and on the Internet— the subject comes to us with a sense of immediacy and reality that seems independent of art. This is one of the distinctive qualities of photography as opposed to painting, drawing, or sculpture. The paint, pencil marks, or stone remind us of the artist's hand. But a photograph has a way of hiding the hand that forms the image. Even the most sophisticated among us can fall into thinking and talking about photographs as unmediated reality.

The less we know of a person or place, the more readily we accept the picture as an authentic representation. Our eye is more alive to the nuances of interpretation when we are familiar with the subject. Straightforward as photographs appear to be, they are also palimpsests. We have to dig for the layers of meaning just as archaeologists dig beneath the surface to discover the layers of cities and structures buried below. The framing of the photo-graph can be a way of documenting the facts, interpreting the world, arguing, editorializing, or simply fabricating. The contest for the control of the image is not just between politicians and the media, celebrities and paparazzi, or between partisans of com-peting YouTube videos; it is endemic to picture taking.

## Still Lives

Few people have ever heard of Florence Owen Thompson and Sharbat Gula, but almost everybody has seen their faces. Each is the subject of a photograph that has become an icon. Florence Thompson is the "Migrant Mother," the pensive, weary-eyed Ma-donna with her huddled children whose photograph by Dorothea Lange (first published in 1936) became the symbol of Depression-

era America. Sharbat Gula is the "Afghan Girl" whose photo-graph by Steve McCurry appeared on the cover of *National Geographic* in 1985 and became a symbol of the plight of refugees everywhere.[3] With her intense green eyes and transcendent beauty poised on the edge of womanhood, she looks directly at us, her innocence betrayed by her circumstances. Both photographers bring out the dignity of their subjects. Although they asked permission to take the photographs, they did not ask their names. In fact, the names and fates of Migrant Mother and the Afghan Girl remained unknown for many years after their faces became famous. The individual was lost in the icon.

Florence Thompson was roiled by the notoriety of her iconic image throughout her life. For some forty years she remained anonymous even as she was proclaimed "immortal" and the "ultimate" expression of Depression-era America.[4] She watched as her image was reproduced in countless books, posters, calendars, and postcards. Finally she spoke out and told her story to her local California paper, the *Modesto Bee*. The story was picked up by the Associated Press under the title, "Woman Fighting Mad over Famous Depression Photo." In the AP story, Thompson rued her encounter with Dorothea Lange: "I wish she hadn't taken my picture." [She] "didn't ask my name. She said she wouldn't sell the pictures. She said she'd send me a copy. She never did."[5]

Dorothea Lange, who was usually scrupulous about documenting her photographs, had been rushed when she photographed Florence Thompson and her children on a dark and drizzling day in a migrant pea-pickers' campsite in Nipomo, California. She took a handful of pictures of Thompson and her children and left after ten minutes. After Lange took the pictures she jotted in her field notes that the hungry family "had just sold their tires to buy food."[6] Lange sent the photographs to Washington and federal officials rushed 20,000 pounds of food to the pea-picker camp in Nipomo. Thompson's "life [was] most likely saved by Lange's photo," a curator noted in a catalogue to a twenty-first-century exhibition of Dorothea Lange's photographs, but Florence Thompson and her family never received any aid. They had not sold their tires either, which remained firmly affixed to

their car when they drove away from the pea-pickers' camp long before the government's food arrived. The family never saw Dorothea Lange again nor did they ever receive any form of monetary compensation for the picture.

Florence Thompson resented being summed up in one image. She was more than the face of the Depression, but in the world's family album she was fixed in that moment in time. "Mother was a woman who loved to enjoy life, who loved her children. . . . She loved music and she loved to dance. When I look at that photo of mother, it saddens me. That's not how I like to remember her," observed one of her children. It was only when Thompson was gravely ill at the age of seventy-nine, and her children issued a plea to the public to raise funds to nurse her back to health, that she and her family came to realize the impact of the photograph. Letters and contributions poured in from all over the country. A woman from Santa Clara wrote: "The famous picture of your mother for years gave me great strength, pride and dignity—only because she exuded those qualities so." An elderly woman from the Central Valley wrote, "I promised the Lord if I won any money in Reno that I would send you some. I wish I could send some more, but this is all I was given." "None of us ever really understood how deeply Mama's photo affected people," reflected her son Troy Owens. "I guess we had only looked at it from our perspective. . . . After all those letters came in, I think it gave us a sense of pride."[7]

Dorothea Lange once wrote: "While there is perhaps a province in which the photograph can tell us nothing more than what we see with our own eyes, there is another in which it proves to us how little our eyes permit us to see."[8] Iconic photographs often contain much our eyes do not see, including indignities the subjects of the photos may suffer far from public view. When the U.S. Postal Service issued a Migrant Mother stamp over a decade after Florence Thompson's death, her children, friends, and coworkers celebrated the event. But when the family was invited to attend the unveiling in Cleveland, they were not asked to tell their mother's story. All the attention at the event was focused on an-

other new stamp—of Superman.⁹ Even the Madonna of the Depression could not compete with a superhero.

The story of Sharbat Gula and her relation to her world-famous photograph known as the "Afghan Girl" could not be more different from the story of Florence Thompson. Sharbat Gula never saw her iconic picture, even though the photo was hanging in a shop near where her husband worked. A member of the Pashtun tribe, she was married not long after the photograph was taken. She carved out a life with her children in the harsh, drought-ridden hills of Tora Bora in her native Afghanistan, while her husband spent much of his time working in a bakery for a dollar a day in Peshawar, Pakistan. Sharbat could join him in the city only in the winter months because the heat and pollution of Peshawar aggravated her asthma. Most of the time she remained in her village, rising before sunrise, praying, fetching water from a stream, cooking, cleaning, and caring for her children.

In 2002, seventeen years after Steve McCurry took Sharbat Gula's photograph, he returned with a National Geographic *Explorer* television and film team to the refugee camp to find her. Cutting-edge technology was employed in the search. A Massachusetts company called Visage electronically loaded McCurry's original photograph so that the facial structure of candidates could be compared. A forensic expert at the National Center for Missing and Exploited Children aged the original picture to give people an idea of what she would look like as an adult.¹⁰ After some false leads, a man who as a child was in the same refugee camp recognized the girl in the picture. He offered to bring her back from her village. As the *National Geographic* magazine account reveals, "Her village was a six-hour drive and three-hour hike across a border that swallows lives. When McCurry saw her walk into the room, he thought to himself: This is her."

Steve McCurry had first seen Sharbat Gula as a twelve-year-old orphan of war-ravaged Afghanistan. Her parents had been killed by Soviet bombs when she was six. Now as she once more posed for the camera she was a married woman of around twenty-nine, wearing a deep purple burqa, the veil lifted to reveal her face now weathered with time and suffering. She had not been photo-

graphed since the famous photo. Her eyes are still intense. In fact, her identity was later confirmed through iris recognition technology; the colored parts of the eye are as unique as fingerprints.

The reunion between McCurry and Sharbat Gula was quiet. He showed her the famous picture. Looking at her girlish image, she was embarrassed by the holes in her red shawl, burned by a cooking fire. She remembered being angry that her picture was taken. Otherwise, the famous picture did not move or interest her that much. What did one photograph matter to a devout Muslim woman who still had her life to live, who lived in a culture in which married women "vanish from the public eye" and do not have their pictures taken by strangers? With her husband's approval, Sharbat Gula agreed to have her picture taken once again.[11] National Geographic offered to help educate her girls, establish a school for girls in Afghanistan, and provide general financial assistance to her family. With the reemergence of the Taliban in Afghanistan, the recent breakthroughs in public education are under threat. Girls' schools have been shut down, even set on fire. One wonders about the fates of the girls whose mother was in the famous picture.

By quirk of fate individuals become icons, without choosing to be actors, their identity forever bound to a photograph they did not create. For their part, photographers become bound to their subjects in unanticipated ways, morally implicated, drawn into their lives, answerable to the public that views and interprets the photograph. At one and the same time an iconic picture is a fait accompli and an unfinished story. Joe Rosenthal's World War II photograph of the flag raising on Iwo Jima stands as an embodiment of American patriotism and courage amid adversity, yet Rosenthal was falsely accused of staging the flag raising; three of the men in the photo died fighting on Iwo Jima, and three others became reluctant heroes enlisted for the War Bond campaign back home.

The Iwo Jima photograph and its aftermath has been the subject of many accounts, most recently *Flags of Our Fathers* (2006), directed by Clint Eastwood. Eastwood's movie (based on the best-selling book of the same title) gives voice to the anguish and

alienation of the men caught in the iconic photograph, who resisted being called heroes for "putting up a pole." By moving back and forth between scenes of the actual battle and reenactments of the flag raising at war bond rallies, Eastwood provides a searing contrast between the desolate bloodied landscape of Iwo Jima and the event as a performance and photo op. "Every jackass thinks he knows what war is," notes the narrator of the film, "especially those who've never been in one. . . . Most guys I knew would never talk about what happened over there, probably because they were trying to forget it. They certainly didn't think of themselves as heroes. They died without glory. Nobody has taken their pictures."

An iconic photograph of a very different and more searing nature is Nick Ut's picture of a nine-year-old Vietnamese girl running naked down a road, burned by an accidental napalm attack. It was taken on June 8, 1972, and released worldwide one day later after editorial debate about showing her naked. (She had thrown off her burning clothes before the photograph was taken.) The photograph has been described as "a rupture, a tearing open of established narratives of justified military action, moral constraint, and national purpose."[12] Some viewers of the photograph mistakenly thought U.S. planes were responsible for the accidental napalm attack on civilians. The accident actually resulted from a South Vietnamese military attack on the North Vietnamese. Others came to see the photo as marking a turning point in public opinion, but a majority of Americans had already turned against the war by 1972.

Whatever political and interpretive framework viewers bring to the photograph, it stands as an icon of war's tragic indifference to the fate of innocent bystanders. Children who should be sheltered and protected are instead victims running on a road toward us, like the naked little girl in the center of the frame, waving her arms helplessly against the ominous background of dark clouds of smoke and napalm. Although we cannot as viewers change what has happened to her, we are summoned by her pain to witness and respond.

Kim Phuc, the little girl in the photograph, forged a life that transcended that searing moment and its long aftermath of suffering. Photographer Nick Ut and other journalists rushed her to a local hospital and later lobbied for the best medical care in specialized hospitals. Grateful to the doctors who saved her life, she dreamed of becoming a doctor herself. In 1982, she was admitted to medical school in Saigon, but when the government learned she was the girl in the picture, they asked her to work with them and become their symbol. When Kim Phuc protested, "Let me study. I don't want to do anything else," she was denied the opportunity to enter medical school. She moved to Canada with her husband and family and has toured the world as an emissary for peace with UNESCO since 1997. "It is not easy to love one's enemies," she reflected. "I could have reacted with hatred and a desire for revenge. That would have been 'normal.' But I chose to understand. That takes time." When she speaks publicly, she does not shy away from sharing the iconic photograph. "I want my experience to serve a purpose. I was burned because of war. . . . War causes nothing but suffering. That's why I show the little girl in the picture. Because she tells my story and the consequences war has had on my life. No father or mother in the world wants what happened in that picture to happen again."[13]

The relation of individual to icon is inevitably complex. What if the person in the picture wants the photograph withdrawn from public view? How far should the rights of the subject extend? Should the sentiments of the subject, however worthy, trump the public good served by a photograph? An interesting case arose in connection with another iconic photograph of the twentieth century, "Tomoko Is Bathed by Her Mother." The intimacy and power of Eugene Smith's 1971 picture—distinctly Japanese in feeling, yet resonant of the pietà—made the photograph an emblem for the fight against industrial pollution. In Minamata, Japan, Tomoko's mother holds the frail body of her daughter, which is ravaged by a congenital disease caused by mercury pollution. The photograph appeared in *Life* magazine, a book of photographs documenting the Minamata disaster, and many other places.

Like "Migrant Mother" and "Afghan Girl," the photograph was taken with the permission of the subjects. But after their daughter died six years later, Tomoko's parents were deeply conflicted. The picture had helped the plaintiffs (their daughter among them) win their case against the Chisso Company for the mercury pollution. Yet after their daughter's death they wanted her to rest in peace. They no longer wanted her photograph to be circulated, even though it was still helping to raise world consciousness about the tragic consequences of industrial pollution. Years later, when Tomoko's parents' dilemma came to the attention of Eugene Smith's widow, Aileen Mioko Smith, she decided to take action. As the copyright holder of the image, she wrote in a letter:

> Generally, the copyright of a photograph belongs to the person who took it, but the model also has rights and I feel that it is important to respect other people's rights and feelings. Therefore, I went to the Uemura family on June 7, 1998 and promised that the photograph in question would no longer be used for publication or exhibition. ... In addition, I would be grateful if any museums, etc. who already own or are displaying the work would take the above consideration before showing the work in the future.[14]

The dilemma of who controls the image extends beyond famous faces. What if you are not an icon, but an ordinary soldier? What rights, if any, should a soldier have over the use of his or her image? In times of war, how does one balance the public's right to know and a soldier's right to privacy? During the first years of the Iraq War, photographs of the wounded could be published after the family was notified, but in 2006, the U.S. military tightened the restrictions. Embedded journalists had to sign an agreement that stated that they would not release "identifiable photographs of wounded service members" without their "prior written consent." Furthermore: "In respect for family members, names or images clearly identifying individuals 'killed in action' will not be released." The military rules specified that the names of soldiers killed could be released a day after the family was officially notified.[15]

These new rules put journalists in a "Catch 22" situation: They could not take photographs of wounded soldiers without their consent, but to ask for their consent beforehand was virtually impossible. As Ashley Gilbertson, a veteran freelance photographer of the Iraq conflict put it: "They are basically asking me to stand in front of a unit before I go out with them and say that in the event that they are wounded, I would like their consent. We are already viewed by some as bloodsucking vultures, and making that kind of announcement would make you an immediate bad luck charm."[16] He went on to say, "They are not letting us cover the reality of war. I think this has got little to do with families or the soldiers and everything to do with politics."[17]

Yet, some soldiers want to shield their families from knowing they are wounded, and families have objected to seeing pictures of their wounded sons and daughters in the newspaper or in Internet videos. In January of 2007, a photograph and video of a mortally wounded Texas soldier published in the *New York Times* upset relatives and army personnel. The immediate family made no public comment, but a cousin who had not seen the images said the pictures would "devastate the grieving parents." Army Col. Dan Baggio, chief of media relations at the Pentagon who served fourteen months in Iraq, observed, "From a soldier's perspective, when I first saw it, I was stunned. With the freshness of the loss the family has endured, this just seemed inappropriate."[18]

News organizations are faced with such dilemmas whenever they cover wars. Tom Rosenstiel, director for the Project for Excellence in Journalism, argues, "The fact that a photograph upsets people, even family members, is not always sufficient reason not to run it. Editors may decide that there is a compelling public interest in running a photograph precisely because it does upset an audience."[19] In response to the controversy about the mortally wounded soldier, *Times* foreign editor Susan Chira noted that, "The *Times* is extremely sensitive to the loss suffered by families when loved ones are killed in Iraq. We have tried to write about the inevitable loss with extreme compassion."[20]

Journalists and other critics of restrictions on photographing the wounded and dead also argue that it is part of a larger pattern

of government control and censorship of images. Since the first Gulf War in 1991, the media has been banned from showing the flag-draped coffins at Dover Air Force Base. During the Vietnam War the flag-draped coffins were a common and troubling sight on network evening newscasts. Even before the Iraq War began, the government tightened the Dover Air Force Base restriction to apply to all military installations around the world. President George W. Bush has not attended any military funerals for the fallen, preferring to convey his condolences privately to the families. One could ask: Why is it that the Italian government held a state funeral, including the display of flag-draped coffins, when their soldiers were killed in a suicide bombing in Iraq, but in the United States journalists are not allowed to take pictures of the flag-draped coffins? Is the government just being sensitive to the needs of the families to privately mourn, as the Bush administration claimed, or is it trying to control these pictures to avoid reminding Americans of the high death toll in Iraq?

One thing is clear. Neither the military nor journalists like to show photographs of men killed in action. Veteran war photographer David Douglas Duncan, renowned for his coverage of World War II, the Korean and Vietnam Wars, and other conflicts, observed that his first commitment was to the humanity of the soldiers: "I felt no sense of mission as a combat photographer. I just felt maybe the guys out there deserved being photographed just the way they are, whether they are running scared, or showing courage, or diving into a hole, or talking and laughing. And I think I did bring a sense of dignity to the battlefield. My only rule: I never photographed the face of the dead, ever, out of respect for the families."[21]

This is a powerful principle, but in recent times it has not always been observed. When the leader of Al Qaeda in Iraq, Abu Musab al-Zarqawi, was killed by American forces in a bombing raid, a photograph of his dead body with a close-up of his bloodied face was displayed on the front pages of most major American newspapers, including the *Washington Post*, the *Los Angeles Times*, and the *New York Times*. The photo opportunity was elaborately staged by the American military, and many papers ran a photo-

graph that called attention to this fact. The photograph shows a large, carefully matted, framed picture of the dead Zarqawi propped on a stand as if it is part of a museum exhibit. To the left of the picture we see a soldier carrying away another framed photograph of Zarqawi, which shows him confidently looking into the camera dressed in black and holding a machine gun (the picture was clearly taken by Zarqawi's people). The backdrop to the "before" and "after" photographs is a half-pulled curtain and an American flag.

The fact that this picture was displayed on the front page of so many American papers seems contrary to the values that military officials and journalists espouse. Why are they collaborating in this photo op? One argument the U.S. government and military have used since the Iraq War began is that the Iraqi people, long acclimated to the deceits of a dictatorial society, will not believe their enemies are dead until they have seen indisputable proof, and pictures provide that proof. If we assume for the sake of argument that this is a sufficient rationale for displaying the picture in Iraq, there is the further question: Why print the picture in American papers? Journalists and the military consider it a matter of principle not to show the faces of soldiers killed in action. Do we have one standard for ourselves, and another for the enemy? And what does it say about us that we do not treat enemy dead with dignity and respect?

Looking at the front-page pictures of Zarqawi in American newspapers I was struck by something else. The tabloids tended to run a different picture. They showed no fancy frame, no matting, nor any of the niceties and self-conscious staging employed by the military and captured in the more high-minded papers, just a giant close-up of Zarqawi's bloodied face. The *New York Daily News*, for example, ran the picture under the headline "Smoked!" Even the *Stars and Stripes* Middle East edition (not a tabloid but a Department of Defense authorized military newspaper distributed oversees) showed the same giant close-up with the headline, "Al-Zarqawi Dead."[22]

That the tabloids showed a shocking image is no surprise; that, after all, is their stock in trade. But what about the other newspa-

pers? Did the fact that they pulled back to show the framed and matted picture lessen their complicity in this photo op of death? Just as calling attention to a photo op does not necessarily diminish its hold or puncture the meaning it conveys, so showing a framed picture of Zarqawi does not exonerate the military or journalists from being purveyors of a gruesome spectacle. A similar photograph of death was displayed more recently on the front page of the *New York Times* after a top operational commander of the Taliban, Mullah Dadullah, was killed by American forces. His bloodied, half-clothed body is laid out awkwardly on a hospital gurney half draped by a pink hospital sheet. His face is recognizable and in repose. Poised behind the dead man's body is a group of Western and Afghani photographers taking pictures.[23] The same question can be asked of this photograph as can be asked of the Zarqawi photos. Does the fact that the *Times* photographer is taking a picture of photographers taking pictures of the dead Taliban leader diminish the *Times*'s complicity in displaying the dead man's body?

## Stealing the Soul

One of the problems intrinsic to picture taking is that it is easy to fall into treating someone as an object. Most of us have had some experience of this when we are tourists. We start taking pictures of people in foreign and exotic settings or even places closer to home without bothering to ask permission or thinking about how the person might feel. But when the situation is reversed, and a tourist or stranger takes our picture, we sometimes have a catch. A friend of mine felt such a catch when she was with her kids on a playground in New York City near their home. A tourist came up, took pictures of her kids playing, and walked away. "Wait a minute," my friend thought, her maternal instincts on high alert. "You can't just carry images of my children away with you. I don't know who you are or what you'll do with them." And even though she tamped down her worries, it still felt like a violation.

A common story we hear about photographs is that tribal people and others unfamiliar with the ways of the modern world believe that photographs steal the soul. There may be more truth to this notion than we often suppose. The story about soul stealing is a metaphor for our mixed feelings about the photograph, our sense of enchantment and suspicion, of treasure and theft.

Part of us wants to say a photograph is just a photograph. It's an image on paper, on our cell phones, on the Internet, or in the newspaper. Our soul is not in the image. And neither is anyone else's. We want to draw a firm, bright line between the person and the picture. To talk about the soul of a photo op is an oxymoron. But in other moods we don't act that way. People kiss pictures, carry them in demonstrations, burn them, bury them, deface them, rescue them from fires and floods, and mark life's passages with them. In all of these acts our attachment to pictures goes deeper than treating them as mere images. If photographs are just images, why is it hard to throw them away? Many people hesitate to throw away even holiday card pictures. Perhaps this is because throwing away a picture can feel like a form of disrespect, as if we are throwing away the person or the memory or a treasured gift.

The idea that the photograph captures the soul, that it has transcendent, even magical properties, is not distinctive to tribal peoples. Europeans and Americans spoke in just such language in the wake of the invention of the photograph in 1839. "No enchantress' wand could be more potent to bring back the loved ones we once cherished than could those faithful resemblances wrought by this almost magic art of Daguerre," observed one nineteenth-century photographer. "For true indeed has this art been termed magic, as it works with such unerring precision . . . that it requires only the spells and incantations of the device [the camera] to complete the task."[24] In 1854, the Webster Brothers of Louisville, Kentucky, said their goal as photographers was to take pictures of loved ones in such a way that "when the eye rests on the 'shadow' of some departed friend it will become full of soul. . . . then it is that your *soul* sees the man himself, and until some heedless person calls you 'back to earth' you believe you are look-

ing on a 'thing of life.' "[25] Photographic historian Richard Rudisill observes that "the magical nature of the daguerreotype's living presence," the sense of immortality a photograph conferred, impressed the American public and conferred a spiritual dimension that other kinds of physical objects did not possess.[26]

It is not surprising, therefore, that tribal peoples initially responded to the camera with wonderment and fear. The camera was often introduced as an instrument of power and control. Responding to the fact that the camera was often accompanied by the gun, Chief Crazy Horse of the Oglala tribe refused to be photographed. He said that those who submitted to being photographed "lost the spirit of resistance."[27] Nineteenth-century accounts of "soul stealing" are deeply entangled with the way early explorers, missionaries, anthropologists, and photographers used photographs to categorize, convert, or simply to collect exotic images of native peoples. A Scotsman traveling through east Africa in 1883 on behalf of the Royal Geographic Society pretended to be a medicine man who could produce amulets that would aid Masai warriors in battle: "This I did by simply photographing them, the pretence of making *dawa* (charms) being a capital and only opportunity of transferring a likeness of the Masai to my collection."[28] As anthropologist Eric Michaels observes, "One could pursue at length the ethnographic significance of people's fear of cameras and accusations of spirit theft. Or one might simply admit that there is a certain sense to the proposition that using someone else's image, property or life as a subject to be recorded, reproduced and distributed is a kind of appropriation."[29]

Picture taking can be a form of theft, particularly when the subject does not wish to be photographed. In his 1988 book *Amish Odyssey*, photographer Bill Coleman relates the following incident about taking a picture of an Amish woman in her carriage: "I had hoped that the fog and the distance had kept me relatively anonymous. Yet when the buggy passed, a woman leaned out and said very clearly, 'You have stolen my soul.' The hurt stayed with me a long time. Though I've heard it a few times since from others, it is that woman in the fog who stays in my memory."[30]

In a 1995 *New York Times* article, "While I Wept: Did I Trade My Soul to a Man With a Camera?," James R. O'Brien talks about his mixed feelings about giving a young professional photographer permission to take his picture while he was seated weeping on a New York subway after receiving a disturbing medical report from his doctor. After the picture was taken, O'Brien recounts, "I was left with a strange empty feeling, as though something had been taken from me. . . . My question is: did I trade my soul for a chance at immortality, my picture to live forever in the collection of a famous photographer, or did I give it away for some frivolous use, my face plastered on the side of every bus in New York City as part of an ad for a new treatment for depression?"[31]

We are caught between seeing the validity of the soul-stealing stories and making claims about the right to take and show images regardless of how the subject of the photograph feels. One of the many paradoxes of photography is that it can be a vehicle both for intimacy and estrangement, sympathetic understanding and objectification. Photographs present themselves as facts, but when we look at photographs we need to be reminded, as art critic Jed Perl astutely observes, "of a particular person's relationship with the facts—and that is finally an ethical relationship. . . . When the work of photographer holds us, there is always an ease about observing the world, a steadiness that has nothing to do with complacency, and you can find this in work that is joyous or grim, maximalist or minimalist."[32]

In the photo-op culture, a reluctance to be photographed can seem like an act of bad sportsmanship. People sometimes express impatience with politicians or celebrities who ask that parts of their private life remain private, who try to evade the camera's eye. Sometimes we think that those who court the media, who play to the camera, should not protest or complain when they do not like the camera's presence or the unflattering images. Other times we sympathize with politicians and celebrities who are hounded and stalked, knowing we too could be among the hounded and stalked in an age when the camera is everywhere.

The drawbacks of modern image consciousness should not obscure its liberating aspects. In reasonable proportion, there is

nothing wrong with reporters and photographers showing when and how politicians stage events. More important, the underlying skepticism behind image consciousness, the desire to expose and unmask the false pose, is an essential ingredient of political reporting, as long as reporters do not simply balance perceptions but ultimately pursue the facts.

More generally, the skepticism that underlies the image-conscious strand of our culture is an important corrective to the way myths are used to whitewash reality and to exempt established conventions from critical examination. Robert Frank's powerful photographs in *The Americans* peeled back the self-satisfied and complacent view of the 1950s purveyed in public boosterism and television comedies like *Ozzie and Harriet* and *Father Knows Best*. Frank documented another and more troubled side of American life, which burst forth in the social turmoil of the 1960s. Frank's work was a central influence on the art photographers of the 1960s who challenged the conventional ways we view society.

The critical exploration of image making can also be a corrective to the false impressions created by the maverick heroes of the movies. The maverick hero, after all, has promulgated illusions as well as ideals. In the introduction to this book, I described the way the popular television series *24* was shaping how the young troops fighting in Iraq viewed the use of torture. In a similar way, John Wayne movies of the 1950s and 60s shaped the image of war for soldiers who went to Vietnam. In his book *Born on the Fourth of July*, Vietnam veteran Ron Kovic observes:

> Like Mickey Mantle and the fabulous New York Yankees, John Wayne in *The Sands of Iwo Jima* became one of my heroes. We'd go home and make up movies like the ones we'd just seen or the ones that were on TV night after night. . . . On Saturdays after the movies all the guys would go down to Sally's Woods . . . with plastic battery-operated machine guns, cap pistols, and sticks. We set ambushes, then led gallant attacks, storming over the top, bayoneting and shooting anyone who got in our way. Then we'd walk out of the woods like the heroes we knew we would become when we were men.[33]

Kovic's book, like many other documentary and fictional accounts of the Vietnam experience, illustrates the shock and disillusion of discovering that the war did not play like a John Wayne film.

The ability to stand back from the ideals and myths that shape our lives is a positive achievement of the photo-op sensibility that has come to infuse American culture since the Second World War. The limitation of this stance, whether expressed in photography, on television, or on the Internet, lies in its tendency to distract us from the meanings that images convey and in its tendency to assume that merely calling attention to images as images will dissolve their power.

The nineteenth century saw in photography the promise of a picture more perfect than art could produce, yet understood nonetheless the importance of the pose. What separates our time from Daguerre's is a shift in sensibility, in emphasis and outlook. Daguerre and his generation were intrigued by the realism of photography; they attended to the pose as a way of capturing the truth about the subject.

We image-conscious sophisticates of the twenty-first century are alive above all to the artifice of the image. From fashion photography to Photoshopped pictures on home computers, from real news to reality television, from docudramas to YouTube videos, our culture blurs the distinction between realism and artifice almost to the vanishing point.

For Daguerre, the distinction was clear. Photography was one thing, his theater of illusions another. He admonished the young artist not to paint the fabricated scenes of the theater of illusions, but to "go out of doors," lest the artist produce a copy of a copy. We, by contrast, are fascinated with copies of copies, images of images. If Daguerre's generation, in its naïveté, failed to glimpse the potential of the camera to distort reality rather than record it, we, in our sophistication, may risk losing the capacity to behold the "spirit of fact" to which the perfect picture can still aspire.

# Notes

🦅

INTRODUCTION
THE AGE OF THE PHOTO OP

1. CNN News Transcripts, "Live from the Headlines 19:00," May 1, 2003, transcript #050100CN.V94, http://www.lexis-nexis.com (accessed September 12, 2005).

2. Keith Olbermann and Chris Matthews, MSNBC News, "Countdown: Iraq 20:00," May 1, 2003, News, Domestic, http://www.lexis-nexis.com (accessed February 20, 2005); FOX News Network Transcripts, "The Big Story with John Gibson (17:14)," May 1, 2003, transcript #050102cb.263, http://www.lexis-nexis.com (accessed March 8, 2005); CNN News Transcripts, "CNN Live Event/Special 21:00," May 1, 2003, transcript #050105CN.V54, http:www.lexis-nexis.com (accessed February 20, 2005).

3. Elisabeth Bumiller, "Keepers of Bush Image Lift Stagecraft to New Heights," *New York Times*, May 16, 2003, A1.

4. A follow-up article on the "Mission Accomplished" banner in the *New York Times* quotes Bush saying, "The 'Mission Accomplished' sign, of course, was put up by the members of the USS *Abraham Lincoln*, saying that their mission was accomplished. . . . I know it was attributed somehow to some ingenious advance man from my staff. They weren't that ingenious, by the way." After the press conference, however, White House press secretary Scott McClellan clarified the president's statement, noting that the banner "was suggested by those on the ship. . . . They asked us to do the production of the banner, and we did. They're the ones who put it up." The *Times* notes that the man responsible for the banner, former ABC producer Scott Sforza (now with the White House communication's office), was known for producing sophisticated backdrops that appear behind Mr. Bush to reinforce his message of the day. Byline by the *New York Times*, "Bush Steps Away from Victory Banner," October 29, 2003, 8 (accessed January 29, 2005). See also Bumiller, "Keepers of Bush Image Lift Stagecraft to New Heights." For a report on how the USS *Abraham Lincoln* was turned around when the coast of San Diego was visible, see Dana Milbank, "Explanation for Bush's Carrier Landing Altered," *Washington Post*, May 7, 2003, A20 (accessed January 29, 2005).

5. The account of Joseph Darby and quotations are drawn from Wil S. Hylton, "Prisoner of Conscience," *GQ*, September 2006, http://men.style.com/gq (accessed July 11, 2007), and Joseph Darby, interview by Michele Norris, "Abu Ghraib Whistle Blower Speaks Out," *All Things Considered*, National Public Radio, August 15, 2006, http://www.npr.org (accessed August 28, 2006).

6. Seymour M. Hersh, "Torture at Abu Ghraib; American Soldiers Brutalized Iraqis. How Far Up Does the Responsibility Go?" *New Yorker*, May 10, 2004, 2.

7. Joseph Darby, interview by Wil S. Hylton, "Prisoner of Conscience."

8. Rory Kennedy, "The Ghosts of Abu Ghraib," HBO, February 22, 2007. Quoted in Alessandra Stanley, "Abu Ghraib and Its Multiple Failures," *New York Times*, February 22, 2007, The Arts/Cultural Desk, Section E, 1.

9. Aileen McCabe, "Weapons of Mass Photography," *Ottawa Citizen*, May 17, 2004, http://www.canwestglobal.com/ (accessed March 8, 2005).

10. Accounts of the exact time of the execution differ.

11. John F. Burns and James Glanz, "Iraq to Examine Abusive Conduct toward Hussein," *New York Times*, January 3, 2007, Foreign Desk, Section A, 1.

12. Ibid.

13. Office of the Press Secretary, "President Bush's Statement on Execution of Saddam Hussein," December 2006, http://www.whitehouse.gov (accessed June 12, 2007).

14. CNN Transcripts, "Anderson Cooper 360 Degree 11:00 PM EST," January 22, 2007, http://www.lexis-nexis.com (accessed March 10, 2007).

15. Interview with the author, March 12, 1990.

16. Ibid.

17. Norman B. Judd to Abraham Lincoln, June 6, 1860, quoted in Harold Holzer, Gabor S. Boritt, and Mark E. Neely Jr., *The Lincoln Image: Abraham Lincoln and the Popular Print* (New York: Scribner Press, 1984), 67.

18. Holzer, Boritt, and Neely, *The Lincoln Image*, 11–14.

19. Ibid., 70.

20. Ibid., 71–78.

21. David E. Sanger and Joseph Kahn, "Chinese Leader Gives Bush a Mixed Message," *New York Times*, November 21, 2005, Foreign Desk, Section A, 1.

22. Byron Calame, "When the Newspaper Is the News," *New York Times*, December 4, 2005, 12.

23. I watched the videotape of George Allen's "macaca" remark on YouTube, http://www.youtube.com/ (accessed September 21, 2006). My account of the incident is drawn from S. R. Sidrath, "I Am Macaca," *Washington Post*, November 12, 2006, Outlook, B02 (accessed January 8, 2007), and Kate Zernike, "Macaca," *New York Times*, December 24, 2006, Section 4, Column 2, Week in Review Desk, 4 (accessed January 8, 2007).

24. Paul Farhi, "Blundering Pols Find Their Oops on Endless Loop of Internet Sites," *Washington Post*, November 3, 2006, Style, C01.

25. Ibid.

26. Jodi Wilgoren, "Kerry on Hunting Photo-Op to Help Image," *New York Times*, October 22, 2004, Section A, Column 1, National Desk, 18.

27. Patrick Healy, "Campaign 2004: Kerry, Edwards Seek Edge in Wis. with Focus on Jobs," *Boston Globe*, February 17, 2004, National/Foreign, A1 (accessed May 5, 2005). Wesley Clark's quotation is from Judy Keen, "Good Iraq PR Tend to Fade Fast for President," *USA Today*, December 1, 2003, 10A (accessed April 29, 2005).

28. Richard A. Oppel Jr. and David S. Cloud, "U.S. Uses Iraq Insurgent's Own Video to Mock Him," *New York Times*, May 5, 2006, Foreign Desk, Section A, 1.

29. Ibid.

30. I had the opportunity to view one network's unedited news videotapes of the toppling of the Saddam statue.

31. "Bush TV Ad Pulled over Doctored Crowd Scene," MediaGuardian.co.uk, Friday, October 29, 2004 (accessed April 15, 2005).

32. Carla Marinucci, "Doctored Kerry Photo Brings Anger, Threat of Suit," *San Francisco Chronicle*, February 20, 2004, A4, http://www.sfgate.com (accessed February 20, 2004).

33. Alex Kuczinski, "On CBS News, Some of What You See Isn't There," *New York Times*, January 12, 2000, A1.

34. James Barron with Glen Collins, Jennifer Steinhauer, and Linda Lee, "Boldface Names," *New York Times*, January 8, 2002, Late Edition, Metropolitan Desk, 2. Additional commentary by Maureen Dowd, "That's Showbiz, Folks—and Television News," *Times Union*, January 9, 2002, A9.

35. John Higgins, "CBS Puts Couric on Photoshop Diet," *The Business of Television, Broadcasting and Cable*, August 29, 2006, http://www.broadcastingcable.com (accessed September 1, 2006), and Margery Regan, "Shrinking Katie Says It All about TV News," *Boston Herald*, August 31, 2006, 3, http://bostonherald.com (accessed April 27, 2007).

36. Jonathan D. Glater, "Martha Stewart Gets New Body in *Newsweek*," *New York Times*, March 3, 2005, C4.

37. Katie Betts, "The Man Who Makes the Pictures Perfect," *New York Times*, February 2, 2003, Style Desk, 1.

38. Susan Sachs, "Sarkozy's Physique Gets a Tweak from Friends in High Places; French President's Cozy Relationship with Powerful Media Barons Has Journalists Up in Arms," *Globe and Mail* (Canada), August 24, 2007, A14 (accessed September 5, 2007).

39. John Lichfield, "Magazine Airbrushes Sarkozy's 'Love Handles,' " *The Independent* (London), August 23, 2007, 22 (accessed September 5, 2007).

40. Anne Kingston, "Say Cheese, and Look Slimmer," *Maclean's*, May 29, 2006, Bazaar, 54.

41. Jennifer Alsever, "In the Computer Dating Fame, Room for a Coach," *New York Times*, March 11, 2007, Money and Business/Financial Desk, 5, http://www.nytimes.com (accessed May 28, 2007).

42. Peter Wayner, "Looking Perfect, One Pixel at a Time," *New York Times*, April 26, 2007, Section C, Business/Financial Desk, 7, http://www.nytimes.com (accessed May 28, 2007).

43. Ibid.

44. Megan Lehmann, "Weight and See—Actress Touchy about Retouch," *New York Post*, February 17, 2003, 27, http://www.nypost.com (accessed May 28, 2007).

45. Andrew Adam Newman, "3 Magazines Are Accused of Retouching Celebrity Photos to Excess," *New York Times*, May 28, 2007, C4.

46. This account of high school yearbooks and the quotations from photographers is drawn from Sandra Ladez Gerdes, "Digital Retouching Enhances Teens' Senior Photos," *Seattle Times*, May 9, 2004, Northwest Life, L2, http://www.seattletimes.newsource.com (accessed May 29, 2007).

47. Ibid.

48. Ibid.

49. Richard Rushfield, "Lonelygirl? Not Any Longer; The 19-Year-Old Actress Whose Fictional Confessions as 'Bree' Captivated Web Watchers Encounters the Media Whirlwind," *Los Angeles Times*, September 16, 2006, Calendar Desk, Part E, 1.

50. Karen Reichert, "Should Videotaping Be Restricted during Labor and Birth?" *American Journal of Maternal/Child Nursing* 26 (March/April 2001): 62.

51. Karen Springen, "No Candid Camera," *Newsweek*, February 20, 2006, 16.

52. Don Gifford, "What We See When We Get to the Videotape," *New York Times*, May 20, 1990, H31.

53. Meghan McEwen, "Is Wedding Photojournalism a Fad?" *WedPix-Magazine*, July/August 2006, 1, http://www.wedpix.com/articles/002/wedding-photojournalism-fad/ (accessed July 24, 2006).

54. Jon Weinbach, "Bride Gone Wild," *Wall Street Journal*, June 2, 2006, Weekend Journal, W1.

55. Interview with Beth Perlman, May 27, 1991.

56. "Live Free or Die," JohnMcCain.com, http://www.johnmccain.com/Informing/Multimedia/Player.aspx?guid=f12227b8-b36b-458b-a4e1–0589c257eae0 (accessed July 11, 2007).

57. "Draft Fred Thompson for President '08," http://www.fred08.com (accessed June 6, 2007).

58. Office of the Press Secretary, "Remarks by the President upon Arrival; The South Lawn," September 16, 2001, http://www.whitehouse.gov (accessed April 15, 2005).

59. "Bush: Bin Laden 'Prime Suspect,'" CNN.com, September 17, 2001, http://www.cnn.com (accessed July 11, 2007).

60. Interview with Vice President Dick Cheney, *Meet the Press*, NBC, Transcript for March 16, 2003.

61. Jane Mayer, "Whatever It Takes: The Politics of the Man Behind '24,'" *New Yorker*, February 19, 2007, 72.

62. Martin Miller, "'24' Gets a Lesson in Torture from the Experts," *Los Angeles Times*, February 13, 2007, Calendar Desk, Part E, 1.

63. Rory Kennedy, "Ghosts of Abu Ghraib," HBO, February 22, 2007. Quoted in Tom Shales, "'Ghosts of Abu Ghraib': Fearlessly Facing the Shame," *Washington Post*, February 22, 2007, Style, C1.

64. David Shoumacher, interview with author, 1991.

65. This account and the quotes are drawn from Ian Fisher, "Now as Before, Pope Relies on Media for His Message," *New York Times*, March 4, 2005, Section A, Foreign Desk, 9.

66. Andrew Sullivan, "Superstar," *New Republic*, April 18, 2005, Washington Diarist, 46.

67. Elaine Sciolino, "French Nun Says Church to Rule on Cure by John Paul II," *New York Times*, March 31, 2007, Section A, Foreign Desk, 3.

68. John King as quoted in CNN Transcripts, "Live from the Headlines 19:00," May 1, 2003, transcript #050100CN.V94, http://www.lexis-nexis.com (accessed September 12, 2005).

69. ABC's *World News Tonight*, May 1, 2004; Terry Moran reporting on ABC's *World News Tonight*.

CHAPTER 1
PICTURE PERFECT

1. Beaumont Newhall, *The Daguerreotype in America* (New York: Dover, 1976), 16. I am indebted to Newhall for the material about Daguerre from which I drew my account.

2. William Henry Fox Talbot, an Englishman, independently invented the photograph using a different process in the 1830s. For accounts of others involved in the invention of the photograph, see Beaumont Newhall, *The History of Photography* (Boston: Little, Brown, 1986) and Jean-Claude Lemagny and André Rouillé, *A History of Photography* (Cambridge: Cambridge University Press, 1987).

3. Richard Rudisill, *Mirror Image: The Influence of the Daguerreotype on American Society* (Albuquerque: University of New Mexico Press, 1971), 57.

4. Oliver Wendell Holmes, "The Stereoscope and the Stereograph," in *Photography: Essays and Images*, ed. Beaumont Newhall (Boston: New York Graphic Society, 1980), 54.

5. Rudisill, *Mirror Image*, 54.

6. Harold Francis Pfister, *Facing the Light* (Washington, DC: Smithsonian Institute Press, 1978), 140.

7. Ibid., 142.

8. Robert A. Sobieszek and Odette M. Appel, *The Spirit of Fact: The Daguerreotypes of Southworth and Hawes, 1843–1862* (New York: Dover, 1976), ix.

9. Marcus Aurelius Root, *The Camera and the Pencil* (1864; repr., Pawlet, VT: Helios, 1971), 143.

10. Newhall, *The Daguerreotype in America*, 44.

11. Pfister, *Facing the Light*, 140; Newhall, *The Daguerreotype in America*, 78.

12. Mark Twain, *Life on the Mississippi* (1883; repr., New York: Penguin Books, 1986), 278.

13. Max Kozloff, *Photography and Fascination* (Danbury, NH: Addison House, 1979), 79.

14. Stephen Hess and Milton Kaplan, *The Ungentlemanly Art: A History of American Political Cartoons* (New York: Macmillan, 1968), 3. Thomas C. Leonard notes that this famous remark by Tweed may be apocryphal, but provides an astute analysis of the power of pictures in *The Power of the Press* (Oxford: Oxford University Press, 1986), 108.

15. Neal Gabler, *Life the Movie: How Entertainment Conquered Reality* (New York: Alfred A. Knopf, 1998), 72. According to Gabler the quote is cited in the *Illustrated Daily News*, June 26, 1919.

16. Ibid., 73.

17. Ibid., 74.

18. Robert Sklar, *Movie-Made America: A Cultural History of American Movies* (New York: Vintage, 1975), 3 and 22.

19. Roland Marchand, *Advertising the American Dream: Making Way for Modernity, 1920–1940* (Berkeley: University of California Press, 1985), 149–52.

20. Ibid., 152.

21. *Life*, November 23, 1936, 3.

22. This account and the quotations are drawn from the historical write-up on the U.S. Senate's "Historical Minutes, 1941–1963: Kefauver Crime Committee Launched," http://www.senate.gov/artandhistory/history/minute/Kefauver_Crime_Committee_ Launched.htm (accessed May 31, 2007), and from William Howard Moore, *The Kefauver Committee and the Politics of Crime, 1950–1952* (Columbia: University of Missouri Press, 1974).

23. U.S. Senate's "Historical Minutes, 1941–1963: Kefauver Crime Committee Launched."

24. Vicki Goldberg, *The Power of Photography: How Photographs Changed Our Lives* (New York: Abbeville Press, 1991), 223.

25. Jeffrey Ruoff, *An American Family: A Televised Life* (Minneapolis: University of Minnesota Press, 2002), xxv. Quoted in Susan Murray, "I Think We Need a New Name for It," in *Reality TV: Remaking Television Culture*, ed. Susan Murray and Laurie Ouellette (New York: New York University Press, 2004), 40–41.

26. "The Company," C-SPAN.org, http://www.cspan.org/about/company/index .asp?code=COMPANY (accessed July 6, 2007).

27. Gabler, *Life the Movie*, 80–81.

28. For an excellent study of how the *Times* came to embrace photography, see Jesse Schumer, "All the Photos Fit to Print: The Struggle and Success of Front-Page Photojournalism in *The New York Times*" (senior thesis in Social Studies, Harvard University, 2006).

29. Ibid., 86–87.

30. Ibid., 118.

31. Niccolo Machiavelli, *The Prince*, ed. Quentin Skinner and Russell Price (Cambridge: Cambridge University Press, 1988), 63.

32. *Boston Globe*, May 1, 1991.

33. The account of Spielberg's visit was provided by Congressman Mike Synar of Oklahoma. Interview with author, May 10, 1991.

34. A Democratic adviser who wished to remain anonymous provided this quotation and the information about the Democrats' attention to camera placement during the Bork hearings. Interview with author, October 24, 1991.

35. *Time*, January 27, 1992, 21.

36. Reported by Jackie Judd on ABC (October 11, 1988) and Ken Bode on NBC (October 11, 1988).

37. Rod Slemmons, *Like a One-Eyed Cat: Photographs of Lee Friedlander* (New York: Harry N. Abrams, 1989), 12.

38. Quoted in Jonathan Green, *American Photography* (New York: Harry N. Abrams, 1984), 99.

39. Patrick S. Smith, *Andy Warhol's Art and Films* (Ann Arbor: UMI Research Press, 1986), 12.

40. Erving Goffman, *The Presentation of Self in Everyday Life* (Edinburgh: University of Edinburgh Press, 1958), 10.

41. Marcia Tucker, "Mechanisms of Exclusion and Relation: Identity," in *Discourses: Conversations in Postmodern Art and Culture*, ed. Russell Ferguson et al. (Cambridge: MIT Press, 1990), 92.

42. Holmes, "The Stereoscope and the Stereograph," in Newhall, *Photography: Essays and Images*, 60.

43. Thomas L. Johnson and Philip C. Dunn, *A True Likeness: The Black South of Richard Samuel Roberts, 1920–1936* (Columbia, SC: B. Clark; Chapel Hill, NC: Algonquin Books of Chapel Hill, 1986), 6.

44. This account is drawn from Paul Andrews, "Keeping Watch Now Goes Both Ways," *Seattle Times*, April 14, 2005, Business, E1.

45. Michael. B. Farrell, "Who's Taping Whom?" *Christian Science Monitor*, September 15, 2004, Features, 16.

46. Quotes and incident reported in Jim Dwyer, "Videos Challenge Hundreds of Convention Arrests" *New York Times*, April 12, 2005, Section A, Metropolitan Desk, 1.

47. Ibid.

48. Tim O'Brien, "The Blog House: A Year Ago, Katrina Revealed Power of the Net," *Star Tribune* (Minneapolis), September 2, 2006, News, 21A.

49. Thomas Doherty, "No Longer Home Movies," *Chronicle of Higher Education*, February 6, 2005, B11–12.

## CHAPTER 2
### PHOTO-OP POLITICS

1. Figures are for Democratic and Republican candidates appearing on ABC, CBS, and NBC weekday evening newscasts from Labor Day to Election Day, 1968 and 1988 (over 280 newscasts in all). Since the networks did not offer Saturday and Sunday evening newscasts during the periods studied, weekend newscasts are omitted to ensure comparability. The videotapes from 1968 were from the Vanderbilt University archives of television news, and the 1988 tapes were recorded by the media services of Harvard University's John F. Kennedy School of Government. All quotations from the newscasts, unless otherwise attributed, come from this sample.

2. For an excellent account of the growing role of political consultants and media advisers in American politics, see Larry Sabato, *The Rise of Political Consultants* (New York: Basic Books, 1981).

3. Michael Deaver, a public-relations expert in charge of Reagan's media, offered an account of his work in his book *Behind the Scenes: In Which the Author Talks about Ronald and Nancy Reagan . . . and Himself* (New York: William Morrow, 1987). Accounts of Deaver's role can also be found in Martin Schram, *The Great American Video Game: Presidential Politics in the Television Age* (New York: William Morrow, 1987), and Mark Hertsgaard, *On Bended Knee: The Press and the Reagan Presidency* (New York: Farrar, Straus, and Giroux, 1988).

4. Don Oliver, interview with author, May 9, 1991.

5. David Schoumacher, interview with author, January 27, 1991.

6. Frank Shakespeare, interview with author, January 14, 1991.

7. The quotations from Roger Mudd and the political consultant are from Lee Dembart, "A Mudd Report on Candidates Rejected by Cronkite Program," *New York Times*, June 8, 1976, 47.

8. Roger Mudd, interview with author, December 2, 1991.

9. Jill Rosenbaum, interview with author, January 9, 1991.

10. Tom Bettag, interview with author, April 17, 1991.

11. Susan Zirinsky, interview with author, May 13, 1991.

12. Leonard Garment, interview with author, February 5, 1991.

13. Joseph Napolitan, interview with author, January 28, 1991.

14. Bob Schieffer, interview with author, January 9, 1991.

15. Jeff Greenfield, interview with author, March 9, 1991.

16. On the role of political ads in the 1968 and earlier campaigns, see Edwin Diamond and Stephen Bates, *The Spot: The Rise of Political Advertising on Television* (Cambridge, MA: MIT Press, 1988), and Kathleen Hall Jamieson, *Packaging the Presidency: A History and Criticism of Presidential Campaign Advertising* (New York: Oxford University Press, 1984).

17. Joseph Napolitan, interview with author, January 28, 1991.

18. Frank Shakespeare, interview with author, January 14, 1991.

19. Roger Ailes, interview with author, July 15, 1991.

20. Jill Rosenbaum, interview with author, January 9, 1991.

21. Andy Franklin, interview with author, January 8, 1991.

22. Brian Healy, interview with author, January 9, 1991.

23. Sanford Socolow, interview with author, December 1989.

24. Ted Koppel, interview with author, February 20, 1991.

25. Reuven Frank, interview with author, May 15, 1991.

26. Quoted in Randall Rothenberg, "Controversy in Commercials Used to Gain Extra Publicity," *New York Times*, January 8, 1990, D8.

27. Quoted in "Rift over Campaign Films," *New York Times*, August 11, 1988, D19.

28. Bill Crawford, interview with author, April 17, 1991.

29. Quoted in Rothenberg, "Controversy in Commercials."

30. Ted Koppel, interview with author, February 20, 1991.

31. *Time*, October 3, 1988, 18.

32. John Sasso, interview with author, March 9, 1991.

33. Roger Ailes, discussion, the Joan Shorenstein Barone Center, Harvard University, November 28, 1990.

34. Walter Cronkite, interview with author, May 28. 1991.

35. David Broder, interview with author, February 20, 1991.

36. The source wished to remain anonymous. Interview with author, 1991.

37. Roger Ailes, in *Campaign for President: The Managers Look at '88*, ed. David R. Runkel (Dover, MA: Auburn House, 1989), 136.

38. Andrew Savitz, interview with author, February 23, 1991.

39. John Sasso, interview with author, March 9, 1991.

40. Tim Russert and Bill Wheatley, interview with author, January 8, 1991.

41. Richard Salant, interview with author, April 6, 1991.

42. Kathryn Murphy, interview with author, May 1989.

43. Dayton Duncan, interview with author, May 1989.

44. The Stahl incident is related in Schram, *The Great American Video Game*, 26.

CHAPTER 3
CONTESTING CONTROL OF THE PICTURE

1. Bill Wheatley, interview with author, April 19, 1991.
2. Bill Wheatley, interview with author, January 8, 1991.
3. Ibid.
4. Bob Schieffer, interview with author, January 9, 1991.
5. Ted Koppel, interview with author, February 20, 1991.
6. Sanford Socolow, interview with author, June 4, 1991.
7. Walter Cronkite, interview with author. May 28, 1991.
8. Shad Northshield, interview with author, April 22, 1991.
9. Tom Bettag, interview with author, April 17, 1991.
10. Susan Zirinksy, interview with author, May 13, 1991.
11. Dan Rather, interview with author, September 23, 1991.
12. Walter Cronkite, interview with author, May 28, 1991.
13. Don Hewitt, interview with author, April 22, 1991.
14. Thomas Dwight to Theodore Sedgwick, February 7, 1789, quoted in David Hacket Fischer, *The Revolution of American Conservatism: The Federalist Party in the Era of Jeffersonian Democracy* (New York: Harper Torchbooks, 1965), 91.
15. Fisher Ames to Theodore Dwight, March 19, 1801, quoted in ibid., 135.
16. Samuel Henshaw to Theodore Sedgwick, April 15, 1789, quoted in ibid., 133–34.
17. Ibid., 146.
18. Gil Troy, *See How They Run: The Changing Role of the Presidential Candidate* (New York: Free Press, 1991), 14, and generally, 7–19.
19. Ibid., 16.
20. Ibid., 22.
21. Ibid., 23–24.
22. Ibid., 30–36.
23. Ibid., 39.
24. Ibid., 142–43.
25. Ibid., 149.
26. Ibid., 164.
27. See Becky M. Nicolaides, "Radio Electioneering in the American Presidential Campaigns of 1932 and 1936," *Historical Journal of Film, Radio, and Television* 8 (1988): 115–38.
28. Ibid., 126; see also Erik Barnouw, *A History of Broadcasting in the United States*, 3 vols. (1966–70); *The Golden Web*, vol. 2 (New York: Oxford University Press, 1968), 51.
29. *New York Times*, June 28, 1936, quoted in Nicolaides, "Radio Electioneering," 130.
30. Sevareid, *CBS Evening News*, October 11, 1968.
31. *New York Times*, June 28, 1936, quoted in Nicolaides, "Radio Electioneering," 131.
32. Quoted in ibid., 124.
33. Quoted in Troy, *See How They Run*, 170.
34. Ibid., 170–71.

35. Thomas C. Leonard, *The Power of the Press: The Birth of American Political Reporting* (New York: Oxford University Press, 1986), 102.

36. Michael Schudson, *Discovering the News: A Social History of American Newspapers* (New York: Basic Books, 1978), 93.

37. Ibid.

38. See Neil Harris, "Iconography and Intellectual History: The Half-Tone Effect," in *New Directions in American Intellectual History,* ed. John Higham and Paul K. Conkin (Baltimore: Johns Hopkins University Press, 1979), 196–211.

39. Leonard, *The Power of the Press,* 100.

40. Harris, "Iconography and Intellectual History," 203.

41. Ibid., 203–4.

42. Ibid., 204.

43. Ibid., 204–5.

44. Walter Cronkite, *Theodore H. White Lecture, November 15, 1990* (Cambridge, MA: The Joan Shorenstein Barone Center, Harvard University, 1990), 23–24.

45. Daniel Boorstin, *The Image: A Guide to Pseudo-Events in America* (1961; repr., New York: Atheneum, 1987), 133. Wallace quoted in John Bainbridge, *Little Wonder; or, The Reader's Digest and How It Grew* (New York: Reynal and Hitchcock, 1945), 36.

46. Boorstin, *The Image,* 133–34.

47. Ibid.; Bainbridge, *Little Wonder,* 53.

48. Quoted in Irving Howe, *The Idea of the Modern in Literature and the Arts* (New York: Horizon Press, 1967), 20.

49. Quoted in Roland Marchand, *Advertising the American Dream: Making Way for Modernity, 1920–1940* (Berkeley: University of California Press, 1985), 3–4.

50. Quoted in Troy, *See How They Run,* 130.

51. Quoted in Nicolaides, "Radio Electioneering," 121.

52. Walter Lippmann, *Drift and Mastery: An Attempt to Diagnose the Current Unrest* (1914; repr., Englewood Cliffs, NJ: Prentice-Hall, 1961), 53.

53. Advertisement in *Life,* December 28, 1936, 73.

54. Reuven Frank, *Out of Thin Air: An Insider's History of Network News* (New York: Simon and Schuster, 1991), 183–84.

55. Dick Salant, *CBS News Standards* (New York: CBS, internal document, April 14, 1976), 38.

56. Charles Quinn, interview with author, January 10, 1991.

57. Don Hewitt, interview with author, April 22, 1991.

58. Ibid.

59. Ibid.

60. Walter Cronkite, interview with author, May 28, 1991.

61. Theodore White, *The Making of the President, 1960* (New York: Atheneum, 1961), 329.

62. Boorstin, *The Image,* 41.

63. Ibid., 36.

64. Richard Nixon, *Six Crises* (Garden City, NY: Doubleday, 1962), 422.

65. Ibid.

66. Frank Shakespeare, interview with author, January 14, 1991.

67. Russ Bensley, interview with author, January 25, 1991.

68. John Hart, interview with author, March 12, 1990.

69. Timothy Crouse, *The Boys on the Bus* (New York: Ballantine Books, 1973), 149–50.

70. Michael Deaver, interviewed by Bill Moyers, *The Public Mind*, "Illusions of News," PBS (New York: Journal Graphic Inc., November 22, 1989), 5.

71. Quoted in Martin Schram, *The Great American Video Game* (New York: William Morrow, 1987), 33.

72. Quoted in Peter J. Boyer, *Who Killed CBS?: The Undoing of America's Number One News Network* (New York: Random House, 1988), 15.

73. Edwin Diamond, "Stay Tuned for Television News," *New York Magazine*, March 16, 1987, 30–33. On the changes in the economics of network news, see Boyer, *Who Killed CBS?* Ken Auletta, *Three Blind Mice: How the TV Networks Lost Their Way* (New York: Random House, 1991); and Ben Bagdikian, *The Media Monopoly* (Boston: Beacon Press, 1983).

74. Murrow is quoted in Robert MacNeil, *The People Machine: The Influence of Television on American Politics* (New York: Harper and Row, 1968), 18.

75. Shad Northshield, interview with author, April 22, 1991.

76. John Ellis, interview with author, March 6, 1991.

77. Boyer, *Who Killed CBS?*, 141.

78. Bob Schieffer, "The New Politics: Some Basic Questions," Society of Professional Journalists Fellowship Lecture, Minneapolis, Minnesota, June 5, 1990, 14.

79. Michael Deaver, interviewed by Bill Moyers, "Illusions of News," 2.

80. Roger Ailes, interview with author, July 15, 1991.

81. Ibid.

82. Boyer, *Who Killed CBS?*, 134.

83. Moyers, "Illusions of News," 4.

84. Lesley Stahl, interview with Bill Moyers, "Illusions of News," 2.

85. Thomas B. Rosenstiel, "TV Political Coverage—Timing, Image, Doughnuts," *Los Angeles Times*, October 23, 1988, 15.

86. Susan Zirinsky, interview with author, May 13, 1991.

87. Schram, *The Great American Video Game*, 55.

88. Susan Zirinsky, interview with author, May 13, 1991.

89. Shad Northshield, interview with author, April 22, 1991.

90. Frank Shakespeare, interview with author, January 14, 1991.

91. Sanford Socolow, interview with author, December 1989.

92. Tom Bettag, interview with author, April 17, 1991.

93. Walter Cronkite, interview with author, May 18, 1991.

94. See Renee Loth, "ABC Says It Will Drop 'Sound-Bite' Coverage," *Boston Globe*, September 11, 1992, 13, and "CBS Vows to Serve Up Chewier Sound Bites," *TV Guide*, July 18, 1992, 25.

95. *New York Times*, July 13, 1992, D14.

96. The general election statistic for 1992 is from S. Robert Lichter, "Campaign '92 Project," Center for Media and Public Affairs, Washington, DC, 1992. The 2004 general election statistic is from a report title, "Broadcast News Coverage of Campaign 2004: September 7–October 1, 2004" by the Center for Media and Public Affairs in Cooperation with Media Tenor, http://www.cmpa.com/documents/04.10.20.ElectionWatch.pdf (accessed September 26, 2007).

97. Julia R. Fox, Glory Koloen, and Volkan Sahin, "No Joke: A Comparison of Substance in *The Daily Show with Jon Stewart* and Broadcast Network Television Coverage of the 2004 Presidential Election Campaign," forthcoming *Journal of Broadcasting and Electronic Media*, 2007.

98. Boorstin, *The Image*, 44, 38.

99. Robert Campbell, "Fabulous Fakery," *Boston Globe*, February 27, 1990, 57, 59.

100. Ibid.

## CHAPTER 4
### EXPOSED IMAGES

1. I did a systematic analysis of all front-page photographs from the *New York Times* of the Democratic and Republican presidential campaigns from the date of the first Democratic or Republican convention through Election Day from 1968 to 2000. I used a ProQuest search of the historical *New York Times* to obtain a copy of every front page. I analyzed over 430 front-page photographs in all. The *Times* ran on average about fifty photographs per campaign during the period I analyzed. ProQuest did not include the 2004 campaign at the time I was writing this book, so I drew on a photographic file I kept of the campaign, which focused on the new image-conscious photographs, and did not include every front-page photo.

2. During the 1968 campaign, only two front-page photographers show a photographer in the frame, and in both cases it is implied that it is a supporter of the candidate. On August 26, 1968, a photograph of Senator Eugene McCarthy at a Democratic pre-convention rally shows a supporter taking a picture; later President Lyndon Johnson speaks to members of his audience with a supporter taking a picture. The *Times* has a TV image of Johnson on the front page on November 1, 1968, when he announces a bombing halt and the beginning of talks with the Vietnamese. In 1984, there is one front-page photo of Reagan with someone taking a picture.

3. Sam Donaldson, "Foreword," in *Choose Me: Portraits of a Presidential Race*, photographs by Arthur Grace (Hanover, NH: Brandeis University Press, 1989), 12.

4. Ibid.

5. A September 11, 1992, photograph of Clinton with lights and television cameras in the frame is captioned, "Gov. Bill Clinton giving a television interview yesterday from his mansion in Little, Rock, Ark., in an effort to control the campaign coverage," A31.

6. Photograph by Guido Bergmann/Agence France-Press-Getty Images in the *New York Times*, June 8, 2007, A1.

7. Don Terry, "Candidates and Issues Stir Small-Town Frenzy," *New York Times*, July 22, 1992, A14.

8. Gwen Ifill, "Clinton Finds Time to Take on GOP," *New York Times*, July 20, 1992, A10.

9. Richard L. Berke, "Playing Diplomat on Television," *New York Times*, July 29, 1992, A12.

10. *New York Times*, above-the-fold photograph by Stephen Crowley, September 20, 2000.

11. Richard L. Berke and Kevin Sack, "In Debate 2, Microscope Focuses on Gore," *New York Times*, October 11, 2000, 1.

12. Stephen Crowley photograph, "Waiting for Clinton," *New York Times*, April 1, 1997, National Report, A16.

13. Ibid.

14. Amy Toensing, "House Freshmen Say, 'Cheese,'" *New York Times*, November 17, 1996, National Report, 22.

15. "The Shadow Old-Time Mystery Radio Show," MysteryNet.com, http://www.mysterynet.com/shadow/ (accessed June 6, 2007).

16. Quoted in Jonathan Green, *American Photography: A Critical History 1945 to the Present* (New York: Harry N. Abrams, 1984), 99.

17. Rod Slemmons, *Like a One-Eyed Cat: Photographs by Lee Friedlander, 1956–1987* (New York: Harry N. Abrams, 1989), 117.

18. Barbara Norfleet, interview with author, May 6, 1991.

19. Quoted in Els Barents, "Introduction," in *Cindy Sherman* (Amsterdam: Stedelijk Museum Amsterdam, 1982), 8.

20. Ibid., 9.

21. John D. Callaway, Judith A. Mayotte, and Elizabeth Altick McCarthy, *Campaigning on Cue* (Chicago: University of Chicago, William Benton Fellowships Program in Broadcast Journalism, 1988), 85.

22. Diane Arbus, *Diane Arbus* (New York: Aperture, 1972), 1–2.

23. Lewis Baltz, "American Photography in the 1970s," in *American Images: Photography 1945–1980* (New York: Penguin, 1985), 161.

24. Ibid., 3.

25. Green, *American Photography,* 112, 113.

26. Hannah Arendt, *The Human Condition* (Chicago: University of Chicago Press, 1958), 52–53.

27. Quoted in John Szarkowski, *Winogrand* (New York: The Museum of Modern Art, 1988), 34.

28. All of the movie quotations in this book are from viewing the films, not from reading the scripts.

29. An article by Todd Gitlin also discusses *A Face in the Crowd* and other movies about television, exploring the question of how movies gradually came to terms with the powerful presence of television. See Gitlin, "Down the Tubes," in *Seeing through Movies,* ed. Mark Crispin Miller (New York: Pantheon, 1990), 14–48.

30. Patrick S. Smith, *Andy Warhol's Art and Films* (Ann Arbor: UMI Research Press, 1986), 114.

31. Marcus Aurelius Root, *The Camera and the Pencil* (1864; repr., Pawlet, VT: Helios, 1971), 143.

CHAPTER 5

MYTHIC PICTURES AND MOVIE HEROES

1. Erik H. Erikson, *Childhood and Society* (New York: W. W. Norton, 1963), 327–28.

2. My analysis of the heroes of American movies is based on viewing all the top-ten grossing movies (based on figures gathered by *Variety* and Worldwide Box Office (http://worldwideboxoffice.com) from 1968 to 1992 and a selection of top-ten movies

from 1992 to 2007. I also viewed critically acclaimed movies from these (and earlier) periods and a sample of fifty of the top movies from the period 1930 to 1968, some 350 films in all. All quotations in the text are drawn from viewing the movies and not from shooting scripts.

3. I am indebted to Robert B. Bly's excellent study, *A Certain Tendency of the Hollywood Cinema, 1930–1980* (Princeton, NJ: Princeton University Press, 1985), for the term *reluctant hero.*

4. For an intriguing study of the changes in American western movies, see Will Wright, *Six Guns and Society: A Structural Study of the Western* (Berkeley: University of California Press, 1975).

5. Stephen Farber, "Coppola and the Godfather," *Sight and Sound* 41 (1972): 220.

CHAPTER 6

THE PERSON AND THE POSE

1. Roland Barthes, *Camera Lucida: Reflections on Photography* (New York: Hill and Wang, 1981), 67–71, 75.

2. Ibid., 73.

3. The photograph was featured on the cover of the April 1985 issue of *National Geographic* and in a one-hour National Geographic *Explorer* documentary on MSNBC.

4. Roy Emerson Stryker, head of the Farm Security Administration, immediately recognized the power of Dorothea Lange's photograph and referred to "Migrant Mother" as the "ultimate" photograph of the Depression era. He felt that Lange never surpassed this photograph. Of "Migrant Mother" he declared, "She is immortal." Roy Emerson Stryker, *In This Proud Land: 1935–1943, as Seen in the FSA Photographs* (New York: New York Graphic Society, 1975).

5. This account is drawn from Geoffrey Dunn, "Photographic License," *New York Times Magazine,* 2002, http://www.newtimes-slo.com/archives/cov_stories-2002/cov_01172002.html (accessed May 12, 2006).

6. Ibid.

7. Ibid.

8. This quote by Dorothea Lange is cited in Giridhar Khasnis, "Two Women and a Photograph," *The Hindu: Online Edition of India's National Newspaper,* April 30, 2006, http://www.hindu.com/mag/2006/04/30/stories/2006043000380500.htm (accessed September 17, 2006).

9. The story of the stamp and its unveiling was reported in Lisa Millegan, "Modestan Stamps Her Approval, Woman Lobbied For Mom's Image to Be Part of Postal Service Series," *Modesto Bee,* October 5, 1998, A1.

10. CNN News Transcripts, "Q & A with Zain Verjee," March 18, 2002, transcript #031801cb.k19, http://www.lexis-nexis.com (accessed July 11, 2007).

11. The phrase "women vanish from the public eye" is a quote from Rahimullah Yusufzai, a respected Pakistani journalist who acted as an interpreter for Steve McCurry and his television crew, and is quoted in Cathy Newman, "A Life Revealed," *Selections from National Geographic,* 2004, 33.

12. The quotation is from Robert Hariman and John Louis Lucaites, "Public Identity and Collective Memory in U.S. Iconic Photograph: The Image of 'Accidental Napalm,'" *Critical Studies in Media Communication* 20 (2003): 41.

13. The account of Kim Phuc is drawn from Denise Chong, *The Girl in the Picture* (New York: Viking, 2000). The specific quotations from Kim Phuc are from a UNESCO Press interview that cites Denise Chong, but lists author as UNESCO Press, "Kim Phuc: The Power of Forgiveness," Feature no. 2002–04, February 28, 2002, http://www.portal.unesco.org (accessed July 9, 2006).

14. The account of "Tomoko Is Bathed by Her Mother" and the letter from Aileen Mioko Smith are drawn from Larry Gross, John Stuart Katz, and Jay Ruby, "Introduction," in *Image Ethics in the Digital Age* (Minneapolis: University of Minnesota Press, 2003), xxi, xxii.

15. Embedded journalists have to sign a fourteen-point agreement. Paragraph 11(a) of IAW Change 3, DoD Directive 5122.5: "Names, video, identifiable written/oral descriptions or identifiable photographs of wounded service members will not be released without the service member's prior written consent." Furthermore: "In respect for family members, names or images clearly identifying individuals 'killed in action' will not be released." The rule specifies that names of soldiers killed can be released a day after the family is officially notified, but it does not address photographs or video images. These excerpts come from David Carr, "Not to See the Fallen Is No Favor, *New York Times*, May 28, 2007, Section C, Business/Financial Desk, 1, http://www.nytimes.com (accessed June 21, 2007), and Michael Hedges and James Pinkerton, "Images of Dying Soldier Renew War Coverage Debate," *Houston Chronicle*, January 31, 2007, Section A, 1, http://www.chron.com (accessed June 21, 2007).

16. Carr, "Not to See the Fallen Is No Favor."

17. Ibid.

18. Ibid.

19. Ibid.

20. Hedges and Pinkerton, "Images of Dying Soldier Renew War Coverage Debate."

21. David Douglas Duncan is quoted in Alan Riding, "An Eye for the Essential Emotion: The Photographer David Douglas Duncan Distills a Lucky Life," *New York Times*, December 24, 2003, Section E, The Arts/Cultural Desk, 1, http://www.nytimes.com (accessed March 27, 2006).

22. Abu Musab al-Zarqawi's photograph appeared on the front pages of American newspapers on June 9, 2006. I viewed the front pages of the American newspapers on the Web site of the Newseum, www.newseum.org/todaysfrontpages/, which displays a selection of national and international front pages submitted via the Internet on a daily basis.

23. "A Taliban Leader Is Killed in Afghanistan," the *New York Times*, May 14, 2007, Section A1. The caption reads, "Fallen Taliban Leader—The body of Mullah Dadullah, thought to be the Taliban's top operational commander, was shown yesterday in Kandahar" (photo by Hamed Zalmy/Agence France-Presse—Getty Images).

24. The statement of N. G. Burgess, a nineteenth-century photographer, is quoted in Richard Rudisill, *Mirror Image* (Albuquerque: University of New Mexico Press, 1971), 214.

25. Ibid., 214–15.

26. Ibid., 218.

27. Marina Warner, "Stolen Shadow, Lost Souls: Body and Soul in Photography," *Raritan* 15 (1995): 35, Academic Search Premier (accessed January 18, 2007).

28. Heike Behrend, "Photo Magic: Photographs in Practices of Healing and Harming in East Africa," *Journal of Religion in Africa* 33, no. 2 (2004): 133.

29. Eric Michaels, "A Primer of Restriction on Picture-Taking in Traditional Areas of Aboriginal Australia," *Visual Anthropology* 4 (1986): 260.

30. Bill Coleman, *Amish Odyssey* (New York: Van der Marck Editions, 1988), 17.

31. James R. O'Brien, "While I Wept: Did I Trade My Soul to a Man With a Camera?" *New York Times*, March 5, 1995, CY13.

32. Jed Perl, "Not-So-Simple Simplicity," *New Republic*, October 27, 2003, 31, 34.

33. Ron Kovic, *Born on the Fourth of July* (New York: Pocket Books, 1976), 54, 55.

# Index

ABC, 74, 79, 87, 92, 97, 99, 107, 109, 137
Abu Ghraib prison, 3–4, 35
action heroes, 224–31
Adams, Eddie, 40
Adams, John, 117
advertising: art and, 56; news coverage of political, 77–86, 97–98; newspapers and, 120; pace of life and, 123; photography and, 47. *See also* negative campaigning
ad watches, 137
"Afghan Girl" photograph, 246–47, 249–50
Agnew, Spiro, 92–93
Ailes, Roger, 81, 86, 88, 90, 91, 93, 130, 132–33
*Air Force One* (movie), 1, 32, 215–17
*Alamo, The* (movie), 213
Alexander, Lamar, 149
Allen, George, 15
Allen, Karen, 225
Altman, Robert, 206
American culture: crisis in, 33, 187, 189; movies heroes and, 185–242; social criticism of, through photography, 155–56, 158, 261
*American Exodus, An* (Taylor and Lange), 125
*American Family, An* (television show), 49–50
*American Idol* (television show), 29
*American Morning* (television show), 19
*Americans, The* (Frank), 156, 261
*America's Funniest Home Videos* (television show), 24–25
Ames, Fisher, 116
*Amish Odyssey* (Coleman), 259
Andrews Air Force Base, 62
*Apocalypse Now* (movie), 35, 190, 208
Apple, R. W., Jr., 142–43
Arabiya (television network), 17
Arbus, Diane, 59, 158, 164–66
Arendt, Hannah, 167
*Arsenio Hall* (television show), 138

art, image consciousness in, 55–57. *See also* art photography
Arthur, Jean, 192, 195
art photography, 153–64
Ashby, Hal, 173
Associated Press, 37, 48, 147, 247
Association of Moving Image Archivists, 65
Astaire, Fred, 46
Auletta, Ken, 131

Bagdikian, Ben, 131
Baggio, Dan (colonel), 254
Baker, James, 89
balance, in journalism, 69, 96–99
Barthes, Roland, 244–45
Basinger, Kim, 220
Bates, Kathy, 177
Batman movies, 219–20
Bauer, Jack (television character), 34–35, 238–42
Bazell, Robert, 96, 105
Beatty, Warren, 28
Beckel, Bob, 88
Bedelia, Bonnie, 201
*Being There* (movie), 173–75, 234
Beirut, 104
Benedict, Pope, 38
Bennett, James Gordon, 120
Bensley, Russ, 129
Bentham, Jeremy, 63
Bentsen, Lloyd, 144
Berenger, Tom, 210
Bergman, Ingrid, 197, 244
Bergmann, Guido, 149
Berke, Richard L., 150–51
Berkeley, Xander, 240
Bernard, Stan, 89
Bettag, Tom, 75, 109–10, 136–37
*Beverly Hills Cop* (movie), 202–3
*Beverly Hills Cop 2* (movie), 203

Bin Laden, Osama, 34
Bloom, Verna, 171
*Bob Roberts* (movie), 177
body, photographic retouching of, 19–24
Bogart, Humphrey, 196, 227–28, 244
Boorstin, Daniel, 57, 122, 127–28, 139
Bork, Robert, 53
*Born on the Fourth of July* (Kovic), 261
*Bourne* movies, 229, 231
Boyer, Peter, 131–32
Brady, Mathew, 11, 44, 45, 185
Brando, Marlon, 218
Brest, Martin, 203
*Brief Encounter, A* (movie), 184
*Broadcast News* (movie), 175–76
Broder, David, 91
Brody, Rick, 67, 102
Brokaw, Tom, 85, 92, 98
Brooker, C. F. Tucker, 121
Brown, Aaron, 2
Brown, Edmund G., Jr., 72
Burns, John, 6
Burton, Tim, 219
Bush, George H. W., 86, 100–101, 147; campaigning by, 54, 78–81, 98; media attention to gaffe by, 91–92; newspaper coverage of, 144, 150–51; and Persian Gulf War, 52; personality of, 32; self-presentation of, 69; and television, 68, 73–76, 85, 88, 90–91, 96–97, 112, 134–35
Bush, George W.: doctored photo of, 18; and flag-draped coffin photographs, 62; and Hussein's hanging, 5; media attention to gaffes of, 12–14, 31; and military funerals, 255; and "Mission Accomplished," 1–2, 6, 8, 13, 32, 38–39, 185, 263n4; and movies, 198; newspaper coverage of, 12–14, 149, 151; and photo op politics, 16; self-presentation of, 32–34, 185

cable television, 50
Calame, Byron, 13
Calhoun, John, 45
*Camera Lucida* (Barthes), 244
camera obscura, 41
Campbell, Martin, 230
Campbell, Robert, 139–40
*Candidate, The* (movie), 171–72
*Candid Camera* (television show), 24
Capra, Frank, 33, 168–69, 194–96, 231–32, 239

Carrey, Jim, 150, 179, 181
Carson, Johnny, 151
Carter, Jimmy, 135, 143–44
*Casablanca* (movie), 196–97, 244
*Casino Royale* (movie), 230–31
*Catch-22* (movie), 205
CBS, 19, 71, 75, 79, 85, 92, 95, 99, 107, 111, 125, 126–27, 131–34, 137
*CBS Evening News* (television show), 10, 73, 83, 108, 109, 112, 133, 136, 137
*CBS Morning News* (television show), 73
*CBS News Standards* (handbook), 130
Cell phone cameras, 5, 6, 7, 15–16, 30, 36, 63, 258
Central Intelligence Agency (CIA), 228–29
Chan, Jackie, 203
Chancellor, John, 100
Chase, Chevy, 58
Cheney, Dick, 16, 34
childbirth, videotaping of, 25–26
Childs, Marquis, 120
Chira, Susan, 254
*Choose Me* (Grace), 145
Church, Frank, 72
Ciavolino, Michael, 157
Cimino, Michael, 207
citizen heroes, 194–97, 218, 231–38
citizen journalists, 30, 63–64
civil rights movement, 126
Clark, Wesley, 16
Clarke, Sarah, 240
Clay, Henry, 117–18
Clement, Frank, 126–27
Clinton, Bill: newspaper coverage of, 147–48, 150, 152, 274n5; *Primary Colors* based on, 177; self-presentation of, 54, 234
Clinton, Hillary, 29–31
Close, Glenn, 216
*Close Encounters of the Third Kind* (movie), 230
CNN, 1–2, 16, 19, 50
Cochran, John, 85
Cochran, Robert, 238
coffins, photographs of soldiers', 62, 255
Cohen, Richard, 130
Colbert, Claudette, 46
*Colbert Report, The* (television show), 58
Coleman, Bill, 259
*Coming Home* (movie), 208
commentary, political, 99–101
commercialism, 56, 131. *See also* advertising
Connery, Sean, 225, 228

Conrad, Fred R., 150
conventions, political party, 11, 63–64, 68, 126–27, 142
Coolidge, Calvin, 118
Cooper, Anderson, 6
Cooper, Gary, 35, 53, 185, 193, 199, 204, 237
Cooper, James Fenimore, 188
Coppola, Francis Ford, 206
Coppola, Sophia, 183
cops, as maverick heroes, 198–204
Cosmatos, George Pan, 211
Costello, Frank, 48
Councill, Andrew, 153
*Countdown* (television show), 2
Couric, Katie, 19
cowboy heroes, 188, 190–94
Cowell, Simon, 29
Craig, Daniel, 230–31
Crawford, Bill, 85, 110–11
Crazy Horse, 259
Crenna, Richard, 211
Cronkite, Walter, 72–73, 78, 90, 108–9, 112–13, 122, 127, 137, 187
Crowley, Stephen, 141, 148, 151, 152, 153
Cruise, Tom, 214
C-SPAN, 50
Curtiz, Michael, 196
Cuthbert, Elisha, 240

Dadullah, Mullah, 257
Dafoe, Willem, 210
Daguerre, Louis-Jacques-Mandé, 41, 45, 258, 262
daguerreotypes, 42–44, 258–59, 262
DailyKos (blog), 18
*Daily News* (tabloid), 46
*Daily Show with Jon Stewart, The* (television show), 58, 138, 139
"daisy ad," 84
Daley, Richard, 68
Damon, Matt, 229, 231, 236
Dangin, Pascal, 20–21
Darby, Joseph, 2–4
*David Letterman Show* (television show), 138
Davis, Javal, 4
dead, photography of the, 254–57
Dean, Howard, 55, 138
Deaver, Michael, 69, 120, 130, 132
debates, presidential, 8–10, 74, 88, 90–91, 127
*Deer Hunter, The* (movie), 33, 190, 207–9
Democratic National Convention (1968), 68

Democratic party, 53, 117
Dench, Judi, 231
De Niro, Robert, 177, 208
*Departed, The* (movie), 228
Depression, 125, 155, 246–48, 276n4
De Wilde, Brandon, 192
Diamond, Edwin, 131
DiCaprio, Leonardo, 228
*Die Hard* (movie), 200–202, 219, 227
digital photography: and Abu Ghraib scandal, 3–4; and candidates' Web sites, 29–31; in everyday life, 35–36, 60–61; and "gotcha moments," 15; preservation of, 65; in *S1m0ne,* 178–79; in *Spider-Man 3,* 223
digital technology: and citizen journalism, 30, 63–64; image enhancement through, 18–24, 178–79, 223; impact of, 6, 50–51; and political scrutiny, 14–16; and traditional photography, 61–62
digital video cameras: and candidates' Web sites, 29–31; and citizen journalism, 30, 63–64; and "gotcha moments," 15
Dionne, E. J., Jr., 145
Diorama, 41
*Dirty Harry* (movie), 199, 219
Dirty Harry movies, 198–200
Disney/MGM Studios, 139–40
Disney World, 139–40
documentary function of pictures: belief in, 8, 65; everyday life and, 36; increasing capacity for, 7; memory and, 60–62; movies and, 46; in news coverage, 133; *New York Times* and, 142–44; photography and, 42–44, 60–62, 124–25, 154; television and, 49–50, 125–26; videos and, 63–65; watchdog role of, 14–16, 261
Doherty, Thomas, 65
Dole, Robert, 147–48
Donaldson, Sam, 74, 93, 97, 101, 145–46
Donner, Richard, 217
*Doonesbury* (comic strip), 52
Douglas, Melvyn, 174
Dover Air Force Base, 255
*Dr. No* (movie), 228
Dukakis, Michael, 101, 147; negative ads aimed at, 54, 78–81, 89, 98; newspaper coverage of, 144–45; self-presentation of, 54, 55; tank ride of, 54, 73–74, 94–95, 145; and television, 68, 73–74, 85, 88–89, 93–94, 96–97, 102–3, 112
Dunaway, Faye, 173
Duncan, David Douglas, 255

Duncan, Dayton, 95
Dunlop, Alexander, 64
Duvall, Robert, 207
Dwight, Thomas, 116

Eastwood, Clint, 33, 198–200, 204, 227, 228, 250–51
Edison, Thomas, 46, 118
editing techniques, television, 109–14
Edwards, John, 30, 31, 138
*Eiger Sanction, The* (movie), 228
Elliott, Denholm, 224
Ellis, David, 61
Ellis, John, 131
Emanuel, Rahm, 150
embedded journalists, 253–54, 277n15
Emerson, Ralph Waldo, 43, 44
Emmerich, Noah, 180
Emmerich, Roland, 215
*Empire Strikes Back, The* (movie), 226
England, Lynndie, 3
entertainment, news as, 19, 46, 50, 94, 108–9, 119, 130–33, 138–39, 172–73
Erikson, Erik, 188
Evans, Walker, 124, 155, 164, 185
everyday life: digitally enhanced pictures and, 21–22; digital photography in, 35–36, 60–61; image consciousness in, 7–8, 27, 58, 243, 260–62; pace of, 122–23; posing in, 36; self-presentation in, 58; videos and, 24–28
*Explorer* (television show), 249, 276n3

Facebook, 30, 31, 220
*Face in the Crowd, A* (movie), 169–70, 188
facts, news coverage treatment of, 69–70, 76, 78–81, 88, 96–97, 105
failed images: as news, 12–14, 91–95; photography and, 161–64; political use of, 16–17
fairness, in journalism, 69, 96–99
Farhi, Paul, 15
Farm Security Administration, 124, 155
fashion photography, 19–21
*Father Knows Best* (television show), 48, 261
Federalist, 116
Field, Sally, 223
films. *See* movies
Finch, Peter, 172
Finnegan, Patrick, 34–35
*Flags of Our Fathers* (movie), 250–51
Flickr, 30
Fonda, Jane, 18

Ford, Betty, 144
Ford, Gerald, 58, 94
Ford, Harrison, 216, 224, 227
Ford, Henry, 118
*Forrest Gump* (movie), 233–36
Forster, Robert, 170
Fox, Julia R., 139
FOX News Network, 2, 50, 132
frames and framing: art photography and, 153–61; failed images and, 12–17, 161–64; as interpretation, 244, 246; movies and, 32; peripheral images and, 152–53; photographers in the frame, 147–49, 163–64, 274n2; photographing photo ops, 141–47; television in the frame, 149–51; television news and, 57; of Zarqawi dead, 256–57
framing the flaw, 12–17, 161–64, 223
Frank, Reuven, 84, 125, 131
Frank, Robert, 59, 156, 164, 191, 261
Frankel, Max, 51–52
Franklin, Andy, 82
*Fredericksburg Free Lance-Star* (newspaper), 61
Friedlander, Lee, 55, 157–60, 164, 191
Friedman, Steve, 19

Gable, Clark, 46
Gabler, Neal, 50
gaffes, 12–16, 91–95. *See also* failed images
Gaines, James R., 20
Garment, Leonard, 76
Gifford, Don, 26
Gilbertson, Ashley, 254
Giuliani, Rudy, 30, 31, 138
Gleason, Jackie, 10
Goffman, Erving, 58
Goldwater, Barry, 84
*Gong Show, The* (television show), 49
*Good Morning America* (television show), 138
Gorbachev, Mikhail, 85, 86
Gore, Al, 149, 150, 151
"gotcha moments," 15
Gottlieb, Martin, 13
Gould, Elliott, 207
Grace, Arthur, 145–47
Grace, Topher, 223
Graner, Charles, 3
Grant, Ulysses S., 121
Green, Jonathan, 167
*Green Berets, The* (movie), 187, 190, 205
Greenfield, Jeff, 77

Grenada, 104
Griffith, Andy, 170
Gula, Sharbat, 246–47, 249–50
Gulf War. *See* Persian Gulf War (1991)

Hamill, Mark, 226
Hanks, Tom, 185, 233, 236
Hanlin, Kirk, 2
Harding, Warren, 118
*Harper's Weekly* (magazine), 44, 122
Harris, Ed, 180
Harris, Neil, 121
Harrison, William Henry, 117
Hart, John, 10, 129
Healy, Brian, 72, 82–83
Hearst, William Randolph, 119
Heflin, Van, 192
Henreid, Paul, 197
Hepburn, Katharine, 168
Hewitt, Don, 113–14, 126–27
Hewlett Packard, 21
*High Noon* (movie), 53, 185, 191–94, 199, 204
high school yearbooks, 23
Hine, Lewis, 185
Hoffman, Dustin, 177, 190
Holmes, Oliver Wendell, 42, 60
home, theme of, 235–38
home movies, 65
home videos, 25–26, 65
Hoover, Herbert, 118
Hope, Leslie, 240
Horton, Willie, 80–81, 98, 144
*Howdy Doody* (television show), 48
Hu Jintao, 12
Hume, Brit, 74, 77, 80, 100, 163
Humphrey, Hubert, 9, 70–72, 74, 77–78, 86, 92, 99, 100, 112, 142
Hunter, Holly, 175
Huntley, Chet, 78
*Huntley-Brinkley Report* (television show), 84, 109, 125, 131, 136
Hurricane Katrina, 61–62, 64
Hurt, William, 175
Hussein, Saddam, 4–6, 17

iconic images: Abu Ghraib, 3; "Afghan Girl," 246–47, 249–50; Iwo Jima, 40, 250–51; media, 234; "Migrant Mother," 246–49, 276n4; popular culture, 55–56, 230; "Tomoko Is Bathed by Her Mother," 252–53; Vietnam War, 40, 251–52; Warhol's art, 55–56

identity. *See* self
Ifill, Gwen, 150
*I Love Lucy* (television show), 48
*Image, The* (Boorstin), 57, 127
image consciousness: in art and photography, 55–57; Disney World and, 139–40; in movies, 31–32, 188, 220–24, 230; in newspapers, 142–53; in photography, 153–64; politicians' Web sites and, 29–31; popular, 7, 27, 58, 243, 260–62; reality television and, 28–29; scholarship on, 57; in television, 57–58, 70–77, 83, 86–87, 109–10, 129, 139–40; videos and, 24–28. *See also* photo-op culture
image control: contest for, 13–14, 16–17, 53–54, 73, 244, 246; government and, 253–55; media and, 254–55; politics and, 8–14, 16, 18, 32–34, 39, 52–55, 71–77, 148; subjects of pictures and, 253–54, 257–60
images. *See* image consciousness; image control; movies; photography; pictures
*Independence Day* (movie), 1, 32, 215–16
*Indiana Jones and the Last Crusade* (movie), 224–26
*Indiana Jones and the Temple of Doom* (movie), 224
infotainment, 50
instant replays, 28, 64
Internet: impact of, 50–51; matchmaking sites on, 22; news coverage on, 51–52; and politics, 55; videos posted on, 25, Web sites of candidates on, 29–31
interpretation, of pictures, 244, 246, 248, 250. *See also* image control
Iran-Contra hearings, 53
Iraq War: and Abu Ghraib scandal, 3–4; and Hussein's hanging, 4–6; Internet and, 51; and "Mission Accomplished" media event, 1–2, 38–39, 263n4; photographs of casualties from, 62, 253–56, 277n15; *Times* photos of Bush during, 14
*It Happened One Night* (movie), 46
*It's a Wonderful Life* (movie), 235
Iwo Jima, 250–51

Jackson, Andrew, 33, 117
James Bond movies, 228–31
Al Jazeera (television network), 17
Jefferson, Thomas, 116, 117
Jennings, Peter, 74, 85, 92, 97, 98
Johansson, Scarlett, 183

John Paul II, Pope, 37–38
Johnson, Lyndon, 84, 187, 274n2
Josephson, Ken, 157
journalism: changing styles of, 99–101, 110, 133; Internet and, 51; photography and, 46, 51; tabloid, 46, 256. *See also* newspapers; photojournalism; television news
journalistic values: balance and fairness, 69, 96–99; military casualty photos and, 254–57; news coverage based on, 130–31; photo ops and, 13–14
journalists: citizen, 30, 63–64; commentary and reporting blurred by, 99–101; complicity of, 9–11, 14, 19, 57, 68–70, 75–78, 80–81, 84–85, 104, 134–36, 139–40, 163, 255–57; critical scrutiny by, 1–2, 9–14, 39–40, 57, 69, 73, 75–77, 103–4, 134–36, 139–40, 147–51; embedded, 253–54, 277n15; and media advisers, 87–91; treatment of, by political campaigns, 83–84, 145. *See also* media; television news
Judd, Jackie, 80–81

Kazan, Elia, 169–70
Keaton, Michael, 219
Kefauver, Estes, 48, 127
Keller, Bill, 13
Kellerman, Sally, 207
Kellogg, Ray, 187
Kelly, Grace, 193
Kennedy, John F., 146, 150, 157; assassination of, 49; Clinton and, 234; and television, 8, 10, 127, 153
Kennedy, Linda, 22
Kennedy, Robert, 187
Kerry, John, 16, 18, 138, 148, 150, 153
Kidder, Margot, 219
King, John, 39
King, Martin Luther, Jr., 187
King, Rodney, 63
Klauber, Edward, 119
Klein, Joe, 177
Kodak, 45
Koppel, Ted, 83–84, 86, 107–8, 129
Kosinski, Jerzy, 173
Kovic, Ron, 261–62
Kurds, 52

Ladd, Alan, 191
Lagouranis, Tony, 35
Landon, Alfred E., 119

Lange, Dorothea, 124–25, 185, 246–48, 276n4
*Larry King Live* (television show), 138
late night television. *See* talk shows
*Leave It to Beaver* (television show), 48
Lee, Russell, 155
Lester, Adrian, 177
Levinson, Barry, 177
Library of Congress, 65
*Life* (magazine), 47–49, 124, 134, 252
Lincoln, Abraham, 11–12, 33, 45, 121
Linney, Laura, 180
Lippmann, Walter, 124
Locke, Sondra, 200
Lombard, Carole, 155
Lombardi, Federico, 37
*Look* (magazine), 124
*Los Angeles Times* (newspaper), 25, 255
*Lost in Translation* (movie), 183–84
Loud family, 49
*Love before Breakfast* (movie), 155
Lucas, George, 226
Lumet, Sidney, 172–73
Lynch (general), 17

macaca, 15
Machiavelli, Niccolò, 52
Mackin, Cassie, 129–30
MacLaine, Shirley, 174
Madonna, 28
magazines, 20, 47–48, 123–24
*Magnum Force* (movie), 199–200
Maguire, Tobey, 220
*Making of the President, The* (White), 86
Mann, Steve, 63
*Marathon Man* (movie), 228
Marchand, Roland, 47
Martinon, David, 21
Masai, 259
*M\*A\*S\*H* (movie), 205–7
*Mask, The* (movie), 150
Matthews, Chris, 2
maverick hero: action hero as, 224–31; in American movies, 185, 188–91; Bush as, 32–34, 185; characteristics of, 189–90; citizen as, 194–97, 231–38; classic, 191–98; cop as, 198–204; cowboy as, 191–94; exposure of, 261–62; versus the institution, 189–90, 194, 205, 213, 217, 228; politician as, 198, 215–17; Reagan as, 33–34, 185–86; soldier as, 204–15; superhero as, 217–24; on *24*, 34–35, 238–42

McCain, John, 29–31, 138, 153
McCarthy, Eugene, 187, 274n2
McCarthy, Larry, 81, 84
McClellan, Scott, 263n4
McCurry, Steve, 247, 249–50
McDonald, Willard "Mac," 23
McGinniss, Joe, 57, 86–87, 110
McGovern, George, 129
McLuhan, Marshall, 57
McMahon, Ed, 151
McTiernan, John, 200
Mead, Margaret, 50
media: communication through, 37; disillu-
    sionment with, 114–15; image manipula-
    tion by, 18–19; presidential politics and,
    116–20; tension in, regarding images, 9–14.
    See also journalists
media advisers, 86–91, 118
media events, 70–77, 129, 162, 164. See also
    photo ops
Medium Cool (movie), 170–71
Meet the Press (television show), 34
mega churches, 28
memorial sites, 62
memory, 60–62, 258
Meyer, Emile, 192
Michaels, Eric, 259
Michelson, Sig, 126
Mickey Mouse Club, The (television show), 48
Midnight Cowboy (movie), 190–91
"Migrant Mother" photograph, 246–49,
    276n4
Mikkelsen, Mads, 230
Mills, Doug, 150
"Mission Accomplished" media event, 1–2, 6,
    8, 13, 32, 38–39, 185, 263n4
modernist drama, 154, 159
Mondale, Walter, 88, 144
Moonraker (movie), 230
Moore, Roger, 228
Morse, Samuel, 41, 42
Morton, Bruce, 73–74, 79–80, 93–95,
    102–3, 145
movie heroes: action heroes, 224–31; citizen
    heroes, 231–38; classic, 191–98; cultural
    meaning of, 187–91; cops, 198–204; politi-
    cians, 215–17; soldiers, 204–15; superhe-
    roes, 217–24
movies: cultural impact of, 46; image con-
    sciousness in, 31–32, 188, 220–24, 230; mav-
    erick hero in, 188–91; mythic qualities of,

188; origins of, 46; television in, 168–84.
    See also movie heroes
Moyers, Bill, 133
Mr. Smith Goes to Washington (movie),
    194–96
MSNBC, 2, 50
MTV, 50, 138
Mudd, Roger, 72–73
Murphy, Eddie, 203
Murphy, Kathryn, 95
Murphy, Kingsley H., Jr., 142
Murray, Bill, 183
Murrow, Edward R., 131
Museum of Modern Art, New York, 165
Muskie, Edmund, 55, 67, 102, 142, 162
Myers, Lisa, 75–76, 88
MySpace, 8, 25, 30, 220
myth/mythology: American, 188, 197, 198,
    202, 207, 226, 231, 235; cultural role of, 65,
    188; exposure of, 188, 197, 219, 261–62; he-
    roic, 190, 207, 215, 226–28, 240; images
    and, 188, 202, 243; movies and, 188, 218–
    19, 224, 226–28, 230, 233; paradoxical atti-
    tude toward, 218–19, 226, 230; political im-
    ages and, 32

Nadar, 44
Napier, Charles, 212
Napolitan, Joe, 76, 81
Nast, Thomas, 44
Nation (magazine), 122
National Film Preservation Board, Library of
    Congress, 65
National Geographic (magazine), 247, 249–50,
    276n3
natural sound, 111–12
NBC, 19, 67, 68, 70, 84, 92, 100, 106, 137
NBC Nightly News (television show), 106
Neal, Patricia, 170
negative campaigning, news coverage of, 54,
    78–81, 88, 98
Net watches, 137
Network (movie), 172–73, 188
New Documents (exhibition), 165
New Republic (magazine), 118
news. See television news
news anchors. See television news anchors
newspapers: and advertising, 120; and cover-
    age of photo ops, 141–53; early politics
    and, 116; Internet and, 51; and pictures, 51,
    120–22; reader behavior and, 51–52; televi-
    sion as subject in, 149–51, 274n5

news values. *See* journalistic values
*Newsweek* (magazine), 20, 26, 34, 119, 137, 145
*New York Daily Graphic* (newspaper), 46
*New York Daily News* (newspaper), 256
*New Yorker* (magazine), 36
*New York Sun* (newspaper), 118
*New York Times* (newspaper), 2, 12–14, 26, 51–52, 62–64, 123, 141–53, 254, 255, 257, 260
Niccol, Andrew, 178–79
Nichols, Mike, 177
Nicholson, Jack, 219
*Nightline* (television show), 107
Nixon, Pat, 143
Nixon, Richard, 37, 92–93, 100, 146, 187, 234; image of, 8–10, 57, 88, 127–28; newspaper coverage of, 142, 143; and television, 71–72, 74, 77–78, 83, 86, 99, 112, 128–29
Norfleet, Barbara, 159–60
North, Oliver, 53
Northshield, Shad, 109, 131, 136

Obama, Barack, 29, 31
O'Brien, James R., 260
O'Connor, Sandra Day, 141
Oklahoma City National Memorial and Museum, 62
Olbermann, Keith, 2
Oliver, Don, 70–71
Operation Photo Rescue, 61–62
*Oprah* (television show), 138
Oreskes, Michael, 145
*Original Amateur Hour, The* (television show), 49
Osbourne, Ozzie, 28
Oswald, Lee Harvey, 49
Owens, Bill, 158–59
Owens, Troy, 247
*Ozzie and Harriet* (television show), 261

pace of life, 122–23
Pacino, Al, 178
Palance, Jack, 192
Panopticon conference, 63
*Paris-Match* (magazine), 21
Park, Robert, 46
patriotism: art photography and, 156, 165; Iwo Jima photograph and, 250; in movies, 187, 194–95, 198, 206–9, 211, 213–18, 224, 232–33, 238, 242; political imagery and,

30–31, 76, 104; as political issue, 77, 89; torture and, 35
*Patton* (movie), 204–6
Pearlman, Beth, 27
perfect/puncture attitude toward pictures, 10–14, 29, 31, 133–40, 221, 223
Perkins, Jack, 72
Perl, Jed, 260
Perot, Ross, 151
Persian Gulf War (1991), 50, 52, 255
person. *See* self
Petersen, Wolfgang, 215
photo finishes, 64
photographers, in newspaper pictures, 147–49, 163–64, 274n2
photographic retouching: advertising and, 47; and body image, 19–24; in early photography, 45; media and, 18–19; of personal photographs, 35–36; politics and, 18; tools/services for, 22; in *S1m0ne*, 178–79
photography: and advertising, 47; art, 153–64; of the dead, 254–57; dual (documentary/artificial) nature of, 45–47, 65–66, 121, 262; ethics of, 260; and failed images, 161–64; iconic, 246–53; image consciousness in, 55–57, 153–64; and the individual, 59; interpretation of, 244, 246, 248, 250; journalistic use of, 46, 51; magazines based on, 47–48, 123–24; memory and, 60–62, 258; "mistakes" in, 158, 163, 166; origins of, 42–43, 258–59, 262, 267n2; person/pose tension in, 243–62; photo ops examined through, 161–64; popularization of, 45–46; and portraiture, 43–45, 59, 61, 184–85, 258–59; public/private tension in, 244–46, 257; and reality, 42–44, 124–25, 154, 246; snapshots, 2–3, 45, 47, 157, 159, 165; television and, 154–55, 158–59; as theft, 257–60. *See also* pictures
photo illustrations, 20
photojournalism: dilemma of, 145–46; new era in, 46; *New York Times* and, 51, 142–53; self-awareness of, 147–49; and television, 149–51
photo-op coverage, 75–77, 92, 103–4, 106, 134, 137, 139, 141, 185
photo-op culture, 7–8, 182, 184, 197–98, 223, 243, 260
photo opportunities, 74. *See also* photo ops
photo ops: art photography and, 161–64; of the dead, 255–57; in early twentieth-century politics, 118; failed, 12–14, 16–17, 91–

95; media consciousness of, 74; newspaper coverage and, 141–53; origin of, 9–10; politics and, 8–14. *See also* framing the flaw

Photoshop, 18, 35. *See also* photographic retouching

Photosmart digital camera, 21–22

Phuc, Kim. *See* Vietnam-era photograph of running girl burned by napalm attack

pictures: appetite for, 60; dual attitude toward, 8–14, 13, 24, 69, 120, 243, 258–62; historical criticisms of, 120–22; impact of, 1–7; interpretation of, 244, 246, 248, 250; journalism and, 120–22; magazines and, 124; media scrutiny of, 1–2, 9–14, 39–40, 57, 69, 103–4, 134–36, 139–40, 147–51; memory and, 60–62; as performances, 159–61; personal use of, 36; self-awareness about (*see* image consciousness); selfhood and, 24–31, 243–62; words versus, 101–5, 107–8. *See also* documentary function of pictures; *entries beginning with* image

Pirandello, Luigi, 159

*Platoon* (movie), 190, 209–11

Poe, Edgar Allan, 42

police officers, as maverick heroes, 198–204

politicians: image of, 54–55; in maverick hero role, 32–34, 198, 215–17; speech of, 67–68, 103, 110–12, 122–24, 137, 151

politics: and advertising, 77–86, 97–98; and candidates' Web sites, 29–31; disillusionment with, 114–15, 151; gaffes in, 12–16; and image control, 8–14, 16, 18, 32–34, 39, 52–55, 71–77, 148; and media events, 70–77; presidential election, 116–20; scrutiny of, by taking pictures, 14–16, 261; television and, 67–86, 114–15, 126–27, 130, 134–35, 168–72, 177–78

Polk, James, 117

PortraitProfessional software, 22

portraits, photographic, 43–45, 59, 61, 184–85, 258–59

posing: candidates and, 30–31; critique of, 37; in everyday life, 36; selfhood and, 243–46

Post, Ted, 199

*Presentation of Self in Everyday Life, The* (Goffman), 58

presidential campaigns: and digital technology, 29–31; history of media involvement in, 116–20; *New York Times* coverage of, 142–53; Web sites for, 29–31

presidents, as maverick heroes, 215–17

press. *See* journalists; television news

press conferences, 83

*Primary Colors* (movie), 177–78

privacy, 244–46, 257

pseudo-events, 37, 57, 127–28, 139

*Public Relations* (Winogrand), 161–64

Pullman, Bill, 215

Al Qaeda, 255

Quayle, Dan, 54, 81

Quinn, Charles, 102, 126

radio, 119, 123–24

Rafshoon, Gerald, 143

*Raiders of the Lost Ark* (movie), 224–25

Raimi, Sam, 220

Rains, Claude, 195, 196

*Rambo: First Blood Part II* (movie), 211–13

Rather, Dan, 19, 89–91, 92, 112

ratings, television, 108–9, 113, 130–33

Ratner, Brett, 203

*Reader's Digest* (magazine), 122–23

Reagan, Nancy, 11, 144

Reagan, Ronald, 83, 88, 158, 198; image of, 8, 33–34, 69, 87, 120, 185–86; and media events, 72–73; newspaper coverage of, 144, 274n2; and religion, 33–34; at Republican convention, 11; and television, 103–4, 130, 134–35

reality: manipulation of, 29–31; photography and, 42–44, 124–25, 154, 246; pseudo-events versus, 37, 57. *See also* documentary function of pictures

reality television shows, 28–29, 49–50, 179

Redford, Robert, 171

Reeve, Christopher, 217

religion: Reagan and, 33–34; Vatican's media use, 37–38

replays, in sports, 28, 64

Republican National Convention (1984), 11

Republican National Convention (2004), 63–64

Republican Party, 118–19

Reston, James "Scottie," 128

revolving-door prison advertisement, 79–80

Reynolds, Frank, 99, 100

Richardson, Eliot, 162

Rickman, Alan, 201

Riis, Jacob, 185

Robbins, Tim, 177

Roberts, Richard Samuel, 61

*Rocky* (movie), 185, 231–32

*Rocky II* (movie), 233
*Rocky IV* (movie), 233
Roddick, Andy, 23
Rogers, Ginger, 46
Rollins, Ed, 88
Romney, Mitt, 29
Roosevelt, Franklin D., 47, 118–19
Roosevelt, Teddy, 14, 33
Root, Marcus Aurelius, 184
Rosenbaum, Jill, 82
Rosenstiel, Thomas, 134, 254
Rosenthal, Joe, 40, 250
Rothstein, Arthur, 155
*Rowan and Martin's Laugh-In* (television show), 57
Ruby, Jack, 49
Rudisill, Richard, 259
Rumsfeld, Donald H., 151
*Rush Hour* movies, 203–4
Russert, Tim, 34

Sack, Kevin, 151
al-Sadr, Muqtada, 5
Salant, Richard, 94, 130
*Sands of Iwo Jima, The* (movie), 261
*San Francisco Examiner* (newspaper), 119
Sarkozy, Nicolas, 21
Sasso, John, 89, 94
*Saturday Night Live* (television show), 57, 138, 151
Savage, John, 208
*Saving Private Ryan* (movie), 185, 236–38
Savitz, Andrew, 94
Schieffer, Bob, 73, 76–77, 107, 132
Schlesinger, John, 190
Schmidt, Steve, 18
Schoumacher, David, 71–72, 92, 129
Schram, Martin, 135
Schudson, Michael, 120
Schwarzenegger, Arnold, 198
Scorsese, Martin, 228
Scott, George C., 204
Scott, Tony, 203, 213
Scott, Winfield, 118
self: American, 185; deformed, 59, 164–68; fabricated, 58–60, 65, 184; in image-conscious culture, 58–59; loss of, 178; of maverick hero, 189; as performance, 159–61; photography and, 243–62; traditional concept of, 65, 184–85
*Self-Portrait* (Friedlander), 55, 157

self-presentation: in everyday life, 58; of politicians, 29–31; videos and, 24–27
Sell, Becky, 61
Seller, Peter, 173
*Selling of the President, The* (McGinniss), 57, 86–87
September 11, 2001, attacks, 62
Serafin, Barry, 87
Sevareid, Eric, 99, 119
Seward, William Henry, 118
Sforza, Scott, 263n4
"Shadow, The" (radio show), 153
Shakespeare, Frank, 72, 81, 88, 128–29, 136
*Shane* (movie), 191–94
Sheen, Charlie, 209
Sherman, Cindy, 160–61
Shevardnadze, Eduard, 74
*Shining, The* (movie), 35
Siegel, Don, 199
Simmons, J. K., 221
*S1m0ne* (movie), 178–79
Simon-Pierre, Marie, 37–38
Simpson, O. J., 20, 50
Sinatra, Frank, 49
*Six Characters in Search of an Author* (Pirandello), 159
*60 Minutes* (television show), 113–14
*60 Minutes II* (television show), 4
Slemmons, Rod, 159
Smith, Aileen Mioko, 253
Smith, Eugene, 252–53
Smith, Lou, 68
Smith, Will, 216
snapshots, 2–3, 45, 47, 157, 159, 165
Socolow, Sanford, 83, 108, 136
soldiers, as maverick heroes, 204–15
Somalia, 52–53
soul, photography and the, 258–60
sound bites, 67–68, 72, 101, 103, 107, 110–12, 137, 151
"sousveillance," 63
Southworth, Albert, 44
*Spider-Man 1* (movie), 220–22
*Spider-Man 3* (movie), 222–24
Spielberg, Steven, 53, 224, 226, 230, 236, 238
sports, 28, 64
*Spy Who Loved Me, The* (movie), 230
stagecraft: newscasts as, 19, 37; politics as, 1–2, 13, 75, 87, 96, 136, 263n4
staging, of televised news, 125–26
Stahl, Lesley, 79, 88, 90–91, 103–4, 133–34
Staley, Lynn, 20

Stallone, Sylvester, 185, 211, 231
Stars and Stripes (newspaper), 256
Star Wars (movie), 226–28
State of the Union (movie), 168–69, 185
Stevens, George, 191
Stewart, James, 194, 237
Stewart, Martha, 20
Stone, Oliver, 209
Stryker, Roy Emerson, 276n4
Suburbia (Owens), 158
Sudden Impact (movie), 200, 227
Sullivan, Andrew, 38
Sununu, John, 81
superheroes, 217–24
Superman (movie), 217–19
Surnow, Joel, 238
Survivor (television show), 29
Sutherland, Donald, 207
Sutherland, Kiefer, 35, 238

tabloid journalism, 46, 256
Talbot, William Henry Fox, 267n2
Taliban, 250
talk shows, 138, 151
Taylor, Paul, 125
Teeter, Bob, 91
television: cable, 50; cultural impact of, 48;
    documentary function of, 49–50, 125–26;
    dual (documentary/artificial) nature of, 50,
    115, 171, 175–76, 178–83; image conscious-
    ness in, 57–58, 70–77, 83, 86–87, 109–10,
    129, 139–40; impact of, 126–27; in movies,
    168–84; news coverage on, 48–50, 57–58;
    newspaper photojournalism and, 149–51,
    274n5; origins of, 48; photography and,
    154–55, 158–59; and politics, 67–86, 114–
    15, 126–27, 130, 134–35, 168–72, 177–78;
    reality, 28–29, 49–50, 179; staging prohib-
    ited on, 125–26; technological changes in,
    110–13
television news: changes in coverage of, 101–
    15; and entertainment, 19, 46, 50, 94, 108–
    9, 119, 130–33, 138–39, 172–73; failed im-
    ages as, 12–14, 91–95; Internet and, 51–52;
    1968 versus 1988, 99–115; pacing of, 107–8,
    110, 113; picture-driven, 107–9, 133–34; po-
    litical ads and, 77–86, 97–98, 106–7; politi-
    cians' abandonment of, 137–38; television
    and, 48–50, 57–58. See also journalists
television news anchors, image of, 19, 57
terrorism, 34–35, 238–42

Terry, Don, 150
theater criticism, as a style of political cover-
    age, 1–2, 37, 75–76, 88, 103, 150. See also
    image consciousness
This Morning (television show), 138
Thompson, Florence Owen. See "Migrant
    Mother" photograph
Thompson, Fred, 29–30, 138, 198
Three Days of the Condor (movie), 228
Threlkeld, Richard, 78–79
Time (magazine), 20, 34, 47, 54, 89, 124
Today (television show), 138
Toensing, Amy, 152
"Tomoko Is Bathed by Her Mother" (photo-
    graph), 252–53
Tonight Show (television show), 30, 138, 151
Top Gun (movie), 1, 32, 213–15
Top Hat (movie), 46
torture, 3–4, 35, 239, 261
Tracy, Spencer, 168, 185
Travolta, John, 177
tribal peoples, and photography, 258–59
Troy, Gil, 116
True Grit (movie), 190
Truman Show, The (movie), 179–83, 188
Trump, Donald, 31
Truth or Dare (movie), 28
Tucker, Chris, 203
TV Guide (magazine), 19–20, 50
Twain, Mark, 44
Tweed, Boss, 44, 52
24 (television show), 34–35, 238–42

Uemura, Tomoko, 252–53
U.S. Army, 17
USA Today (newspaper), 51
U.S. Defense Department, 256
USS Abraham Lincoln, 1, 39
U.S. Supreme Court, 141
Ut, Nick, 251–52

Vatican, 37–38
Venardos, Lane, 85
video cameras: and control of images, 5–6;
    and documentation of controversial events,
    15–16, 62–64; in everyday life, 24–26; and
    political coverage, 15–16; and reality televi-
    sion, 29. See also digital video cameras
videos: America's Funniest Home Videos and,
    24–25; documentary function of, 62–65;
    home, 25–26, 65; of Hussein's hanging,

videos (*cont'd*)
  5–6; Internet posting of, 25; of politicians,
  15–16, 29–31; on screens at large events,
  27–28; on YouTube, 8, 15, 16, 24, 25, 27,
  31, 246, 262; of Zarqawi, 17
Vietnam-era photograph of fighter's
  execution, 40
Vietnam-era photograph of running girl
  burned by napalm attack, 251–52
Vietnam Veterans Memorial, Washington,
  D.C., 62
Vietnam War, 33, 187, 189–90, 205–6,
  208–11, 251, 255, 261–62
visual images. *See* pictures
Voight, John, 190

*Wag the Dog* (movie), 177
Walken, Christopher, 208
Wallace, Chris, 93–95
Wallace, DeWitt, 122–23
Wallace, George, 9, 71, 100
wallpaper, pictures as, 133–34
*Wall Street Journal* (newspaper), 27, 51
war, control of images from, 253–55
Warhol, Andy, 55–57, 59–60, 178
*Washington Post* (newspaper), 15, 255
*Watch* (magazine), 19
Watergate scandal, 189
Wayne, John, 35, 187, 190, 213, 227–28,
  261–62
Webb, Jim, 15
Web sites: for presidential candidates, 29–31;
  for Vatican, 38
Webster Brothers, 258

wedding photojournalism, 27
Weir, Peter, 179
westerns, 191–94, 200
Wexler, Haskell, 170
Wheatley, Bill, 94, 106–7
Whig Party, 117–18
Whitaker, Bill, 95
White, Theodore, 86, 127
Whitman, Christine Todd, 149–50
wide-angle photography, 148–49
Willis, Bruce, 200, 227–28
Willis, N. P., 44
Wilson, Woodrow, 123
Winfrey, Oprah, 19, 151
Winogrand, Garry, 59, 153–54, 157, 161–64,
  166–68, 191
Winslet, Kate, 22–23
*Wizard of Oz, The* (movie), 139, 223, 235
Wooten, Jim, 88, 96–97, 105
words: images versus, 101–5, 107–8; politi-
  cians' televised speeches, 67–68; signifi-
  cance of, 38–40; *60 Minutes* and, 113–14
*World News Tonight* (television show), 137
World Trade Center, New York, 62

YouTube, 8, 15, 16, 25, 27, 30, 31, 220, 246, 262

Zahn, Paula, 19
Zamyatin, Evgeny, 123
Zapruder, Abraham, 49
Zarqawi, Abu Musab al-, 17, 255–56
Zemeckis, Robert, 233
Zinnemann, Fred, 191
Zirinsky, Susan, 75, 111–12, 135